Table of Contents

Purpose:
To increase awareness, promote understanding, and encourage
further inquiry into art related women's *issues* by exploring the
problem of sexism and the need for sex equity in art and art
education.

Purpose:
To increase awareness, promote understanding, and encourage
further inquiry into art related sex equity *progress* by exploring the
implications of individual and organized sex equity effort for art and
art education.

 a. Self-Education
 b. Formal Education
 c. Informal Education
 5. WHY? (Summary)
 a. The Need for Sex Equity Revisions in Art Education
 b. Alternative Ways of Achieving Sex Equity in Art Education
 c. The Art Teacher and Sex Equity Needs of Students
 d. Conclusion

 (2) Filmstrips
 (3) Audiotapes
 (4) Videotapes
 (5) Films
 (6) Instructional Materials
 b. Education
 (1) Instructional Materials
 (2) Other Sources of Instructional Materials

Plates

Acknowledgments

From its initial inspiration to its final realization, *Women, Art, and Education*, has been a collaborative effort. First and foremost, it involved a harmonious collegial joining of ideas, values, and efforts, all set against a backdrop of competing professional commitments and personal-life demands, frequently echoing the issues raised in this book. Time, space, and a sense of privacy do not permit us to adequately recount the arduous but rewarding process of writing this book.

The authors hereby express our thanks and appreciation to the many individuals who have given us their generous and enthusiastic support. Those colleagues and friends who have made immediate and valuable contributions to the form and substance of this book include Mary Ann Stankiewicz, Enid Zimmerman, and Ann Sherman, whose chapters increase the depth and relevance of the text; June King McFee, whose Introduction examines its significance in the larger cultural context; and Nancy MacGregor, whose Preface adds a timely perspective. The women artists who have enabled us to illustrate our text with relevant works by supplying us with photographs and information about their art include: Mary Beth Edelson, Sylvia Sleigh, May Stevens, Miriam Schapiro, June Blum, and Charlotte Robinson. Making *Women, Art, and Education* a concrete reality, the National Art Education Association has provided financial and editorial support for its preparation, publication, and dissemination.

In many ways this project has its true beginnings in the late 1970s when the co-authors were pursuing their research interests in women, art, and education as doctoral students in art education at The Ohio State University. For this reason, we thank our advisors: Robert Arnold for directing our attention to the educational relevance of contemporary art movements and issues, and Kenneth Marantz for demanding the pursuit of excellence in all phases of our teaching and research. Special thanks is due to Dr. Marantz, who, recognizing our common interest, has continued to encourage our collaboration in this and other projects.

In 1980, the authors submitted their first proposal to the NAEA for a monograph on women's issues in art education. Nevertheless, our first real opportunity for collaboration was to be the co-authoring with Ann Sherman of a chapter of the *Handbook for Achieving Sex Equity through Education* edited by Susan Klein. We feel the work done on this chapter prepared us for the larger task of writing *Women, Art, and Education* and therefore thank Ann Sherman for securing the inclusion of our chapter on visual arts in the *Handbook* as well as her direct contributions to it, Marylou Kuhn and John Mahlmann for reviewing our work, and Susan Klein, Lillian N. Russo, and Peggy J. Blackwell for editing the text.

As with many NAEA publications, ours began with formal proposals put before the Professional Materials Committee of the Board of Directors. We express our appreciation to the following individuals and groups whose support was instrumental in obtaining final acceptance of our project: John Mahlmann for encouragement and help in writing and rewriting the project proposal; the Women's Caucus of the NAEA for its formal support of the proposal; and Pearl Greenberg, Chair of the Professional Materials Committee, for her initial and continuing counsel, support and enthusiasm for this project. We also acknowledge the crucial support of two NAEA presidents, Edmund Feldman and Nancy MacGregor.

The authors appreciate the many contributions of reviewers and consultants to the final form of the manuscript. Daniel G. Cannon, Elliot W. Eisner, Pearl Greenberg, and Ann Richardson undertook the arduous task of reviewing the final draft; Mary Garrard generously agreed to review Chapter 5 for art historical accuracy and balance; Beverly Jeanne Davis typed and edited the manuscript and helped obtain the reproductions; Charlene Gridley designed the cover and graphics; Eugene Grigsby, Barbara Robinson Nicholson, and Leona Zastrow advised us on ethnic and minority artists; Laura Chapman gave her support and advice; J. Theodore Anderson and Daniel G. Cannon saw the project through to its successful completion; and our husbands, Clint and Steven, children, Gregg, Lynn, Christine, Laurence, and David, friends, and babysitters sustained us with their patience, understanding and love.

And at last, we thank you, the perceptive reader, for recognizing that the foregoing acknowledgments of individuals who have been helpful to our project in no way implicates them in the possible failings of our text. In this regard, we share with you this caution: our attempt to be comprehensive should not mislead us into the erroneous belief that we have included every important woman artist and teacher in our listings. We hope only to have suggested by such inclusions the wide variety and great number of heretofore unrecognized women's achievements and contributions in art and art education and to engage you in this process.

Georgia Collins
Renee Sandell

Preface

A worthwhile book in any field is a product of choices that have been made carefully. These choices are contingent on the judgment of those persons who made them. Professors Collins and Sandell knew what they were after when they searched the literature. They applied rigorous criteria and made proper selections to address issues related to past, present, and future sex equity in art education.

Their stated purpose is to increase readers' awareness and understanding of some of the major concerns to women in art, education, and art education. To carry out the job requires sensitivity both to the specific issues and to the women's movement at large. Collins and Sandell—because of their combination of background interest centered on women, art, and education—have compiled a manuscript which is appropriate for classroom art teachers and other art educators as well as those preparing to enter the field. The text, also designed as a handbook, is appropriate in that each chapter serves a specific purpose moving from a review of sex equity issues to practical applications in art education.

The authors have accomplished more than a simple presentation of information. They invite participation in the issues. A heritage for women is built, one that has been obscure or unknown. For me, their insight helps women place themselves in continuity by raising pertinent questions and providing female role models. They point out that the roles of women in art education have been different but no less important than those of their male counterparts. A sense of the nature of the contributions of women can help readers visualize themselves in a more meaningful context. The premise of Collins and Sandell is that once it is understood how women have contributed to art education, then there is a possibility that all art educators will develop new conceptions where equality will prevail.

The publication of this book is timely because it marks the tenth anniversary of the Women's Caucus of the National Art Education Association. The Collins/Sandell manuscript presents problems that have concerned the Caucus as well as opened up new avenues for the education of teachers and of teachers of teachers. They not only include a review of research relevant to sex equity in art education but also put forth a pluralistic approach to art teacher education that will assist in achieving sex equity. They fortunately identify resources and present practical strategies to achieve sex equity and excellence in the art curriculum and classroom. One would profit by reading, for example, about women's achievements or the charts in the last chapter. To read the entire book, however, is to appreciate the creative contribution to the field.

Nancy P. MacGregor
President
National Art Education Association

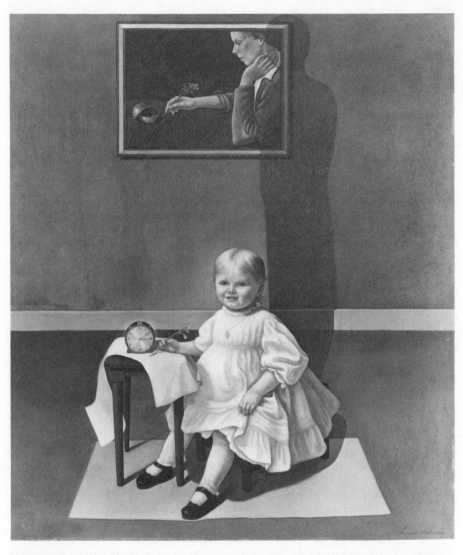

Helen Lundeberg. *Double Portrait of the Artist in Time*. 1935. Oil on masonite. 47-¾''
x 40''. 1978, 51. National Museum of American Art, Smithsonian Institution, Museum
Purchase.

Introduction

The interrelated impact of three facets of society—the traditional role of women, the cultural history of art, and the structure of education as these mold society—is addressed in this bench mark book. It is the first to be written for classroom teachers that reviews the background implications and stimulates student inquiry into this pivotal issue. The book is of considerable value to art education: to supervisors, teacher educators, scholars and researchers, as well as artists, art historians, and others concerned with the way cultural expectations and stereotypes about women and art affect the nature of our society and the ways we prepare young people for it.

Women, Art, and Education brings into focus a fundamental social deficiency that affects the quality of everyone's life. This deficiency stems from a hierarchical value system that esteems one sex and gender over another, attributes genderlike qualities to kinds of activities and types of products, and inhibits the contributions of the less esteemed group. Woven into the fabric of society through history, the work and products of one group are examined and their excellence rewarded and recorded while the work and products of the other group are largely unrewarded by the dominant sex. Thus the work of women has less effect on the quality of the society because it has been obscured and left unstudied.

Collins and Sandell and the book's other contributors address these stereotypic systems as applied to art and to women. They show how sexist values have distorted history, hidden or inhibited women's artistic achievement, deprived society of many of the qualities they might contribute, and perpetuated these distorted priorities in the education of younger members of society.

The book also increases our understanding of the nature of present society and the role and place of women, art, and education in it. The stifling of art because it is considered effeminate has reduced the impact of the arts as humanizing factors particularly when dehumanizing attitudes that value force and monetary rewards are rampant. Reading this text makes apparent that the impact of both women and art has been depressed and under utilized in the development of American society and what may be called American national character. This in turn effects the nature of American education.

Certainly the *values* of women and art in the major decision making processes that form the quality of our society have not been realized. Yet this is the society in which women and men, art and education interact and develop and to which we educate our children.

The authors expose the complexities of the problems—how art itself has not only been given effeminate connotations generally but how the visual arts are inversely valued from least to most feminine. They differentiate

mainstream art as recognized by art historians and traditionally shown in art museums and galleries, and hiddenstream art, the less rewarded more applied arts done primarily by women. They compare the roles, social structure, communication networks, and reward systems of both mainstream and hiddenstream art. Further effects of these modes on women's creativity and self esteem are discussed. Differences in autographic expressiveness in these two types of art are insightfully dissected—hiddenstream art being considered less personal, mainstream art more powerfully self expressive. The authors clarify the conflicts of women artists who succeeded in mainstream art.

The authors brilliantly analyze these effects on the reception art receives in public schools. They raise the critical question as to whether overcoming sexism generally would not help promote art as subject matter. Those who emphasize basic education at the expense of qualitative education, and concern for earning a living over the quality of living may be influenced in part by these same stereotypic attitudes.

Although not directly addressed in this book, the built environment is affected by the emphasis on the expedient, the economic, the massive, the monotonous. This seems more of a reflection of the stereotypically male aspects of society rather than utilization of the qualitative, individual, interpersonal, and interactive values of people with the environment that more women appear to imbibe.

Documentation of the place of women artists and the degree to which they are ignored in art history is another valuable contribution made in this book. This information is juxtaposed with a history of the women's movements helping us to place the feminist efforts of women artists and art historians in the context of the general women's movements of their time.

Excellent review is made of the role of women in art education. The history of women's contributions is shown as the major force in the development of the field, in offices held, in publications, in contributions made to the professional organizations. Yet the proportion of women to men in leadership positions does not reflect that contribution. For example, not having a balance of women in leadership positions on the national board may have encouraged the current business model of job alike organization which reinforces hierarchies and inhibits dialog from one part of the organization to another.

The book helps classroom teachers to become more aware of the ways their own teaching involves sexist expectations. The authors inform teachers of the many interlocking effects that produce the covert values, attitudes, and assumptions that underlie practices. They introduce them to historical and psychological research that identifies these effects.

But the authors do not leave the teacher there but develop specific analytical inquiry that can be used with students to help both sexes overcome their stereotypic thinking and behaving in relation to women and art. Thus the history documented is brought into play in the inquiry with students. At the end of the book the teaching strategy presented helps alert students to their own acceptance of stereotypes. Penetrating questions are asked that are valuable for self-reflection by all concerned with art and education to help them become aware of how far reaching their own cultural con-

ditioning to stereotypic thinking has become. Increased awareness of art teachers will be necessary if this continuing transmission of sexist values on women and art is to be changed.

There are other related questions raised by the data collected for this book, such as: Is the degree to which valuing women's art as of lesser quality also reflected in attitudes towards women's contributions to the profession, whether it be in publications, professional organization work, or program development in elementary, secondary, and higher education? Are we alerting teachers to the pervasiveness of cultural values that develop and maintain these sexist stereotypes? These values come from deep-seated learning in early childhood and are reinforced through life in what is said, what is done, what is believed, what is constructed, and how it is constructed. They reinforce not only sexist attitudes about children and their appropriate attitudes and role expectations but reinforce sexist attitudes about art as well. The evidence of cultural values is very apparent in the material documented in this book, but teachers need to be aware that the attitudes that cause them are often deeply ingrained, certainly reinforced by mass media and the dominant culture, and will take consistent, persistent effort to change them. The resistance to the women's movement is evidence of this.

In discussing stereotypes and cultural expectations and/or normative behavior, we have to bear in mind that these are trends, somewhat generally held beliefs that operate in maintaining a society's cultural value system. When we look at the range of values held by women and the range of values held by men, we find there is much overlap. We also recognize that there are individual women whose values are much more like cultural expectations for men, and individual men with values more like the expectations for women. This is compounded when individuals hold composites of values that might appear to be in conflict. For example, a woman teacher's concerns for individual children contrasted with the more masculine concern for subject matter is further complicated by the dichotomy between humanistic liberalism and the more disciplined conservative emphasis on academic excellence. Her politics could either strengthen or be in conflict with her concern for children. The authors skillfully deal with the stereotypes yet show the diversity and complexity of individual and group behavior.

Each individual in higher education who is training teachers, be it man or woman, is caught up in some phases of these dichotomies which strongly affects their preparation of teachers. The materials documented in this book will help both men and women understand more of their own positions and attitudes and what they may be transmitting to students. It may also help all teachers understand the problems of individual students whose aptitudes do not necessarily fit with their expected sex roles. All the tentacles of centuries of reinforcement in the many aspects of women and art will need to be addressed continually.

Another, perhaps more subtle, influence is on the field of art education itself. The role expectations of both men and women scholars in the field may also affect their contributions to art education. The male art educator working in a field that has feminine overtones has different socially reinforced role expectations to fulfill to assert his own values, and he may resort to more intense opinions. The female scholar if she chooses to excel may

appear more aggressive. The sensitive artistic male may resist the discipline of scholarship and emphasize creative work in art, as might the more sensitive female.

But the need to solve the problem of the sex role imbalance in our society can be spurred by imagining a democratic society where the affective, qualitative, and humane are balanced with the logical, quantitative, and technical in interpersonal, social, environmental, economic, and political decisions, and where both women and men have freer options for choosing their ways to contribute to that society.

June King McFee
Professor Emeritus
University of Oregon

SECTION I.

Matters of Conscience and Consciousness

PURPOSE: To increase awareness, promote understanding, and encourage further inquiry into art related women's *issues* by exploring the problem of sexism and the need for sex equity in art and art education.

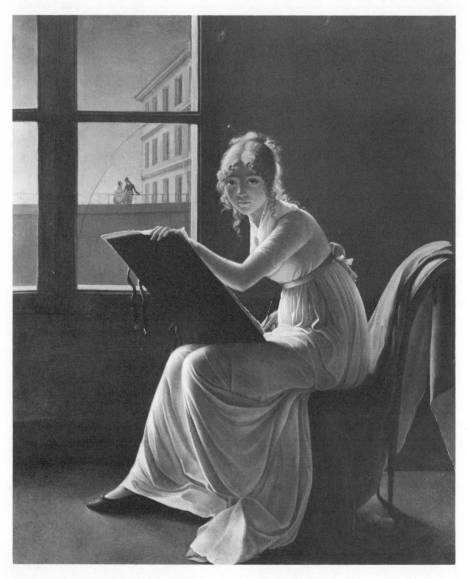

Constance Marie Charpentier. *Mlle. Charlotte de Val d'Ognes.* c. 1800. Oil on canvas. Courtesy of The Metropolitan Museum of Art, New York.

CHAPTER 1:

Art Education and Sex Equity

It is the engaged feminist intellect . . .that can pierce through the cultural-ideological limitations of the time and its specific "professionalism" to reveal biases and inadequacies not merely in the dealing with the question of women, but in the very way of formulating the crucial questions of the discipline as a whole. Thus, the so-called woman question, far from being a minor, peripheral and laughably provincial sub-issue grafted onto a serious, established discipline, can become a catalyst, an intellectual instrument, probing basic and "natural" assumptions, providing a paradigm for other kinds of internal questioning, and in turn, providing links with paradigms established by radical approaches in other fields.
—Linda Nochlin(1971)

A. ART EDUCATION AND THE WOMEN'S MOVEMENT

1. Background

As educators, we have undertaken to facilitate the development of all our students, regardless of their sex, race, religion, ethnic origins, handicap, or for that matter, their "talent." As artists, we have cultivated a high regard for individual differences and have tried to avoid the artistic corruption inherent in group prejudice. Discrimination against women, then, would seem, on the face of it, to be discontinuous with the egalitarian values of education and the individualistic, apolitical traditions of art. Our general assumptions of innocence in this regard have nevertheless been challenged by the recent women's movement. Under its impetus, women in America are questioning their "place" in our society and protesting sexual inequities long taken for granted in our culture.

In the art world, feminist artists, art historians, and art crtics have begun to document and move vigorously against sexism and its effects on western art and artists. In the world of professional educa-

tion, the campaign for sex equity has already brought about major changes in the curriculum and instruction of math, social studies, language arts, science, and physical education. Predictably, the women's movement has made itself felt within the field of art education as well: a Women's Caucus, formed in 1974, has been active within the National Art Education Association;[1] our journals, *Art Education* and *Studies in Art Education*, have devoted an entire issue to women;[2] and in higher education, women's studies programs are beginning to include courses in art education as well as art studio and art history. When compared to feminist inspired activity and change in our "parent" worlds of professional education and art, however, the magnitude and scope of art education's response to the women's movement has been somewhat limited. Except for the initiatives of a few pioneering teachers, no systematic sex equity effort has been made at the levels of art teacher education and public school art teaching. Therefore, a few of the factors which have tended to reduce the impact of feminism on art education are worth considering at the outset.

2. Problems and Considerations

a. The Social Relevance of Art Education

Over the years, art education has been responsive to trends and movements within the larger society. Its drive for social relevance has been prompted, in large measure, by a need to provide convincing arguments for the value of art in public school education. Spending what some would say were inordinate amounts of energy in the development of "timely" rationales and new goals for public school art, art educators have generated a seemingly endless series of justifications for various approaches to art in the curriculum. To the extent these efforts have been for the purpose of securing more than a marginal role for art in elementary and secondary education, we must regard them as failures: our society still thinks of art as an education frill.

In our more despairing moments, we sense the futility of searching each new trend for potential justifications for art in the schools and begin to fear that our preoccupation with social relevance has begun to undermine our credibility and integrity as a serious field of endeavor. In our more idealistic moments, however, we understand that the burden of justification has been thrust upon us, and that we have demonstrated both courage and persistence in our attempts to increase and argue the social relevance of our subject. In the process, we art educators have developed an unusual sensitivity to social needs and concerns, have become articulate critics of the value systems of our society, art, and schools, and have provided ourselves with a full range of legitimate goals which encouraged both our flexibility and ingenuity as teachers. If we have earned the right to be somewhat cynical regarding assumptions that increasing the social relevance of art education will automatically raise its status in the public school curriculum, we nevertheless seem well-equipped to undertake the task of examin-

ing the implications of the women's movement for the theory and practice of art education.

b. The Art Educational Relevance of the Women's Movement

Unlike many movements that have begun outside of art education but have come to influence thought, research, and practice in the field, the women's movement has repeatedly addressed itself to the importance of education. In the artworld, feminist art historian, Linda Nochlin, in her now celebrated essay "Why Have There Been No Great Women Artists?" cites the formal art education of women as a crucial variable in their art activity and achievement.[3] Art critic Lucy R. Lippard and artist Judy Chicago have both spoken of the importance of art education.[4] More significantly, the feminist critique of Western art and art history has focused its attention on many areas of traditional concern to our field: the feminine identification and low status of art in this society; the fine arts/crafts hierarchy; the separation of art and life; the cult of genius; the disparagement of part-time art involvement as dilettantism; the self-promotion and competiveness associated with "serious" art production; and the masculine and elitist value systems associated with art in our culture.

Despite such shared concerns, exploring the art educational relevance of the women's movement has not become priority for many art educators. If there have been fewer "great" women artists, the education of artists has not been the only, or even the primary, goal of public school art education. To art teachers whose energies are absorbed in the daily struggle for curricular survival as they face budget cuts and the back-to-basics movement, demands for the equality of women in a field where women already outnumber men, are likely to seem somewhat frivolous. It is sometimes not immediately apparent that

> Even in those special professions where they dominate, social prejudice against women has its effect. For whatever women touch is instantly considered "feminine" and is kept trivial by social pressure and the denigration of its being "woman's work.[5]

Furthermore, another reason for the lack or concern of real action, which compounds rather than remedies the "woman" problem, lies in the prevalence of skeptical attitudes regarding the manifestations and even the existence of the problematic relationship of women, art, and education. Whether due to an individual's unfamiliarity, background, and/or expertise, expressions of doubt and concern persist among art educators. To illustrate, a list of questions and comments representative of the initial concerns of many art educators follows. It should be noted that one important purpose of this book is to acknowledge and answer these concerns in a positive manner while addressing the matters related to the art educational relevance of the women's movement in society, art, and education.

If previous and ongoing efforts to increase the social relevance of art education[6] have thus far failed to secure a central place for art in the public school curriculum, the women's movement can provide us

with some insight into why this may have been so. Women and art (as well as education) have suffered from their stereotypical feminine identifications in this society. They have shared the same status and played similar roles in our culture. It may be, then, that the achievement of both curricular equality for art in schools and full equality for women will hinge on the elimination of sexism in our society.

B. SEXISM IS AN UGLY WORD

Feminists in the 19th century concentrated their energies on obtaining basic legal rights for women in America. When women's right to vote was finally guaranteed by the 19th Amendment in 1920, many men and women in this country naively believed (or feared) that full equality between the sexes would naturally follow. Taking a lesson from history, as well as from modern social psychology and political philosophies, contemporary feminists argue that true equality for women will entail long term efforts to change attitudes, institutions, and socialization practices, as well as the law. On this assumption, the movement has set about to identify those attitudes and practices in our society which deny the equality of women and have called these "sexist." The movement has also been concerned with identifying those attitudes and practices which tend to promote equality between women and men and have called these "nonsexist." Calling attention to parallels with racism, the women's movement initially defined sexism as the belief (or systems, policies, and behaviors based on this belief) that one sex is superior to the other and that individuals of the superior sex are different in ways which justify or necessitate their special treatment, privilege, power, or reward. Because we do not need to ask which sex has been regarded as superior in western culture and American society, the term "reverse sexism" has been coined to indicate those instances in which women are regarded as the superior sex.

As contemporary feminists have worked toward the identification and elimination of the causes and effects of sexism against women in America, many have come to the conclusion that men, as well as women, have been oppressed by sex role conditioning in our society. Thus, for many, the concept of sexism has taken on new meanings and "has been broadened to describe rigidly prescribed and thereby limiting roles for either sex."[7] Although the desirability of differential sex roles continues to be debated, all feminists agree that the assumption that men are biologically, intellectually, emotionally, spiritually, or in any other way superior to women is sexist indeed.

C. SEX EQUITY AS A GOAL FOR ART EDUCATION

The identification and analysis of sexism in art and art education, as well as prescriptions for its remedy, should be matters of continuing inquiry for art educators concerned with bringing about higher degrees of sex equity in our field. Nevertheless, certain inequities between women and men in the art professions and in the public schools have already been documented by feminists working in these areas.

The Art Educational Relevance of the Women's Movement: Some Expressions of Doubt and Concern

- What is the matter, and what is all the fuss about?
- I've never experienced sexual discrimination in art/I've never discriminated against women in art: so what's the problem?
- Art and politics just don't mix.
- Aren't there more important issues: budget, minorities, the handicapped, career education, ecology, etc.?
- There might be a problem, but I find women's protest boring; trivial; irritating; divisive; or a matter of misdirected energy.
- Isn't feminism in art just another passing fad?
- If women in art have so badly treated for so long , why haven't they complained before this?
- It seems to me that the arts are one of few areas in this society which have not discriminated against women—or, indeed, against "feminine" values and traits.
- Women outnumber men in art education, so they probably 1) have all the power, 2) are not discriminated against, 3) like things the way they are, 4) discriminate against themselves or each other, or 5) are not willing or able to undertake action on their own behalf.
- I'm sympathetic with the "cause" but the way you're going about it only alienates people (me, for example).
- Why do you cite the small number of famous women artists when you know the training and preparation of professional artists is not our major business?
- Okay, I agree we have a problem, but what can I who have no power do about it?
- If I get upset, involved, and committed on this matter, how will I have time or energy left for my own art and teaching?
- How do I deal with hostile resistance or "militant" apathy when I take positive steps to increase sex equity in art education? How do I deal with my lack of self-confidence and isolation?
- Won't compensatory education for women in art 1) be unfair to men (reverse discrimination), 2) lower traditional standards of excellence in order to give women an equal "chance," 3) further reduce art's status by increasing its feminine identification, 4) masculinize women, 5) lead to propaganda in art and the classroom, 6) create a backlash?
- Compared to other education disciplines and studio and art history, art education is pretty slow when it comes to sex equity effort. (What can be done?)

A review of sexual inequities reveals certain recurring patterns. Generalizing on the types of inequity that have been identified in fields closely related to our own, we might tentatively define the goal of sex equity in art education in the following way: *Sex equity in art education would mean equal female and male participation in all art related activities,*

under equal conditions, with commensurate achievement and reward. Equal participation would be in all types and all levels of art activity. It would also mean that women (and girls) would have equal representation in the establishment and application of criteria for achievement in art and would be equally involved in the determination and distribution of the benefits and rewards for ascertained merit. This goal would further require that the conditions for participation and achievement in art would require equal effort and bring equal satisfaction for individuals of either sex. While this statement of sex equity as a goal for art education for both men and women is both very dry and general, it should serve to remind us that equality of opportunity is not to be measured solely in terms of equal achievement and reward, but also in terms of equal participation, conditions, and personal satisfaction at all levels of art and art education.

D. PREVIEWING THE TEXT

This book is written for classroom art teachers and other art educators. It reviews sex equity issues and efforts in art, education, and art education and presents new approaches, strategies, and resources to further stimulate the achievement of sex equity in art education. The book is organized in the following manner: There are five major sections, each containing two chapters. The sections are devoted to "matters" of importance with regard to women, art, and education: awareness of sexism; protest and progress; history and achievements; research and approaches; and revisions related to sex equity in art education. These sections, their chapters and purposes, are further described as follows:

The first section of the book, *Matters of Conscience and Consciousness,* attempts to raise awareness and focus attention on the problematic relationship between women, art, and education. Chapter 1, *Art Education and Sex Equity,* has provided a general orientation to the implications of the women's movement for art education in terms of present impact, potential relevance, and special concerns. Chapter 2, *Symptoms of Sexism in Art and Art Education,* presents a topical review of the facts and fictions surrounding sex inequity in art and art education along with short, question-raising discussions of related issues. The purpose of this chapter is to familiarize the art educator with the nature and extent of sexism in our field and to encourage critical inquiry into the problem.

The purpose of Section II, *Matters of Protest and Progress,* is to raise awareness and focus attention on the sex equity progress that has already been made in our society, education, and art. Chapter 3, *The Women's Movement: Responses to Sexism in Society, Education, and Art,* provides a short review of the women's movement in America along with related sex-equity achievements in education and art. The purpose of this chapter is to increase understanding of how progress toward sex equity has been achieved through organized protest and effort in society, education, and art in order that we may assess how

far we have come and how far we have to go. Chapter 4, *The Women's Art Movement as An Educational Force,* examines the educational implications of the contemporary women's art movement and analyzes the educational purposes, strategies, and effects of feminist approaches to art education. The purpose of this chapter is to structure thinking about the broad educational implications of feminism in art.

Section III, *Matters of Herstory and Heritage,* attempts to raise awareness and focus attention on women's achievements in art and art education. Chapter 5, *Women's Achievements in Art,* a review of women's contributions to Western art, distinguishes mainstream from hiddenstream art traditions, and examines the conditions for and obstacles to women's achievements and recognition in both traditions. The purpose of this chapter is to familiarize the reader with women's individual and collective art achievements and to stimulate further inquiry into their contributions. Chapter 6, *Women's Achievements in Art Education,* reviews women's contributions to American art education, distinguishes mainstream from hiddenstream traditions in our field, and reviews the conditions for and obstacles to women's achievement and recognition in both traditions. The purpose of this chapter is to familiarize the reader with women's individual and collective achievement in our field and to stimulate further inquiry into their contributions.

The general purpose of Section IV, *Matters of Research and Vision,* is to raise awareness and focus attention on relevant research on sex differences and alternative approaches to sex equity in art education. Chapter 7, *Sex Differences and Research Relevant to Art Education,* provides a review of research relevant to sex equity in art education and identifies the need for further research in this area. The purpose of this chapter is to aid the reader in the interpretation and evaluation of both theoretical and empirical research regarding art-related sex differences. In Chapter 8, *Approaches to Sex Equity in Art Education,* three major approaches to the achievement of sex equity are reviewed and examined for their implications for art education; a discipline specific, pluralistic model for sex equity effort in art education is suggested. The purpose of this chapter is to increase the readers' understanding of the problems and possibilities inherent in alternative approaches to sex equity and to recommend a nonsexist, pluralistic approach to art teacher education.

Section V, *Matters of Revision, Strategy, and Resource,* aim to increase awareness and focus attention on the need for practical classroom applications. Chapter 9, *Sex Equity Revision Through Practical Applications in Art Education,* provides self-awareness tools, nonsexist guidelines, and classroom art problems and exercises for increasing sex equity effort in art education at the classroom level and to stimulate sex equity curriculum development by individual art teachers. Chapter 10, *Strategies and Resources for Sex Equity in Art Education,* outlines a variety of sex equity strategies for art educators working in different capacities and areas and identifies current resources available in the field. The purpose of this chapter is to encourage immediate action at all levels

of art education and to provide a list of resources that might be used, tested, and further developed.

A comprehensive list of women artists, from pre-history to the present which includes ethnic/minority groups, is provide in Appendix A. Appendix B presents a compilation of women's publications for art education, divided into two sections: before and after 1960. Appendix C presents a set of questions for nonsexist art education.

The sections and chapters of this text are organized in sequential fashion and tend to build one on another. Nevertheless, the authors have attempted to provide for the varying priorities and needs of the readers by organizing the material in each chapter around topics of coherent interest. Thus it is hoped that individual chapters will retain a high degree of value even when pulled from their original context. In any case, readers are encouraged to "preview" the content of the text by referring to subtitles and reference materials contained in each chapter. Surveys of issues, summaries of events, and lists of individuals often must give up in-depth coverage for the sake of breadth or overview. The authors' hope is that the reader will use the references and bibliographies to secure more information on any item of question, concern, or interest.

Notes and References

[1] For information see Chapter 6 and Sandra Packard's "Finally! A Women's Caucus in Art Education," *The Feminist Art Journal* 3, 3 (1974), p. 15

[2] See *Art Education* (November 1975) and *Studies in Art Education* 18, 2 (1977).

[3] Linda Nochlin, "Why Have There Been No Great Women Artists?" *Art News* 69, 9 (1971), pp. 22-39, 67-70.

[4] Lucy R. Lippard, "Sexual Politics, Art Style," *Art in America* 59, 5 (September/October 1971), pp. 19-20; Judy Chicago, *Through the Flower, My Struggle as a Woman Artist* (Garden City, New York: Anchor Books, 1977 (1975)).

[5] Vivian Gornick and Barbara K. Moran (eds.), *Woman in Sexist Society—Studies in Power and Powerlessness* (New York: Basic Books, Inc., 1971), p. xxix.

[6] For example, Stephen M. Dobbs (ed.), *Arts Education and Back to Basics* (Reston, Va.: National Art Education Association, 1979); Edmund Burke Feldman, "Art in the Mainstream: A Statement of Value and Commitment" *Art Education* 35, 2 (March 1982): 4-5.

[7] Pauline Gough, *Sexism: New Issue in American Education* (Bloomington, Indiana: The Phi Delta Kappa Educational Foundation, 1976), p. 7.

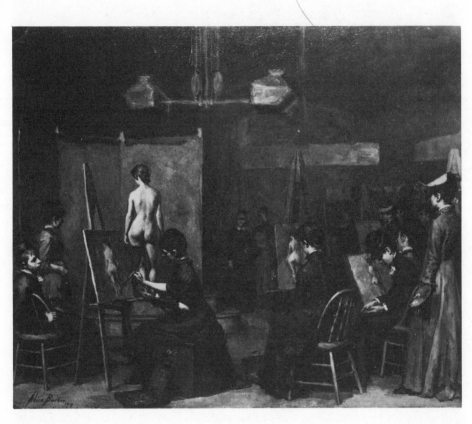

Alice Barber (Stevens). *Female Life Class.* Courtesy of the Pennsylvania Academy of the Fine Arts.

CHAPTER 2:

Symptoms of Sexism in Art and Art Education

The status of art in our society closely parallels the status of women . . . Like women, the arts are simultaneously cherished for their purifying, uplifting value even as they are regarded as frivolous and a luxury in the larger scheme.

—Mary Garrard (1976)

Art teachers need to be especially skillful and assertive in enlightening parents about the values of the art experience for their children, since parents are either ignorant of the values of such experiences or regard art as a pleasant but unimportant adjunct to the school's "more important" business of preparing their children to compete and succeed (i.e., make more money) in society.

—Bette Acuff (1979)

A. LOOKING FOR TROUBLE

Before we can determine to what degree our theory and practice anticipate, counter, or reinforce gender inequities in our society, we need to know something about the particular ways in which sexism has revealed itself in art and art education. In order to familiarize ourselves with the signs and symptoms of sex inequity in our field and to get a sense of the issues which surround them, we must go looking for trouble, as it were. This might indeed seem a dangerous course for art educators already confronted by program cut-backs and budget problems. A positive attitude can be brought to the search, however, if we keep in mind that sexism itself might be a major factor in art education's marginal status in the public schools. In any case, an informed awareness of the sex inequities related to our field will be prerequisite to working toward higher degrees of sex equity in art, education, and our society as well as appreciating progress already made toward this end.

What are the symptoms of sex inequity in art and art education? The following short, topical survey attempts to identify a few of the most obvious manifestations of sex inequity in our field and to provide an introduction to a few of the issues which have been raised in connection with them. The discussions are meant to raise more questions that they answer and to encourage the reader to keep an open, hopeful, and critical mind in exploring the complex of fiction and fact that both reveals and perpetuates sex inequities in our discipline.

B. SYMPTOMS OF SEXISM IN ART

1. Differences in Number

> Q. Are artists usually men?
>
> A. Selective surveys suggest that in the past, artists were usually men, but that today, nearly 40% of America's professional artists are women.

Asked to make a picture of an artist, young children are more likely to draw male than female artists.[1] Most of the art we have seen or heard and learned about has been done by men. Having little knowledge about women artists, we assume that they have been few in number. This assumption, in turn, is frequently used to "explain" why we have had so little opportunity to learn about women artists.

We are told that little evidence remains of women artists' work prior to 1400; that between 1400 and 1800 only a very small proportion of European artists were women; and that by the end of the 19th century women represented only 25% of western artists.[2] According to the U.S. Census figures, in 1970, approximately 32% of America's artists were women, and in 1980, the percentage of women artists was closer to 40%.[3] A survey conducted in 1976 by the College Art Association indicated that nearly half the members of that professional art organization were women. Given that women are about 51% of our population, we must assume that in terms of numbers they are approaching but have not yet achieved complete equity as professional artists.

Taken at face value, our historical legacy of numerical inequity would encourage us to celebrate the current gender ratio in art as an unqualified, if belated, achievement in sex equity. We might also be tempted to resign ourselves to the numerical gender deficit built into our official art history. Both our celebration and our resignation will be somewhat tempered, however, if we remember how it is that one comes to "count" as an artist in our culture.

Surveys of living artists rely on self-disclosure and membership in professional organizations. Their accuracy is therefore inherently problematic. If our means of counting the heads of living artists are

somewhat unreliable, surveys of past artists have involved the selectivity of art historians. Art history has traditionally concerned itself with those autographic art forms and intense full-time careers they have identified as constituting the mainstream of western art. Yet we know that for centuries, countless women and men have been involved in utlilitarian and minor art forms; have produced work anonymously or not deemed worthy of record or preservation; or have engaged in art on part-time or some-time bases. If these also-artists must remain unknown, we can nevertheless understand that the apparent increase in relative numbers of women artists is, more precisely, an increase in women's participation in culturally prestigious art forms which were originally dominated by men.

2. Differences in Exhibition

Q. Is women's art less visible than men's art?

A. After a small but rapid increase in the prestigious exhibition of women's art in the 1970s, the "quota" for their work seems to have settled around 20 to 25%.

If nearly 40% of America's professional artists are women, recent gender ratios in work shown through America's prestigious exhibition system suggest grave inequities. Art critic Lucy Lippard has reportedly estimated that "the 'international quota' of women in leading museum exhibitions and collections has settled in at between 20 and 25 percent."[5] Surveys of major museums and galleries in New York, Washington, and Los Angeles taken in the 1970s reveal that at that time less than 10 percent of their collected and exhibited works were by women and that in some instances zero percentage of work in many collections, group exhibitions, and one-artist show schedules was by women.[6] If recent exhibition rates for women are low, they are nevertheless in marked contrast to the situation of a century ago when women were sometimes categorically denied the right to exhibit[7] or, upon entering a blind competition, might be disqualified when it was discovered that the winning work was done by a woman.[8]

Although the artistic, cultural, and pedagogical values of exhibition are often distorted in our competitive consumer oriented society, making art visible through the mechanism of public, juried exhibition must be a serious and continuing concern for artists and educators. Through exhibition, artists secure opportunities for feedback and peer support; academic appointment, promotion, and tenure; grants, commissions, and sales; and media, critical, and historical coverage. It is the works held by our major museums and galleries that are subsequently reproduced in slides, journals, and texts and which become assimilated into commercial reproductions, imitations, and variations. Through this

spin-off system, art finds its way to broader audiences and into the public school and college art classrooms. If a lesser exhibition rate at the upper reaches of the artworld does not undermine the confidence and development of individuals who are stimulated and supported by local and regional exhibition, it is nevertheless the cultural sanction granted by prestigious national exhibition that moves exemplary art and artists into our consciousness and makes them available for study in academic settings. Gender inequities in prestigious exhibition, then, tend to reinforce the notion that if women have been artists, they have produced little art worthy of note.

3. Differences in Historical and Critical Coverage

> Q. Have women made any art worth mentioning?
>
> A. Recently published feminist art histories have "discovered" many women artists, but basic art history survey texts give no, or only token, mention of women artists.

If we have not had the opportunity to view an artist's work first hand, the artist's existence may be made manifest to us through critical and historical accountings. Artists not in exhibition are, of course, less likely to receive these secondary attentions.

Inspired by the women's movement, a dozen new art history texts and several art journals devoted to reviewing the works and lives of women artists have become available.[9] Only a handful of these artists have been included in those texts which purport to be surveys of western or world art history. In extensive use during the 1970s, basic texts such as Janson's and Gombrich's made no mention of women artists at all, and texts such as Gardner's and Canaday's mention only four of five, about the same number as were included in Vasari's 1550 text, *Lives of the Artist*.[10] Similarly, critical coverage of contemporary women artists has been even lower than their exhibition rates would lead us to expect.[11] While increased visibility and coverage of women's art have been bolstered by special exhibitions[12] and histories of their work, the future integration and recognition of these artists by mainstream art historians is by no means assured.

During the late 1800s and early 1900s, a similar flurry of exhibition of and publication on women artists accompanied the first wave of feminism in this country (see Chapter 3), but this did not eventuate in equitable coverage of women artists in America's general art history texts. Numerous women artists throughout western history have achieved fame and fortune in their lifetimes (see Chapter 5), yet were never recognized by traditional art historians as worthy of inclusion in their surveys of mainstream art history. If inequitable critical and historical coverage of women artists tends to reinforce notions of women's artistic inferiority, it should also call our attention to the possible bias of our art historical and critical traditions which have tended

to take masculine norms and myths of greatness as bases for standards of excellence in art.

If increases in the exhibition of women's art and reductions of masculine bias in art criticism and history promise to provide more equitable gender coverage, we must still deal with the educational lag which finds art teachers unfamiliar with the "new" art history still using outdated texts, slide collections, and curriculum. In the meantime, the availability of special texts, slide registries, journals, women's exhibitions, and women's studies courses should increase our awareness of the existence and significance of women artists, past and present.

4. Differences in Historical and Critical Treatment

Q. Is women's art all alike and not very good?

A. Historical and critical treatments of women's art have tended to be blatantly sexist in their negative and stereotypical assumptions and references to gender; recent feminist treatments have been positive but segregated in nature.

If our awareness of women artists depends on their presence in exhibitions, journals, and texts, our opinions of these artists are greatly influenced by the type of historical and critical treatment they receive. Prior to the current feminist critique of art history and criticism, when women artists were mentioned at all, their treatment usually involved both assumptions and assertions of their difference and inferiority.[13] If a woman's work was experienced as successful, its discussion was likely to focus on the presence or absence of gender related characteristics. If feminine characteristics could be found or imputed, the work was judged inferior as if by definition. If masculine characteristics could be found or imputed, the artist and her work were viewed as freakish, inappropriate, or, at best, exceptional ("She paints like a man"). One pervasive theme in such prejudicial discussions of women's art involved disproportionate attention to the personality, eccentricity, celebrity, and personal relationships of the artist.[14] Another aspect of sexist art criticism and history has been its presumptive vocabulary: feminine adjectives are used to describe and denigrate bad art.

Women artists today are being given positive and intensive coverage by feminist critics and historians who have undertaken this task in the spirit of advocacy and reclamation. Their discussions generally reject the assumption that women artists and their works are inferior to men artists and their works. Women's apparent failure to become "great" artists as often as men is examined in terms of inequities of condition[15] or male bias in previous accountings.[16] The new feminist critics and historians divide, however, on the question of possible similarities in women's art due to gender differences.[17] Some seek to attach positive art value to feminine characteristics in style, subject matter, content,

and media they associate with women's art,[18] while others stress the variety and individuality of women's work.[19]

A criticism and history which equates masculine values and characteristics with artistic value would, one way or another, put women artists at a disadvantage. On the other hand, if all women's art is evaluated as authentic or inauthentic expression of female, as opposed to human or individual experience, this too implies severe limitations and bias. The relationship between gender and art will continue to raise perplexing issues for an art criticism and history determined to give equitable treatment to women and men artists and their work.

5. Differences in the Status and Gender Identifications of Art Forms

> Q. Have women artists tended to work in media, processes, styles, and forms of lesser art value?
>
> A. In the past, women artists worked predominantly in utilitarian, decorative, and minor art forms which have coincidently been assigned secondary status in western art.

Historically, women are said to have dominated the arts of domestic utility: weaving, needlework, blanket and quilt making, and, in some periods and societies, basketry and ceramics.[20] These forms seem to invite or allow for repetitive patterns and embellishments and are closely associated with clothing and household interiors. Perhaps for this reason, women are said to have been preoccupied with the decorative in art. Men, on the other hand, are said to have dominated monumental sculpture and large scale painting. These forms seem to invite or allow for stylistic innovation and autographic expression and are closely associated with the church, state, and academy. Perhaps for this reason, men are said to have been preoccupied with the heroic and the serious in art. Those art media, processes, styles, subjects, and forms historically dominated by women have been assigned a low status in our art and culture; those dominated by men have been assigned a high status.

It is interesting to note that women's progress toward sex equity in art has assumed and reinforced this hierarchy of values in western art. Moving from crafts of domestic utility, women later began to engage in the so-called minor art forms of miniatures, portraits, illuminations, still lifes, and genre scenes. As they gained access to art academies, women began to engage in the production of large scale sculpture and painting involving historical, religious, and allegorical subjects. As the mainstream of western art moved away from the academic to a progressive series of more or less international avant garde movements, women played increasingly larger roles in these movements until the advent of the women's art movement.

With the advent of the women's art movement, although women artists are now working in the full range of art forms available to western artists, many women have developed a new consciousness of the historical sexual divisions of labor that have pertained to western art. As a consequence, they have attached new significance and meaning to the use of feminine identified media and processes and have begun to question the low art status that has attached to art forms associated with women. In so doing, the perennial questions of the relationship between art and life and the elitism of the art/crafts hierarchy have been raised in a contemporary feminist context.

6. Differences in "Greatness"

Q. "Why have there been no great women artists?"[21]

A. Various explanations have been put forth including: biological differences, sex-role conditioning, and inequitable conditions. The issue of sex-bias in the discipline of art history has only recently been raised.

Traditional accounts of western art imply that ours is a progressive art tradition, sparked and led by heroic innovators and geniuses who have inspired significant movements or lifted certain periods or regions to exemplary heights of art achievement. According to these accounts, the great artists of western civilization have always been men. With the sole exception of the contemporary women's art movement, women artists seem to have played only minor or secondary roles in the mainstream of western art:[22] we have no female equivalents to Michelangelo, Rembrandt, Cézanne, or Picasso. Hence, Linda Nochlin's presumptive and now famous question: "Why have there been no famous women artists?"

Among those who agree that there have no great women artists, women's failure to achieve artistic greatness has been explained either as a result of biology or environment. For example, Hugo Munsterberg in the last pages of his book, *A History of Women Artists*, suggests the possibility that genius in visual art is biologically sex-linked.[23] On the other hand, many women's art historians have sought explanation in gender-related disparities in concrete social and psychological conditions in western culture which have made the development, training, and careers of women artists extremely problematic. In their research, they have identified a number of specific obstacles to, as well as conditions for, women's art achievement (see summary of these in Chapter 5).

Those who disagree or reserve opinion regarding the greatness of women artists have suggested that some women artists may have qualified for greatness but have been ignored or disparaged by traditional art historians and critics.[24] Still others suspect that the question

of gender as a variable in artistic greatness begs other, more important questions about possible masculine bias in the discipline of art history. Linda Nochlin raises this issue when she asks:

> Why has art history focussed so exclusively on certain individuals and not others, why on individuals and not on groups, why on art works in the foreground and something called social conditions in the background rather than seeing them as mutually interactive?[25]

7. Differences in Sex Role Conflict

Q. Are successful women artists unsuccessful women?

A. Practical and psychological sex role conflicts exist for both female and male artists in our society, but this conflict is experienced in different degree and at different phases of their art training and careers.

In our society, art has been popularly identified as a feminine activity.[26] If the serious pursuit of art careers remains more compatible with the conventional sex role of the male than of the female, the young boy's initial choice to be an artist is taken under greater psychological and social stress as his adolescent sense of masculinity is put to the qeustion by his peers or parents.[27] Passing this test, however, is taken as evidence by himself and others of his serious commitment to art. If a young girl's interest in art is consonant with popular notions of femininity, she must prove over and over again her serious commitment to an artistic career.[28] If no more painful than the role conflicts experienced by the male artist, those experienced by women have had a more devastating effect on the self-esteem and confidence of women undertaking careers in art.[29]

Although artists of either sex are likely to have sexual relationships, marry, raise children, or engage in other occupations to support themselves and their art, when women have done so they are more likely to be regarded as part-time or dilettante artists. Giving up conventional sex roles, women artists are more likely to be regarded as neurotic or pitiful.[30] Women artists supporting themselves as housewives, while having no less time to devote to their art than their male counterparts engaged in bread-winning occupations outside the home, have found their time and space for art work to be more fragmented.[31] In addition, the singlemindedness, competitiveness, and willingness to promote oneself required of artists in our society, run counter to conventional female role conditioning and stereotyping notions of femininity in our culture. Perhaps even more discouraging to the young, would-be female artist, is the thoughtless disparagement of her potential role models by presenting them as successful artists but unsuccessful women or visa-versa. For example, an author of this text searching for a children's book on women artists for her daughter

was directed by the librarian to a volume entitled *Great Artists of America* by Lillian Freedgood which was published in 1963. Only one woman artist, Mary Cassatt, was discussed in the book in a chapter called "The Old Maid." The concluding paragraph of this chapter read: "Mary Cassatt may possibly have 'failed as a woman, but she triumphed as an artist.'"

8. Differences in Position and Power

> Q. Do women in positions of power in the art world discriminate against other women?
>
> A. Very few women have occupied positions of power in the art world, and women in such positions both disappoint and confirm stereotypical expectations and fears.

Although women hold comparatively few positions of power in the contemporary art establishment, they have had increasing opportunity to prove themselves capable as directors of museums and galleries, journal editors, academic department chairpersons, and officers of professional art organizations.[32] Their presence, even in limited number, in such positions challenges persistent and often inconsistent notions about women's leadership roles in organized endeavors of cultural significance.

While women have been viewed as only capable of playing supportive roles in western art, they have been given perhaps exaggerated credit for being powerful patrons of the arts and guardians of high culture. Women have indeed founded museums, galleries, and art programs.[33] Their role as patron of the arts, however, has often been more of a symbolic than a definitive nature as they have been historically excluded from the most powerful institutions of patronage in western culture: the church, state, academy, and business.

As numbers of women and their demands for an equitable share of position and authority in the contemporary art world increase, the fear and accusation persist that women in power tend to discriminate against other women. Because relatively few women hold such positions,[34] we might dismiss this notion as both premature and exaggerated. The notion itself, however, might be used as a prejudicial rationale for retarding the upward climb of women in art and therefore warrants attention.

Women in power are in a "doublebind" regarding stereotypical expectations and interpretations of their behavior. If they behave in a feminine manner, we will regard them as weak and unfit for leadership. If they exhibit what we can identify as leadership behavior, we will regard them as unnaturally masculine or rather monstrous. Because women in positions of power are still rare, we watch them closely and tend to overgeneralize our experiences with them. We are less likely to repress our resentment of power and authority in the person of a

woman, and that woman is less likely to pretend to gallantry by lowering standards they expect us to meet. Women in power are also likely to make us forget that the real power resides in groups, systems, and institutions which are still dominated by men.

If the model for leadership and dominance in the art world has been established by males and is consonant with the stereotypical male sex role, some women are attempting to introduce feminine values as a humanizing influence within highly depersonalized and competitive institutions. They have also become involved in establishing cooperative support networks among women in the art professions. These efforts should decrease the fears that women in power will discriminate against women, but cooperation among women in power is likely to increase fears of reverse discrimination against men. Until women in positions of power in the art world and elsewhere in our society are not the exception, a great deal of positive communication will be necessary before gender seems totally irrelevant to our interpretation of leadership behavior and purpose.

9. Differences in Gender-Related Imagery

Q. Why were women permitted to pose in, but not draw from, the nude?

A. Because the human figure, and woman's face and body in particular, have been traditional subject matter in western art, the training of artists has included the study of the anatomy of live models. At the height of the academy, when sexual prudery and double-standards were in effect the virtue and respectability of young female art students was considered more important than their training and expertise in anatomical drawing.

The quantity of female images in western art plays tribute to women's value as a source of artistic inspiration. While such attention might be regarded as flattering or harmless, modern social psychology tells us what artists have always known: that visual images have the power to reinforce cultural values and influence concepts of self. Images of women in western art have tended to define and prescribe women's value and role in severely limited and stereotypical ways.[35] In the nude genre which runs the gamut from fine through calendar art, and while the aesthetic value of these works varies drastically, the message seems always the same: women are "passive, available, possessable, (and) powerless."[36] Females presented in advertising and commercial illustrations are typically shown engaged in occupations involving nurturing, helping, cleaning, cooking, or other stereotypical female roles.[37] Gesture and composition in these presentations tend to reinforce the image of women as submissive, subservient, and playing roles of secondary status.[38] While no image could or should be accused of undermining or shaping women's sense of value and self, an overwhelm-

ing number of images present women as passive, attractive objects, and very few present women as active, effective doers.

Many contemporary women artists are projecting new images of themselves and other women as they explore women's shared political, social, and sexual experience. Art exploring the significance of women's bodies and experience from a woman's point of view is a radical departure from the treatment and meanings which have attached to the female and femininity in the traditional, popular, and commercial arts of our culture. New and often startling self-images serve to make us doubly aware of the fact that the image art has provided of the female has been dominated by a distinctively male perspective. Women, once restricted from viewing but not from posing nude,[39] are challenging both the denigration and idealization of the female body for commercial and aesthetic purposes in their recent explorations of female body art and vaginal imagery.[40] They have begun to project women's sexuality as an active rather than passive one and have indulged in playful role reversals by painting passive, male nudes, as well as other sexual political statements. In any case, the issue has been raised as both a vital force in contemporary women's art and a basis for historical critique.

C. SYMPTOMS OF SEXISM IN ART EDUCATION

The content of art education is a special mixture, found in varying proportions, of art studio, art history, and art criticism. The art teacher not only draws on concepts, skills, and values from these areas, but has tended to build models of teaching theory and practice on the artist, the historian, and the critic. It will not be surprising to learn, therefore, that many symptoms of sex inequity in art education will be echoes and variations of those found in the art world. Art education, however, is a discipline in its own right, with a history and purpose of its own. As a subject matter area of education, art education has not only concerned itself with the teaching of art and future artists, but with the value of art in the development of the individual and our society. The particular manifestations of sex inequity in art education, then, will present themselves not only as problems shared with the art world, but as problems unique to our field.

1. Differences in Curricular Status

Q. Is art a feminine frill in education?

A. The feminine identification of art and the role it has been encouraged to play in public school education interacts with and reinforces its marginal curricular status.

All art educators have had to deal, at one time or another, with the debilitating effects of art's marginal status in the public school and

higher education curriculum. The first program to be cut in a budget crisis, art at all levels of education receives consistently less than its fair and necessary share of the supply, scholarship, research, and program development dollar. An elective or sporadically required subject in the public schools, art is not required for college admission, nor, in an era of competency based education and teacher accountability, included as a basic in the powerful standardized testing system. Although originally securing a place for itself in the school as a set of pre-vocational skills or part of a vocational manual training program, art is now considered a non-academic cultural frill, retaining elitist overtones in a democratic and pragmatic society.

Art, along with home economics, secretarial studies, and nursing, has a distinctly feminine identification in our society and its schools. Popular notions of art as feminine have been reinforced by mythological, analogical, and personifying associations between art and femininity in our culture.[41] Art has been used as an indicator of femininity on personality tests, and art has often been placed in the women's section (now often called "lifestyle" sections) of the newspaper. Adjectives used in stereotypical descriptions of women and art are disconcertingly similar: ornamental, consoling, frivolous, sensuous, and emotional. It should not surprise anyone, then, that art has taken on the functions and values of the feminine role within many public schools.

Art is often used as a convenient but drastically unprepared and undersupported "dumping ground" for students suffering from academic, social, and psychological problems. Its feminine function is further assumed in that it is highly regarded for its therapeutic value and usefulness for the articulation and catharsis of emotions. Art is pressed into more prosaic domestic service activities and expected to decorate the school's austere hallways and to add a "feminine touch" to communications and celebrations within the institution.

Although serious art study and careers take on masculine identified values and purposes in the art world, the feminine identification of art and the devaluation of the feminine continue to interact with and reinforce the marginal status of art in the public school curriculum.[42] If the marginal status of art in education is not wholly a matter of sex bias in our culture, its feminine identification makes sex equity effort difficult even while it obscures the need for such effort in public school art education.

2. Differences in Art World Status

Q. Is teaching a low status, feminine identified art profession?

A. Teaching is not a highly regarded profession in American society, and, within the art world, many factors reinforce both the low status and feminine identification of this occupation at public school levels.

During periods when teachers, doctors, lawyers, and ministers were often the only educated persons in one's community, teaching was a "calling" of relatively high status. As education has become more available to larger numbers of people and as more teachers have been employed in the public schools, the status of teaching has declined. Today, our school systems are underfunded, our teachers are underpaid, and education has become a favorite target of criticism and disparagement for politicians, parents, and the intellectual elite. The complaint and then 'flight' of highly qualified teachers into other occupations is a sign of low morale and a diminishing regard for teaching within the profession itself.

Within the art world, the making of art is a higher status occupation than the teaching of art as stated in the adage "Those who can, do; those can't, teach." Indeed, the majority of art teachers enter teaching in order to support themselves as artists. If teaching has relatively low art status, some forms of teaching have higher status than others: college level art teaching is more culturally prestigious than teaching art to preschoolers, and teaching studio majors is viewed as more important than teaching education majors. While considerations of differential status may seem at first petty and irrelevant, individuals who work in occupations of lower status in our society generally receive lower pay, have less control over work loads and schedules, are required to have less training, have poorer working conditions, fewer fringe benefits, and lower self-esteem. When, as is the case with public art teaching, the majority of individuals in the occupation are women, issues of sex inequity must be raised.

There is general agreement in the art world that making art is prerequisite to excellence in teaching art. Art teachers at the male dominated levels of higher education are given time, space, and reward for their own art production and exhibition. How has the fact that public school art teachers' needs to promote their own art development have not been similarly accommodated affected their status in the art world? How has the feminine identification of public school art teaching discouraged otherwise qualified male art teachers from working at this level? Now that many other occupations are opening up for women, will some otherwise highly qualified female art teachers avoid teaching art to children because of its low status and feminine identification?

3. Differences in Position and Power

Q. Do women dominate the field of art education?

A. There are more women in art education, but men have tended to hold the majority of leadership and power positions in our field.

Although women dominate the field of art education in terms of numbers, they tend to cluster at public school levels of teaching and

have occupied fewer of the various formal and informal positions of leadership in art education. While gender ratios fluctuate, fewer women than men have been state art supervisors, chairs of college art education programs, or officers in the National Art Education Association.[43] The ratios of women and men in city art supervision positions and state art education associations, however, is fairly equitable.[44] In higher education programs, women hold fewer rank positions, receive promotion less often, have heavier teaching loads, teach lower division courses more often, and are found in fewer numbers and high positions in the larger, more prestigious departments offering graduate programs and opportunities for research and publication.[45] Women have held fewer editiorships of our journals, published fewer books,[46] received fewer grants and awards and less media coverage, and have had their work in museum collections less often than men in our field.[47]

Women in art education, however, have exercised leadership and are increasingly elected or appointed to positions of power (see Chapter 6). The curious fact remains, however, that while the public school art teacher is theoretically the primary occupation in the field of art education, secondary occupations such as teacher educator, administrator, researcher, and curriculum developer have tended to set the goals and directions in our field and to receive higher rewards and status. Definitions of leadership and the hierarchical structure of the art education "establishment" have tended to be dominated by males and masculine value systems. As women and men take their places at all levels of art education, traditional structures and values in our field will need to be reviewed for more subtle symptoms of sexism.

4. Differences in the Interpretation of Art Interest

Q. Do girls like art and art education for the wrong reasons?

A. An interest in art and art education has been viewed as sex appropriate for women, and as a result their possible interest in "serious" art careers has often been disregarded.

The feminine identification of art and the public school art teacher presents problems in both the motivation and interpretation of girls' and boys' art interests. Girls are more likely to find parental, counseling, and peer support for opting to follow up on their interest in art.[48] Boys, however, are more likely to be put through the rigorous test of serious career commitment upon their expression of art interest.[49] Nonserious male art students tend to be discouraged whereas non-serious female art students are likely to have their interest encouraged but not to be informed of the demands of higher level art education and careers.

While male interest in art at entry levels may be regarded as inap-

propriately feminine, it is not regarded as frivolous in nature. If girls are not given realistic career guidance in art and are increasingly encouraged by sex equity efforts in previously male identified subjects such as math, they may be likely to repress their art interest as a sign of second class citizenship or feminine role conditioning.

The phenomenon of applying a double, sex-related standard to female and male art interest tends to repeat itself at higher levels of education. Studio professors have tended to see art education as more appropriate for females and less serious art students. Women art students find subtle and not so subtle encouragements to go into public school art teaching as something to "fall back on" after they have raised their children. Differential interpretations of art interest and the assumption that non-career interests are less appropriate for males and that dilettante interests and art education are more appropriate for females has perpetuated both elitism and sex inequity in art and society.

5. Differences in the Provision of Role Models

> Q. Do girls want to grow up to be male artists?
>
> A. Girls who choose art careers as artists, historians, critics, or teachers have fewer successful like-sex role models than do boys making similar choices.

Although a girl's elementary art teacher is likely to be a woman, the chances increase that her high school and college art teachers will be men. Should she pursue her education through terminal degrees in art, she will not only find the majority of her graduate teachers are male, but that those who have earned power and prestige in her chosen profession are mostly men. In her course work in art history and art education, she will find that the heroes, pioneers, theorists, and leaders have been mostly men. Chances are the art textbooks and journals she reads will have been written by men.

The infrequent but concentrated version of art history taught in the studio oriented art courses in high school and college have generally not included any discussion of women artists and why women artists have received so little recognition. Female role models in art at the local level are often disparaged and devalued by art teachers who orient to East and West coast contemporary mainstream art. Feminine identified art activities such as quilt making receive little if any attention, and the bulletin board decorations of female classroom teachers are derided by the art teachers trying to increase their students' aesthetic awareness. In sum, girls presented with few positive like-sex models in art, and boys who are exposed to the new realities of women's professional art activity will be ill prepared to break new ground and anticipate the problems and possibilities of art careers for both sexes.

6. Differences in the Status and Gender Identification of Art Forms

> Q. Do girls like fiber and boys like stone?
>
> A. Children are sensitive to the gender identifications surrounding different media, processes, and forms, and girls and boys learn that those with feminine associations have less art status than those with masculine associations.

Within traditional studio offerings at all levels of art education, the status and values that have attached to male dominated art forms is reinforced and taught as a not so hidden curriculum. Painting, sculpture, drawing, and printmaking are offered with pride, while jewelry making, weaving, needlework, ceramics, and crafts are offered somewhat apologetically or in certain college art departments, offered in art education rather than studio programs.[50] The teacher who offers students the opportunity to work in less prestigious, feminine identified art forms often makes it clear that such offerings are merely pragmatic responses to popular demand or for the purpose of recruiting more students. Female students who show an interest in art forms of domestic utility, decorative embellishment, pastels, watercolors, and miniature work are suspect of giving in to feminine impulses of lesser art value rather than getting in touch with their female art heritage. Boys who show similar interests risk being stigmatized as effeminate. If both girls and boys need to be made more aware of women's work in male identified art forms, they also need help in understanding the human art value in art media, processes, and forms historically dominated by the female.

7. Differences in Gender-Related Imagery

> Q. Are girls more interested in drawing Barbie than Batman?
>
> A. Boys and girls tend to use subject matter in their art which is closely related to stereotypical sex roles, and subjects chosen by girls tend to be assigned less art value by teachers.

One of the few sex differences we find discussed in the literature of art education is gender related differences in preferred subject matter.[51] In *Teaching Children to Draw — A Guide for Teachers and Parents* by Marjorie and Brent Wilson, the authors claim that "In the United States, for example, boys' drawings contain a profusion of violence, of villainy, and vehicles; girls' drawings are full of benign animals, bugs, and blooms."[52] Suggesting that boys are more influenced by the

media, the Wilsons go on to say that "The realities that they reinvent are often richer, more complex, and more dynamic than are those of girls."[53]

If children's images in their art represent their views of reality and fantastic projections of imagined possibility, the images of men and women undoubtedly affect gender differences in subject matter choices. Art teachers concerned that the images of women and men in both fine art and the mass media are stereotypical distortions of human possibility tend to discuss with their students the political, social, and personal impact of such imagery. On the other hand, the assumption that stereotypical masculine imagery sparks children's art of higher aesthetic value, that is, "richer, more complex, and more dynamic" needs to be examined for its possible equation of masculine values with human art values. If a child prefers "benign blooms" to "vehicles," is he or she bound to produce poor, simple, and static art?

8. Differences in Creativity

Q. Are girls less creative than boys?

A. Conventional measures of creativity and visual perception suggest that boys are more creative and visual than girls. However, conventional models of creativity and tests of visual perception may be biased toward the masculine.

Even though art teachers regard creativity and visual awareness as major goals of art education, they rarely take objective measurements of these capabilities or openly discuss the possible gender related differences in them. Nevertheless, psycholanalytic theory and experimental research in psychology have suggested that women are less creative than men and that girls are more verbal and boys more visual in their perceptions and expressions.[54] In addition, research on creative women reports that they are more masculine in their behaviors and attitudes.[55] If the creative and perceptual behaviors being measured in these studies are not necessarily identical to or predictive of artistic creativity and aesthetic awareness, the history of western art itself has singled out male artists as the primary exemplars of these characteristics. Women, on the other hand, have an historical association with weaving, needlework, and miniature painting which would seem to reinforce the notion that they are better at small muscle occupations demanding mindless patience with repetition and detail.[56]

The models of creativity and visual perception that have evolved in art and psychology set a high premium on male identified skills, attitudes, values, and preferences. If boys are better at spatial perception, illusionistic space has been a preoccupation in western art; if girls have been associated with decorative and miniature work, these have been given low art status. The recent problem-solving models of

creativity have emphasized an aggressive overcoming of obstacles and independent behaviors which are associated with masculinity in our society.[57] Some have therefore suggested that our models of creativity and visual perception are guilty of masculine bias. As an alternative, the development of a feminine model of creativity, more consonant with women's body images, experiences, and values, has been recommended.[58] Such a model would emphasize sensitivity, nuance, openness, holism, and intuitive taking-in behaviors. Until we have a truly sex-neutral human model of creativity and perception in art education, female students will need certain compensatory attention with regard to the skills, attitudes, and values now associated with art achievement in our field.

9. Differences in Classroom Interactions

Q. Are girls better at cleaning brushes?

A. Many of us reinforce stereotypical sex role behaviors of questionable art value by our thoughtless responses and classroom routines.

Perhaps our first awareness of sexism in the art classroom will involve our realization that we are inadvertently reinforcing sex stereotyped behaviors of questionable art value for either sex.[59] Our society has taught us that girls are neater, more orderly, need more direction and protection, are better suited to prosaic domestic tasks, and are less disruptive than boys. We also believe that boys have higher energy levels, a greater need for big muscle acitivity, and are easily bored and rowdy. We automatically ask girls to clean the brushes, call the roll, and take the notes; we ask boys to lift and fix heavy equipment, climb ladders, and pry lids off cans.

More difficult to detect are those subtle treatments of students which differentiate them on the basis of sex. Our interactions with students tend to give boys and masculine behaviors exhibited by them more attention. We reinforce girls for asking for help in setting goals and for seeking intimacy and affection. We reinforce boys for setting goals independently asking for instrumental help, and repressing their emotions. By and large, those feminine behaviors we reinforce in female students we also regard as having lesser art and art career value. Reinforcing stereotypical sex role behaviors for either girls or boys is not likely to help them develop the wholeness and individuality we would like to see in our citizens and artists of tomorrow.

In the next two chapters, we will look at how women have become conscious of sexism in our society, art, and education, how they have organized to protest its worst effects, and what progress they have made toward sex equity in areas which relate to art education.

NOTES AND REFERENCES

[1] Linda Bastian, "Women as Artists and Teachers," *Art Education*, 28, 7 (November 1975), pp. 12-15.

[2] Ann Sutherland Harris and Linda Nochlin, *Women Artists: 1550-1950* (New York: Alfred A. Knopf, 1976); and, Hugo Munsterberg, *A History of Women Artists* (New York: Clarkson N. Potter, 1975).

[3] These percentages are for Artist,Writers, and Entertainers taken as a group as cited in: Table 651, "Employed Persons by Sex, Race, and Occupation: 1972-1981," *Statistical Abstracts of the United States 1982-83* (Washington, D.C.: Bureau of Census, U.S. Department of Commerce).

[4] Norma Broude, "Women's Caucus Report," *Art Journal* 37, 4 (Summer 1978), p. 337; and Judith K. Brodsky, "The Status of Women in Art," in Judy Loeb (ed.) *Feminist College — Educating Women in the Visual Arts* (New York: Teacher's College Press, 1979), p. 292.

[5] Grace Glueck, "'A Matter of Redefining the Whole Relationship Between Art and Society'," *Art News* 79, 8 (October 1980), p. 62; and Lynn F. Miller and Sally S. Swenson, *Lives and Works: Talks with Women Artists* (Metuchen, New Jersey: The Scarecrow Press, Inc., 1981), p. 210.

[6] Barbara Ehrlich White, "A 1974 Perspective: Why Women's Studies in Art and Art History?" *Art Journal* 35, 4 (Summer 1976), pp. 340-344; Lucy R. Lippard, "Sexual Politics Art Style," *Art in America* 59, (September/October 1971), pp. 19-20; and Elizabeth C. Baker, "Sexual Art-Politics," in Thomas B. Hess and Elizabeth C. Baker (eds.) *Art and Sexual Politcs* (New York: Collier Books, 1973), pp. 108-119.

[7] The right to exhibit was generally tied to membership in an academy, but some women artists denied membership were still given the opportunity to exhibit. See Harris and Nochlin, *op.cit.*

[8] Karen Petersen and J.J. Wilson, *Women Artists: Recognition and Reappraisal from the Early Middle Ages to the 20th Century* (New York: Harper, 1976), p. 83.

[9] See Chapters 4 and 10 for texts and journals devoted to women's art.

[10] Often cited. See Petersen and Wilson, *op.cit.*, p. 5, White, *op.cit.*, p. 341; Joelyn Snyder-Ott, *Women and Creativity* (Millbrae, California: Les Femmes Publishing, 1978), p. 123; Cindy Nemser, *Art Talk: Conversations with Twelve Women Artists* (New York: Charles Scribner's Sons, 1975), p. xiii; and Eleanor Dickinson, *Statistics: Sex Differentials in Art Employment and Exhibition Opportunities* (Chevy Chase, Maryland: Coalition of Women's Art Organizations, after 1978).

[11] June Wayne (ed.), *Sex Differentials in Art Exhibition Reviews: A Statistical Study* (Los Angeles, California: Tamarind Lithography Workshop, Inc., 1972); and Dickinson, *op.cit.*

[12] Lawrence Alloway, "Women's Art in the '70s," *Art in America* (May/June 1976), p. 66.

[13] Cindy Nesmer, "Art Criticism and Gender Prejudice," *Arts Magazine* (March 1972), 44-46; and "Art Criticism and Women Artists," *The Journal of Aesthetic Education* 7, 3 (July 1973), pp: 73-83.

[14] For example, see Munsterburg, *op.cit.*, who reports and represents this point of view.

[15] Linda Nochlin, "Why Have There Been No Great Women Artists?" *Art News* 69, 9 (1971), pp. 22-39, 67-70.

[16] Linda Nochlin, "Toward a Juster Vision: How Feminism Can Change Our Ways of Looking at Art History," in Judy Loeb, *op.cit.*, pp. 3-13.

[17] Renee Sandell, "Female Aesthetics: The Women's Art Movement and Its Aesthetic Split," *Journal of Aesthetic Education* 14, 4 (1980): 106-11.

[18] Lucy R. Lippard, *From the Center—Feminist Essays on Women's Art* (New York: Dutton, 1976).

[19] For example, Lawrence Alloway, *op.cit.*; and John Russell, "It's Not 'Women's Art,' It's Good Art," *The New York Times* (Sunday, July 24, 1983) Section 2, pp. 1, 25.

[20] See Munsterberg, *op.cit.*: Petersen and Wilson, *op.cit.*; and Harris and Nochlin, *op.cit.*

[21] Nochlin, "Why Have There Been No Great Women Artists?" *op.cit.*

[22] See Alloway, *op.cit.*: and Munsterberg, *op.cit.*

[23] See Munsterberg, *op.cit.*, pp. 145-147.

[24] See Nemser, "Art Criticism and Gender Prejudice," *op.cit.*, p. 5.

[26] Mary P. Garrard, "Of Men, Women, and Art," *Art Journal* 35, 4 (Summer 1976), pp. 324-329; and June Wayne, "The Male Artist as Stereotypical Female," *Arts in Society* 2, 1 (Spring/Summer 1974), pp. 107-113.

[27] Guy Hubbard, *Art in the High School*, (Belmont, California: Wadsworth, 1967), pp. 91-98.

[28] Harris and Nochlin, *op.cit.*, p. 41.

[29] Lita S. Whitesel, "Attitudes of Women Art Students," *Art Education* 30, 1 (1977), pp. 25-27; "Women as Art Students, Teachers, and Artists," *Art Education* 28, 3 (1975), pp. 21-26.

[30] Literature, media, and popular versions of Freudian psychology have tended to characterize achieving women as sexually or maternally frustrated. Renoir put it bluntly: "The woman who is an artist is merely ridiculous." (cited in Synder-Ott, *op.cit.*, pp. 10-11.)

[31] Miller and Swenson, *op.cit.*

[32] Ann Sutherland Harris, "The Second Sex in Academe, Fine Arts Division," *Art in America* 60, 3 (May/June 1972), pp. 18-19; and White, *op.cit.*

[33] Baker, *op.cit.*

[34] Harris, *op.cit.*; Baker, *op.cit.*; and Dickinson, *op.cit.*

[35] John Berger (Producer), *Ways of Seeing: Painting Nudes and Women* (New York: Time-Life Films, 1974)

[36] Rozsika Parker and Griselda Pollack, *Old Mistresses: Women, Art and Ideology*. (New York: Pantheon Books, 1981), p. 116.

[37] Erving Goffman, *Gender Advertisements* (New York: Harper & Row, 1979).

[38] *Ibid.*

[39] Nochlin, "Why Have There Been No Great Women Artists?", *op.cit.*

[40] Lucy R. Lippard, "The Pains and Pleasures of Rebirth: Women's Body Art," *Art in America* (May/June 1976), pp. 73-81.

[41] Garrard, *op.cit.*; and Wayne, *op.cit.*

[42] Georgia Collins, "Women and Art: The Problem of Status," *Studies in Art Education* 21, 1 (1979), pp. 57-64.

[43] Jessie Lovano-Kerr, Vicky Semler, and Enid Zimmerman, "A Profile of Art Educators in Higher Education: Male/Female Comparative Data," pp. 21-37; John A. Michael, "Women/Men in Leadership Roles in Art Education," pp. 7-20; and Sandra Packard, "An Analysis of Current Statistics and Trends as They Influence the Status and Future for Women in Art Academe," pp. 38-48: all in *Studies in Art Education* 18, 2 (1977).

[44] *Ibid.*

[45] *Ibid.*, and White, *op.cit.*

[46] *Ibid.*

[47] Whitesel, *op.cit.*

[48] Hubbard, *op.cit.*

[49] *Ibid.*; and Whitesel, *op.cit.*

[50] Laura H. Chapman, *Instant Art, Instant Culture—The Unspoken Policy for American Schools* (New York: Teacher's College Press, 1982), pp. 92-93.

[51] Viktor Lowenfeld and W. Lambert Brittain, *Creative and Mental Growth*, 7th ed. (New York: The Macmillan Company, 1982 (1947), pp. 304-305; and Marjorie and Brent Wilson, *Teaching Children to Draw—A Guide for Teachers and Parents* (Englewood Cliffs, New Jersey: Prentice-Hall, Inc., 1982), p. _____.

[52] Wilson and Wilson, *Ibid.*

[53] *Ibid.*

[54] Caroline Whitbeck, "Theories of Sex Difference," in Carol C. Gould and Marx W. Wartofsky, eds., *Women and Philosophy* (New York: G. P. Putnam's Sons, 1976); Leona E. Tyler, *The Psychology of Human Differences* (New York: Appleton-Century-Crofts, Inc., 1947); and, disputing much of this theory and research, Eleanor E. Maccoby and C. N. Jacklin, *The Psychology of Sex Differences* (Stanford, California:

Stanford University Press, 1974). See Chapter 7 for criticism, update, and review of sex difference theory and research relevant to art education.

[55] Ravenna Helson, "Personality of Women with Imaginative and Artistic Interests: The Role of Masculinity, Originality, and Other Characteristics in Their Creativity," *Journal of Personality* 43, 1 (1966), pp. 1-25.

[56] Nemser, "Art Criticism and Gender Prejudice," *op.cit.*

[57] See Chapter 7 for review of recent research on these behaviors.

[58] Ravenna Helson, "Inner Reality of Women," *Arts in Society* 2, 1 (Spring/Summer 1974), pp. 25-36.

[59] See Chapter 7.

SECTION II.

Matters of Protest and Progress

PURPOSE: To increase awareness, promote understanding, and encourage further inquiry into art related sex equity *progress* by exploring the implications of individual and organized sex equity effort for art and art education.

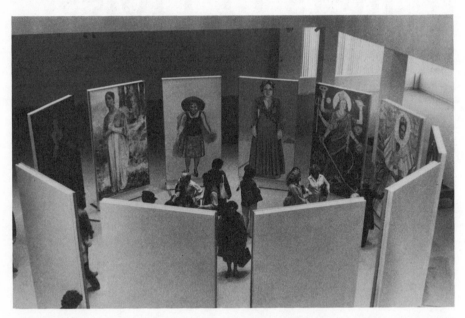

The Sister Chapel at Stony Brook University, November 1978. A collaborative artists project: Ilise Greenstein, June Blum, Sylvia Sleigh, Elsa Goldsmith, Shirley Gorelick, May Stevens, Alice Neel, Maureen Connor, Diana Kurz, Martha Edelheit, Cynthia Mailman, Sharon Wybrants, and Betty Holliday. Shown here are 5' x 9' paintings in oil or acrylic. From left: ''Artemisia Gentileschi'' by May Stevens; ''Joan of Arc'' by Elsa Goldsmith; ''Bella Abzug'' by Alice Neel; ''Betty Friedan'' by June Blum; ''Durga'' by Diana Kurz and ''Frida Kahlo'' by Shirley Gorelick. Photo by Maurice Blum.

CHAPTER 3.

The Women's Movement: Response to Sexism in Society, Education, and Art

Using their situation as underdogs and outsiders as a vantage point, women can reveal institutional and intellectual weaknesses in general, and, at the same time that they destroy false consciousness, take part in the creation of institutions in which clear thought and true greatness are challenges open to anyone—man or woman—courageous enough to take the necessary risk, the leap into the unknown.

—Linda Nochlin ()

A. SEX EQUITY PROGRESS

Having become more familiar with the symptoms of sexism in art and art education, we might well wonder what women have done in response to the problem and what progress has been made toward sex-equity in our society, education, and art. In this chapter we present a brief review of sex equity efforts and achievements that have been associated with the women's movement in America and suggest the impact this movement has had on the status of women in our society, education, and art. In addition to increasing our appreciation for the historical steps that have led to the degree of sexual equality we now enjoy, such a survey should help us to identify effective sex-equity strategies, clarify shared goals, and understand the magnitude and significance of what is yet to be accomplished.

B. THE FIRST WAVE: THE WOMEN'S SUFFRAGE MOVEMENT

1. Women's "Place " in the New World

The promise of freedom and opportunity which prompted the exploration and settlement of America by Europeans kindled hope in the hearts of many women as well as men colonists. For women, however, the realization of America's promise was to be frustrated by a legacy of profound sexual inequity which the settlers brought with them from Europe.[1] Women's work and childbearing had high survival value on the frontier, and women were granted a degree of functional equality under what were often desperate circumstances of pioneer life.[2] With few exceptions, however, women in early America were deprived of public identity and legal status: women were not allowed to own property, had no right to their earnings, no legal custody of their children, were not permitted to testify in court or serve on juries, vote, hold office, preach, or speak in public meetings.

The powerlessness, innocence, and vulnerability of women were viewed as natural and desirable in early America, and their intellectual and physical inferiority were assumed.[3] White women who kept their "place" might hope that custom, religion, and luck would provide them with a protective and paternalistic father, husband, brother, uncle, or son to insure their safety and welfare. Women of "color," however, were afforded no such shelter and shared the bondage, displacement, and poverty of their male counterparts.[4]

As individual need and social forces drew women out of the home to become part of the general labor force, they were channeled into feminine identified occupations in textile mills, teaching, domestic service, nursing, and low-level clerical work. Predictably these women suffered inequities of condition, pay, and promotion and were subject to both economic and sexual exploitation.[5]

Although the voices and deeds of early American women have rarely been recorded by historians,[6] individual women with great personal courage and vehemence, protested the perpetuation of sexual discrimination in the new country. In the 1600s, Anne Hutchinson broke the rule of silence imposed on women in her church and risked her life in order to preach.[7] Deborah Sampson risked ridicule as well as life and limb by dressing as a male in order to fight as a soldier in the American Revolution.[8] In 1776, Abigail Adams wrote a letter to her husband pointing up the irony of women's continuing colonial status at the time when American men where announcing man's right to rebel against governments in which they had no effective voice.[9]

2. The Women's Suffrage Movement

a. PROTOTYPICAL ORGANIZATION OF WOMEN

Excluded from membership in male organizations and prohibited from speaking out in public meetings, early American women quietly

organized themselves into local work-social groups which seemed harmless extensions of traditional feminine concerns: sewing circles, literary societies, and service oriented women's auxilliaries and clubs.[10] The purposes of such organizations included companionship, self-improvement, and working for the welfare of others. Many women as well as men were firmly committed to the abolition of slavery and worked tirelessly for this cause. Nevertheless because of their gender, women were denied full membership in early abolitionist organizations, the freedom to speak publicly, and the right to present petitions before legislative bodies.[11] In working for the aboliton of slavery, women became acutely aware of the crippling effects of their own restricted rights. They formed separate women's abolitionist organizations and spurred by the necessity, learned to speak, write, and petition effectively for this cause in the face of social and legal opposition.[12] It is not surprising that many women associated with the abolitionist movement became leaders of the women's rights movement. Among these were Sarah and Angelina Grimke, Lucy Stone, Lucretia Mott, Sojourner Truth, Susan Anthony, and Maria Stewart.

b. THE SENECA FALLS WOMEN'S RIGHTS CONVENTION

The women's suffrage movement is often dated from the Seneca Falls Women's Rights Convention held in 1848 and organized by Lucretia Mott and Elizabeth Cady Stanton among others.[13] This major effort to organize women in their own behalf involved a Declaration of Principles pointedly rephrasing the Declaration of Independence. The Declaration asked for women's property, child custody, educational, economic, and legal rights. The most controversial demand was for women's right to vote. It was Elizabeth Cady Stanton who insisted upon its inclusion.[14] The enfranchisement of women eventually was to become the focal point of women's 19th century fight for equality.

c. WOMEN WIN THE RIGHT TO VOTE

Although the Woman's Suffrage Amendment to the Constitution was first proposed in 1868,[15] it was not until 1920, with the passage of the 19th Amendment, that women were finally guaranteed the right to vote in the United States. Nearly 100 years had elapsed since the Seneca Falls convention. During this time, countless women and men attended conventions, gave speeches, wrote and distributed pamphlets, published journals and newspapers, gathered signatures on petitions, demonstrated, and engaged in acts of civil disobedience in order to secure this elemental right for America's women.

There were many reasons why it took so long to win the vote for women. The opposition included the press, Southern white supremacists, the brewers, and other major business and industrial interests, all of whom were organized and powerful.[16] Arguments against giving women the vote included dire preditions of block voting, the disruption of women's role in the private sphere, and the encouragement of disparate interests between husband and wife. Fur-

thermore, there were many setbacks and discouragements: the Civil War required a hiatus in the suffrage movement;[17] women were disappointed when females were excluded from the 15th amendment[18]; and conservative and radical splits occured in the 1870s and 1880s[19], with some women working to change laws at state levels while others believed only an amendment to the Constitution would suffice.

The feminist movement in England and the writings of Mary Wollstonecraft[20] and John Stuart Mill, whose wife, Harriet Taylor, was an active feminist,[21] lent an international tone and support to the women's suffrage movement.[22] Nevertheless, it was courageous American women such as Lucretia Mott, Lucy Stone, Elizabeth Cady Stanton, Susan Anthony, Sojourner Truth, and Carrie Chapman Catt, with a willingness to sustain effort over their lifetimes, who provided the leadership required to secure women's right to vote in America.

In addition to the fight for women's vote, the women's movement in the 19th century encouraged women to work for many reforms. Women provided progressive leadership in the areas of education, social welfare, labor legislation, birth control, the penal system, mental health, and perhaps with questionable results, temperance.[23] Along with the right to vote, the first wave of the feminist movement secured for women the right to own property, control their earnings, child custody, elective office, and trial by their peers.

3. Sex-equity Progress in Education and Art

a. THE EDUCATION OF WOMEN TEACHERS

As the provision of an elementary education gradually became a priority in America, women were recruited as teachers of young children.[24] Viewed as an extension of the maternal role, teaching was a respectable occupation for unmarried women at a time when few jobs were open to them. It became clear to women engaged in teaching that their own restricted education was inadequate preparation for the task. In 1819, Emma Willard saw fit to lobby for the serious training of women teachers in content areas as well as in teaching methods.[25] In 1921, she established the Troy Female Seminary for this purpose, and in 1937 she organized the Association for the Mutual Improvement of Female Teachers. Catharine Beecher, who advocated the technical training of future housewives and mothers in domestic science, also worked for the education and training of women teachers.[26] Beecher established the American Women's Education Association in 1852.

b. GENERAL, HIGHER, AND PROFESSIONAL EDUCATION FOR WOMEN

Women in early America protested the narrow and unequal education given to young girls for the sole purpose of preparing them to be wives and mothers. In 1790 Judith Sargent Murray wrote in behalf

of women's need for a better education,[27] and in 1818 Hannah Mather Crocker argued that women's minds were equal to men's minds and that therefore they ought to have equal educational opportunity.[28] Frances Wright spoke in behalf of education for poor women[29] and Prudence Crandall fought for the education of black female children.[30]

Because efforts at co-education in colleges such as Oberlin were exceedingly slow and often segregated women into programs emphasizing "proper" feminine accomplishment,[31] the women's college movement, led by Mary Lyon who founded Mount Holyoke in 1837, was to be a major force in securing a more nearly equal higher education for women in this country.[32] Although we now regard colleges such as Vassar, Smith, Wellesley, and Bryn Mawr as exclusive, they were founded on the feminist premise that women deserve an education equivalent to men's.[33] The difficult road to professional education opportunity was opened by individual women willing to brave unjust treatment and harrassment as they petitioned for entrance into professional schools in order to secure training as the "first woman doctor" or the "first woman lawyer."

c. ART EDUCATION AND WOMEN IN ART

Art, of one form or another, was a part of everywoman's education in early America. For those of high economic and social status, a little embroidery, sketching, and painting were part of a privileged but limited education.[34] For the rest, practical arts and crafts such as weaving, quilting, knitting, and clothing design were learned at home in preparation for woman's domestic role.[35] A higher education for early Americans who chose to become professional artists was difficult to obtain for either sex. Such artists were likely to be self-taught and work in so-called primitive styles.

As American women's artistic aspirations rose during the 19th century, certain sex inequities in art educational opportunity had to be overcome. In the 1840s women art students began to be granted regular admission to America's art schools and academies.[36] However, it was not until the second half of the century that women were permitted to study the anatomy of a posed nude.[37] During this period several art schools for women opened to provide formal training in craft design and the decorative arts.[38] Travel and study abroad were still viewed as somewhat inappropriate for a young woman artist. Ironically, the dangers of study in Europe became a rationale for giving women more educational opportunity at home in America.[39] In the latter half of the 19th century, however, courageous and unconventional women artists such as Elisabet Ney, Harriet Hosmer, Edmonia Lewis, and Cecilia Beaux, were asserting their need and right to study art in Europe.[40] In 1879 May Alcott wrote *Studying Art Abroad* acknowleding this new phenomenon.[41] By the 1880s and 1890s, women were actually taking leadership roles and holding office in newly formed associations of art teachers.[42]

The culmination of the first wave of the women's movement

stimulated a desire to learn about and give recognition to women artists and women's art. In 1893, a Woman's Building, designed by architect Sarah Hayden, was part of the World's Columbian Exposition in Chicago.[43] Solicited and chosen by women, women's art work from around the world was placed on exhibition and Mary Cassatt and Mary Fairchild MacMonnies were commissioned to paint murals commemorating women's contributions to culture. A number of books on women artists were published at this time. Among these were Elizabeth Ellet's *Women Artists in All Ages and Countries* (1859); Ellen Clayton's *English Female Artists* (1876); Clara Clement's *Women in the Fine Arts* (1904); and Walter Sparrow's *Women Painters of the World* (1905).

C. THE SECOND WAVE: THE WOMEN'S LIBERATION MOVEMENT

1. In the Interim

If the fears of a women's bloc vote were never realized after the passage of the 19th Amendment, neither were naive beliefs that, having secured the vote, women would naturally gain full equality with no further need for organized protest and effort. Between the European publications of Virginia Woolf's *A Room of One's Own* in 1929, and Simone de Beauvoir's *The Second Sex* in 1949, American organized support for sex equity was at a low ebb. The majority of women who had been energized by the battle for suffrage, turned to private pursuits or worked in apolitical organizations such as the League of Women Voters.[44] Only a handful of "radical" women, led by Alice Paul, continued to work actively for women's rights. It was members of this group who introduced the first proposal for an Equal Rights Amendment to the Congress in 1923 and who reintroduced the ERA to Congress every year until 1970 when it was at last given serious attention under the impetus of the second wave of the women's movement.[45]

Up to and including the Second World War, women seemed to be making slow but steady progress toward the full acheivement of equality. The first wave of the women's movement, however, was given very little attention in school and college history courses.[46] When treated by the media, suffragettes were presented with condescending humor. Many young women coming of age in this period were ignorant of or made slightly ashamed by derisive comments on the organized movement of women which had secured for them opportunities they took for granted. During World War II, women "manned" the homefront, taking over a full range of jobs traditionally done by men. After the war, women were encouraged to enjoy the fruits of peace by returning thankfully to the home and roles of wife and mother. During the 1950s, what Betty Friedan has called the "feminine mystique", was resurrected by the media, psychological literature, and advertising interests who were convinced and set about convincing others that women's preferred careers were housewife and mother.[47]

2. The Women's Liberation Movement

a. "UNFINISHED BUSINESS"[48]

It is perhaps not surprising that both the first and second waves of the women's movement in America were stimulated by and found precedence in egalitarian black protest movements. Idealistic women working in the Black Civil Right Movement as well as in anti-Vietnam War groups, began to draw parallels between the second class citizenship of Blacks and women.[49] They further had their consciousnesses raised by the experience of second-class citizenship and stereotypical expectations of women's "place" that prevailed even within these organizations. As did the women working for the abolition of slavery, women working in the radical movements in the 1960s soon broke off to form organizations dedicated to obtaining equality for women.[50]

Although many of the issues raised by the new wave of feminism in America involved similar, if updated, concerns expressed by 19th century women, it was clear to women liberationists that the accomplishment of sex-equity would entail more than the right to vote. Rationales for the equality of women shifted from the earlier moral and philosophical arguments to modern psychological, political, and sociological analyses. Drawing upon the theory of these disciplines as well as their own experience, the new feminists focused on problems of economic exploitation of women, sex-role conditioning of both men and women, and their negative effects on human development and the quality of life in America. Surveys and statistical reports comparing males and females with regard to education, employment, pay, promotion, mental health, self-concept, and achievement, suggested sexual discrimination and the frustration of women's full potential.[51] Along with 19th century strategies employed for the advancement of women's rights, the Women's Liberation Movement introduced consciousness raising and support groups as a means of changing women's alienated opinions of themselves and helping them achieve a measure of self-definition. Assertiveness training and self-defense were also introduced.[52] The experience of carrying the dual load of domestic and outside employment suggested the exploration of innovative, nonsexist sharing of household and childrearing tasks and the establishment of quality daycare services.

b. SOME KEY PUBLICATIONS, ORGANIZATIONS, AND EVENTS ASSOCIATED WITH THE INITIATION OF THE SECOND WAVE

The following are a few highlights suggestive of the sequence and interlocking of publication, organization, and protest that attended the initiation of the Women's Liberation Movement in the 1960s:

1959 - *The publication of* CENTURY OF STRUGGLE - THE WOMAN'S RIGHTS MOVEMENT IN THE UNITED STATES *by Eleanor Flexner;* A CENTURY OF HIGER EDUCATION FOR WOMEN *by Mabel Newcomer; and* WOMEN AND WORK IN AMERICA *by Robert W. Smuts.* These three publications anticipated the

second wave of feminism in the United States by reviewing the history and contemporary situation of women in this country. Following the cold war, McCarthysim, the "silent generation," suburbanization, and the baby boom which characterized the post World War II era, America in the 1950s rediscovered its social conscience, first in the Black civil rights movement and then in the women's liberation movement.

1961 - *John F. Kennedy's appointment of his Presidential Commision on the Status of Women.* In 1963, this Commission reported continuing sexual discrimination in the employment and treatment of women by the national and state governments and made recommendations for its mitigation.[53]

1963 - *The publication of* THE FEMININE MYSTIQUE *by Betty Friedan.* This book challenged the conservative and somewhat cynical "programming" of women for the homemaker-consumer role by American social scientists and business men. Raising consciousness of the media's stereotypical treatment of the female, it tapped the repressed anger and frustration of many educated, middle class women.

1964 - *Passage of Title VII of the Civil Rights Bill.* A sex amendment was added to this Bill as an obstructionist measure.[54] Nevertheless, it passed, and women gained federal protection against discrimination in employment.

1966 - *The beginning of the National Organization of Women (NOW).* Although national and state governmental commissions on women had made recommendations regarding the elimination of sexual discrimination, progress was very slow. Out of the need to "watchdog" and pressure for implementation, NOW was founded, and Betty Friedan became its first president.

1966 - *The organization of women's caucuses in new left organizations.* While NOW pressed for sexual equality through traditional legal and political channels, many young women discouraged with liberalism and reform as means for bringing about social and economic justice, joined organizations such as the Students for Democratic Action (SDS) which espoused revolutionary political philosophies. Finding themselves victims of male chauvinism in these new left organizations, women formed caucuses or broke off to form new radical feminist organizations in order to explore the relationship between class and sexual inequities and to eliminate sexism in socialist ideology and practice.[55]

1967 - *The grassroots formation of consciousness raising groups.*[56] Drawing in many women who were not engaged in either liberal or radical political organizations of the liberation movement, small, local groups of women formed for the purpose of raising consciousness and giving mutual support as they explored the personal ramifications of changing sex roles.

1968 - *The organization of women's caucuses in national professional associations.* Still a minority in most professions, women began to form caucuses within their national organizations in order to work for the professional equality of women and to eliminate sex bias in the theory and practice of their discipline.[57] In deference to these caucuses, many national professional organizations later refused to hold conventions in states which had not ratified the Equal Rights Amendment (ERA).

1969 - *The formation of Women's Equity Action League (WEAL).* Typical of numerous organizations set up to serve the special needs of women, WEAL offered both encouragement and practical legal support to women fighting discriminatory laws or practices.[58]

1971 - *The organization of the National Women's Political Caucus (NWPC).*[59] In order to encourage and support women for political office and to raise women's issues within the national party system, women formed political caucuses at both the national and state levels.

1972 - *The Equal Rights Amendment passes Congress.* First proposed in 1923 as a follow-up to the 19th Amendment, the ERA which would simply guarantee women the equal protection of the law, finally passed Congress in 1972. Conservative "pro-family" forces and those who feared the loss of special privileges for women under the law, organized against this Amendment. Working against an extended deadline, in 1982, supporters of the ERA failed to secure its ratification by 3/4 of the States. Early in 1983, the Amendment was reintroduced to Congress, and its supporters have begun to recognize the necessity of gaining the support of state legislatures as well as the majority of Americans.

Although the women's liberation movement has gone a long way in the matter of changing negative and stereotypical beliefs about women, the full equality of women must still be considered "unfinished business." It has become obvious to many second wave feminists that prejudice against those different than ourselves develops early and easily and that the damage prejudice does to the self-concepts of the young individual requires remedial and affirmative responses.[60] Thus, sex equity effort in education becomes a significant aspect of the women's liberation movement in contemporary America.

3. Sex-Equity Progress in General Education

a. TITLE IX[61]

Passed in 1972, Title IX of the Education Amendments specifies that

"No person in the United States shall, on the basis of sex, be excluded from participation in, be denied the benefits of, or be subjected to discrimination under any education program or activity receiving Federal financial assistance."

In combination with Title VII of the Civil Rights Bill, Title IX promises equal educational opportunity for women and makes available to them a grievance system and legal sanction for enforcement. Guidelines, established by the Department of Health, Education, and Welfare, have promoted active self-investigation by educational institutions on the matter of sex-inequity in admission, hiring, pay, status, regulations, curriculum, facilities, and all areas of student and faculty activity. They have further required affirmative action plans which propose specific sex-equity efforts and goals. Many states have also established sex-equity guidelines for their educational systems and review of textbooks and curriculum for possible sexist intent or effect.

b. WOMEN'S CAUCUSES

In addition to legal imperatives and impetus for the achievement of sex-equity in general education, women have formed caucuses in professional teacher organizations and have supported programs and research which deal with educational issues related to women.[62] In-service workshops, publications for teachers, and the development of non-sexist curriculum and teaching materials have marked sex-equity efforts in the many content areas of education.[63]

c. WOMEN'S STUDIES

In colleges and universities, women have worked to establish Women's Studies degrees, programs, and courses.[64] They have shared their ideas and findings through conference presentations, workshops, and newsletters. Incorporating feminine identified teaching and learning methods such as consciousness raising and journal writing, women in education have sought to alter not only the content but the form of education in ways that promise to eliminate both overt and subtle sex-inequity.

The impact of the second wave of America's women's movement on the theory and practice of art and art education is of particular concern to art teachers and will be discussed at length in Chapters 4, 5, and 6.

NOTES AND REFERENCES

[1] See Chapter 1, "The Position of American Women Up to 1800" in Eleanor Flexner, *Century of Struggle: The Woman's Rights Movement in the United States* (Cambridge, Massachusetts: Harvard University Press, 1959, 1975), pp. 3-22.

[2] For a summary of liberating forces for women in the "new world," see Elsa Honig Fine, *Women and Art: A History of Women Painters and Sculptors from the Renaissance to the 20th Century* (Montclair, New Jersey: Allanheld & Schram, 1978), pp. 89-91. See also, Flexner, *op.cit.*, p. 9.

[3] For an excellent analysis of persisting rationales for women's inferior status in western culture, see Caroline Whitbeck, "Theories of Sex Difference," in Carol C. Gould and Marx W. Wartofsky, eds., *Women and Philosophy: Toward a Theory of Liberation* (New York: G.P. Putnam's Sons, 1976), pp. 54-80.

[4] Flexner, *op.cit.*, pp. 18-22.

5 *Ibid.*, pp. 53-61. For more recent examples, see Corinne H. Rieder, "Work, Women, and Vocational Education," in *Taking Sexism Out of Education* (Washington, D.C.: Government Printing Office, 1978), pp. 69-79.

6 Jane Lewis, "Women, Lost and Found: The Impact of Feminism on History," in Dale Spender, ed., *Men's Studies Modified: The Impact of Feminism on the Academic Disciplines* (Elmsford, New York: Pergamon Press, Inc., 1981), pp. 55-81.

7 Flexner, *op.cit.*, pp. 9-12.

8 *Ibid.*, p. 12.

9 Alice S. Rossi, ed., *The Feminist Papers—From Adams to De Beauvoir* (New York: Bantam Books, Inc., 1973, 1974), pp. 7-15.

10 Flexner, *op.cit.*, pp. 41-42.

11 *Ibid.*

12 *Ibid.*

13 *Ibid.*, pp. 70-77.

14 *Ibid.*

15 *Ibid.*, p. 176

16 *Ibid.*, Chapter XXII, "Who Opposed Woman Suffrage?" pp. 304-318.

17 *Ibid.*, p. 109

18 *Ibid.*, pp. 150-151.

19 *Ibid.*, pp. 154-158.

20 Rossi, *op.cit.*, pp. 25-85.

21 *Ibid.*, pp. 183-184.

22 William O'Neill, ed., *The Woman Movement—Feminism in the United States and England* (Chicago: Quadrangle Books, Inc., 1969, 1971), pp. 15-32.

23 Flexner, *op.cit.*, pp. 79-80; 61-68; 185-189; and 208-221.

24 *Ibid.*, p. 24.

25 *Ibid.*, pp. 25-26.

26 *Ibid.*, p. 31.

27 *Ibid.*, p. 16.

28 *Ibid.*, p. 25

29 *Ibid.*, pp. 27-28.

30 *Ibid.*, pp 38-40.

31 Jill K. Conway, "Perspective on the History of Women's Education in the United States" *History of Education Quarterly* 14, 1 (1974): 5-7.

32 Fine, *op.cit.*, p. 92

33 Liz Schneider, "Our Failures Only Marry: Bryn Mawr and the Failure of Feminism" in Vivian Gornick and Barbara K. Moran, eds., *Woman in Sexist Society: Studies in Power and Powerlessness* (New York: Basic Books, Inc., 1971), pp. 579-600.

34 Gordon S. Plummer, "Past and Present Inequities in Art Education" in Judy Loeb, ed., *Feminist College—Educating Women in the Visual Arts* (New York: Teachers College Press, 1979), pp. 14-15.

35 Flexner, *op.cit.*, p. 9.

36 Fine, *op.cit.*, p. 95.

37 *Ibid.*, p. 96.

38 *Ibid.*

39 Plummer, *op.cit.*, p. 16

40 See particular accounts in Fine, *op.cit.*.

41 *Ibid.*, p. 93.

42 *Plummer*, *op.cit.*, p. 18.

43 Jeanne Madeline Weimann, *The Fair Women* (Chicago: Academy Chicago, 1981).

44 Flexner, *op.cit.*, p. 340.

45 Gayle Graham Yates, *What Women Want—The Ideas of the Movement* (Cambridge, Massachusetts: Harvard University Press, 1975), p. 52.

46 Flexner, *op.cit.*, pp. x-xii.

47 Betty Friedan, *The Feminine Mystique* (New York: Dell, 1963).

48 Flexner, *op.cit.*, p. 344.

49 Yates, *op.cit.*, pp. 6-7.

50 *Ibid.*, pp. 7-8.

51 For example, see summaries and references to such surveys in the report of the National Commission on the Observance of International Women's Year, " . . . *To*

Form a More Perfect Union . . .''—Justice for American Women (Washington, D.C.: Government Printing Office, 1976), pp. 337-348. See also, Myra Pollack Sadker and David Miller Sadker, *Sex Equity Handbook for Schools* (New York: Longman, 1982), pp. 1-8. A copy of Sadkers' *The Report Card* which summarizes the ''costs' of sexual discrimination can be found in Chapter 7 of this book.

[52] Bette Acuff, ''Learning To Be Assertive: First Steps Toward the Liberation of Women,'' in Judy Loeb, ed., *op.cit.*, pp. 230-240.

[53] Yates, *op.cit.*, p. 4.

[54] *Ibid.*, p. 5.

[55] *Ibid.*, pp. 6-8.

[56] *Ibid.*, p. 9.

[57] *Ibid.*, p. 11.

[58] *Ibid.*

[59] *Ibid.*

[60] See for example, Pauline Gough, *Sexism: New Issue in American Education* (Bloomington, Indiana: The Phi Delta Kappa Educational Foundation, 1976).

[61] Bernice Sandler, ''Title IX: Antisexism's Big Legal Stick'' in *Taking Sexism Out of Education, op.cit.*, pp. 1-12.

[62] See for example, Sandra Packard, ''Finally! A Women's Caucus in Art Education'' *The Feminist Art Journal* 3,3 (1974):15.

[63] Susan S. Klein, ed., *Achieving Sex Equity Through Education* (Baltimore, Maryland: The Johns Hopkins University Press, forthcoming.)

[64] For an early account of such efforts in art, see Athena Spear, ed., *Women's Studies in Art and Art History: Description of Current Courses with Other Related Information* (New York: College Art Association of America, 1975).

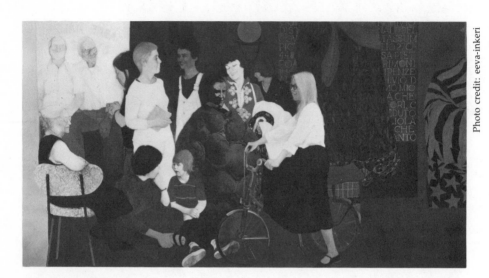

May Stevens. *SOHO Women Artists 1978*. Acrylic/canvas 6½' x 12'. Photo credit: Eeva-Inkeri.

CHAPTER 4:

The Women's Art Movement As An Educational Force

The revolutionary factor [in women's art] is not a style, but the identity, cultural and individual, of the artists themselves.
—Lawrence Alloway (1975)

A. INTRODUCTION

In the 1970s women artists, art historians, and art critics challenged the notable absence of women in the visual arts and the prevailing view that "over the years our modern civilization has produced, at best, a 'woman of the century' and little more."[1] The women's art movement represented the joining of two streams of social protest: the feminist movements of the 1960s and 1970s and the artists' protest movement against both the existing art structures and American support of an unjust war in Vietnam.[2] Women artists, concerned with achieving access to the career patterns and structures open to their male counterparts, engaged in bringing about sexual-political reform in the established art world. Members of the women's art movement pointed out that women have indeed contributed to artistic heritage but that women's achievements have been limited by their access and opportunities in training, media, and exposure. Women artists' limited success and prestige in their past and present worlds have been due to restrictions imposed upon them by prevailing social/historical conditions, the lack of recognition by art historians and art and educational institutions, and finally, by the inadequacy of traditional art standards.

The women's art movement of the 1970s, then, has primarily involved women artists and art historians engaged in bringing about sexual political reform in the established art world and in promoting a "revisionist" art history to reexamine art history and traditional

aesthetics from a feminist perspective.[3] While the benefits of the move-
ment have been mainly directed toward the problematic issues regard-
ing the making (production) and the marketing of women's art, its in-
fluence as an educational force has succeeded in increasing the visi-
bility, interest in, and value of women's art and education during the
past decade.[4]

This chapter reviews the educational processes of the women's art
movement and discusses the goals, approaches, outcomes and value
of feminist art education taking place in institutions of higher educa-
tion. It concludes with a discussion of the relationship and importance
of the women's art movement and feminist art education to the field
of art education.

B. MODEL: WOMEN'S ART MOVEMENT AS AN EDUCATIONAL FORCE

The women's art movement can be described in terms of the educa-
tional model which it provides. By educational we mean not only the
learning acquired inside and outside the public school classroom but
also awareness and knowledge obtained through the events and
changes that take place in the art world and society. The parts and
whole of the educational process involve and affect both the individual
and groups and ultimately help to transform cultural values, ideas, and
forms. The process of education of the women's art movement occurs
through (a) self, (b) informal, and (c) formal education "routes" (see
Figure 1). Descriptions of these areas and related sex equity efforts
follow.

1. Self-Education

Self-education involves a personal dialogue—the sharing and
developing of an ideology which can establish personal and profes-
sional support and build toward eventual nonsexist changes in the art
world as well as society. The self education route begins with increased
awareness of sex discrimination and women's weak position in the art
making and teaching labor markets,[5] as well as in the art making and
selling product markets (i.e., women's low representation in museums
and art publications)[6]. Provoked by sexist conditions which limited
women's visibility in museums and galleries, women artists began to
organize in 1969 to establish a fine arts community for women[7] which
would later effect changes in the older, male-dominated systems within
the art world. Initially, new support systems for professional women
in the arts, based on shared philosophies and needs, were established.
Some of these began as consciousness-raising groups and developed
into group art projects and cooperative agencies such as
"Womanhouse" and the Feminist Studio Workshop, respectively.[8]

a. MANIFESTATIONS: PROLIFERATION OF NETWORKS FOR WOMEN IN ARTS

Women's art groups first emerged on both the East and West coasts

and later spread nationally and internationally. The process of self-identification and education for women in the arts has occurred in and through the following newly created networks:

(1) Organizations, Cooperatives, and Galleries for Women Artists

Such as: Women Artists in Revolution (W.A.R.); Los Angeles Council of Women Artists (L.A.C.W.A.); Red Stockings; Women Art Students and Artists for Black Artists' Liberation (W.A.S.A.B.A.L.); Women's Ad Hoc Committee (which protested the Whitney annual); West-East Bag (W.E.B.); Women for Art; Artists in Residence (A.I.R.); Where We At; Women in the Arts (W.I.A.); Women's Interart Center; Washington Women's Art Center (W.W.A.C.); Coalition of Women's Art Organizations (C.W.A.O.); International Organization of Women in the Arts; New York Feminist Art Institute; A Rose By Any Other Name; Women's Cultural Center; and many other national and state art organizations and galleries.[9] The National Museum of Women in the Arts is scheduled to open in Washington, D.C. in 1986.

(2) Women's Caucuses in Existing Professional Organizations

Such as: The Women's Caucus for Art (which emerged from the College Art Association) and the National Art Education Association's Women's Caucus, with special programs and publications.

(3) Group Exhibitions of Women's Art and Collective Women's Art Projects

Such as: "X to the 12th Power"; "Unmanly Art"; "13 Women Artists"; "Women Artists Here and Now"; "26 Contemporary Women Artists"; "Works on Paper—Women Artists"; "Ten Artists (Who Also Happen to be Women)"; "The Female President"; "Women Choose Women"; "Womanhouse"; "Women Artists Living in Brooklyn"; "Old Mistresses: Women Artists of the Past"; "The Dinner Party"; "Women Artists: 1550-1950"; "Perspective '78: Works by Women"; "Forever Free: An Exhibition of Art by Afro-American Women 1862-1980"; "Women Look at Women: Feminist Art for the '80's"; "The Sister Chapel" (pl. 4); "The Artist and the Quilt" (pl. 11); as well as shows of individual women artists of the past and present.

(4) Publications that Disseminate Information To and About Women in the Arts

Such as: *Women and Art; Feminist Art Journal; Womanspace; Womanart; Visual Dialogue; Women Artists Newsletter; Heresies; Chrysalis; Women's Caucus for Art Newsletter* (now called *Hue Points*); *The Report: Newsletter of the NAEA Women's Caucus; Woman's Art Journal.*

(5) Programs for Women to Participate In

Such as: slide registries and directories of women's art such as West-East Bag (W.E.B.) and The Women's History Research Center

(Berkeley, California); women's art workshops in settings such as Feminist Studio Workshop in The Women's Building (Los Angeles), Women's Interart Center (New York City), and the N.Y. Feminist Art Institute; special conferences on women in the arts; as well as special sessions on women and art at the Women's Caucus for Art and College Art Association meetings and the National Art Education Association conventions.

Figure 1
MODEL OF THE WOMEN'S ART MOVEMENT AS AN EDUCATIONAL FORCE*

*Based on a similar figure by Renee Sandell printed in ''Feminist Art Education: An Analysis of the Women's Art Movement As an Educational Force,'' *Studies in Art Education,* XX, 2, Winter 1979 and in *Handbook for Achieving Sex Equity Through Education,* edited by Susan Klein. Baltimore, Md: John Hopkins University Press, forthcoming.

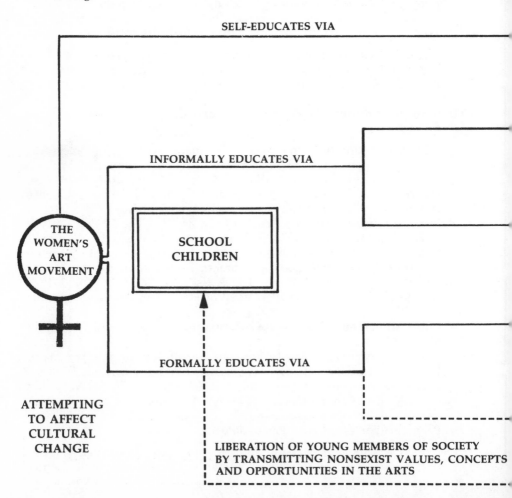

SELF-EDUCATES VIA

INFORMALLY EDUCATES VIA

THE WOMEN'S ART MOVEMENT

SCHOOL CHILDREN

FORMALLY EDUCATES VIA

ATTEMPTING TO AFFECT CULTURAL CHANGE

LIBERATION OF YOUNG MEMBERS OF SOCIETY BY TRANSMITTING NONSEXIST VALUES, CONCEPTS AND OPPORTUNITIES IN THE ARTS

b. OUTCOMES/DEVELOPMENTS

(1) Increased Access to Professional Opportunities

These networks of the movement have not only helped educate women artists but also provided women with access to the process of exhibiting, the consummation experience for the professional artist. The exhibitions, as well as the caucuses and workshops, have provided women with a haven in which to work out their particular concerns. Both women artists and viewers have been encouraged to "get in touch with their feelings" in these participatory environments as well as with the feminist content in the art works. For example, as Judy Chicago wrote after the success of the Womanhouse exhibit, "to express feeling is to be 'womanly,' and if we want to change the values of this

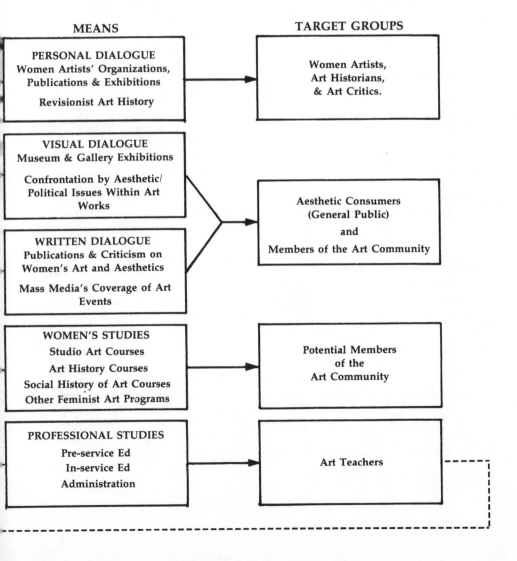

MEANS

TARGET GROUPS

PERSONAL DIALOGUE
Women Artists' Organizations,
Publications & Exhibitions

Revisionist Art History

Women Artists,
Art Historians,
& Art Critics.

VISUAL DIALOGUE
Museum & Gallery Exhibitions

Confrontation by Aesthetic/
Political Issues Within Art
Works

WRITTEN DIALOGUE
Publications & Criticism on
Women's Art and Aesthetics

Mass Media's Coverage of Art
Events

Aesthetic Consumers
(General Public)
and
Members of the Art Community

WOMEN'S STUDIES
Studio Art Courses
Art History Courses
Social History of Art Courses
Other Feminist Art Programs

Potential Members
of the
Art Community

PROFESSIONAL STUDIES
Pre-service Ed
In-service Ed
Administration

Art Teachers

culture, we must educate the entire society to appreciate rather than denigrate 'womanliness' in art and in life.''[10]

(2) Increased Female Role Models and Supportive Systems

Not only have a variety of conceptions of "woman" been presented by and to many women in a contemporary context, but the history of women in art has become increasingly important. Women artists, historians, and educators have sought information on female artists in an attempt to establish models and recover a lost correspondence of feminine sensibilities *and* liabilities within a patriarchal society. For example, as part of the seven-day Women's Art Festival at the California Institute of the Arts in 1974, women who had actively participated in the Feminist Art Program published their ideas with pictorial results in *Anonymous was a Woman*. It contained a collection of solicited letters to young women artists from established contemporary female artist or art historian models. In introducing their book, they raised these points:

> What does it mean to make art as a woman? Some themes seem to repeat themselves: covering and uncovering, central imagery, intimacy, sensuality, personal symbology. What about the art made by women working in the mainstream? The more we learn about our sensibilities, the more complex and beautiful they become. We have come to re-define ourselves in this strange territory. A long process of removing layers of social conditioning has kept our vision unformed, confused and repressed. Our marks are now a poetic outcry against the void of history. We have the audacity to be faithful to this dream.[11]

c. SUMMARY

The self-education developed by the women's art movement promises women participating in the arts strengthened individual and collective identity, achieved through group dialogue, effort, and support. The self-education route, then, has functioned as a self-constructed path by which women artists, art historians, art critics, educators, and students, can enter, transcend, and transform the existing art market and its many phases: creating, promoting, exhibiting, curating and cataloguing, and buying and selling. From such initial educational efforts would later emerge feminist art education.

2. Informal Education

Beyond developing their personal dialogue, members of the women's art movement have educated other women and men through informal means—that is, outside of the traditional formal classroom. Their target has been members of the established art world and the general public. The informal education process includes visual and verbal dialogues which tend to threaten existing aesthetic and social values.

a. VISUAL DIALOGUE

A *visual dialogue* which confronts the public and the art world has

been conducted through special exhibitions of women's art in museums and art galleries as well as by the aesthetic and political issues contained within the art works themselves. Through their art, women artists have been "bringing the 'private' sphere (usually maintained by women) into the light, making the private public and in doing so taking a large step towards bridging the culture chasm between men and women"[12] which subtly lies in our societal divisions of a male public universe vs. a private female cosmos. Artist Judy Chicago felt that,

> not only do women have to move into public life, but men have to share the burdens of private life before any real change can take place. This means that men have to be educated emotionally, and the first step in that education is to be made to 'see' women, to feel with us, experience our point of view.[13]

These works, which purported to share female aesthetic views or sensibilities, have paralleled other current directions in contemporary art while establishing a separate categorical importance by their segregated mode of presentation. Feminist art, as opposed to feminine art, has made its political intent clear. It includes these trends: political art, autobiographical art, a conscious search for archetypal imagery, exploration of female sexuality, and a return to crafts and decorative arts which are historically associated with women[14]. Some women artists such as Helen Alm Roth[15] and Kate Millett[16] have advocated greater use of popular media such as video and graphics in order to reach a wider audience. In sum, the new visual dialogue of feminist artists with art audiences has been expressed in different aesthetic dialects and political tones while communicating through the contemporary visual vocabulary.

b. WRITTEN DIALOGUE

A *written dialogue* has accompanied the visual dialogue. It has been carried on by and between art critics and art historians strongly identified with the women's art movement, such as Linda Nochlin, Lucy Lippard, Mary Garrard, Cindy Nemser, Gloria Orenstein, and Lawrence Alloway, and verbally articulate artists and art educators such as Judy Chicago, Miriam Schapiro, and June Wayne. Sociologists such as Jacqueline Skiles have added another perspective to the written dialogue. The written dialogue has resulted in an extensive body of literature found in feminist and art journals and articles, books, and monographs.[17] This literature surveys the work of women artists, exhibition catalogues, bibliographies, and newsletters, all of which deal with the subject of women and art and a variety of aesthetic and political issues of the past and present. In addition to the specialized feminist art publications, the mass media has covered events and ideas surrounding the women artists' efforts to inform the general public.[18]

3. Formal Education

Beyond self- and informal educational routes for the enlightenment of the art world and the general public, the women's art movement

has had an impact on formal education primarily at the higher education level. It has affected the contents of university art galleries as well as studio art and art history curricula. College art departments have expanded their slide collections to include women's artistic contributions and have offered special seminars on women's art. These attempts have fostered greater awareness of the historical perspective as well as current personal and professional needs for women.[19] Since the 1970s courses in fine arts and art history have been offered by university art departments and women's studies programs around the country. The courses deal with various issues raised by the women's art movement, falling into three main categories: studio courses for women art students; art history courses about women artists and/or the image of women in art; and socially-oriented courses about the role and fate of women in the art world.[20] These courses and their derivative exhibitions and research projects constitute "feminist art education" which is ongoing, influencing the potential art community as well as supportive aesthetic consumers.

C. FEMINIST ART EDUCATION

Feminist art education, the formal educational activity emerging from the women's art movement, is conceptually located, as indicated in *Figure 2*, at the central intersection of feminism, the art world, and education, surrounded by the joint areas of women's studies, women's art movement, and art education. This unique nucleus/intersection may in fact be the one area that offers the most potential for cultural change in all of the areas related to it as well as society at large. The following section will review the goals, approaches, positive outcomes, and values of feminist art education and its application to art education.

1. Goals of Feminist Art Education

The goals of feminist art education correspond to those of women's studies programs in the fine arts.[21] These, based on the basic goals of women's studies as stated by Florence Howe,[22] include research into the history of past and present women artists, rediscovering and reinterpreting their work as well as reinforcing the image of women in art, compensatory education (filling in the gaps of knowledge about women as creators and as subjects in art), consciousness-raising concerning the barriers that have prevented women from producing the quality and quantity of art that men have, and changing the status of women in the art world. An analysis of feminist art education based on a sample of 50 course syllabi offered in the U.S. from 1970-78, noted the curricula and instruction of women's studies courses in studio art, art history, and sociological women's issues in the arts.[23] The three kinds of courses plus related efforts in art education are briefly described in the paragraphs that follow.

2. Approaches to Feminist Art Education: Types of Courses

a. STUDIO ART

Women's studies courses in studio art are designed to further develop women's artistic skills by utilizing traditionally "masculine" materials and processes such as power tools or large scale projects. They also attempt to develop "authentic imagery" and survival skills that would make women's art training more practical and professional. An im-

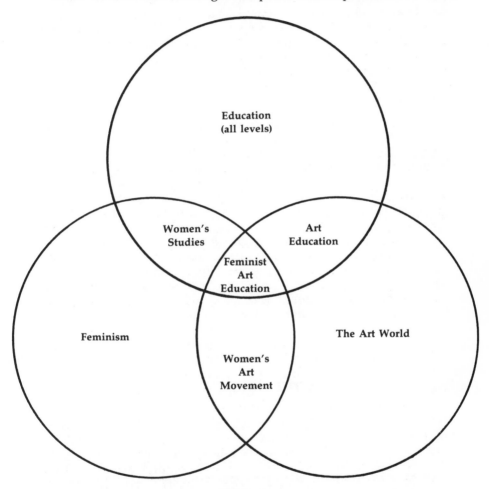

Figure 2
FEMINIST ART EDUCATION: LOCATION WITHIN THE UNIVERSES OF FEMINISM, EDUCATION AND THE ART WORLD*

*From Renee Sandell, "Feminist Art Education: An Analysis of the Women's Art Movement As An Educational Force," *Studies in Art Education*, XX, 2, Winter 1979; also printed in *Handbook for Achieving Sex Equity Through Education*, Susan Klein, ed. Baltimore, Md: John Hopkins University Press (forthcoming).

portant course goal is to furnish women students with a supportive system (i.e., a community of women artists who share ideas, sensibilities, and problems) in order to avoid the traditional isolation of women artists while strengthening their own professional commitment. In several cases, collective student works have culminated in public presentations of exhibitions around feminist themes such as "Womanhouse" and "The Wedding."[24] Some courses incorporate practical survival skills for women training to become professional artists: employment procedures, setting up a studio, making slides of one's work and presenting them to art dealers, maximizing tax deductions, and coordinating family responsibilities with studio work. These topics, along with the experience of working with less traditional media, tools, and processes to which access has generally been restricted for women, comprise a kind of *remedial* instruction.

b. ART HISTORY

Courses in "revisionist" art history focus on women artists' contributions to the history of art. Serving as a reversal of sexist surveys and filling in the great gaps in traditional art history books which never mention women's art, these courses also examine the social biases affecting the iconographic role of women in works of art. Women have generally been portrayed in service to men, either as temptress/whore or venerated madonna, mother, or muse. Since much of the information on women and art of the past has been either unavailable, unknown, or misrepresentated in art historical writings and textbooks, an overriding goal of these courses is to fill the great need for scholarly research and enlarge the historical perspective of art. Involving students in original research on women's art works and with the subject of historiography itself, has partially fulfilled the continuing need for basic instructional materials such as slides, visual illustrations, and texts. Exhibitions of women's art and women's art festivals are frequently coordinated with course offerings, reinforcing in an immediate sense the ideas and concepts covered in class.

c. WOMEN'S ISSUES IN THE ARTS

While the goals of women's studies courses about women's issues in the arts tend to combine those of feminist art courses in studio and art history, these courses focus upon the contemporary art world from sociological, feminist, and aesthetic perspectives. The primary goal of these courses is, therefore, awareness and comprehension of sexual-political issues for the contemporary woman artist, art historian, and critic, as well as common themes and problems of women in the arts as expressed in art products. Diverse topics broaden the scope of the different courses to include: female imagery and female aesthetics; the education of the woman artist; identity and the woman artist; imagery of male vs. female artists; standards and women's art/art criticism; artistic hierarchies (i.e. crafts vs. fine arts); art and economics; collecting, curating, and gallery directing; and alternative modes of exhibiting art.

d. ART EDUCATION

Finally, there have been only a few recent attempts, including those of the authors and contributors to this book, to develop and teach women's studies courses that deal with women and art and nonsexist art education. These courses are designed to impact directly upon art teachers at the pre-service and graduate study levels. The relative nonexistence of this kind of nonsexist programming in professional studies, i.e. at the pre- and in-service education levels in art education accounts in part for the virtual absence of sex equity activities at the elementary and secondary art education levels.

3. Outcomes of Feminist Art Education

a. DEVELOPMENTS

Feminist art education has dramatically grown and developed since the early 1970s and continues to make an impact in the 1980s. The quality of curriculum and instruction of women's studies courses in the arts have been improved by the increased availability of research and teaching resources about women and art such as books, slides, and films. An increased number of courses that deal with art historical and sociological views of women and art have been offered, in contrast to the earlier studio courses which focused on personal and political feminist ideology. While alternative feminist art education programs designed specifically to train women in the arts, such as the Feminist Studio Workshop in Los Angeles and the New York Feminist Art Institute, have tended to serve as radically-focused and separatist paradigms of feminist art education, other courses/programs attached to universities and cultural institutions have reflected an integration of new knowledge and revision of earlier feminist art education approaches.

b. POTENTIAL VALUE OF FEMINIST ART EDUCATION

The success of women's studies courses and the instructional approaches and the valuable knowledge which has emerged from students' and scholars' research has advanced and benefitted the individual, art as a subject, and society. In other words, feminist art education offers several kinds of potential value: psychological, aesthetic, and social, each of which is briefly discussed in the succeeding paragraphs.

(1) Psychological Value

The psychological value of feminist art education lies in its potential to provide compensatory education about art and women. Feminist art education has helped individual women positively develop their confidence, abilities, and aspirations, seriously promoting their future professional participation through greater access to skills in making and marketing art. By breaking down some of the hierachies and gender barriers that exist in the art world and society as well as polar-

ized teacher-student roles in the classroom, feminist art education can foster a cooperative and supportive community and heritage for women that provides the psychological goal that in the future "there will be enough achievement around so that we can watch another woman building a temple and rejoice in it ourselves because of the hope it offers that we will be able to do likewise".[25] The psychological value can be extended to the liberation of men from the limits of their stereotyped sex roles.

(2) Aesthetic Value

The aesthetic value of feminist art education lies in its capacity to revise art history, providing new paradigms for comprehending and valuing works of art. Feminist art education has helped improve the internal validity of art, made in its many forms by persons of both sexes and all social classes, by questioning its inequitable premises and providing new approaches and standards that affect the contributions to the history and contemporary nature of art.

(3) Social Value

Feminist art education has increasing social value as it promotes awareness and raises the status of women and art in society. By demystifying the image of women, as well as that of art as a "feminine" subject, it presents a critical view of art in society that includes issues of race and class as well as sex. by promoting a new kind of understanding of the roles of art and the artist in society, feminist art education builds sex equity awareness within the art community while it invitingly provides other members of society with involvement and insight into the arts as a seriously life-enriching, rather than an entertaining or passively decorative aspect of humanity.

c. SPECIFIC BENEFITS/CONTRIBUTIONS OF FEMINIST ART EDUCATION

To summarize and state specifically, feminist art education, in addressing key sex equity needs in higher art education, has had the following positive outcomes/benefits which impact upon the fields of art and art education, as it affects individual students and teachers of women's studies courses in art:

1. Feminist art education has begun to provide compensatory education for women students' personal and professional development in art.
2. Feminist art education has begun to raise the status and participation of women in art academia and the art world via art exhibitions and journal coverage.
3. Feminist art education has begun to raise the status of art as a "feminine" subject while demystifying the role of the artist and art in society.
4. Feminist art education has attempted to break down hierachies

in the academic study of art while providing new paradigms for art study.

5. Feminist art education has begun to revise and reappraise the content in studio art and art history and broaden their scope to include current issues.

6. Feminist art education has begun to increase research efforts about women's art, roles, iconography as well as the historiography of art.

7. Feminist art education has begun to increase curricular changes that reinforce and further the previous outcome including revision of slide collections to include women's art works, mainstream courses in art to include women's contributions, and general art textbooks to include women's art work (Janson, Feldman).

d. IMPACT AND LONGTERM VALUE OF FEMINIST ART EDUCATION

Since the longterm value of the women's art movement via feminist art education lies in part in its educational potential to affect feminism, the art world, and education, we can already observe certain effects. Feminist art education has promoted feminism, applying feminist ideology to the content and function of art (as well as demonstrating the role/value of art in society to feminists). The art world has been affected both by new visual and written ideas as well as organized actions that attempt to extend its traditionally limited and elitist boundaries. Finally, in the area of education, the university (higher education) has slowly become responsive to feminist concerns, both by incorporating women's issues in art course offerings and in making hiring, promotion, and salary policies more sex equitable.[26] Thus, we can see that feminist art education has already begun to have an impact on the contingent universes from which it originates (see *Figure 2*). While the ultimate value of women's studies in art and art history may lie in its current contributions to art and education, its eventual termination as a form of remedial art education may be expected when women's studies will have produced a human art history out of what has been "men's" art history:

> Expanded knowledge will bring new perceptions of existing knowledge. Women's studies can promote social and political change by raising the consciousness of both women and men in our profession, in colleges and universities, and in society at large. Ultimately, women's studies in art will elevate the status of women by recognizing and honoring their creative achievements, past and present. In the future, women will no longer be invisible in the art world, in the content of a university education, or on its faculties—any more than they will be in the world outside the university.[27]

D. THE WOMEN'S ART MOVEMENT AND ART EDUCATION

1. Impact of the Women's Art Movement on Art Education

Although the women's art movement has functioned educationally

by addressing the need for improving the status of women in the visual arts and establishing sex fair and affirmative content and practice in art and art education at the higher education levels through feminist art education, it has had a weak impact on the field of art education as it affects the schools (grades K-12 via pre- and in-service art education). As shown in *Figure 1*, the educational efforts of artists, art historians, and art critics who comprise the women's art movement have for the most part ignored art teachers *and* by-passed school-age children. These populations have not been part of the educational process. Despite advances made by feminists in art, only minute, indirect portions of their efforts have been directed toward formal, non-artist-oriented art education which takes place in the schools. Finally, members of the movement have paid little attention to the potential role that the field of art education might play in helping to eradicate earlier and perhaps more pervasive sexist influences in art and education.[28] This is ironic since many feminists and educators from other disciplines, believing that "a woman's place is in the curriculum"[29] have been campaigning actively for the implementation of nonsexist amendments in school subjects such as math, social studies, language arts, and physical education, to form a more androgynous education for both sexes at *all* education levels.

2. Sex Equity Efforts in Pre- and In-Service Art Education

Except for NAEA Women's Caucus presentations at national and state art education conventions and the publication of this book, there are few, isolated, and recent efforts at conducting in-service education related to sex equity in visual art education which have been developed *outside* of the field of art education. For example, the Midwest Center for Race and Sex Desegregation in Manhattan, Kansas, has conducted a few in-service workshops on nonsexist and nonracist arts education which focus primarily on consciousness-raising discussion groups for public school teachers. In addition, summer institutes and mini-conferences that provide in-service education on sex equity in arts education have begun to be offered at university campuses. For example, the Mid-Atlantic Center for Sex Equity held a one-day conference entitled "Nonsexist Approaches to Teaching Visual and Performing Arts" at the American University in Washington, D.C., in March 1983.

3. Sex Equity Efforts in Elementary and Secondary Art Education

Beyond the few attempts at pre-service and in-service programming of nonsexist art education for teachers already mentioned, current systematic sex equity efforts in elementary and secondary art education are hardly discernible. Although there are anecdotal reports of spontaneous sex equity activities in public school art programs, these scattered efforts remain undocumented, and, to date, evaluations of their successes have not been published. Similarly, nonsexist instruc-

tional materials for classroom use are few in number, and, for those available, there is no information on their actual usage or effectiveness; however, some recent art education texts are beginning to reflect a sensitivity to sex equity issues in art, if only indirectly.

a. ELEMENTARY ART EDUCATION

At the elementary art education level, sex equity efforts generally involve the individual in the design and preparation of instructional materials. For example, Enid Zimmerman, who teaches art education at Indiana University, has developed two sets of slide/discussion materials which she has subsequently tested with elementary classroom teachers, art teachers, and elementary students in her region.[30] Both sets take an art historical approach and involve the pairing of art works by men and women artists. According to Zimmerman, "Women Make Art: An Androgynous Point of View" was most successful, making the point that art objects themselves have no sex when she encouraged the children to review the images and discuss them fully.

b. SECONDARY ART EDUCATION

Sex equity efforts at the secondary level also involve the individual teacher in the design and preparation of instructional materials. For example, Barbara Arnold, a secondary art teacher in Lexington, Kentucky, has developed several nonsexist slide shows to use in her studio and art history teaching.[31] She incorporates art by women and women's images with popular music as background. Arnold finds that presenting these shows with "no comment" stirs up discussion among her high school art students and is an effective consciousness-raiser.

4. Need for Sex Equity Modification in Art Teacher Education

More practical and direct educational efforts such as curricular modifications in art teacher education as well as in the elementary and secondary art education will be needed if we are to fully recognize the increased potential of women's place in art and art education. As shown in *Figure 1*, most art teachers-in-training are not currently part of the educational process of the women's art movement. These future teachers require some understanding of women's issues in the arts and education. With some formal feminist art education content, art teachers could transmit nonsexist values and concepts in the arts to their students, and thus educate the younger members of our society and liberate them from unjust sexist influences. Inclusion of feminist art educational content would be both compensatory and important in the training and cultivating of art teachers (the majority of whom are women), since they influence and train the general public to make and appreciate art, a small percentage of whom actually become artists. Additionally, this process of training art teachers would be a more efficient way of educating society against sexism than the current combination of educational processes of the women's art movement;

Feminist art education would lose its remedial nature and ultimately become obsolete.

5. Conclusion

If sex equity progress in public school art and art teacher education is to be expedited, spontaneous sex equity efforts at these levels need to be documented, evaluated, and disseminated. Strategies that have proved successful at higher levels of art and education need to be adapted for classroom use, and those instructional materials already available need to be assessed for their effectiveness. In addition, new sex equity materials of greater depth, breadth, and relevance, need to be devised for studio teaching and career education in the schools. By becoming a more active educational force against the condition of sexism in art and society, the field of art education can contribute to a more truly humanized world in which both sexes have equal access to the visual skills and sensibilities necessary to play an active role in their self-actualization and cultural participation.

NOTES AND REFERENCES

[1] Bernard Rosenberg and Norris Fliegel, *The Vanguard Artist: Portrait and Self-Portrait* (New York: Quadrangle, 1965), p. 253.
[2] Jacqueline Skiles, "The Women Artists Movement," paper presented at the annual meeting of the American Sociological Association, New Orleans, Louisiana, 28 August, 1972.
[3] Linda Nochlin, "Why Have There Been No Great Women Artists?" *Art News* 69, 9 (1971): 22-39, 67-70; Therese Schwartz, "They Built Women a Bad Art History" *Feminist Art Journal* 2, 3 (1973): 10-11, 22; Gloria F. Orenstein, "Art History" *Signs* 1, 1 (1975): 505-525.
[4] Renee Sandell, "Feminist Art Education: An Analysis of the Women's Art Movement As An Educational Force" *Studies in Art Education* 20, 2 (1979): 18-28; Renee Sandell, "Female Aesthetics: The Women's Art Movement and Its Aesthetic Split" *The Journal of Aesthetic Education* 14, 4 (1980): 106-110.
[5] Ann Sutherland Harris, "The Second Sex in Academe, Fine Art Division" *Art in America* 60, 3 (1972): 18-19; Ann Sutherland Harris, "Women in College Art Departments and Museums" *Art Journal* 32, 4 (1983): 417-419; Barbara E. White and Leon S. White "Survey on the Status of Women in College Art Departments" *Art Journal* 32, 4 (1983): 420-422.
[6] Elizabeth Baker, "Sexual Art-Politics" *Art News* 69, 9 (1971): 60-62; Lucy Lippard, "Sexual Politics, Art Style" *Art in America* 59, 5 (1971): 19-20; June Wayne, ed. *Sex Differentials in Art Exhibition Reviews: A Statistical Study* (Los Angeles, California: Tamarind Lithography Workshop, Inc., 1972).
[7] Cindy Nemser, "The Women's Art Movement" *Feminist Art Journal* 2, 4 (1974): 8-10; Lawrence Alloway, "Women's Art of the '70s" *Art in America* (May/June 1976): 64-72.
[8] Judy Chicago, *Through the Flower, My Struggle as A Woman Artist* (New York: Doubleday, 1975); Faith Wilding, *By Our Own Hands: The Women Artists' Movement. Southern California 1970-76* (Santa Monica, California: Double X, 1977).
[9] For a more extensive list and further information in this and the following categories, see Cynthia Navaretta, *Guide to Women's Art Organizations and Directory for the Arts* (New York: Midmarch Associates, 1982). A chronology is presented in Grace Glueck, "'A Matter of Redefining the Whole Relationship Between Art and Society'" *Art News* 79, 8: pp. 58-63.

10 Judy Chicago, *op.cit.*, p. 131.
11 Miriam Schapiro, ed., *Anonymous Was A Woman—A Documentation of the Women's Art Festival and Collection of Letters to Young Women Artists* (Los Angeles, California: Feminist Art Program, 1974), p. 1.
12 Judy Chicago, *op.cit.*, p. 131.
13 *Ibid.*
14 Cindy Nesmer, "Towards a Feminist Sensibility: Contemporary Trends in Women's Art" *Feminist Art Journal*, 5, 2 (summer, 1976): 19-23.
15 Interview with Helen Alm Roth, The Women's Graphic Center at The Feminist Studio Workshop, Los Angeles, California, 19 June 1977.
16 Kate Millett, "Women and Power: The Position of Women in the Arts," lecture presented at The Ohio State University, Columbus, Ohio, 25 May 1977.
17 See Art Bibliographies and Resources Guides and Recommended Reading Materials in Chapter 10.
18 Robert Hughes, "Myths of Sensibility," *Time*, March 20, 1972, pp. 72-77; Robert Hughes, "Rediscovered—Women Painters," *Time*, January 10, 1977, pp. 60-63; Douglas Davis, "Women, Women, Women," *Newsweek*, January 29, 1973, p. 77; Grace Glueck, "The Woman as Artist," *New York Times Magazine*, September 25, 1977, pp. 48-68; Thomas B. Hess, "Women's Work," *New York Magazine*, October 17, 1977, pp. 90-93; Francine Du Plessix Gray, "Women Writing About Women's Art," *New York Times Book Review*, September 4, 1977, pp. 18; John Russell, "It's Not 'Women's Art,' It's Good Art," *New York Times*, July 24, 1983.
19 Barbara E. White, "A 1974 Perspective: Why Women's Studies in Art and Art History?" *Art Journal*, 35, 4 (1976): 340-344.
20 Athena T. Spear and Lola Gellman, *Women's Studies in Art and Art History*, 2nd Ed. (New York: The Women's Caucus for Art, 1975).
21 White, 1976, *op.cit.*
22 Florence Howe, "Sexism and the Aspirations of Women," *Phi Delta Kappan*, 55, 2 (October, 1973): 99-104.
23 Renee Sandell, "Feminist Art Education: Definition, Assessment, and Application to Contemporary Art Education" (Ph.D. dissertation, The Ohio State University, 1978).
24 Wilding, *op.cit.*
25 Anne T. Long, "Forum: The Mail on Trashing" *Ms.*, September, 1976, p. 64.
26 Sandra Packard, "An Analysis of Current Statistics and Trends As They Influence the Status and Future for Women in Art Academe," *Studies in Art Education* 18, 2 (1977): 38-48.
27 Barbara White, "We've Come A Long Way, Ms!" in *Women's Studies in the Arts*, ed. Elsa H. Fine, Lola B. Gellman, and Judy Loeb (New York: The Women's Caucus for Art, 1978): 9.
28 Sandell, 1979, *op.cit.*
29 Janice L. Trecker, "Women's Place is in the Curriculum" *Saturday Review*, October 16, 1971, pp. 83-86; Florence Howe, "Sexual Stereotypes and the Public Schools" in *Successful Women in the Sciences: An Analysis of Determinants*, ed. Ruth Kundsin (New York: Annals of the New York Academy of Sciences, March 1973).
30 Renee Sandell, Georgia Collins and Ann Sherman, "Sex Equity in Visual Arts Education," to be published in *Handbook for Achieving Sex Equity Through Education*, ed. Susan Klein, Baltimore, Md: John Hopkins University Press.
31 *Ibid.*

SECTION III.

Matters of Herstory and Heritage

PURPOSE: To increase awareness, promote understanding, and encourage further inquiry into art related women's *achievements* by exploring the nature and extent of women's contributions to art and art education.

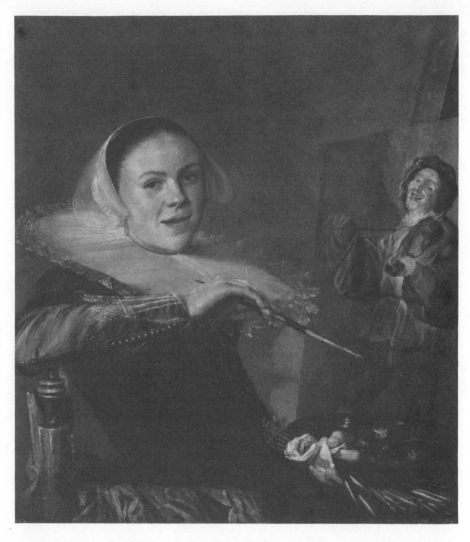

Judith Leyster. *Self-Portrait*. c. 1635. National Gallery of Art, Washington, D. C. Gift of Mr. and Mrs. Robert Woods Bliss, 1949. Photograph by courtesy of the National Gallery of Art, Washington, D.C. 20565.

CHAPTER 5:

Women's Acheivements in Art

Why has art history focussed so exclusively on certain individuals and not others, why on individuals and not on groups, why on art works in the foreground and something called social conditions in the background rather than seeing them as mutually interactive?

—Linda Nochlin (1979)

Separated from the "light" of the dominant society, we women have perpetuated a culture of our own, expressed in our own forms, which has frequently been transmitted, as is the case with other oppressed cultures, in subtle, uncodified ways. Not taught in schools, it is communicated in the home, through kinship lines, laterally through sisters, grandmothers, friends.

—Deena Metzger (1977)

A. THE RECOGNITION OF WOMEN'S ACHIEVEMENTS AS ARTISTS

1. Sources of Information on Women's Art Achievements.

Have there been any women artists? If so, how many and who are they? What kind of work have they done? Is it any good, and, when not, why not? Feminist art historians and critics are attempting to answer these old, and until recently, unvoiced, questions. As a consequence, we now have an extensive literture and many educational programs which provide us with new knowledge about women's art achievements, past and present. If this knowledge has not yet been fully integrated into general art survey texts and courses, it is nevertheless accessible to us through the special texts, journals, and courses devoted to its dissemination.[1]

2. Questions Raised by the Study of Women Artists

The recent, intense research on women in art promises to answer many questions about the nature and extent of women's art activity

in our culture. It also has raised many new questions: If there have been numerous women artists, why have they received so little attention from our historians, critics, and educators? What purposes and values have been assumed to justify their exclusion? Could it be there is fundamental or incidental sex bias in our art tradition? These and other art questions have formed the basis of a new feminist critique of the disciplines of art, art history, criticism, and education. Their answers promise to give us all new perspectives on art as it has been practiced and viewed in Western culture.

3. The Purpose of Studying Women Artists

The new history and criticism of women's art has challenged traditional accounts of western art and found them wanting. A great burden of justification and proof has necessarily been assumed by those who have undertaken this unprecedented inquiry into the achievements of a whole population of artists which has heretofore not been found worthy of such attention in our general art history surveys. The desire to learn more about women in art has called for the development and articulation of convincing rationales.[2] These have indeed been forthcoming and have included some or all of the following goals:

a. To identify, document, and give recognition to women artists whose work has been undiscovered, ignored, or disparaged by western art historians, critics, and educators.

b. To restore women in search of their collective identity and "roots", a lost heritage of artistic endeavor and achievement.

c. To analyze both the conditions for and obstacles to women's participation and achievement in art.

d. To uncover and eliminate both incidental and fundamental sex bias in western art.

e. To provide for all a more complete, complex, and "true" picture of artistic achievement in our culture.

f. To critique and develop traditional and innovative methods of scholarly inquiry to better serve these ends.

4. The Importance of Studying Women Artists (for Art Education)

As one of the art related professions which is highly concerned with social, artistic, and educational relevance and integrity, art education has a natural stake in equalitarian movements of thought which im-

pact our society and its art. The issues that have been raised and the new knowledge that has been made available on women in art promise to add vitality to our courses by providing a more comprehensive content and serving the special needs of one half of our students. A fuller recognition of women's artistic endeavors and achievements and an examination of the issues raised by this belated recognition should help our students recognize and deal with any vestiges of sexism they might encounter in their future pursuits. In addition, our recognition of women's achievements in art will provide like-sex role models for our female students and the increased pride and self-esteem associated with such provision. An awareness of women's achievements in art will also be a realistic preparation for our male students who will be entering a more pluralistic society and art world in which women as well as men participate, cooperate, and compete.

5. The Recognition of Different Types of Women's Art Achievement

Art in western societies has involved a broad range of media, processes, techniques, styles, subjects, forms, and purposes. Similarly, art "careers" in our culture have followed various paths and formed various patterns. When we think of Art with a capital A, however, our definitions of art and artist tend to narrow to those which have been given prestige by our art historians, critics, educators, and market systems. The art forms and career patterns, as well as the disciplines and institutions which have given them primary attention, have been dominated by white males. This is not to say, however, that women artists have not made contributions to the male dominated mainstream of western art: rather, it is to suggest that we might also expect that women over time have developed their own traditions and pursued art forms and careers outside and beyond the mainstream. We might also expect that as contemporary women artists have taken their place in the mainstream of western art, they have brought with them increasing degrees of awareness of their traditional women's art heritage. In affirmation of this hiddenstream heritage, they have begun to insist that art forms and career patterns previously ignored by the mainstream establishment have both personal and cultural artistic relevance.

In order to gain the broadest understanding of women's achievements in art , it will be helpful to approach them as falling into one of the above three categories: the mainstream tradition; the hiddenstream or women's art tradition; and the convergence of these two traditions in the women's art movement. It should be kept in mind, however, that many forms and values are shared by all three traditions and that, in fact, many women artists have achieved in all three. If the distinctions between mainstream and women's art have been invidious in the past, we wish only to perpetuate them to the extent necessary for their reevaluation and usefulness in recognizing the full range of women's art achievements.

B. WOMEN ARTISTS IN THE MAINSTREAM TRADITION

1. The Nature of Mainstream Art Achievement and Recognition

The preferred art forms of mainstream western art are painting, sculpture, and graphics, forms which seem to invite creative self-expression and use media which promise permanence. The preferred subject matter of this tradition is that which refers to people, events, themes, and ideas of public or cultural "importance," including, of course, art itself. Mainstream value systems developed in and since the Renaissance set high standards for artistic achievement and recognition and lend themselves to the making of hierarchical distinctions: some media are better than other media; some art is better than other art; some artists are better than other artists, and so on.

A progressive tradition, the mainstream records its history, defines itself as consisting of a series of periods and movements, and evaluates itself in terms of "flowerings" and stylistic innovations. Although in the past mainstream art has served establishment institutions of church, state, and class, it has recently played the role of critic and prophet without honor in modern society making efforts to maintain artistic independence from the patronage systems upon which it is financially dependent.

Further definition and impetus to mainstream art activity is found in its identification and praise of a pantheon of historical great artists (heroes, masters, geniuses) who have either epitomized important periods in art history or who have been stylistic innovators sparking and leading avant garde movements in modern and contemporary art. The model provided by these great artists prescribes early commitment to art, rigorous education and training, full-time art "careers", and willingness to forego immediate success and recognition. Thus, young artists bound for the mainstream are expected to devote immense energies to the production of an original and substantial body of work that is at once continuous with a departure from the immediate mainstream past. Dedication, sacrifice, and single-mindedness are required along with the ability to promote one's work through competitive exhibition. Although the values, behaviors, and institutions that have been associated with mainstream art proclaim a humanism derived from the Renaissance and an egalitarianism absorbed from the Enlightenment, those which assume or prescribe an aggressive competitive approach to full-time careers are, on the whole, more consonant with the stereotypical masculine than with the stereotypical feminine.[3] Dedicated women who have achieved in the mainstream have often been viewed as atypical and, in the popular mind, if artists are not normal, the normal artist is a man. When one considers the degree to which the mechanisms of recognition in western art and culture have been male dominated, it is not too surprising that the major achievements in the mainstream art tradition have been attributed to men.

2. Conditions For and Obstacles to Women's Mainstream Art Achievement and Recognition

A general awareness of the factors facilitating or retarding women's mainstream art achievement and recognition should help us to grasp the full significance of women's contributions to the mainstream of western art. If there have been whole eras when legal, economic, religious, and social restrictions on women made their mainstream participation all but impossible, there were special cases and exceptional circumstances which allowed a number of women to achieve in the mainstream. And if today many concrete barriers to women's achievement in art have been eliminated, many linger on to make mainstream participation more problematic for women than men. In addition to general sex role conditioning which has encouraged the development of feminine identified behaviors, attitudes, and goals of low mainstream art value, the following factors have provided both conditions for and obstacles to women's successful participation in mainstream Western art.

a. GENERAL ENCOURAGEMENTS AND DISCOURAGEMENTS

(1) **Art as Feminine Accomplishment.** Stemming from ideals of feminine education associated with the Renaissance, the notion of art as a feminine accomplishment has encouraged women to develop certain fine art related skills and sensibilities for the purpose of enhancing their attractivenss to educated males.[4] Art as feminine accomplishment invites women to engage in a little drawing and painting with the stipulation that such activities be kept at dilettante levels which do not interfere with the primary duties of a mistress, wife, mother, hostess, and/or domestic. *Negative effects:* Suppression of women's mainstream art activity and aspiration. Prejudicial assumption that women engaged in art production are dabblers and amateurs. *Positive effects:* Encouraging women into even limited art activity has allowed certain of them to discover and manifest serious art commitments, providing the initial condition for mainstream art participation. *Examples:* Properzia di Rossi made the shift from delicate miniature carvings on fruit stones to competitive professional production of marble relief sculpture.[5]

(2) **Benevolent Patriarchs.** In eras when a woman's educational opportunity was almost wholly dependent on the circumstances and direction of her patriarchal family, the father's decision to educate rather than "marry-off" his daughter at an early age played a crucial role in the development of a would-be mainstream artist. *Negative effects:* Women "married-off" at the tender ages of 12 or 13 were denied the support and training necessary for mainstream art production. Women receiving education as a favor from benevolent fathers whose arbitrary power in such matters had legal and social sanction, would find it difficult to establish the independence we now associate with mainstream

art pursuits. They would also be more likely to reject female role models and tend to devalue feminine identification. *Examples:* Marietta Robusti Tintoretto's father provided for her artistic training but rejected a court appointment for her and kept her in his home even after her marriage.[6] Anna Maria Schurmann resisted feminine identified art pursuits which were recommended to her by her mother.[7] *Positive Effects:* Numerous women artists have benefitted from the encouragement of artist and non-artist fathers who saw either the practical or moral value in educating their daughters. *Examples:* Benevolent artist fathers helped Lavinia Fontana, Artemisia Gentileschi, and Angelica Kauffmann.[8] Benevolent non-artist fathers helped Sofonisba Anguissola, Rachel Ruysch, and Rosalba Carriera.[9]

(3) Precocity. Early signs of "genius" have been remarked in the biographies of many mainstream artists.[10] If precociousness was important for historically early men artists, for women prior to delayed marriages and prolonged general educations, such early demonstration of art interest and skill were especially crucial for the development of women artists. *Negative effects:* Today we might realize that art educations dependent upon precocity would not serve late-bloomers. We might also frown on pressing young teenagers of either sex into intense preemptive professional training, production, and celebrity. *Positive effects:* Many women artists who might otherwise be lost to art where recipients of attention and support because of their precocity. *Examples:* Sofonisba Anguissola, Judith Leyster (pl. 6), and Angelica Kauffmann.[11]

(4) Feminist impulses. A few women artists have had mothers who were either amateur or professional artists. Other women artists had feminists in their families or themselves demonstrated marked concern for the welfare of women and women artists. *Negative effects:* A conscious sense of female identity as an artist has perhaps made some women artists sensitive to the negative implications of being labeled a woman artist. It caused others to feel some defensiveness or regret in having time and energy to forward the cause of women only by concentrating on their own art production. *Examples:* When Lilly Martin Spencer's feminist mother urged her to do more for the feminist cause, Lilly asserted that devotion to her art career was in fact an exercise of the very rights feminists were seeking to secure for women.[12] Meret Oppenheim, whose grandmother was a feminist, identified with the feminist movement but refused to show her work in all-women exhibitions.[13] *Positive effects:* In addition to inspiring role models for other women artists, feminist consciousness has prompted individuals to speak and work in behalf of more equitable conditions for women in art. *Examples:* Adelaide Labille-Guiard protested quota systems which restricted women's admission to the Royal Academy.[14] Through her writings, Barbara Leigh Smith Bodichon protested against sexism and helped to found a college for women.[15] Kathe Kollwitz helped to organize a society for women artists.[16]

b. TRAINING AND EDUCATION

(1) **Artist Fathers and Daughters.** During eras when apprenticeship and travel were central to the education of the artist, the felt need to protect the virtue and reputation of young, unmarried women made their training problematic. In addition to the social and physical dangers of apprenticeship for the young female, she was likely to be thought of as a potential sexual distraction in a workshop or studio. Later, women were denied entrance to academies. It is not surprising then, to find that many historically early women artists had artist fathers who either tolerated or actively trained their daughters within the confines of the family studio. *Negative effects:* This ''solution'' to the problem was not available to women with non-artist fathers. More importantly, for those with artist fathers, their options for training and need to establish independent artistic identities were severely restricted. Those who ventured beyond the family to seek training were still vulnerable to sexual harassment. *Examples:* Adelaide Labille-Guiard and Marie Louise Elizabeth Vigee-Lebrun became the butt of sexual jokes because of their audacious life-styles.[17] Artemesia Gentileschi was raped by her teacher and underwent a tortuous public trial.[18] *Positive effects:* Numerous women artists who otherwise might have been denied training and education, received it directly or indirectly in their artist father's studios. Women artists willing to teach female students provided safe options. *Examples:* Lavinia Fontana, Marietta Robusti Tintoretto, Artemisia Gentileschi, Levina Teerlinc, Caterina van Hemessen, Louise Moillon, Sophie Cheron, Anne Vallayer-Coster, Mary Beale, Angelica Kauffmann, Mary Moser, Lucy Maddox Brown Rossetti, Anna and Sarah Peale, and Jane Stuart.[19] Also teaching female students were: Elisabetta Sirani, Elizabeth Vigee-Lebrun, Adelaide Labille-Guiard, and Marie Guillemine Benoist.[20]

(2) **Reluctant Academies.** Although the gender policies of art academies varied with place and time, at the height of their hegemony they severely restricted the admission, training, and exhibition privileges of women artists. *Negative effects:* During periods when drawing and anatomy were required for prestigious history painting, women were denied requisite training and criticized for their lack of anatomical knowledge. *Examples:* As the importance of academic training grew and numbers of women artists increased, academies variously forbade the admission of women, set drastic quotas for their admission, restricted or denied their entrance in classes, forbade their drawing of the nude, segregated them for drawing nudes, and disallowed them to enter competitions for major prizes.[21] Long after the power of academies subsided, artists such as Kathe Kollwitz and Gabriele Munter were refused admission on the basis of sex.[22] *Positive Effects:* Ironically, women secured and enjoyed equal academic opportunity when such training was no longer viewed as crucial.[23] Nevertheless, the equalization of opportunity for academic training encouraged women into formal education. Blatant discrimination itself had undoubtedly raised feminist

consciousness and stimulated the organization of art academies for women. It also pushed women into less prestigious but often lucrative genres. *Examples:* Before academies monopolized training and when women artists were a rarity, Lavinia Fontana and Artemisia Gentileschi were honored by admission.[24] Academies opened fully to women about the time avant garde movements were challenging their power, giving not only women but all artists more options.

(3) **Bias in Higher Education.** Although coeducation and the opening of careers to women have resulted in equal numbers of women and men students in college and university art degree programs, the majority of their teachers are male, and the historical and critical curriculum focuses on men's achievements in mainstream art.[25] *Negative effects:* An incomplete picture of western art is presented to all students which does not prepare them for a pluralistic contemporary art world. Women students are denied equal provisions of gender related heritage and like-sex role models. *Positive effects:* Although the women's studies movement and affirmative action in hiring of faculty cannot be regarded as the effects of bias in higher art education, they have been a positve response to it. Thus, institutions of higher education have begun to provide a richer more accurate picture of western art for students preparing to be artists and have begun to offer special courses in which women students can discover their heritage as women artists.[26] Also, more female faculty and visiting artists are available as role models.

c. CAREER INITIATIONS

(1) **Establishing Credibility.** In early periods of western mainstream art, the rigidity of sex roles, the assumptions of female inferiority, and the rarity of women artists combined to make the achievement of women in art seem to be an impossibility. Women who in fact produced laudable works were likely to be suspected of palming off the work of a man as her own. When it was proven that a woman had indeed done the work, she was viewed as the exception that proves the rule and likely to be given the disturbing compliment, "You paint like a man." *Negative effects:* While all artists must prove their skill and merit to the critics and public, by producing credible works, early women artists suffered the burden of double proof because of the disbelief regarding the possibility of a woman producing such a work. Women achievers perpetually regarded as exceptions reinforced persisting notions that "normal" women could not produce credible art works. The identification of art skill with masculine skill reinforced both bias in the art establishment and sex-role conflict in women artists. *Examples:* Elisabetta Sirani, Adelaide Labille-Guiard, Marie Louise Elizabeth Vigee-Lebrun, and Antoinette Cecile Hortense Haudebourt-Lescot were all accused of having had men do or touch-up their work.[27] Both Elisabetta Sirani and Adelaide Labille-Guiard felt called upon to give public demonstrations to prove their capability and that their works were by their own hands.[28] Countless women artists including Anne

Vallayer-Coster, Adelaide Labille-Guiard, Rosa Bonheur, and Lee Krasner have been told they paint like or as well as a man.[29] *Positive effects:* The exceptionalness and disbelief surrounding women's art achievement perhaps facilitated certain women artists' career by increasing their curiosity and celebrity value. However, historians have used this as a pretext for dismissing success of early women artists in their lifetimes.[30] The ambiguous encouragement of being told one paints like a man if one is not a man has to be weighed against the implications in a sexist society of being told one paints like a woman.[31]

(2) **"Personality"**. In establishing careers, women artists had not only to demonstrate skill but cultivate their feminine charm and physical beauty. *Negative effects:* Pressure to be charming and exhibit sex appropriate behavior have been experienced by artists of both sexes. Feminine behavior, however, is more likely to undermine an artist's integrity and credibility because of social values attached to it. *Examples:* The charm and femininity of artists such as Elisabetta Sirani, Marie Louise Elizabeth Vigee-Lebrun, and Angelica Kauffmann were perhaps given disproportionate attention by their contemporaries.[32] Later historians suggest this is so and tend to imply that without such charms their careers would have perhaps never been established.[33] The actual work of these artists is given less attention than the role their personality played in their career. *Positive effects:* Given that women artists whose careers seem to have been forwarded by feminine charm worked in periods of profound sexual discrimination against women, the artistically irrelevant aspects of personality have to be seen as almost necessary for the establishment of their careers.[34]

(3) **Male Mentors.** In addition to the direct support of male relatives, patrons, and teachers, women artists have often relied on male mentors or advisors in the establishment of their careers. *Negative effects:* Although mentorship has played an honorable role in the establishment of artists' careers, cross-sex mentorships tend to be viewed as potentially compromising of one's sexual and artistic "virtue." This is especially true if the older more powerful mentor is a male. *Example:* Although Apollinaire and Marie Laurencin were mutually supportive, his recommendation of her as an artist was suspect and irritating to many of their contemporaries.[35] *Positive effects:* Powerful, knowledgeable, and supportive men have helped many women artists gain acceptance and negotiate the male-dominated career world. *Examples:* In the face of her brother Joshua's harsh criticism, Frances Reynolds obtained the somewhat reluctant but stimulating support of her friend, Dr. Johnson;[36] David Hume provided challenge for Anne Seymour Damer;[37] Maritain, Rodin, and Rilke were concerned friends of Gwen John.[38]

(4) **Specialization.** The majority of early women specialized in copywork, manuscript illumination, miniatures, portraits, still lifes, flower or genre painting. It has been suggested that the historical propensity of women

to work in the so-called minor art forms was due to gender related restrictions on their training, education, travel, and life-style. Two major factors steering women artists into less prestigious art forms were proscriptions against learning anatomy by drawing the nude and pressures to confine work to the home and safe social circles.[39] *Negative effects:* Women's options were effectively reduced by denial of educational opportunity. Those that ventured into major art forms such as large scale history painting and commissioned sculpture were open to criticism regarding their lack of anatomical knowledge. Those that pursued minor forms with great success increased stereotypical association of women with art forms of lesser perceived value. *Examples:* The work of Elisabeta Sirani and Lilly Martin Spencer shows these artists had some trouble with "correct" anatomical drawing.[40] Catherine Read is said to have restricted herself to portraits because of her lack of anatomical training.[41] Angelica Kauffmann's portraits are regarded as more successful than her efforts at history painting.[22] *Positive effects:* Although minor art forms hold less interest for mainstream art historians, and inability to produce large scale historical painting and sculpture eliminated the possibility of major commissions for many women artists, the minor art forms were very popular, and there was a ready and steady market for women's skills in these areas. By developing the minor art forms women were able to work under existing conditions and find outlet for expressive documentation of concerns close to many women. *Examples:* A first century artist, Laya, is said to have invented miniature painting and earned a good living with it.[43] Whether or not this is historically accurate, we know that many women during the Middle Ages such as Guda, Claricia, Ende, and Diemud who were nuns and later women artists such as Levina Teerlinc, Anna Wasser, Sarah Goodridge, and Anna Claypoole Peale developed the skills and tradition associated with this art form.[44]

(5) **Independent Wealth and Economic Necessity.** Women artists, like their male counterparts, have always had to deal with economic realities. Although inherited or married wealth secured training and artistic independence for women such as Anne Seymour Damer, Barbara Leigh Smith Bodichon, and Mary Cassatt,[45] economic necessity played a major role in establishing the careers of many women artists. *Negative effects:* In addition to working primarily in art forms responsive to popular demand, women artists who took on the burden of supporting their families had increased pressures to conform to existing markets. *Examples:* Lilly Martin Spencer was at one point reduced to making illustrations for *Godey's Lady's Book*,[46] and Herminia Borchard Dassel painted portraits of the rich to support her study abroad.[47] *Positive effects:* The need to support self and family proved a vital incentive and justification for non-traditional pursuit of career for such women artists as Elisabetta Sirani, Sophie Cheron, Felicie de Fauveau, Mary Beale, Henrietta Johnston, and Sarah Goodridge.[48]

d. CAREER DEVELOPMENT AND CONTINUITY

(1) **Early Patronage Systems.** At certain times and places in the history of western mainstream art, the church and the courts of royalty made room for women artists. For both female and male artists, such support was highly conditional. *Negative effects:* The church supported the art work of nuns but required vows of obedience and chastity and removed them somewhat from mainstream influences. Receiving court appointment, women artists were expected not only to be competent artists, but to be socially adept and charming. Thus the patronage of these male dominated institutions tended to limit artistic independence and impose tasks more closely related to the female role than to art.[49] *Positive effects:* Many women artists received support and protection necessary to continue their work. *Examples:* Artist nuns involved in manuscript illumination. Sofonisba Anguissola, Lavina Teerlinc, and Rachel Ruysch were court appointed artists.[50]

(2) **Galleries, Grants, Prizes and Commissions.** The institutional mechanisms which offer the artist support and aid in developing a career have been less open and responsive to women than to men. *Negative effects:* Both systematic and incidental discrimination against women in the competition to obtain concrete support for making and marketing art have put women artists at a competitive disadvantage. *Examples:* Women were not allowed to enter prestigious prize competitions at the height of the academy, and commissions were often awarded to prize winners.[51] Upon winning a ''blind'' competition for a sculpture commission, Anne Whitney was disqualified when it was found the winner was a female.[52] Galleries disclaiming prejudice against women have nevertheless refused to display women artists' works because they claimed women's art just didn't sell as well as men's.[53] *Positive effects:* Whenever competitions have been truly blind to gender of the artist, women have been afforded equal opportunity for career support. Whenever special competitions have been set up for women, women have been afforded special or compensatory support for career development. *Examples:* The WPA supported many women artists including Alice Neel and Lee Krasner.[54] Cooperative galleries and exhibitions for women have lent support to many contemporary women artists.[55]

(3) **Marriage.** Although many women artists have found marriage and child rearing humanly desirable, the particular role women have played within the family has presented a variety of problems as well as opportunities for artistic careers. *Negative effects:* Because of the excessive and fragmenting demands conventionally placed upon wives and mothers, many woman artists have refused to marry or have found marriage incompatible with art careers. *Example:* Among the women artists who never married and often spoke of incompatibilities between female and artist roles were Elisabetta Sirani, Maria Van Oosterwych, Rosalba Carriera, Marguerite Gerard, Rosa Bonheur, Gwen John, Jane

Stuart, Harriet Hosmer, Edmonia Lewis, and Mary Cassatt.[56] Among women artists who married but whose work ended or dropped off as a result are Anna Claypoole Peale, Mary Moser, Anne Seymour Damer, and Marie Guillemine Benoist.[57] Artists such as Clara Peeters, Sophie Cheron, Natalya Sergeevna Goncharnova, and Meret Oppenheim found it desirable to marry late.[58] Both Alice Neel and Louise Nevelson have spoken of the difficulties of sustaining both marriage and career.[59] *Positive effects:* Women artists with extraordinary energy, supportive husbands, or innovative integrations of career and family have found marriage and child rearing either compatible or highly enriching for their art. *Examples:* Women artists who have had extremely supportive husbands willing to take on or share the traditional responsibilities of wives and mothers include: Lavinia Fontana, Mary Beale, Angelica Kauffmann, Lilly Martin Spencer, Berthe Morisot, and Kathe Kollwitz.[60] Paula Modersohn-Becker and Georgia O'Keeffe set aside long periods of time to be separated from their husbands in order to work.[61] Marguerite Thompson Zorach and Faith Ringgold found that certain art forms and media allowed them to work without withdrawing from the family circle.[62] Barbara Hepworth believed that being a wife and mother enriched her life as an artist.[63]

e. Recogntion

(1) **Fleeting Fame.** Many women artists who were celebrated in their lifetimes have been ignored by mainsteam art historians. *Negative effects:* Failure to mention even categorically that many women have practiced art and achieved acclaim in the past presents a distorted picture of western art history by suggesting that women did not involve themselves in fine art careers. When their "temporary" success is discussed, it is often suggested that their feminine ability to conform to prevailing tastes and their oddity-value were the sole basis of their contemporary achievements thereby reinforcing notions of female inferiority in art. *Examples:* Hugo Munsterberg, one of the few male art historians who even discusses women artists of the past, suggests that the success of the following women artists was based more on their personal charm and curiosity value than on the mainstream art value of their work: Sofonisba Anguissola, Marie Louise Elizabeth Vigee-Lebrun, Angelica Kauffmann, and Rosa Bonheur.[64] *Positive effect:* The temporal acclaim of past women artists has provided documentary evidence of their existence and allowed feminist historians to review and evaluate their achievements and contributions. *Examples:* Women artists successful in their lifetimes and now being studied include: Sofonisba Anguissola, Lavinia Fontana, Judith Leyster, Anne Vallayer-Coster, Marie Louise Elizabeth Vigee-Lebrun, Antoinette Cecile Hortense Haudebourt-Lescot, Felicie de Fauveau, and Rosa Bonheur.

(2) **In the Shadow Of.** The achievements of famous artists' daughters or sisters such as Marietta Robusti Tintoretto, Lucy Maddox Brown Rossetti, Jane Stuart, and Frances Reynolds if stimulated by their relation-

ship have tended to be over-shadowed by their more famous male relatives. Not surprisingly, many famous male artists have had artists as wives. *Negative effects:* Women artists married to famous male artists have tended to find it either difficult or undesirable to establish a separate identity and seek recognition. Among the wife-husband artist pairs in which the male has gained more recognition are: Susan Macdowell Eakins and Thomas Eakins; Sonia Terk-Delaunay and Robert Delaunay; Sophie Tauber-Arp and Jean Arp; Marguerite Thompson Zorach and William Zorach; Kay Sage and Yves Tanguay; Annie Albers and Joseph Albers; Lee Krasner and Jackson Pollack; Dorothea Tanning and Max Ernst; Elaine de Kooning and Willem de Kooning; Helen Frankenthaler and Robert Motherwell; and Frida Kahlo and Diega Rivera.[65] Other similar associations include Marguerite Gerard and Jean-Honore Fragonard, and Gabriele Munter and Wasily Kandinsky. *Positive effects:* Many of these pairs formed mutual support "systems" for both artistic endeavor and child rearing.[66] While women have undoubtedly been inequitably involved in the promotion of their husbands' careers,[67] their association surely stimulated their own artistic production and development.

(3) **Rediscovery.** Feminist art critics and historians have begun to research women artists and to reevaluate their achievements and contributions. *Negative effects:* As in any such rescue effort, unwanted attention and interpretation has been given to certain women artists who have expressed a desire not to be considered as "women artists" or have their work discussed in terms of their gender. *Examples:* Georgia O'Keeffe, Paula Modersohn-Becker, Elaine de Kooning, and Bridget Riley have expressed either mild annoyance or anger at having their work or career discussed in terms of gender.[68] *Positive effects:* Research into the history of women artists has provided a more complete picture of the past and made available to young women artists in search of roots and models, information and inspiration helpful to them. *Examples:* Young women artists, students, and teachers have expressed their satisfaction and described the positive impact of learning about "lost" women artists of the past.[69] Texts, reproductions, journals, Women's Studies courses as well as personal research have provided us with new information which is slowly being integrated into general art history texts and courses.

f. **TO SUMMARIZE:**

As legal, social, and educational conditions have improved for women, progressively larger numbers of them have entered mainstream art careers. The legacy of the past, however, remains, and is itself an obstacle to women's contemporary art achievement. In so far as young artists draw inspiration and identity from the past, the fact that lesser numbers of women have participated and achieved in western mainstream art means that young women artists have available to them fewer numbers of like-sex historical role models. In addition,

a review of the obstacles that have faced women artists in the past should remind us that many persist, often in more subtle forms, into our present. Until sex equity is an accomplished fact in our society, the old cliche that women must be twice as good as men in order to be treated as equals will contain a certain amount of truth.[70] It will be especially important, then, that until equity is accomplished, women and men should be made intensely aware of the obstacles individual women artists have had to overcome, the conditions that have been supportive of this best efforts, and the achievements and contributions they have made to mainstream western art.

3. Achievements.

a. A FEW EXAMPLES

A study of the lives and art of women artists who have worked in the mainstream will reveal their various personal and artistic achievements. What they share in common, however, is their demonstrated ability to sacrifice, endure, and respond flexibily to the adverse circumstances which women in our society as well as artists have had to face. They have demonstrated a courage definitely human but not often associated with women in our culture, and they have seized those opportunities available to them as individuals. Here are just a few of the many examples of women's achievements as mainstream artists:

- One of the first woman artists to achieve international recognition and to make an early contribution to genre painting: Sofonisba Anguissola (c.1532-1625).[71]
- One of the first women artists to attempt large scale sculpture: Properzia Di Rossi (c.1490-1530).[72]
- Some women artists who combined child rearing and career: Rachel Ruysch (1664-1750), 10 children; Lavinia Fontana (1552-1614), 11 children; Lilly Martin Spencer (1822-1902), 7 children.[73]
- One of the first women to attempt large scale history painting: Angelica Kauffmann (1741-1807).[74]
- Some women artists who died young but achieved much within their short lifetimes: Elisabetta Sirani (1638-1665); Anne Killegrew (1660-1685); Eva Gonzales (1849-1883); Paula Modersohn-Becker (1876-1907); Eva Hesse (1936-1970).[75]
- Some women artists who asserted their right to "go on location" to study their subjects: Rosa Bonheur (1822-1899) studied animals; Elizabeth Thompson (Lady Butler) (1850-1933) studied the military.[76]
- Some women artists who combined career with active feminist efforts on behalf of other women artists: Adelaide Labille-Guiard (1749-1803); Marie Guillemine Benoist (1768-1826); Rosa Bonheur (1822-1899); Barbara Leigh Smith Bodichon (1827-1891); Mary Cassatt (1844-1926); Edmonia Lewis (1843-1900); Kathe Kollwitz (1867-1945).[77]

- Some women artists whose work was misattributed to famous male artists: Marietta Robusti Tintoretto's (1560-1590) to her father, Tintoretto[78]; Judith Leyster's (1609-1660) *The Jolly Toper* and other works to Frans Hals[79]; Marie Charpentier's (1767-1849) *Portrait of Mlle. Charlotte du Val d'Ognes* (pl. 2) to Jacques-Louis David[80]; Adelaide Labille-Guiard's (1749-1803) *Portrait of Dublin-Tornelle* to Jacques-Louis David.[81]
- Some women artists who introduced women heroines or women's points of view into their work: Artemisia Gentileschi (1593-c.1652); Elisabetta Sirani (1638-1665); Marie Victoire Lemoine (1754-1820) (pl. 7); Judith Leyster (1609-1660); Kathe Kollwitz (1867-1945).[82]
- One of the first artists to employ pastels with success: Rosalba Carriera (1675-1757)[83]
- One of the first artist-naturalists: Maria Sibylla Merian (1647-1717).[84]
- One of the first artists to conduct a major effort to introduce the American public to avant garde mainstream art: Mary Cassatt (1844-1926).[85]

As conditions became more equitable for women in western societies and art, the numbers of mainstream women artists progressively increased. *Figure 3, Some Women Artists in the Mainstream: A Timeline,* illustrates this increase. The inclusion of some major male artists and dates should be helpful to the art teacher attempting to place and integrate women artists into historical discussion of western art. The reader's attention is directed to Appendix A for a partial list of women artists for the use of teachers and students wishing to learn more about women's achievements in mainstream art. This list is necessarily incomplete, and we hope that it will encourage additions by the user.

C. WOMEN ARTISTS IN THE HIDDENSTREAM TRADITION OF WOMEN'S ART

1. The Nature of Hiddenstream Art Achievement and Recognition

The art forms associated with the hiddenstream of women's art are weaving, quilting, stitchery, ceramics, and body decoration, forms which promise to be both useful and decorative.[86] Although permanence is sought, this value is secondary to the use of products in the service of everyday life. The tools and materials used in this tradition are often those at hand, and the work space of the artisit is integrated into living or domestic environments. High degrees of practiced skill are required, but the cost, space requirements, and formal instruction required for high tech processes effectively eliminates their employment. The subject matters have tended to be those of immediate concern to women. When abstraction is sought, it is closely related to technique or process and is likely to involve traditional "favorite" shapes and patterns.

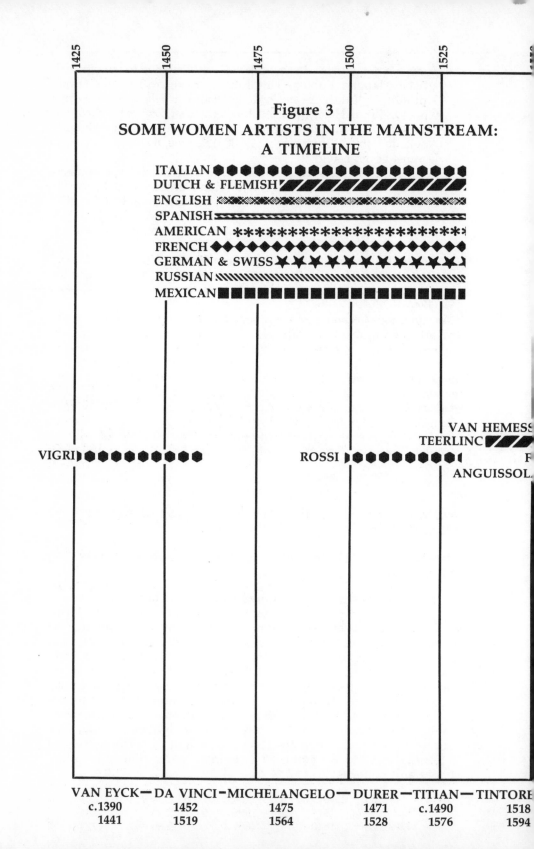

Figure 3

SOME WOMEN ARTISTS IN THE MAINSTREAM:
A TIMELINE

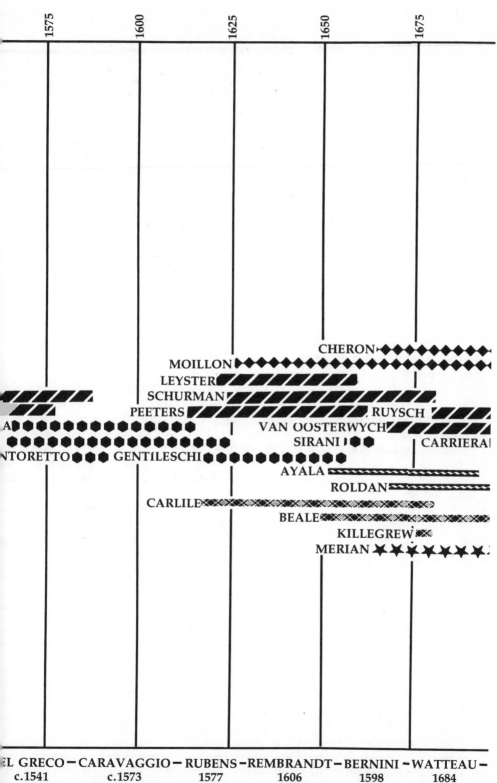

1575	1600	1625	1650	1675

CHERON

MOILLON

LEYSTER

SCHURMAN

PEETERS · RUYSCH

VAN OOSTERWYCH

SIRANI

CARRIERA

NTORETTO · GENTILESCHI

AYALA

ROLDAN

CARLILE

BEALE

KILLEGREW

MERIAN

EL GRECO — CARAVAGGIO — RUBENS — REMBRANDT — BERNINI — WATTEAU —
c.1541 c.1573 1577 1606 1598 1684
1614 1610 1640 1669 1680 1721

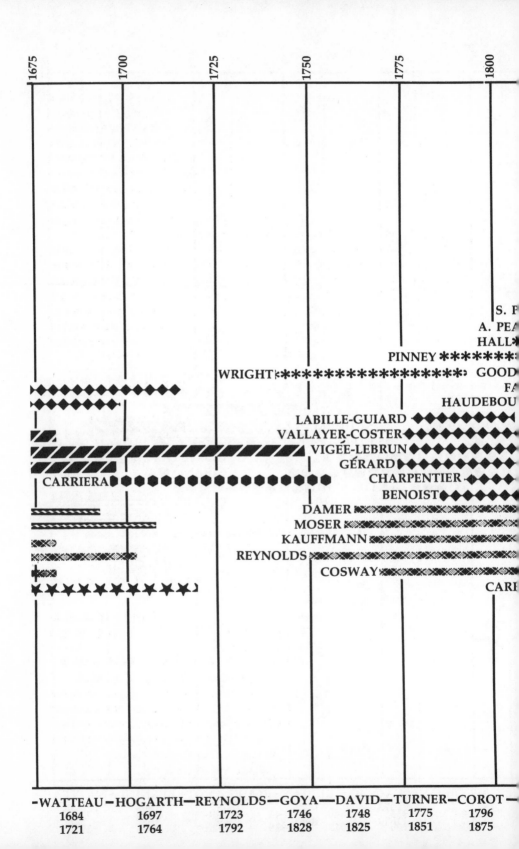

1675 1700 1725 1750 1775 1800

S. P
A. PEA
HALL
PINNEY ✶✶✶✶✶✶✶
WRIGHT ✶✶✶✶✶✶✶✶✶✶✶✶✶✶✶✶✶✶ GOOD
FA
HAUDEBOU
LABILLE-GUIARD ◆◆◆◆◆◆◆◆
VALLAYER-COSTER ◆◆◆◆◆◆
VIGÉE-LEBRUN ◆◆◆◆◆◆
GÉRARD ◆◆◆◆◆◆◆
CHARPENTIER ◆◆◆
BENOIST ◆◆◆◆◆
CARRIERA
DAMER
MOSER
KAUFFMANN
REYNOLDS
COSWAY
CARI

—WATTEAU —HOGARTH —REYNOLDS —GOYA —DAVID —TURNER —COROT —
1684 1697 1723 1746 1748 1775 1796
1721 1764 1792 1828 1825 1851 1875

WILSON★★★★★
BLAINE ★★★★★
HARTIGAN ★★★
DEKOONING★★★
BOURGEOIS★★★★★★
TANNING ★★★★★★★★
PEREIRA ★★★★★★★★★
JONES★★★★★★★★★★★
BROOKS★★★★★★★★★★★★★★★★★★★★
CASSATT ★★★★★★★★★★★★★★★★★★★★★
LEWIS★★★★★★★★★★★★★★★ NEEL ★★★★★★★★★★★★★
HOSMER★★★★★★★★★★★★★★★★★★★ MacIVER★★★★★★★★★★
PENCER★★★★★★★★★★★★★★★★★★★★★★ BISHOP★★★★★★★★★★★★★
UART★★★★★★★★★★★★★★★★★★★ NEVELSON ★★★★★★★★★★★★
★★★★★★★★★★★★★★★★★★★★★ SAGE ★★★★★★★★★★★★★★★★
★★★★★★★★★★★★★★★★★★★★ O'KEEFFE ★★★★★★★★★★★★★★★★★
★★★★★★★★★★★★★★ STETTHEIMER★★★★★★★★★★★★★★★★★★★★
★★★★★★★★ KLUMPKE★★★★★★★★★★★★★★★★★★★★★★★
★★★★★★ BEAUX★★★★★★★★★★★★★★★★★★★★★★★★★
◆◆◆◆◆◆◆◆◆◆◆◆◆◆◆◆◆◆ KRASNER ★★★★★★★★★
T ◆◆◆◆◆ EAKINS ★★★★★★★★★★★★★★★★★★★★★★★★★
VALADON◆◆◆◆◆◆◆◆◆◆◆◆◆◆◆◆◆◆◆◆
ONHEUR◆◆◆◆◆◆◆◆◆◆◆◆◆◆◆◆ RICHIER ◆◆◆◆◆◆◆◆◆◆◆◆◆◆
◆◆◆◆◆◆ GONZALES◆◆◆◆◆◆◆◆◆ DELAUNAY ◆◆◆◆◆◆◆◆◆◆◆◆◆◆◆
◆◆◆◆◆ MORISOT ◆◆◆◆◆◆◆◆◆◆◆◆◆ FINI ◆◆◆◆◆◆◆◆◆◆◆◆◆◆
◆◆◆◆◆◆◆◆◆◆◆◆◆◆◆ LAURENCIN◆◆◆◆◆◆◆◆◆◆◆◆
KAHLO ■■■■■■■■■
HEPWORTH ▨▨▨▨▨▨▨▨▨
JOHN ▨▨▨▨▨▨▨▨▨▨▨▨▨▨▨▨▨▨▨▨
BELL ▨▨▨▨▨▨▨▨▨▨▨▨▨
LADY BUTLER ▨▨▨▨▨▨▨▨▨▨▨▨▨▨▨▨▨▨
BODICHON ▨▨▨▨▨▨▨▨▨▨▨▨▨▨
ROSSETTI ▨▨▨▨▨▨▨▨▨▨▨▨▨ OPPENHEIM ✦✦✦✦
KOLLWITZ ✦✦✦✦✦✦✦✦✦✦✦✦✦✦✦✦✦
M.-BECKER✦✦✦
MUNTER ✦✦✦✦✦✦✦✦✦✦✦✦✦✦✦
TAEUBER-ARP ✦✦✦✦✦✦✦
BASHKIRTSEFF ∾∾∾∾∾∾∾∾∾∾∾∾∾∾∾∾∾
GONCHAROVA ∾∾∾∾∾∾∾∾∾∾∾∾∾∾∾
EXTER∾∾∾∾∾∾∾∾∾∾∾∾∾
UDALTSOVA ∾∾∾∾∾∾∾∾∾∾∾∾
ROSANOVA ∾∾∾∾∾∾
POPOVA ∾∾∾∾∾∾

X—EAKINS	—CEZANNE	—RODIN	—RENOIR	—MONET	—MATISSE	—PICASSO
1844	1839	1840	1841	1840	1869	1881
1916	1906	1917	1919	1926	1954	1974

Cooperation and informal support are valued in the hiddenstream, and female children are inducted into the skills and "mysteries" of this tradition at an early age. Work tends to be part-time, between-times, or pass-time, and processes are chosen which allow the individual to remain in and interact with the family or social group to which she belongs. The art forms, artists, and supporting institutions in this tradition are cooperative rather than hierachical. Such prestige that attaches to individuals is often local or regional as in fairs, festivals, or voluntary fund-raising events. Works that survive the individual and use for which they were produced take on an anonymous character and are viewed as relics of cultural heritage.[87]

On the whole, the hiddenstream has been disparaged by mainstream artists and is often the subject of academic jokes as for example references to "underwater basketweaving."[88] Hiddenstream materials and processes adapted for mainstream art production require the artist to distinguish him or herself by employing high levels of creativity and autographic expressiveness. Nevertheless, fiber and ceramics remain low in the mainstream hierarchy of art forms. In the hiddenstream, the pantheon of heroes, masters, and all-time-greats is replaced with a pantheon of revered patterns, styles, and techniques. The tradition is not progressive but rather cyclical with repetition and reproduction values sustaining continuity. Getting in touch with the hiddenstream tradition is done through informal education by relatives or, more recently, women's magazines. A long range view is not preserved through a written history but a vague sense of connectedness with ancestors surrounds the tradition. Unlike the mainstream tradition, artists in the hiddenstream are not admired for sacrificing tradition, social comforts, roles, and values, but rather they are expected to enhance these through their artistic efforts. Paradoxically, although the notion of hand-made and use of left-over materials is part of the grassroots tradition, the commercial manufacture of cheaper products has injected an elitist expensiveness to the hand-made items of this tradition. Except for occasional attention by museums undertaking to preserve the handwork of fading cultures, the mechanisms of recognition have been female dominated, and the major achievements in the hiddenstream art tradition have been attributed to women.

2. Conditions for and Obstacles to Women's Hiddenstream Art Achievements and Recognition

A. GENERAL ENCOURAGEMENTS AND DISCOURAGEMENTS

(1) **Feminine Identification of Media, Processes, and Products.** Hiddenstream art has a feminine identification and is regarded as appropriate for women and inappropriate for men. *Negative effects:* Men are discouraged from participating in the hiddenstream art forms because such involvement would not conform to masculine ideals and stereotypes. Women who reject feminine stereotyping or who undertake serious careers in mainstream art find the feminine identification of hiddenstream art forms a social and artistic liability.[89] *Positive effects:*

Participation in an art tradition dominated by the female, gives women a positive sense of identity as women and allows them to integrate art production and conventional feminine roles and life styles.

(2) **The Fine Arts/Crafts Hierarchy.** Historically dominated by women, many hiddenstream art forms, such as weaving, stitchery, and pottery, have been and continue to be regarded as crafts. Traditional western art history and criticism have assumed and reinforced the lower cultural status of these and other applied and utilitarian forms, while carefully distinguishing them from highly valued mainstream "fine" art forms such as sculpture and painting.[90] *Negative effects:* Although participation in the hiddenstream tradition can give women a positive sense of feminine identity, the inferior status of feminine identified art forms will tend to undermine the self-esteem of the practitioner when viewed in the broader social context. *Positive effects:* Because status seeking and competition are made somewhat irrelevant or ludicrous by the cultural inferiority of the hiddenstream, encouragements to participation have been regarded as ranging from craftmanship to instant gratification, from the utilitarian to the quaint, and from the therapeutic to the mindless.

(3) **Industrial Revolution.** As mass buying and selling of the utilitarian art products of the hiddenstream tradition was made viable by machinery, capital, displaced labor, and promise of profit, hiddenstream art production was progressively taken over by male dominated guilds, shops, and mills.[91] *Negative effects:* During the 19th century mass production of hiddenstream art products effectively broke the link between design and execution and between producer and user. Women following the industry out of the home became an exploited labor force, and the utility of producing work at home by hand was severely undermined in terms of time and money. *Positive effects:* Socially concerned artists in the mainstream made efforts to restore the art and craft to hiddenstream forms now being commercially produced.[92] Women who maintained home production became more aware of traditional values and inherent virtues of handmade art products for family and community use.

(4) **Leisure and Therapy.** As the utility of hiddenstream art production by women at home lessened, the combination of new social and psychological needs and possibilities attending the industrial and technological revolutions suggested new purposes and rationales for hiddenstream art involvement.[93] *Negative effects:* Because producing hiddenstream work became less efficient in terms of cost and time than commerical products, elitist or frivolous values attached themselves. The work retained its feminine identification but lost the dignifying values of utility. *Positive effects:* The recognition that hiddenstream work could fulfill human needs beyond the utilitarian and the growing suspicion that cost efficiency was ecologically unsound have enriched the values of hiddenstream art involvement.

b. TRAINING AND EDUCATION

(1) **Artist Mothers and Daughters.** Grandmothers, mothers, aunts, and sisters are both models and teachers of the skills and values associated with the hiddenstream tradition. *Negative effects:* Because of its close association with the female sex role and the almost exclusive domination of women in this tradition, young boys are discouraged from and young girls resisting subservient sex role conditioning become ambivalent or closed to the full range of values that surround this tradition. *Positive effects:* Early, informal, and continuous training is available to the young girl who wishes to participate in the hiddenstream art tradition.

(2) **Women's Magazines and Classes.** The isolated family unit and women busy with careers outside the home have eroded the informal, home-based education of girls in the hiddenstream tradition. Filling the vacuum and serving commercial purposes, women's magazines and local classes in hiddenstream art production have become major avenues for training and education. *Negative effects:* These new mechanisms for training young women in hiddenstream art forms are "motored" by profit and tend to promote consumerism or the buying of expensive kits, materials, and tools. Unlike the more basic values of craft associated with hiddenstream art, women's magazines and classes sponsored by yarn shops and ceramic stores promise easy, quick, and superficially charming results in return for the woman student's dollar. They also promote status seeking and competition between women. *Positive effects:* The magazines and classes have become repositories of traditional skills, processes, and designs associated with the hiddenstream.

(3) **Public and Higher Education.** Formal instruction in hiddenstream art forms has secured a marginal place for itself in the curriculum of public schools and universities by emphasizing its therapeutic, consumer, and applied arts career values. Significantly, the feminine identified and lower status art education and home economics programs are expected to offer subjects related to the hiddenstream (such as jewelry, crafts, fabric design, needlework, and certain types of ceramics).[94] *Negative effects:* An invidious distinction between fine and applied arts is perpetuated, and reluctant art educators resist or degrade the teaching of hiddenstream art forms. *Positive effects:* Instruction is available for women otherwise alienated from the tradition, and situations are created whereby men interested in hiddenstream art production can more easily cross the sex taboo lines.

c. DEVELOPMENT AND CONTINUITY OF INVOLVEMENT

(1) **Early Patronage Systems.** The early church and royal courts supported and made use of women artists involved in hiddenstream art production. *Negative effects:* In return for the opportunity to pursue and develop hiddenstream art forms, these women artists were expected

to produce work celebrating male heroes and male dominated institutions. *Examples:* Queen Mathilda and other court ladies produced the Bayeux Tapestry (actually stitchery) celebrating William's conquest of England.[95] Nuns embroidered mitres, sandals, and altar clothes for the Pope and priests.[96] *Positive effects:* For a time the hiddenstream was stimulated by the larger social values attached to it by institutions of patronage.

(2) **Sewing Bees and Fairs.** Artists of the hiddenstream have found support and stimulation to higher effort through participation in quilting bees and sewing clubs, display, sale, and prizes for their work in church and club bazaars and county and state fairs. *Negative effects:* As the economic and cultural importance of fairs diminished, the intersection of women's magazines and commerical kit art with fund-raising projects for churches and women's clubs has tended to reduce the earlier high quality of hiddenstream art work at the point where it receives public exposure. *Positive effects:* The cooperative socializing of the bee or club reinforces positive female identity, and the competitive pride instilled by exhibiting at fairs along with exposure to other hiddenstream artists has promoted quality work in the hiddenstream.[97]

(3) **Marriage.** In times past a certain level of competency in hiddenstream art production was understood to make one a more valuable marriage partner. The perpetuation of family through marriage and child rearing created and sustained a "market" for hiddenstream art products. *Negative effects:* With much of the domestic utility of hiddenstream art production gone, male members of the family are more likely to disparage hiddenstream art involvement and be resentful of the time and attention it takes. *Positive effects:* Hiddenstream art production has allowed women to identify and work with other female family members and become more involved in the rituals and holidays associated with the family. Oral transmission recalling the importance of women's utilitarian contribution to family survival through hiddenstream arts surrounds participation. Women family members, unmarried, can also find means of identifying with other women through hiddenstream art forms.

d. RECOGNITION

(1) **Immediacy.** Hiddenstream art production and products involve face-to-face personal transaction and recognition. *Negative effects:* In a culture which values impersonal impacts and monetary reward, recognition of family and friends is sometimes viewed as compensatory rather than desirable. *Positive effects:* The immediate feedback and multilevel meanings of recognition stimulate hiddenstream art production.

(2) **Anonymity.** Such hiddenstream art products that survive use and time either are kept as family relics, sold in garage sales, or collected by museums. They have the character of anonymity about them because

they are unsigned or signatures are ignored,[98] because the artist was not perceived as involved in establishing a career or gaining historical recognition, and because the forms themselves seem to speak more of communal than individual values. *Negative effects:* As histories tend to be written in terms of individual achievements in the west, anonymous art receives less attention and recognition than autographic art. Because even women in this society are encouraged to identify with exemplary or heroic individuals rather than with groups, the lack of visible like-sex role models discourages contemporary pursuit of hiddenstream art production. *Positive effects:* The anonymity of hiddenstream art objects has suggested their collection and valuation by institutions and disciplines more concerned with values in tune with those attached to the tradition itself. Those objects which remain in a family take on personal heritage values.

(3) **Rediscovery.** Mainstream artists, critics, historians, and educators have periodically undertaken to re-discover women artists in the hiddenstream tradition and to evaluate their achievements and contributions.[99] *Negative effects:* There has sometimes been a tendency to give more attention to women artists in the hiddenstream than in the mainstream thereby reinforcing stereotypical feminine identifications.[100] Related attempts to make art products of the hiddenstream available to the public often involve jarring changes of context where quilts and blankets are hung in fine art galleries and museums where their values and meanings are presumptuously altered. *Positive effects:* Modern western artists seeking revitalization have used primitive and folk art, including that made by women, as sources of periodic inspiration. The women's art movement has also found a rich female heritage and an alternative set of art values in hiddenstream art and is attempting to integrate these into the mainstream.[101]

3. Achievement

Throughout time and all around the world large numbers of women artists have worked in the hiddenstream art tradition. As contemporary feminist artists, historians, and teachers continue to explore this tradition, more and more names will be attached to hiddenstream achievements. What is significant at this point in time, however, is that even working more or less anonymously, women as a group have made significant contributions to art and culture. A few examples are the following. Women in the hiddenstream art tradition have

- Developed art forms and processes which have served both the aesthetic and the survival needs of humankind.
- Evolved art production techniques and values which have allowed for the integration of a working artist into the everyday life of family and community.
- Preserved and modeled the values of craftmanship at grassroots levels of society.

- Produced art objects and "institutions" such as quilting and sewing circles which reinforce social bonds in a non-competitive atmosphere.
- Promoted awareness and imagination regarding the aesthetic possibilities inherent in everyday materials and needs.
- Demonstrated high levels of ecological concern by recycling products and avoiding technologies which are harmful to environment and human health.
- Been willing and able to work in the presence of infants and children thereby providing role models and early training in aesthetic making activity.
- Exemplified in their work principles such as form follows function and design as the spontaneous result of material and process.
- Provided images, symbols, and designs which have been a vital source of inspiration for mainstream artists.
- Persisted in the face of disparagement by mainstream artists and academics.
- Provided culture with coherent bodies of anonymous work with high anthropological, historical, and minority interest.
- Executed work with aesthetic values able to survive brutal changes of context (the hanging of bed quilts on gallery walls, etc.)
- Resisted the separation of art and life, consumption and production, and work and home.

b. WOMEN'S ART IN THE HIDDENSTREAM

Table 1, Women's Art in the Hiddenstream, suggests the range of materials, processes, products, and purposes that have been associated with this tradition. The reader is reminded that many, if not all, of these materials and processes have been used by mainstream male and female artists and that many of the products and purposes have been designed and pursued by applied artists and professional designers as well as by hiddenstream women artists.

D. WOMEN ARTISTS AND THE INTEGRATION OF MAINSTREAM AND HIDDENSTREAM TRADITIONS

1. Signs of Convergence

Contemporary feminist artists such as Judy Chicago, Miriam Schapiro, and Faith Ringgold have engaged in conscious efforts to reclaim women's hiddenstream art heritage and to demonstrate its art value in the mainsteam.[102] Although the career patterns of these artists are distinctly mainstream in character, these and other women artists have developed high levels of consciousness regarding the desirability of integrating women's personal values with professional art production. The content and subject matter of much contemporary women's art also reflects a new interest in women's life and body experience as well as in mainstream uses of media and processes which have long been associated with women's art.[103] Cooperative values

Table 1
WOMEN'S ART IN THE HIDDENSTREAM

TEXTILES	
MEDIA	PROCESS
FIBERS: cotton, linen, wool, silk, fur, hair, bark, straw, grasses, quills, etc.	Gathering, sorting, cleaning, spinning, weaving, knitting, crocheting, knotting, plaiting
FABRICS: organic and synthetic cloth; leather, pelts. Used clothing and remnants.	Cutting, sewing. Tanning, tooling. Quilting, piecing, appliqueing, lining, stuffing. Developing or following patterns.
FABRICS, THREADS, DYES, BEADS, FEATHERS, ETC.	Stitchery, embroidery, needlepoint, etc. Couching, smocking. Dyeing yarns, thread, fabrics. Painting fabric. Batik. Tie-Dye.
CERAMICS	
CLAY AND GLAZE	Digging, screening, mixing, kneading, hand building, wheel throwing, firing, glazing, incising.
FACE AND BODY ART	
FACE, BODY, PIGMENTS, AND OTHER MATERIALS.	Applied designs, incisions, punctures. Plucking, shaving, cutting, curling, waving, straightening, dyeing, braiding, bleaching, teasing, spraying. Girdling, binding, padding. Tatooing, scraping, plastic surgery. Lip, cheek, eye coloring. Ear and nose rings. Beauty marks. Dieting, exercising, tanning. Bracelets, necklaces, pins, rings, ribbons, bows, eyelashes and wigs.

PRODUCT	PURPOSE
Threads, yarns, and fabrics. Clothing, sweaters, hats, scarves, mittens, stockings, togas, saries, etc. Woven and knotted blankets. Woven, hooked, braided rugs. Nets and hammocks. Baskets. Table clothes, towels, napkins. Dolls and fetishes.	Body warmth and protection. Coverings of domestic utility. Containers for storage and carrying. Objects for play and ritual. Tribal, regional, or personal identifications. Trade and sales. Hope chests, gifts, and pastimes.
Custom designed and fitted garments. Tents, pouches, belts, shoes. Quilts, blankets. Pillows and toys. Moles and hangings. Banners and flags.	Fitted body warmth and protection. Coverings of domestic utility. Pillowed comfort. Play. Moveable housing. Recycling. Social collaboration. Fund raising. Personal satisfaction and skill. Perpetuation of traditional designs and processes.
Embellished clothing and coverings. Tapestries, samplers, mummy wrappings, wall hangings. Quillwork. Beadwork.	Aesthetically pleasing clothing and coverings. Religious and social rituals. Exhibition of sex-appropriate skills. Trade and sales. Storytelling and communication.
Containers: bowls, cups, plates, vases, jars, sculptural pots. Tiles. Small sculpture figurines, grace figures, dolls. Beads.	Containers for storage, serving, disposal, carrying. Objects for ritual and play. Perpetuation of traditional and identifying designs and patterns. Commemoration. Play. Jewelry. Trade and sales.
Altered bodies, faces, hair matching current styles and ideals or personal images and fantasies.	To gain power as attractive objects. To avoid criticism for non-conformity. To express non-conformity. To identify marital, social, and economic status. To affirm ethnic origins. To create new persona. To dramatize self or take part in drama and ritual.

Table 1 continued
WOMEN'S ART IN THE HIDDENSTREAM

MISCELLANEOUS FORMS	
MEDIA	PROCESS
Memorabilia	Cutting, gluing, arranging, printing, painting, labeling, collecting.
Traditional holiday materials (low tech materials/tools)	Hand construction and arrangements.
Flowers and fruits	Growing, selecting, collecting, arranging, preserving.
Found, cheap, manageable materials.	As suggested by women's magazines. Creative recycling. Fine art materials and processes for home use.

have not yet supplanted the competitive, autographic values of the mainstream, but successful mainstream artists are today more likely to be involved in women's support groups, cooperative studio and galleries, and women's group exhibitions. The influx of hiddenstream art values has affected male as well as female artists in the artworld. Artists such as Ron Gorchov, Nicholas Africana, and Robert Zakanitch have spoken of the liberating effect of being able to express both the masculine and the feminine aspects of their minds and artistic sensibilities.[104]

2. Problems and Possibilities

Whether the injection of hiddenstream art forms and content into mainstream art has been but another pretext for a passing avant garde movement or whether the merging of these two traditions promises a more permanent integration of masculine and feminine values in western art will depend in large part on the achievement of cultural parity for women and the value system that has been associated with femininity.[105] The achievement of cultural equality for women and hiddenstream art values will in turn, depend on how well we, as art educators, understand the nature of hiddenstream and mainstream art values and are able, as artists and teachers, to sustain a creative balance between the two.

PRODUCT	PURPOSE
Scrapbooks, family photo albums, journals, bulletin boards, collage and decoupage. Calendars annotated.	Sentimental and personal records, greetings, and identifications.
Xmas tree decorations. Holiday cookies. Cake decoration. Egg decoration. Greeting cards homemade. Table decorations. Party decorations. Children's Halloween and class play costumes. Wreaths, festoons, centerpieces, fancy dishes and garnishes.	Celebration, ritual, heritage. Personal satisfaction. Entertainment of children. Marking cyclic time.
Flower arrangements. Fruit centerpieces. Pressed flowers. Dried flowers. Decorated stationery and wall pieces. Waxed fruit.	Celebration of reproductive aspects of nature. Naturalizing interior environments. Non-utilitarian objects of aesthetic value.
All manner of aesthetic and utilitarian objects for home use and gift giving. Small scale art works: watercolors, miniature oils, drawings and sketches, plaster figurines, etc.	To satisfy need to make something with own hands. To find means of personal expression on scale, mode, and cost outlay appropriate for circumstance. To copy, imitate, emulate the admired.

NOTES AND REFERENCES

[1] See Chapter 10 for bibliography of major sources of information on women's art achievements.

[2] For some examples, see Norma Broude and Mary D. Garrard, "Introduction: Feminism and Art History" in Norma Broude and Mary D. Garrard, eds. *Feminism and Art History—Questioning the Litany* (New York: Harper & Row, 1982), pp. 1-17; Barbara Erlich White, "A 1974 Perspective: Why Women's Studies in Art and Art History?" *Art Journal* 35, 4 (1976): 340-344; and the Prefaces and Introductions to many of the recently published women's art history texts listed in Chapter 10.

[3] For discussion, see Broude and Garrard, *op.cit.*, p. 2; and Georgia Collins, "Considering an Androgynous Model for Art Education" *Studies in Art Education* 18, 2 (1977): 54-62.

[4] For discussion of this phenomenon, see Elsa Honig Fine, *Women and Art—A History of Women Painters and Sculptors from the Renaissance to the 20th Century* (Montclair, New Jersey: Allanheld & Schram, 1978), pp. 3-6; and Linda Nochlin, "Why Have There Been No Great Women Artists?" In Thomas B. Hess and Elizabeth C. Baker, eds., *Art and Sexual Politics—Women's Liberation, Women Artists and Art History* (New York: Collier Books, 1973), pp. 1-43.

[5] Rozsika Parker and Griselda Pollock, *Old Mistresses: Women, Art, and Ideology* (New York: Pantheon Books, 1981), pp. 17-18; and Hugo Munsterberg, *A History of Women Artists* (New York: Clarkson N. Potter, Inc., 1979), p. 86.

[6] Fine, *op.cit.*, p. 13.

[7] *Ibid.*, p. 31.

[8] Nochlin, *op.cit.*, p. 30.

[9] Fine, *op.cit.*, pp. 9, 35, 20.
[10] For examples, see Nochlin, *op.cit.*, p. 7.
[11] Fine, *op.cit.*, pp. 9, 31, 72.
[12] *Ibid.*, p. 105.
[13] *Ibid.*, p. 178.
[14] *Ibid.*, p. 48.
[15] *Ibid.*, p. 81.
[16] *Ibid.*, p. 153
[17] *Ibid.*, pp. 45-46.
[18] Germaine Greer, *The Obstacle Race—The Fortunes of Women Painters and Their Work* (New York: Farrar Straus Giroux, 1979), pp. 192-193.
[19] See Nochlin, *op.cit.*, p. 30; see biographical references to these artists in Fine, *op.cit.*, and Munsterberg, *op.cit.*
[20] See biographical references to these artists in Fine, *op cit.* and Munsterberg, *op.cit.* For extended discussion of one example, see Greer, *op.cit.*, pp. 264-265.
[21] See Nochlin, *op.cit.*, pp. 24-27; and Parker and Pollock, *op.cit.*, p. 35.
[22] See Fine, *op.cit.*, pp. 150, 160.
[23] Parker and Pollock, *op.cit.*, p. 35.
[24] Fine, *op.cit.*, pp. 12, 15.
[25] Ann Sutherland Harris, "The Second Sex in Academe, Fine Arts Division" *Art in American* 60, 3 (1972): 18-19; Lee Hall, "In the University" in Hess and Baker, *op.cit.*, pp. 130-146; and Barbara Erlich White, *op.cit.*
[26] Athena Spear, ed. *Women's Studies in Art and Art History: Description of Current Courses with Other Related Information* (New York: College Art Association of America, 1975).
[27] Fine, *op.cit.*
[28] *Ibid.*
[29] *Ibid.*
[30] For example, see Munsterberg, *op.cit.*, for his treatment of such artists as Anguissola, Fontana, Schurman, and Vigee-Lebrun.
[31] For discussion, see Cindy Nemser, "Art Criticism and Gender Prejudice" *Arts Magazine* (March 1972): 44-46 and Cindy Nemser, "Stereotypes and Women Artists" *The Feminist Art Journal* 1, 1 (1972): 1, 22-23.
[32] See Greer, *op.cit.*, and Fine, *op.cit.*, for discussion. For particular examples, see Parker and Pollock, *op.cit.*, pp. 92-97.
[33] For example, see Munsterberg, *op.cit.*
[34] For an interesting discussion of this dilemma, see Greer, *op.cit.*, pp. 68-87.
[35] Fine, *op.cit.*, pp. 171-172.
[36] *Ibid.*, pp. 71-72.
[37] *Ibid.*, p. 76.
[38] *Ibid.*, p. 87.
[39] For an excellent discussion, see Ann Sutherland Harris and Linda Nochlin, *Women Artists 1550-1950* (New York: Alfred A. Knopf, 1976), pp. 26-38.
[40] Fine, *op.cit.*, pp. 19, 105.
[41] *Ibid.*, p. 71.
[42] *Ibid.*, p. 73.
[43] Clara Erskine Clement, *Women in the Fine Arts* (Boston: Houghton, Mifflin and Company, 1905), p. xii.
[44] For particular accounts, see Petersen and Wilson, *op.cit.* and Fine, *op.cit.*
[45] *Ibid.*
[46] *Ibid.*, p. 106.
[47] *Ibid.*, p. 103.
[48] For particular accounts, see Fine, *op.cit.*
[49] Greer, *op.cit.*, pp. 151-188.
[50] *Ibid.*
[51] Nochlin, *op.cit.*, p. 26.
[52] Karen Petersen and J.J. Wilson, *Women Artists: Recognition and Reappraisal from the Early Middle Ages to the Twentieth Century* (New York: Harper Colophon Books, 1976), p. 83.

53 Elizabeth C. Baker, "Sexual Art-Politics" in Hess and Baker, *op.cit.*, p. 112.

54 Charlotte Streifer Rubinstein, *American Women Artists—From Early Indian Times to the Present* (Boston: G.K. Hall & Co., 1982), pp. 382, 271; and Fine, *op.cit.*, pp. 143-144.

55 Grace Glueck, "'A Matter of Redefining the Whole Relationship Between Art and Society'" *Art News* 79, 8 (1980), pp. 58-63.

56 For particular accounts, see Fine, *op.cit.*

57 *Ibid.*

58 *Ibid.*

59 *Ibid.*

60 *Ibid.*

61 *Ibid.*

62 *Ibid.*, p. 196; and, Avis Berman, "A Decade of Progress, But Could a Female Chardin Make a Living?" *Art News* 79, 8 (1980): 76-77.

63 Petersen and Wilson, *op.cit.*, p. 120; and Fine, *op.cit.*, p. 181.

64 For particular accounts, see Munsterberg, *op.cit.*

65 The wife-husband artist phenomenon was acknowledged by a 1949 exhibition, "Artists: Man and Wife" held at the Sidney Janis Gallery, Fine, *op. cit.*, p. 146.

66 Notable among these for their sharing of domestic responsibilities were Marguerite and William Zorach, Fine, *op.cit.*, p. 194. Pairs whose artistic collaborations seem to have been mutually beneficial are Sonia Terk-Delaunay and Robert Delaunay, Sophie Taeuber-Arp and Jean Arp, and Anni and Josef Albers. For particular accounts, see Fine, *op.cit.*

67 Fine, *op.cit.*, p. 114, raises the question with regard to Susan Macdowell Eakins, who is said to have "supported her husband's career at the expense of her own: . . . would she have been a better painter if she had not been associated with Eakins, or did her talent grow and mature because of their relationship?"

68 For particular accounts, see Fine, *op.cit.*

69 Joelynn Snyder-Ott, *Women and Creativity* (Millbrae, California: Les Femmes Publishing, 1978), pp. 27-41.

70 Berman, *op.cit.*, p. 78.

71 Munsterberg, *op.cit.*, p. 20; and Parker and Pollock, *op.cit.*, p. 20.

72 Fine, *op.cit.*, pp. 8-9.

73 *Ibid.*, pp. 36, 13, 106.

74 *Ibid.*, p. 73.

75 For particular accounts, see Fine, *op.cit.*

76 *Ibid.*, pp. 57, 84.

77 For particular accounts, see Fine, *op.cit.*

78 *Ibid.*, p. 13.

79 Petersen and Wilson, *op.cit.*, p. 38.

80 Munsterberg, *op. cit.*, p. 48.

81 Fine, *op.cit.*, p. 48.

82 For particular accounts, see Fine, *op.cit.*

83 Eleanor Tufts, *Our Hidden Heritage: Five Centuries of Women Artists* (New York: Paddington Press, Ltd., 1974), p. 107.

84 Harris and Nochlin, *op.cit.*, pp. 153-155.

85 Fine, *op.cit.*, pp. 129-130.

86 For various discussions, see Munsterberg, *op.cit.*, pp. 1-9; Patricia Mainardi, "Quilts: The Great American Art" in Broude and Garrard, *op.cit.*, pp. 331-346; Lucy R. Lippard, "The Pains and Pleasures of Rebirth: Women's Body Art" *Art in America* 64, 3 (1976): 73-81; and Rubenstein, *op.cit.*, pp. 1-12.

87 Mainardi argues that the anonymity of such works would seem to have more to do with the prejudice of the art historian than with the humility of the artist. For example, even though a quilt might bear the signature of the artist, the artist's name will not be attached to the work in its catalogue description. See Broude and Garrard, *op.cit.*, pp. 332-333.

88 Broude suggests that as the dichotomy between art and craft, between abstract and decorative blur, distinctions such as mainstream and hiddenstream art tend to become more invidious. For example, she quotes Le Corbusier and Amedee

Ozenfant as claiming that "There is a hierarchy in the arts: decorative art at the bottom, and the human form at the top. Because we are men!" See p. 315, Norma Broude, "Miriam Schapiro and 'Femmage': Reflections on the Conflict Between Decoration and Abstraction in Twentieth-Century Art" in Broude and Garrard, op.cit.

[89] For a personal discussion of the tensions between mainstream and hiddenstream art values, see Radka Donnell-Vogt's memoir in Lynn F. Miller and Sally S. Swenson, Lives and Works: Talks with Women Artists (Metuchen, New Jersey: The Scarecrow Press, 1981), pp. 37-56.

[90] See Broude and Garrard, op.cit., p. 2 and Collins, op.cit.

[91] Fine, op.cit., pp. 5, 64-65.

[92] Ibid., pp. 198-199.

[93] The therapeutic and developmental aspects of clay and fiber were early rationales for their use in occupational and physical therapy as well as in some elementary classrooms. Women's magazines continue to suggest that hand crafts can satisfy both creative and emotional needs.

[94] Laura H. Chapman, Instant Art, Instant Culture: The Unspoken Policy for American Schools (New York: Teachers College Press, 1982), p. 93

[95] Petersen and Wilson, op.cit., pp. 17-18.

[96] Munsterberg, op.cit., pp. 12-16.

[97] Mainardi in Broude and Garrard, op.cit., pp. 331-333, 341-342.

[98] Ibid., pp. 332-333; and Rubenstein, op.cit., pp. 1-9.

[99] Although Mainardi argues that " . . . art historians have not written about [quilts] as art" in Broude and Garrard, op.cit., p. 343, other hiddenstream art forms such as blankets, pottery, and tapestries have received at least passing attention as "art" by mainstream artists, historians, critics, and educators.

[100] For example, some artists and historians seem to find it easier to praise the quality of such hiddenstream genre as Navaho blankets and prehistoric pottery than the quality of individual women's work in the mainstream art forms. See for example, Rubenstein, op.cit., p. 2; and Munsterberg, op.cit., pp. 9, 144-147.

[101] See Kay Larson, "For the First Time Women Are Leading Not Following" Art News 79, 8 (1980): 64-72; and Broude in Broude and Garrard, op.cit., pp. 315-329.

[102] See Lucy R. Lippard, From the Center: Feminist Essays on Women's Art (New York: E.P. Dutton and Company, 1976) for discussion of these and other contemporary feminist artists.

[103] Lawrence Alloway, "Women's Art in the '70's" Art in America (1976):64-72; and Lippard, "The Pains and Pleasures of Rebirth: Women's Body Art" op.cit., pp. 73-81.

[104] Larson, op.cit., pp. 68-71.

[105] Collins, op.cit.

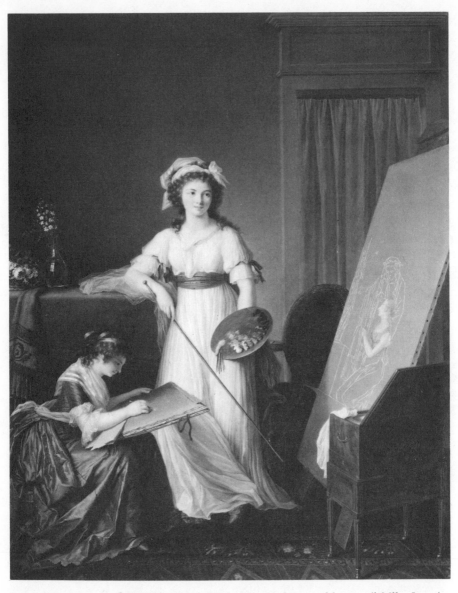

Marie Victoire Lemoine (1754-1820). *Mme. Vigee-Lebrun and her pupil Mlle. Lemoine.*
Oil on canvas. H. 45-7/8'' W. 35-1/4''. Gift of Mrs. Throneycroft Ryle, 1957. Courtesy
of The Metropolitan Museum of Art, New York.

CHAPTER 6:

Women's Acheivements in Art Education*

There is an unworked mine of untold wealth among us in the art education of women. In the field of general education here I am informed that nine-tenths of the teachers are women; and some explanation of its excellence may be found in that fact.
—Walter Smith (1873)

As educators, most of us find our satisfaction in the achievements of others. When we do something well, the most natural response is to think of others' contributions to our efforts, to think second of struggles along the way, and to think last of the role of our own wit and hard-earned skill in various undertakings . . . Women of my generation in particular have been programmed . . . not to claim credit for what we do.
—Laura Chapman (1978)

A. THE RECOGNITION OF WOMEN'S ACHIEVEMENTS AS ART EDUCATORS

1. An Overview of Art Education History

Most books and articles that present an overview of the history of art education in the United States give more attention to the contributions of men than those of women, although research shows that women have made significant contributions to the field of art education. Many histories of art education give the impression that responsibility for the development of art in public schooling has been transferred to a great extent from the hands of Walter Smith to those of Arthur Wesley Dow, Thomas Munro, John Dewey, Viktor Lowenfeld, Victor D'Amico, and so on.[1] Chapters in art education textbooks that

*Chapter contributed by Mary Ann Stankiewicz and Enid Zimmerman.

focus on changing roles and goals of art in American public schools seldom mention women as contributors to art in schooling.[2]

More recently, however, journal articles, conference presentations, and monographs have begun to fill in missing chapters about women's contributions to art education history. Erickson has examined the work of Alice Robinson at The Ohio State University, and Packard has written about Jane Addam[3]. *Women Art Educators,* a monograph edited by Zimmerman and Stankiewicz dedicated to the memory of Mary Jane Rouse, and sponsored by the NAEA Women's Caucus, includes articles about Louisa Minott, Belle Boas, Malvina Hoffman, Mary Rouse, American Indian women as art educators, and women art educators at Syracuse University.[4] Stankiewicz has also published articles about collegiate art education for women in the nineteenth century and about the work of Rilla Jackman, Syracuse University art educator.[5] Among presentations about women art educators, made at more recent National Art Education Association conventions, Smith reported on five powerful women who contributed to art education in the years before Lowenfeld became well known; Plummer spoke about the history of women in art education; and Saunders analyzed roles of women in art education before 1900.[6]

2. Toward a Philosophy of Women's Art Education History

While there are no histories of art education that recognize the myriad roles that women have played in the field and equally integrate their contributions with those of male art educators, a start has been made toward a feminist revision of the literature on the history of the field. By discussing women art educators' contributions, the social constraints and other obstacles they have had to overcome, researchers are beginning to make important contributions to the history of art education. By challenging the inequities and stereotypes existing with respect to women and replacing them with an awareness of the past roles of women and their present status in the field, sound research can provide both grounds and motivation for change. By revising standard interpretations of the history of art education to include contributions of women, feminist history helps to create a richer and more complete picture of the past. Thus, feminist revisions of art education history can enrich the historical tradition, correcting bias and distortion found in earlier accounts.

a. TYPES OF ACHIEVEMENT AND THEIR RECOGNITION

(1) **The Mainstream.** Women's achievements in art education can be discussed as mainstream and hiddenstream achievements. Mainstream contributions to art education are those recognized by standard historical accounts of the field or paralleling their place in official recognition structures. In the mainstream, achievement is generally defined in masculine terms. Contributions are made to art education nationally, and the contributor participates in recognized power structures. Mainstream achievements might include holding office in

regional or national organizations, extensive conference presentation, publishing research, or receiving an award from a national organization. This sphere of achievement is competitive; there is an emphasis on personal recognition and upward career mobility. Most histories of art education focus on mainstream contributions because these are fully documented and furnish accounts of the past.

(2) **The Hiddenstream.** Hiddenstream contributions often occur at the local, grassroots level. They are personal, sometimes known only to a few people, or they may be cooperative, shared achievements. Hiddenstream contributions often seem anonymous to those outside a local area because they are rarely documented in standard written sources or journals that have a national readership. Frequently, hiddenstream contributions may only be found in oral tradition. Chapman has noted that women are often major contributors to the hiddenstream, partly because stereotyped expectations for feminine behavior emphasize modesty, humility, and non-assertive dedication to the needs of others.[7] Thus, a mainstream woman art educator might have taught at a major university program during an era in which it was the center for professional development and achieved national recognition. On the other hand, a notable hiddenstream woman art educator could be the retired art teacher whose contributions to art education are recognized by former colleagues and pupils who recount stories of lessons she taught, exhibits she staged, her contributions to a local art society, and her overall aesthetic influence on her community.

b. ROLES OF WOMEN ART EDUCATORS

Among the roles in which women art educators have contributed to both mainstream and hiddenstream tradition are those of master teachers, authors of art education books or articles, local or state art supervisors or curriculum coordinators, administrators of college or university art or art education programs, museum art educators, researchers, artist-teachers, developers of curriculum materials for classroom use, college or university studio art or art history professors, art education professors at a college or university, art therapists, art educators in community centers or recreational programs, art critics, political office holders in state or national art education organizations, and art advocates or lobbyists. The list could go on and on; women have filled many roles in which they were directly or indirectly facilitating learning in the visual arts. To further illustrate this point, the remaining portion of this chapter will describe, with examples, first the mainstream and then the hiddenstream traditions of women working as art educators, from the past to the present day.

B. WOMEN ART EDUCATORS IN THE MAINSTREAM

Within the mainstream tradition, conditions for women's achievement and recognition have included dedicated hard work, willingness to assume responsibility in administrative or supervisory positions, will-

ingness to make ideas and contributions public, and the ability to balance priorities of both personal and professional life. Often these qualities have been in opposition to stereotyped notions of femininity or romantic conceptions of the artistic personality. Such stereotyped self-images among women art educators have been one barrier to their achievement.

1. Conditions for and Obstacles to Women's Achievement and Recognition

Difficulties inherent in combining marriage, family, and home responsibilities with a career have kept many women art educators from assuming roles that would gain them mainstream recognition. Another factor that has prevented women from achieving the same status as men has been the lack of access to hierarchies and institutions of power. While many male educators have been part of an "old boys" network with common graduate schooling and mentors to introduce them to higher education systems, women art educators in higher education institutions generally have had limited access to the same networks. In the past, most women art educators taught at the elementary levels and were educated at normal schools or teachers' colleges: others entered the field of art education through art history or studio programs, often at women's colleges. While these programs were often more prestigious than those found in teachers' colleges, they did not offer access to power structures in public schools. Once within the school system, the woman art educator was and often is perceived as outside the academic mainstream, less because of her gender than her subject matter. While nineteenth-century notions of "woman's sphere" affected women's achievements up through the turn of the century, the effect was both positive and negative. It was positive because the linking of women with art and the teaching of children promoted female access to art education. It was negative because of the separation of men's and women's work, with higher status accruing to the former and lower salaries to the latter.[8] Art teaching became a peripheral, low status part of the larger art world.

From the beginnings of public school art education, women have contributed as faculty by preparing teachers, and as art teachers and supervisors. The "feminine mystique" of the years following World War II led to the replacement of many of these powerful women department heads at universities and state supervisors by the new generation of GI Bill graduates, predominantly men. These male administrators often believed that male supervisors and faculty members were needed to improve the status of art education.

Another attitude, held by many, is expressed when young women indicate a desire to study art and are advised, "Of course, you'll plan to teach for a few years before you marry. When the children are older, you can always go back to teaching." Fortunately, many of these at-

titudes are changing; women art educators are now making lifelong commitments to teaching. More women are entering the mainstream, studying in major graduate programs, and assuming leadership in the field of art education. Other women do not seek mainstream recognition, finding rich and full professional lives in the quieter waters of the hiddenstream.

2. Types of Mainstream Achievements in the Past

Art education, in the mid-nineteenth century, was industrial art education, a practical study of drawing to prepare workers for American industries. As it developed, industrial art education grew to include the foundations of industrial arts, manual arts, home economics, and other vocationally oriented branches of schooling. Women contributed to vocational art education through their teaching and writing and through the establishment of schools to train women for art-related work, industrial or commerical art, or art teaching. Women were also active in the kindergarten movement and contributed to the literature of art education for the young child. As guardians of culture in the late nineteenth century, women were expected to take particular interest in aesthetic matters. Many women turned this interest into careers in art history and art criticism.[9] Others wrote about art appreciation or taught art appreciation courses. Women became a link between the public and their appreciation of art works; they began as "picture ladies" in the public schools and now make up the vast majority of museum docents.

The assumed connection between women and art also fostered feminine interest in avocational uses of arts or crafts. Through teaching and writing, women advocated art as leisure activity for children and other women. Women's work with settlement houses was an important contribution toward awareness of art as a means to social adjustment, interests that have grown to include personal adjustment and art therapy. Women have contributed, also, to the literature of art education through research about art teaching and learning. Finally, but not least, women have served as leaders in professional organizations within the field of art education. While it would be impossible to tell the whole story of women's contributions to art education, we will describe the contributions of some of the countless women who have worked in both mainstream and hiddenstream art education. A selection of books and some important articles published by women art educators is listed in Appendix B. *Figure 4,* a time line of women art educators born between 1800 and 1900 illustrates some mainstream activity of women in art education. One reason for selecting the women mentioned here has been the availability of secondary source material, especially from biographical dictionaries such as *Notable American Women* and others. The achievements of many women art educators have not been documented in such sources, and written sources often have to be supplemented by oral histories.

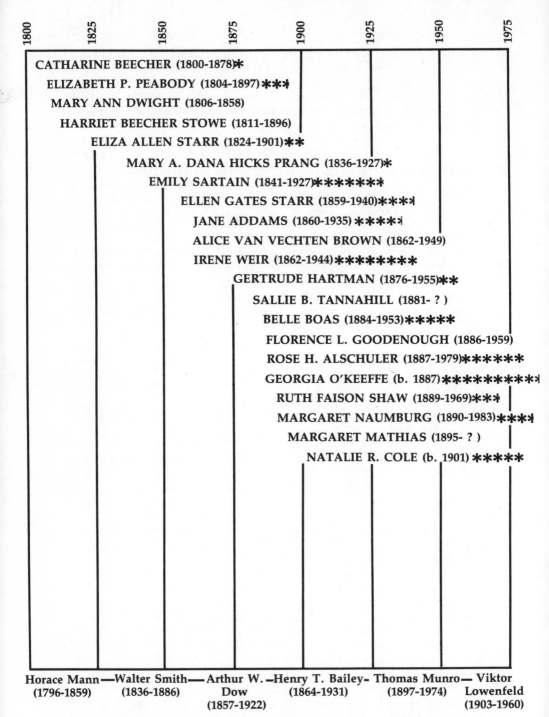

Figure 4

SOME WOMEN CONTRIBUTORS TO MAINSTREAM
ART EDUCATION, BORN 1800-1900: A TIMELINE.

3. 19th and Early 20th Century Mainstream Achievements

a. ELIZABETH PEABODY

Among early nineteenth century women, Elizabeth Peabody (1804-1894) contributed to art education for the young child within the kindergarten movement. Elizabeth Peabody, sister-in-law of Horace Mann, and Mary Peabody Mann (1806-1887), her sister, both taught drawing from time to time.[10] After a visit to Germany in 1867, Elizabeth Peabody returned to Boston as an advocate of Froebel's methods of early childhood education. Her kindergarten, established in 1860, was the first formal English speaking kindergarten in the United States. According to Saunders:

> "She used nature study and object lessons to develop the perceptual awareness and sense impressions necessary for moral culture.The materials she used included Froebel's "gifts" (balls of colored yarn, beans, and cork work), building blocks, and parquetry; activities for the children included pricking (using materials much like pegboards for sewing), weaving and braiding paper strips into mats, modeling in beeswax and clay, and laying sticks."[11]

Peabody also published drawing books and was an advocate of art education in the public schools. Her paper "A Plea for Froebel's Kindergarten, As the First Grade of Primary Education"[12] argued that artist and artisan must be reunited through public school art education. She advocated the Froebel kindergarten as the best way to begin such art education because it used the child's natural creative activity, taught principles of design found in nature and art, led the child to religious truth through recognition of God as the first designer, and, by making labor artistic, made it attractive to the worker. Peabody also assumed that women would be best suited to be trained as Froebellian teachers because of their motherly instincts. It is intriguing to notice that many of the kindegarten materials she used were typical materials of nineteenth century feminine decorative art. Many women art educators today have taken a special interest in art for the young child, continuing work begun by Elizabeth Peabody.

b. MARY ANY DWIGHT

Mary Ann Dwight (1806-1858) was a teacher of drawing and painting who wrote and translated a variety of books, including several volumes about art. Her *Introduction to the Study of Art* (1856) included chapters on taste and style, drawing, perspective and line, light and shade, color, composition, ancient art, sculpture, and other areas of visual art. She described the content of the book as the result of her many years of practical teaching experience. Her expertise was recognized in her own era; in 1856-1857 a series of articles by Dwight was published in Barnard's *American Journal of Education* and later reprinted in pamphlet form. Clarke excerpted Dwight's articles, writing:

it is clear that more than a quarter of a century ago, this writer not only understood the value of the study of drawing to all school children but had also as correct a conception of the practical method of instruction in this study as Walter Smith himself.[13]

Dwight argued that instruction in drawing should begin early, as it did in music, and that sequential instruction should build on fundamentals, as it did in mathematics. She stated that neither parents not students should expect to reach a level of mastery and knowledge of the rules governing the science of art without hard work over an extended time. Dwight's work was praised by her contemporaries, and teachers she taught used her system in public schools in the Northeast.[14] In spite of her contributions to American art education, Mary Ann Dwight has rarely been mentioned in histories of the field. Little is known about her life; her work was overshadowed by the more publicized contributions of Walter Smith.

c. MARY DANA HICKS PRANG

Another nineteenth century woman art director, often in the shadow of a man, was Mary Dana Hicks Prang (1836-1927).[15] Mary A. Dana was born in Syracuse, New York, and educated at a local seminary for women. Married at twenty, Hicks was left a widow with a young daughter just two years later. To support herself and her child, she began taking private pupils in drawing and other subjects. Thus, her educational work began, as had Elizabeth Peabody's, outside the context of public schooling. She soon shifted her field of enterprise to the Syracuse Public High School and, in 1868, she was appointed supervisor of drawing for all the city schools. Part of her work was establishment of a normal art class for the public school teachers, a venture that preceeded Smith's establishment of Massachusetts Normal Art School by at least three years. Hicks was an active professional who traveled to Boston in 1875-76 to study with Smith at Massachusetts Normal Art School. She moved permanently to Boston in 1879 to work for the Prang Educational Company. In 1884, she became director of a correspondence normal art course established by Prang. Along with John S. Clark and other educators employed by Prang, Hicks was a major influence on art education in the late nineteenth century. She was active in a variety of professional organizations, often speaking at national conferences. In 1895, she published "Color in the Public Schools," based on her three years research on children's perception of color. This research formed the basis for her recommendations about color study in public schools, a development which would add a new dimension to the drawing curriculum. In 1900, Mary Hicks married Louis Prang and virtually retired from professional art education. In her seventies, after Louis Prang's death, Mary Prang resumed public activity in progressive reform and pacifist associations. In her eightieth year, she earned an Associate in Arts degree from Radcliffe. Four years later, she completed her Master of Education degree at Harvard. While the contributions of Walter Smith, Louis Prang, John Clark, and other men of the era have overshadowed contributions by Mary Dana Hicks

Prang, she should be remembered as a teacher and co-author of many art texts published by Prang.

d. EMILY SARTAIN

While Mary Dana Hicks Prang was making her contributions to art in public schooling, Emily Sartain (1841-1927) was working in a different sphere of art education. The only daughter among eight children of John Sartain, an artist and engraver, Sartain's early interest in art was encouraged by her father. She studied art at the Pennsylvania Academy of Fine Art, then continued her education in Europe. In her youth, she was the only woman mezzotint engraver on either continent. Her paintings were exhibited in the Paris Salons of 1875 and 1883, and, in 1876, another painting won a medal at the Centennial Exposition in Philadelphia. She was a magazine art editor from 1881-1883. This background prepared her for the position she assumed in 1886 as principal of the Philadelphia School of Design for Women. This school, the first industrial art school for women in the United States, was founded in 1884 by Sarah Worthington King Peter (1800-1877), in her home. The school began by offering instruction in simple principles of drawing and wood engraving to young women earning their living by needlework.[16] By the early 1880s, the school offered instruction in architecture, engraving, lithography, and practical design. About 300 students attended the school annually; most became teachers of art or were employed in industry. Emily Sartain, with her broad experience in both fine and industrial art, headed the school from 1886 until 1920, shifting its curriculum from the South Kensington to the French method using live models.[17]

e. ELLEN GATES STARR AND JANE ADDAMS

Most writers credit Ellen Gates Starr (1859-1940), Jane Addams' friend and co-founder of Hull House, with responsibility for much of the art, crafts, and art appreciation program at the settlement house. Jane Addams' (1860-1935) contributions to art education have been discussed by Packard. Addams herself acknowledged that Starr directed the "effort to make the aesthetic and the artistic a vital influence in the lives of [Hull House's] neighbors."[18] Starr's interest in art was encouraged by her aunt, Eliza Allen Starr (1824-1901), who wrote and lectured on art and religion, founding the art department at St. Mary's Academy near South Bend, Indiana, around 1871. Starr was influenced by her aunt's work as well as by the writings of Ruskin and William Morris, read while she and Jane Addams attended Rockford Seminary. Due to lack of money, Starr had to leave the Seminary after one year and teach school. In 1888, Starr and Adams made plans to fulfill Addams' dream of establishing a settlement house in America, following British precedents. Starr believed in the power of art for moral uplift, a reflection of her early influences, and saw to it that photographs of masterpieces were hung on the walls of Hull House, setting an example for those who wished to borrow from the small circulating library of pic-

tures. Starr taught classes in the history of art and organized exhibitions in the Butler Art Gallery, part of the first addition to Hull House. She found the Chicago Public School Art League in 1894, serving as first president of this group established to develop collections of pictures for school decoration and art appreciation. Later in the decade, Starr studied bookbinding in London, uniting her interest in art appreciation with crafts skills. Starr considered herself a Christian socialist and was active in a variety of labor reform movements. The shift from recognition of the moral power of art to a desire for general social reform that characterized such Victorians as Ruskin is apparent in Starr's contributions to art education.

f. ALICE VAN VECHTEN BROWN

Some women art educators, such as Alice Van Vechten Brown (1862-1949), have made their contributions in more elite spheres. Brown was the daughter of a minister who served on the faculty of Dartmouth College and in 1868 became president of Hamilton College. Brown's desire to become an artist must have surprised her family, but from 1881-85 she studied at the Art Students' League in New York. Her teachers included William Merritt Chase, Abbott Thayer, and others. Family illness caused her to turn from painting to art history and art teaching. She taught at the Norwich, Connecticut, Art School, becoming Director in 1894. Interest in her method of teaching art history as part of studio work in a laboratory context led to an appointment at Wellesley College in 1897. Brown reorganized the art program, instituting her laboratory method so successfully that, in 1900, Wellesley was the only American college with an art history major. Wellesely's "Direct Approach" was recognized as exemplary by the 1956 Report of the Committee on the Visual Arts at Harvard. Brown's contributions at Wellesley, including her work as director of the college's Farnsworth Museum, are discussed in Sherman and Holcomb.

g. IRENE WEIR

Many women artists and art educators have been the daughters of male artists; Irene Weir (1862-1944) was the granddaughter of Robert W. Weir, painter and teacher of art at West Point. Her uncles were the painters Julian Alden Weir and John Ferguson Weir, who was also first director of the School of Fine Arts at Yale. Weir combined both family interests in her own career as an art educator and painter. She studied at the Yale School of Fine Arts in 1881-82, receiving a BFA from Yale in 1906. From 1887 to 1890, Weir taught drawing in the New Haven public schools, and for the next three years, served as director of the Slater Museum School of Art in Norwich, Connecticut. From 1893 through 1910, Weir was art supervisor in the Brookline, Massachusetts, Public Schools. During this period, she wrote an art curriculum for Brookline as well as numerous articles on picture study and monographs on artists published by Perry Prints. In 1910, Weir moved to New York City where she taught at the Ethical Culture School,

then from 1917 through 1929, she founded and taught at the School of Design and Liberal Arts. Weir received her diploma from the *Ecole des Beaux Arts Americaine* in Fountainbleau in 1923. She remained active as artist, critic, and teacher to the end of her life.

h. GEORGIA O'KEEFFE

Contributions of the generation of women art educators born before the Civil War show that women were active in all aspects of art education ranging from the teaching of drawing in public schools through higher education in art. Some women of the next generation, born in the 1880s, shared the common ground of having studied with Arthur Wesley Dow at Columbia Teachers College. Of these, Georgia O'Keeffe (b. 1887) is perhaps the best known American woman painter. She was also, from 1912 to 1914, a public school art teacher in Amarillo, Texas. In the fall of 1914, she gave up her teaching position to move to New York where she studied with Dow. During this period she was also teaching summer art classes to teachers at the University of Virginia, working with Alon Bement, who had introduced her to Dow.[19]

i. BELLE BOAS

While teaching was merely a small part of O'Keeffe's career, it was a major aspect in the lives of other students of Dow, such as Belle Boas (1884-1953). According to Zimmerman, Boas began teaching at the age of sixteen. She later received formal training studying with Dow at Columbia University where she completed an MA in art education. This was a common pattern at the turn of the century; young women often began teaching just after high school; then, after a few years experience, they took course work in pedagogy. Boas served as Art Director of the Horace Mann School and as Assistant and later Associate Professor of Fine Arts at Columbia Teachers College. In 1935, she was appointed Editor-in-Chief of *Art Education Today,* an annual published by the Fine Arts staff. Although Boas held prestigious positions, little documentation of her life can be found. She was close to her younger brother George, a philosopher; they shared an interest in art and probably influenced each other's work.[20] Among Boas' publications was *Art in the Schools* (1924), dedicated to the memory of Dow. From 1943 until her death in 1953, Boas served as the Director of Education at the Baltimore Museum of Art, adding contributions to museum education to her other achievements.

j. SALLIE BELLE TANNAHILL

Another student of Dow's who also served as Instructor and Associate Professor of Fine Arts at Teachers College was Sallie Belle Tannahill (b. 1881). Tannahill dedicated her first book *P's and Q's of Lettering* (1923) to Dow. Her second book, *Fine Arts for Public School Administrators* (1932), shows Dow's influence in its balance between creative expression and appreciation.

k. MARGARET MATHIAS

Margaret Mathias (b. 1895) graduated from The Ohio State University in 1916, later receiving her masters from Columbia.[21] Mathias served as Director of Art in Montclair, New Jersey, and head of Fine Arts at New Jersey State College in Upper Montclair. She also taught during the summer at Columbia Teachers College, then at Western Reserve. Her publications include three books: *Beginnings of Art in the Public Schools* (1924), *Art in the Elementary School* (1929), and *The Teaching of Art* (1932). Mathias combined influences from Dow and Dewey in her tri-partite stage theory of children's artistic development and her books were considered appropriate to the child-centered education of the Progressives.

l. Other Women Art Educator Authors in the Early Twentieth Century

Other women art educators were active during the early part of the century and wrote books, yet their histories remain to be researched. Among these women are Mabel Sarah Emery, *How to Enjoy Pictures* (1898); Estelle May Hurll, *How to Show Pictures to Children* (1914); and Bonnie Mellinger, *Children's Interest in Pictures* (1932). Harriet and Vetta Goldstein first published their *Art in Everyday Life* in 1925, with a second edition in 1932, a revision in 1935, a third edition in 1940, and a fourth edition in 1954.

m. WOMEN RESEARCHERS IN THE EARLY TWENTIETH CENTURY

The generation born in the 1880s was among the first to make significant contributions to art education research. Florence L. Goodenough (1886-1959) was a developmental psychologist who developed the Draw-a-Man Test for her doctoral dissertation, completed with Lewis Terman at Stanford in 1924. The work was published in 1926 as *Measurement of Intelligence by Drawing*. Rose Haas Alschuler (1887-1979) and LaBerta Hatwick (b. 1909) in 1947, published *Painting and Personality*, a two-volume study of young children's expression through art. Alschuler was primarily an early childhood educator and consultant, as well as the wife of an architect and mother of five children. Focus on the developmental and expressive values of art is found in *Creative Expression* (1932), edited by Gertrude Hartman (1876-1955) and Ann Shumaker (dates unknown). This collection of children's art and articles by leading Progressive educators was first published by *Progressive Education* in 1926, during Hartman's term as the magazine's first editor. Women authors who contributed to the volume were Florence E. House, Elizabeth Byrne Ferm, Lucy Sprague Mitchell, Florence Cane, Margaret Naumburg, Ellen W. Steele, and Helen Ericson.

n. Women Pioneers in Art Therapy

Margaret Naumburg (1890-1983) and her sister, Florence Cane, (birth

date unknown) were major contributors to what has been described as the expressive-psychoanalytic tradition in art education.[22] Naumberg graduated from Barnard in 1911, did graduate work at Columbia and the London School of Economics, and took the first course for teachers offered by Maria Montessori in Rome.[23] In 1915, Naumburg opened the Walden School in New York, one of the foremost Progressive schools. During the 1930s she combined her experience in psychoanalaysis with her interests in art and children, beginning work in the area that would become art therapy. Her books include: *The Child and the World* (1928), *Dynamically Oriented Art Therapy* (1966); and *An Introduction to Art Therapy* (1973), among others. She is regarded as one of the pioneers of American art therapy, along with Lauretta Bender, and Edith Kramer.[24] Florence Cane also followed a therapeutic orientation in her art teaching. Cane studied painting with William M. Chase, Kenyon Dox, and Robert Henri.[25] She taught at the Walden School and, during the early 1930s, was Arts Chairman at the Dalton School. Her book *The Artist in Each of Us* (1951) sets forth her philosophy and methods as an artist-teacher seeking to foster creative self-expression in students.

o. RUTH FAISON SHAW

Another advocate of expressive-psychoanalytic art education, Ruth Faison Shaw has had an impact on the field; however, she tends to fit into the hiddenstream tradition in many respects because her contributions in developing a medium widely used with young children are not well known. Ruth Faison Shaw (1889-1969) began her career as a teacher in North Carolina. She had little formal art instruction though she did exhibit with local women's groups. After the First World War, Shaw founded a school in Rome for English-speaking children. There she developed finger-painting as a simple means of visual expression for young children. When Shaw returned to the United States in 1932, her art medium was hailed by critics and psychologists, and her finger-paint was marketed by Binney and Smith. During the 1930s and 1940s, Shaw toured the country demonstrating the medium and her teaching methods. She was involved with therapeutic uses of finger-painting from the beginning. When she retired to Chapel Hill, North Carolina, in the late 1950s, she worked with patients at the North Carolina Memorial Hospital and other organizations. From 1960 to 1961, Shaw was the star of her own finger-painting series on educational television in North Carolina.

4. Achievements of Women Art Educators in the Mid-Twentieth Century

a. NATALIE ROBINSON COLE

During the 1940 and 1950s, many women were making their marks as teachers and authors. Natalie Robinson Cole (b. 1901) has been described as a one-woman arts program.[26] Her book, *The Arts in the*

Classroom, (1940) describes her way of teaching painting, clay modeling, block printing, dancing, and writing to an ethnically mixed group of low I.Q. students in Los Angeles. Cole demonstrated her teaching at art education conferences, leaving a vivid impression of pedagogic mastery on observers. Her second book, *Children's Art from Deep Down Inside,* was published in 1966.

b. OTHER WOMEN ART EDUCATORS IN THE MID-TWENTIETH CENTURY

While it is difficult to make a comprehensive list of women publishing in art education during the mid-century, any list should include H. Rosabelle MacDonald (Mann) whose *Art as Education,* published in 1941, described her experiences as a secondary art teacher in New York City. Other women authors include: Anna Berry, *Art for Children (1947), Jane Cooper Bland, Art of the Young Child* (1957); Maude Ellsworth, *Art for the High School* (1954); and with Michael F. Andrews, *Growing with Art* (1950); Louise Kainz and Olive Riley, *Exploring Art* (1947); Mildred Landis, *Meaningful Art Education* (1951); Miriam Lindstrom, *Children's Art: A Study of Normal Development in Children's Modes of Visualization* (1957); the British art educator Marion Richardson, *Art and the Child* (1952).

5. Achievements of and for Women Art Educators in the 1960s, 1970s, and the 1980s

a. MAINSTREAM CONTRIBUTIONS AS AUTHORS OF ART EDUCATION LITERATURE

In the 1960s, 1970s, and 1980s, women art educators made mainsteam contributions to the field of art education by authoring, co-authoring, and editing books on a variety of topics directly related to the field of art education. It would be impossible to list all the women who authored art education books. Some popular topics of interest to art educators include: 1) art making processes and art appreciation, 2) art and child development, 3) curriculum and methods of teaching art, 4) policy criticism and feminist issues, 5) student textbooks, 6) art for special populations, and 7) young readers' books on art. In Appendix B, examples of women who have written books related to these topics are listed, following a list of earlier women's publications (before 1960) for art education. These mainstream contributions, in terms of authoring, co-authoring, and editing books, demonstrate the enormous impact that contributions and achievements of women art educators have had on the field. These citations are representative of the contributions of all women who have traveled the mainstream and reached a public audience through hard work, intellectual accomplishments, and personal achievement.

b. MAINSTREAM CONTRIBUTIONS IN NATIONAL LEADERSHIP ROLES

From the time the Art Department of the National Education Association (NEA) was established in 1883, women were involved in its professional activities. The stories of women's contributions to the variety of professional art education organizations that have been active at both local, state, and national levels wait for interested researchers.[27] Women's involvement in the NEA Art Department may suggest further research. Josephine C. Locke of St. Louis was the first woman officer and first secretary of the Art Department. Three years after the organization was established, Mrs. Elizabeth F. Dimmock, Supervisor of Drawing from Chicago, was elected the first woman vice-president. She also presented a paper on Drawing in Primary and Grammar Schools at that 1886 convention. The first woman president of the Art Department was elected in 1891 when Hannah Johnson Carter of New York took office. In the years between 1900 and 1909, most of the group's presidents were women. Following Christine Sullivan (1894) and Harriet C. Magee (1898) were F. E. Ransom (1900), Bonnie E. Snow (1901), Myra Jones (1902), C. A. Wilson (1903), Matilda F. Riley (1905), and Florence E. Ellis (1908). The Art Department merged with the Department of Manual Training in 1910, reflecting a national trend to combine art with industrial arts, home economics, and vocational education. While women served as vice-presidents or secretaries of the reconstructed department, men held the highest office through 1919 when art was dropped from the name of what became the Vocational Education Department.

Many women who contributed to art education during the 1930s were not always art teachers but often general educators or psychologists. The varied interests of art educators during the years of Progressive Education and Depression were reflected in a variety of professional organizations. The NEA voted to establish a new Department of Art Education in July 1933. Although there were Eastern, Southeastern, Pacific, and Western arts associations, a group of art educators headed by Elizabeth Wells Robertson felt the need for a new national group. Robertson, District Supervisor of Art in the Chicago Public Schools, was elected first president of the department. Edna E. Hood of Kenosha, Wisconsin, was secretary, and Marcella Jackson of the State Teachers College at Castleton, Vermont, served as first treasurer. Women dominated the slates of officers in the Department of Art Education, a reflection perhaps of the leadership roles many women exercised in art education prior to the Second World War. Robertson served as president through 1936, followed by Grace M. Baker of Colorado (1936-38), Clara MacGowan of Illinois (1938-1940), Olive S. DeLuce of Missouri (1940-41), Marion E. Miller of Colorado (1942-1945), and Idella R. Church of California (1946-47). Saunders has described the events leading to the merger of the NEA Art Department with the Eastern Arts Association, Western Arts Association, Pacific Arts Association, and Southeastern Arts Association in 1947.[28] Idella

Church, Marion Quin Dix, Olga Schubkegel were active participants in the merger that resulted in creation of the National Art Education Association. Dix served as the first woman president of the NAEA (1953-55) and was also president of the EAA from 1949-50. Gregory has interviewed Dix regarding these and her other contributions to art education.[29] Other women presidents of the NAEA have been: Ruth E. Halvorsen (1961-62), Ruth M. Ebken (1967-69), and Nancy P. MacGregor (1983-85). It is impossible to list all the women who have held national leadership positions in States Assembly and as Regional and Divisional directors. Their numbers over the years have been many, and their achievements and accomplishments have contributed greatly to NAEA successes.

c. THE NAEA WOMEN'S CAUCUS AND THE ADVANCEMENT OF WOMEN IN ART EDUCATION

The Women's Caucus of the National Art Education Association was founded in 1974 at the annual NAEA meeting in Chicago. Frances Heussenstamm and Judy Loeb became co-chairs of this new organization. By-laws, modeled on those of the Women's Caucus for Art, were drafted by Judy Loeb in 1975. In the same year, the Women's Caucus was granted Affiliate group status by the NAEA Board of Directors. An official position statement was unanimously adopted, in 1976, by the Women's Caucus membership. The position statement, coordinated by Sandra Packard, begins:

> The National Art Education Association's Women's Caucus exists to eradicate sexual discrimination in all areas of art education and to support women art educators in their professional endeavors.

This position statement outlines the role of the Women's Caucus under topics of increasing support action on behalf of equity for women, supporting equity for women within the national organization, public advocacy by eliminating sex discrimination and stereotyping in the art education profession, and acting as an educational agent for positive change.

At the NAEA conference in 1975, the Women's Caucus sponsored an invited talk by June K. McFee, "Women: Perspectives and Projections" and an open "rap room" for women was organized. The Women's Caucus began to hold its own program sessions in 1976. Presentations and workshops since that date have focused on building professional goals, teacher survival, strategies for success, issues of status, stereotypes in art, women's history, political and legal issues, women in administration, alternative futures, research about male/female differences in art education, women artists past and present, and many other topics too numerous to list individually. The variety of topics presented reveals the complexity and scope of issues that concern women art educators. A number of papers presented at these sessions were later published, and some of the ideas, information, and experiences that were shared had a great impact on the lives of many of those who attended.

In March 1980, the Women's Caucus convened separately from the national NAEA convention. Choosing not to meet in Georgia, a state that had not ratified the Equal Rights Amendment, the Women's Caucus met at The Ohio State University in Columbus for three days of business meetings, research reports, and other sessions. During that meeting, "Letters in Absentia," in which Women's Caucus members' goals and aspirations were expressed, were addressed to NAEA members. These letters were compiled and distributed at the NAEA meeting in Atlanta, Georgia.

The Women's Caucus publishes a newsletter, *The Report*, in which research articles, funding sources for non-sexist art education, bibliographies on women and on art, book reviews, and speeches by Women's Caucus award winners have appeared along with business policy and membership information. The Women's Caucus has also stimulated involvement at the state and local levels by encouraging each state art association to have an appointed Women's Caucus state representative. This involvement at local and state levels facilitates communication among state representatives about activities, problems, and progress of the Women's Caucus and serves as a means of sponsoring activities, talks, and research papers about women's issues in the local "grass roots" arena. The Women's Caucus also has a number of task forces that study such concerns as advocacy, information/education/research, and resource development. The task forces meet regularly and report and publish their analyses and recommendations in *The Report*.

Editors of NAEA publications have been encouraged by the Women's Caucus leadership to use nonsexist language and to publish articles and sponsor special journal issues about nonsexist art education. Due to the efforts of the Women's Caucus leadership, in 1974, *Art Education* (December, 1974) devoted several pages to viewpoints of women art educators. Career education, employment practices, professional achievement, and social conditions in academic life, and discrimination were among topics discussed. The next year, an entire issue of *Art Education* (November, 1976), edited by Bette Acuff, was devoted to an exploration of the roles and problems of women in art education. In 1977, an entire issue of *Studies in Art Education* (Winter, 1977), edited by Sandra Packard and Enid Zimmerman, was devoted to research about sex differences as they relate to art education.

The Women's Caucus presents two awards at each national meeting. These awards are named for two outstanding women art educators, June King McFee and Mary Jane Rouse. The June King McFee Award is given in recognition of outstanding service to art education. The ten past winners of this award include:
- June King McFee (1975)
- Mary J. Rouse (1976)
- Eugenia M. Oole (1977)
- Laura H. Chapman (1978)
- Ruth Freyberger (1979)
- Joan Adams Mondale (1979)

- Helen Patton (1980)
- Marylou Kuhn (1981)
- Hilda Present Lewis (1982)
- Jessie Lovano-Kerr (1983)

The Mary J. Rouse Award is given in recognition of the young or early professional. The five winners of the award have been:

- Mary Ann Suggs (1979)
- Marion Jefferson (1980)
- Phillip C. Dunn (1981)
- Beverly J. Jones (1982)
- George Geahigan (1983)

In the brief time since its inception, the Women's Caucus has worked diligently to improve the status of women in art education. There have been many women who have played vital leadership roles within the Women's Caucus. At national, state, and local levels there have been a dedicated group of men and women working to achieve recognition and sex-equity for women art educators through Women's Caucus activities. Space does not allow a complete list of contributors, therefore the following list of presidents of the Women's Caucus will serve to represent all those who have dedicated extensive time and energy to this organization:

- Judy Loeb (1975-76)
- Sandra Packard (1976-78)
- Marylou Kuhn (1978-79)
- Rogena Degge (1979-80)
- Enid Zimmerman (1980-81)
- Ann Sherman (1981-83)
- Renee Sandell (1983-84)

d. MAINSTREAM CONTRIBUTIONS TO NAEA JOURNALS

Since 1974, the year of the founding of the Women's Caucus, women art educators have made great strides in achieving recognition in research at the national level. Thirty-six percent of the articles published in *Studies in Art Education,* from its inception in 1959 to 1983, have been authored or co-authored by women. Until 1974, only 21% of all articles in *Studies* were authored or co-authored by women: since 1974, about 50% of the articles in *Studies* have been authored or co-authored by women, indicating the growing contribution of women to research and issues in art education. There have been 14 editors of *Studies,* six of whom have been women. The women editors of *Studies* include:

- June King McFee (1966-69)
- Mary J. Rouse (1970-73)
- Marylou Kuhn (1973-75)
- Laura H. Chapman (1977-79)
- Sandra P. Packard (1979-81)
- Jean C. Rush (1983-85)

e. OTHER MAINSTREAM CONTRIBUTIONS OF WOMEN TO NAEA

There have been many more men than women who have been keynote speakers at NAEA General Sessions at national conventions, but since 1974, the year of the founding of the Women's Caucus, a number of distinguished women have delivered keynote addresses. Among these women have been artists Judy Chicago and Alice Neel, art educators Hilda Lewis and Laura Chapman, and philosopher of education Maxine Greene.

Each year NAEA offers a number of awards for scholarship, leadership, and service to the field of art education. It would be impossible to name all the women who have won national awards in these categories over the years; therefore only one award will be noted and women who won this award will be listed.

The Manuel Barkan Memorial Award, established in 1970 and administered by the NAEA, is given yearly for published work in either *Art Education* or *Studies in Art Education* that has contributed scholarly merit to the field. There have been 14 past recipients of the Manuel Barkan Award; four of these have been women. They are:

- Merle Flannery (1973)
- Enid Zimmerman (with Gilbert Clark) (1978)
- Marjorie Wilson (with Brent Wilson) (1980)
- Hermine Feinstein (1983)

Another national award, the Marion Quin Dix Leadership Award, established in 1983, was named for the first woman president of NAEA. The first winner of this award was George Trogler. The NAEA (1983) has produced cassette tapes by prominent art educators who share their thoughts about art education. Laura Chapman and June King McFee are two of the five art educators included on these tapes; the others are Elliot W. Eisner, Lambert Brittain, and Edmund B. Feldman. These tapes reinforce the notion that women art educators recently have made great strides in gaining recognition in the national arena.

It has been impossible to mention all the women art educators, in various roles, who have made contributions in the mainstream tradition. This chapter is a beginning, an introduction to the mainstream and hiddenstream contributions of women art educators. It is by no means an attempt at a comprehensive treatment of women's achievements in art education.

C. WOMEN ART EDUCATORS IN THE HIDDENSTREAM

1. Contributing Factors

Some women art educators are part of the hiddenstream because they do not seek or receive public recognition; others are part of the hiddenstream because they work in a non-traditional form of art education. One such non-traditional form would be "feminine" arts and crafts. Lippard has examined the status of women's hobby art, pointing out that within the craft world there are high status and low status

forms.[30] Often, the high status forms are created by men and most near-ly approximate forms recognized as high or fine art. Low status forms include crafts using feathers, natural materials, or household discards. Such crafts are taught through women's magazines and local craft groups. Often they find their way into the elementary school art room as holiday art projects. Although such projects have long been decried by mainstream art educators, any visit to a public school would show how pervasive they are. Without discussing the art education value of such crafts, we must recognize that they do exist and represent one type of feminine contribution to art education, often left in the back hall of culture.

2. Hiddenstream Achievements in the Past: Tendencies and Examples

When histories of art education define the field only in terms of public school drawing instruction and its direct descendents, many women art educators enter the hidden tributaries of art education. In the past, some women art educators have been virtually ignored because their contributions were, for the most part, made outside public school teaching. Feminist history and criticism is one means to help art educators re-examine the assumed mainstream, to explore and map the tributaries that eventually flow into the broad river of art teaching and learning. Hiddenstream art educators include women whose con-tributions are well known at local or state levels but whose work has not been documented in written or oral sources available to scholars. They might include women who are merely mentioned in passing in conference records or organizational and institutional histories and then disappear from public view. They might include a class of women or an ethnic group, such as the American Indian women art educators described by Zastrow.[31] Hiddenstream women art educators also in-clude the authors of craft books and articles, media advisors on good taste in home furnishings, clothings, or make-up colors, and teachers of needlework or china painting.

An example of an art educator who worked in the mainstream of her day but who nearly disappeared from written history is Louisa Minot. Saunders has described his search for this elusive lady whose contributions in teaching and writing manuals were overshadowed by those of her illustrious publisher, Elizabeth Peabody.[32] Erickson presented another hiddenstream woman, Alice Robinson of The Ohio State University as an example of how one woman's professional self-image as woman and artist might have contributed to the continuing split between research and teaching in the field.[33] Hagaman has presented research about Mary Huntoon (1896-1970) both a pioneer-ing art educator and art therapist in Topeka, Kansas.[34] Stankiewicz has examined the possibility that the "Alice Robinson" model may have prevailed at other institutions as well.[35] At Syracuse University, art teacher preparation was dominated by women from its official incep-tion in 1900. Women such as Mary Ketcham, Rilla Jackman, and

Catharine Condon led productive professional lives at Syracuse, but they and their programs remained in a quiet eddy of art education.

Careful examination of the principal primary sources for the history of art education can reveal other women, for example, Adeline Valentine Pond, teacher and later director of drawing in the Newton, Massachusetts, Public Schools. Pond floats through the pages of Clarke's massive study of industrial art education.[36] Pond's paper, "Influence of the Study of Drawing in the Development of Character," presented to the Massachusetts Industrial Art Teachers' Association at its 1884 meeting was voted worthy of publication and was reprinted by Clarke. Another paper on art galleries and museums of Paris, delivered in 1889 in Boston, was also included by Clarke. What other papers, if any, did Miss Pond write? What effects did her teaching leave on the children of Newton? The story of Adeline Pond remains to be told. Stankiewicz has discussed reference materials useful in researching women art educators of the past.[37]

Women who are part of the hiddenstream by the nature of their work in low-status arts and crafts may be well known for work in other areas. Catharine Beecher (1800-1878), daughter of Connecticut minister Lyman Beecher and older sister of Harriet Beecher Stowe, was typical of many young women in their early twenties when she left home to teach drawing and other subjects.[38] Beecher later established the New Haven Female Seminary, an influential example of feminine education, which included fine needlework, drawing, perspective, and the painting of landscapes, figures, and flowers on velvet.[39] While Beecher's major contribution to women's education was her advocacy of schooling to prepare women for roles as housewives and mothers, she also contributed to the aesthetic education of American women by suggesting ways to beautify the home. A glance at Beecher and Stowe's *The American Women's Home* (1869), with its chapter on Home Decoration, reveals a forerunner of such books as Harriet and Vetta Goldstein's *Art in Everyday Life* (1925), a popular art appreciation text during the 1930s and 1940s. Beecher and Stowe suggested ways to furnish a parlor with good taste and a limited budget. They suggested color schemes and chromolithographs to be purchased, framed, and hung on the walls as an educative influence on the children of the house. Goldstein and Goldstein's discussions of art principles liberally illustrated by examples of home furnishings and clothing styles is part of art education's concern for the cultivation of good taste. Before Beecher and Stowe published *The American Women's Home*, Madame Levina Buoncuore Urbino edited a how-to book for art and crafts. Unlike Dwight's *Introduction to the Study of Art* (1856) which offered a serious sequential discussion of art principles, Urbino's *Art Recreations* (1864) was directed at amateurs who wanted directions for specific crafts such as papier mache, leather work, waxwork flowers and fruit, and ornaments made from plaster of paris, seaweed, moss, hair, feathers, cones, shells, or seeds. The book did include simple principles of drawing and directions for painting in oils or watercolor, Grecian painting (on the back of varnished engravings), Oriental painting

(on glass with foil), and others. This book fits into the literature of art education in a place somewhere between Elizabeth Smith's cookery book and the craft books that can be found in any contemporary bookstore.[40]

3. Contemporary Hiddenstream Contributions

Mainstream contributions by contemporary women art educators who write books and journal articles and assume leadership roles at the national level are easier to research and document than hiddenstream contributors. Today many women art educators are not known nationally for their acheivements in the field, but rather to a few select people who are interested in specific areas of study or who are acquainted with contributions at the local or state level.

a. CURRICULUM MATERIALS

Women art educators are often involved in developing art curriculum materials, but their efforts may go unnoticed because they are part of a team of developers and writers whose efforts are not individually or publicly acknowledged. Carmen Armstrong is one example of an art curriculum designer who has developed a set of materials for public distribution. Her program, *PAC* (Planning Art Curriculum, ABAFA Systems, DeKalb, Illinois), is a curriculum aid for K-8 teachers; it consists of a guide book and 400 cards that, when combined according to a system, form an art curriculum for the school year.

b. INSTRUCTIONAL FILM AND SLIDE MEDIA

Producers and distributors of filmstrips, slide sets, and films designed for the field of art education do not often acknowledge the people who developed these resources. Sandak, Inc., Stamford, Connecticut, does advertise that Jerome Hausman and Flora Hausman are the developers of a teacher's guide and 35 film strips that use works of art to form a total art curriculum. The film company, ACI Films, Inc., New York, advertises three films by women filmmakers in their *A Focus on Curriculum: Art and Humanities* series. *Weaving with Looms You Can Make* and *With Fabric and Thread* are both by Nancy Belfer, and *Discovering the Arts of Bali* is by Diana Colson. The Women's Movement has inspired many women to produce, write, and direct films and create other related art education materials. For example, *Killing Us Softly: Advertising's Image of Women* (Cambridge, Documentary Films, Inc., Cambridge, Massachusetts) and *The Naked Truth: Advertising Image of Women* (Lordly and Dune, Inc., Boston, Massachusetts) are two films based on multi-media presentations created by Jean Kilbourne. Through the Flower (Santa Monica, California) is a non-profit feminist organization dedicated to social change through art and art education. This organization distributes slide sets, films, post cards, lithographs, and books all by women artists. Dotty Mandlin (Mandlin Films, New York) is an independent filmmaker and art educator who has made a number of films that focus on teaching the art elements to young children.

c. MUSEUM ART EDUCATION MATERIALS

Many museums sponsor art education programs and receive grants, or are funded in other ways, to produce a variety of educational materials. Women art educators are often involved in designing these programs, working with local school children in museum settings, and creating and distributing educational materials at local and state levels. Some examples of educational materials designed by museum educators are:

> Ann Bay, *Museum Programs for Young People* (Washington, D.C.: Smithsonian Institution, 1973).
> Eleanor Lazarus, ed., *Project Art Band: A Program for Visually Gifted Children* (Lincoln, Mass.: DeCordova Museum, 1982).
> Becky Reese, Susan Mayer, Margaret Blagg, Kim Williams, and Donna Vliet, *Art Enrichment: How to Implement a Museum/School Program* (Austin, Texas: University Publication, The University of Texas at Austin, 1980).

d. OTHER KINDS OF CONTRIBUTIONS

Often a job description does not fully describe the contribution that a person makes to a particular field. For example, Beverly Jeanne Davis has been managing editor of the *NAEA News* and *Art Education* for a great number of years. Her behind-the-scenes decisions and her thoughtful comments in her monthly column, *Fragments of Thought by the Managing Editor,* attest to her important contribution to the field of art education.

e. SOME REPRESENTATIVE PROFILES AND PROTOTYPES

In a 1982 issue of the *NAEA News* Renee Sandell and Georgia Collins solicited information from NAEA members about outstanding achievements by women that have made a lasting impact on the field of art education. While a few nomination forms contained information about well-known women art educators, most were about women art educators who worked in a variety of educational settings, assumed leadership roles, produced art works and/or educational materials that might not be well known to the general art education audience, and who have received recognition for their efforts mostly at local and state levels. The short resumes about the contributions of the following six women art educators who were nominated are representative of many hiddenstream women who have contributed time, energy, creative thinking, and leadership to the field of art education. In several cases, their contributions overlap into the mainsteam.

June E. Baskin is art supervisor, Williamsport School District, Williamsport, Pennsylvania. She has developed an Idea Process and Skills Shop located at the Lycoming County Historical Museum. This Skills Shop evolved from art workshops held for all teachers in the Williamsport Area school district. The Skills Shop helps teachers make instructional games and other teaching materials they can use in their classrooms. Teachers who attend workshops and make projects receive in-service credits and credit toward teacher certification. The Skills Shop

is funded under Title III of the Elementary and Secondary Education Act and received nationwide attention when it was featured with eight other arts projects in the *Title III Quarterly*.

Sylvia Corwin is Assistant Principal/Supervison Department of Fine Art, John F. Kennedy High School in the Bronx, New York. She is developer and demonstrator of Reading Improvement Through Art (New York State Education Department) in which students who are at least two grade levels below the norm in reading use a variety of visual arts materials that motivate and stimulate reading. Corwin is author of a teacher's manual and sound filmstrip, *Your Portfolio Speaks to You* (Son-A-Vision, New York). In this filmstrip, students are introduced to the field of graphic art and details of preparing a school and professional portfolio are explained. She is also author to the *Meet the Artist* series, *America in Art* series, and *American Revolution: History Through Art*, all filmstrips produced by Miller-Brody Productions, Random House. Corwin has held numerous leadership roles including President of New York City Art Teachers Association (section 8) and has won a number of awards including the NAEA Eastern Regional Secondary Award.

Francis D. Hine is a retired art education consultant for the Los Angeles County Schools, a position she held for over 35 years. She has received a number of government grants and is author of the final reports of the *Aesthetic Eye Project* and *Visual Awareness Project*. Hine has conducted inservice workshops in aesthetic education for public school teachers, museum educators, community workers, and school administrators. She has written a number of articles and guides focusing on curriculum planning in the public schools. She has been a supporter of art in the public schools and has assumed a number of leadership roles in state organizations.

Christine Joy Koczwara (Trella) is associate professor of art and art education, Tennessee Technological University, Cookeville, Tennessee. She is a professional artist who is a representative of Grumbacher, Inc., and lectures and gives painting demonstrations to schools around the country. She also teaches elementary art education methods classes and has videotaped a television series, *Painting with Trella* that focuses on painting instruction and demonstration. As a professional United States Navy combat artist, she was the first woman combat artist in Vietnam. Among her assignments was the launch of Apollo 7 space flight at Cape Kennedy. She has won over 30 prizes for her art work, including a trip to Europe.

Betty La Duke is professor of art, Southern Oregon State College, Ashland, Oregon. She has travelled to remote villages in China, India, Southeast Asia, Melanesia, and Latin America to document, through sketchbooks and journals, women's art in third world cultures. She writes about women's changing roles and responsibilities in their societies. La Duke interviews, photographs, and makes sketches of women in their home or studio environments. She is most interested in educating the public about the contribution of women's art in these countries. She is author of *Mexico: A Sketchbook Journey of Easter* (Print

Impressions, 1980) and has organized a traveling exhibit, *Latin American Women as Artists and Artisans.* She has given lectures nationally and internationally about third world women and their art work and has written a number of articles about this topic.

Penny Platt is an award-winning artist who has exhibited at the Baltimore Museum, Corcoran Gallery of Art, and the Smithsonian. She has been an elementary art teacher in Washington, D.C., for 22 years and is the author of an art-oriented reading program *The Early Reading Program* (Addison-Wesley Publishing Co., Menlo Park, California, 1973). This program consists of seven volumes for kindergarten, first and second grades and is based on the theory that words which correspond to the predictable images that young children draw, such as a sun, sky, tree, grass, and bird should become their first reading and writing words. Platt's four years of tested research on cognitive uses of drawing confirms that in the early years drawing is most beneficial when used as preparation for the symbol-making processes of writing, reading, thinking, and even speaking. The concept that drawing be used in the early grades to help young children make the transition from visual to verbal modes of expression has been more enthusiastically received by reading educators than art educators.

D. WOMEN ART EDUCATORS AND FUTURE ACHIEVEMENTS

While it is impossible to predict the extent and kind of achievements women art educators will attain in the future, the current image of women art educators as an actively growing force, both individually and collectively, is an extremely positive sign. Our review of women art educators' achievements and our attempt to recognize some of the countless female contributors to the field from the past through the present, is offered to balance the sketchy and somewhat obscure treatment of women in much historical literature. We hope that this chapter will inspire others to do research about women's contributions to art education. It is not only likely that female participation in and contributions to art education will increase, but also that increased visibility through systems for support and recognition will continue to break down barriers of overt and covert sexism in our field and our society. Our awareness of the female heritage in art education, both mainstream and hiddenstream traditions, enriches our knowledge and, in turn, influences art education. More importantly, it provides positive, diverse role models which can instill personal and professional pride to motivate future achievements of women in art education.

It is the authors' premise that an awareness of the past will help in understanding how the roles of women art educators have sometimes been different from, but no less important than, those of their male counterparts. Once there is recognition of how women have contributed to the field, it is possible that all art educators' conceptions of their field will be changed so that new concepts, based on equality, will predominate.

NOTES AND REFERENCES

[1] See Frederick M. Logan, *Growth of Art in American Schools* (New York: Harper & Brothers, 1955); Harry Beck Green, "The Introduction of Art as a General Education Subject in American Schools" (Ed.D. dissertation, Stanford University, 1948); Elliot W. Eisner and David W. Ecker, "What is Art Education?", Introduction to *Readings in Art Education* (Waltham: Blaisdell Publishing Company, 1966), pp. 1-27; *The Encyclopedia of Education*, s. v. "Art Education: History," by Robert J. Saunders, Foster Wygant, *Art in American Schools in the Nineteenth Century* (Cincinnati: Interwood Press, 1983) does discuss contributions of Elizabeth Peabody, Mary Peabody Mann, Mary Hicks Prang, and other women.

[2] See Elliot W. Eisner, *Educating Artistic Vision* (New York: Macmillan Publishing Co., Inc., 1972) pp. 29-64; and Laura H. Chapman, *Approaches to Art in Education* (New York: Harcourt Brace Jovanovich, Inc., 1978), pp. 5-17.

[3] Mary Erickson, "An Historical Explanation of the Schism between Research and Practice in Art Education," *Studies in Art Education* 20 (1979): 5-13; Sandra Packard, "Jane Addams: Contributions and Solutions for Art Education," *Art Education* 29 (January 1976): 9-12.

[4] Enid Zimmerman and Mary Ann Stankiewicz, eds., *Women Art Educators* (Bloomington, IN: Mary Rouse Memorial Fund, 1982).

[5] Mary Ann Stankiewicz, "'The Creative Sister': An Historical Look at Women, the Arts, and Higher Education," *Studies in Art Education* 24 (1982): 48-56; also, "Rilla Jackman, Pioneer at Syracuse," *Art Education* 36 (January 1983): 13-15.

[6] Peter J. Smith, "Before Lowenfeld: Five Women of Power in Art Education," unpublished paper presented at the National Art Education Association Conference, New York City, 5 April, 1982; Gordon Plummer, "The History of Women in Art Education," unpublished paper presented at the National Art Education Association Women's Caucus, St. Louis, April, 1976; Robert J. Saunders, "Women in the Field of Art Education before 1900," unpublished paper presented at the National Art Education Association Women's Caucus, St. Louis, April, 1976.

[7] Laura H. Chapman, "Leadership and the Question of Professional Identity in Art Education: Some Personal Reservations," NAEA Women's Caucus *The Report* 13 (Fall 1979): 8.

[8] Statistics gathered for a federal report on manual arts education, including art education, show that in 1906-07 salaries were higher in institutions that employed more male instructors. In public high schools, private high schools, and women's colleges, all of which employed more female than male arts teachers, the average salary was under $2,000. Manual and industrial training schools, co-educational and men's colleges not only employed predominantly male instructors, but the average salary was over $11,000. U.S., Bureau of Education, *Instruction in Fine and Manual Arts in the United States*, ed. by Henry Turner Bailey, Statistical Monograph, Forming Bulletin VI (Washington, D.C.: Government Printing Office, 1909), pp. 98-159.

[9] See Claire Richter Sherman with Adele H. Holcomb, *Women as Interpreters of the Visual Arts, 1820-1979* (Westport, CT: Greenwood Press, 1981).

[10] The third Peabody sister, Sophia Peabody Hawthorne (1809-1871), is recognized as a competent painter whose life as an artist fell between amateur and the professional. See Josephine Withers, "Artistic Women and Women Artists," *Art Journal* 35 (Summer 1976): 330-336.

[11] Saunders, "Art Education: History," p. 284.

[12] Elizabeth P. Peabody, "A Plea for Froebel's [sic] Kindergarten, As the First Grade of Primary Education," in *Art and Industry. Education in the Industrial and Fine Arts in the United States. Part II.—Industrial and Manual Training in Public Schools*, by Issac Edwards Clarke (Washington, D.C.: Government Printing Office, 1892), pp. 658-662.

[13] Issac Edwards Clarke, *Art and Industry. Education in the Industrial and Fine Arts in the United States. Part I.—Drawing in Public Schools* (Washington, D.C.: Government Printing Office, 1885), p. 431.

14 "Instruction in Drawing," (Barnard's) *American Journal of Education* 4 (September 1857): 229-232.

15 Biographical information on Mary Hicks Prang is based on Frances E. Willard and Mary A. Livermore, eds., *A Woman of the Century* (Buffalo: Charles Wells Moulton, 1893; reprint ed., Detroit: Gale Research Co., 1976), pp. 377-378; Julia Ward Howe, ed., *Representative Women of New England* (Boston: New England Historical Pub. Co., 1904), pp. 40-43; and Edward T. James, ed, *Notable American Women 1607-1950*, vol. III (Cambridge, MA: The Belknap Press of Harvard University Press, 1971), pp. 92-93. The first entry above is under Hicks, the two late entries under Prang, illustrating one common problem for the researcher; women often change their names upon marriage.

16 Thomas Woody, *A History of Women's Education in the United States*, vol. 2 (New York: Science Press, 1929), pp. 76-77.

17 James, *Notable American Women*, 3, pp. 235-236. Biographical information on Sartain can also be found in John F. Ohles, ed., *Biographical Dictionary of American Educators*, vol. 3 (Westport, CT: Greenwood Press, 1978), pp. 1148-1149.

18 Jane Addams, "The Art-Work Done by Hull House, Chicago," *The Forum* 19 (July 1895), p. 614.

19 See Laurie Lisle, *Portrait of an Artist, A Biography of Georgia O'Keeffe* (New York: Washington Square Press, Pocket Books, 1980).

20 Both Smith, "Five Women" and Enid Zimmerman, "Belle Boas: Her Kindly Spirit Touched All," in Zimmerman and Stankiewicz, *Women Art Educators*, discuss probable cross influences between George and Belle Boas.

21 There is little available biographical information on Mathias as Smith, "Five Women," has shown. Both Mathias and Tannahill are thus mainstream in their contributions to art education but hiddenstream in personal recognition.

22 Arthur D. Efland, "Conceptions of Teaching in Art Education," *Art Education* 32 (April 1979): 21-33.

23 Shawn G. Kennedy, "Margaret Naumberg, Walden School Founder, Dies," *The New York Times*, 6 March 1983, p. 44.

24 Cay Drachnik, "A Historical Relationship between Art Therapy and Art Education and the Possibilities for Future Integration," *Art Education* 29 (November 1976), pp. 16-19.

25 Smith, "Five Women."

26 *Ibid*.

27 The history of at least one state art education association has been written and published; see Ross A. Norris and Mary Ann Stankiewicz, "A Brief History of the Ohio Art Education Association," *OAEA Journal* 17 (1978): 8-21. Material on the role of women in the Art Departments of the NEA can be found in *Journal of Proceedings and Addresses of the National Education Association Annual Meeting*, published by the Association annually since 1884.

28 See Robert J. Saunders, "NAEA: An Excursion into the Past," *Art Education* 19 (January 1966): 21-29.

29 Anne Gregory, "People Make Traditions: An Interview with Marion Quin Dix," *Art Education* 35 (January 1982): 16-21; see also Gregory, "Marion Quin Dix: A People Picker and an Innovator in American Art Education," and Jerome J. Hausman, "Marion Quin Dix: Facilitator, Helper, Colleague and Friend," both in Zimmerman and Stankiewicz, *Women Art Educators*.

30 Lucy R. Lippard, "Making Something from Nothing," *Herersies*, Winter 1978 pp. 62-65.

31 Leona M. Zastrow, "American Indian Women as Art Educators," in Zimmerman and Stankiewicz, *Women Art Educators*.

32 Robert J. Saunders, "The Search for Mrs. Minot: An Essay on the Caprices of Historical Research," *Studies in Art Education* 6 (Autumn 1964): 1-7.

33 Erickson, "An Historical Explanation."

34 Sally Hagaman, "A Case Study of Mary Huntoon—Artist, Teacher, Art Therapist," paper presented at the National Art Education Association Conference, Detroit, 25 March 1983.

35 Mary Ann Stankiewicz, "Woman, Artist, Art Educator: Professional Image among

Women Art Educators," in Zimmerman and Stankiewicz, *Women Art Educators.*

[36] *See Clarke, Art and Industry,* Part II, pp. 1261ff and 1271ff.

[37] Mary Ann Stankiewicz, "Searching for Women Art Educators of the Past," in Zimmerman and Stankiewicz, *Women Art Educators.*

[38] For a biography of C. Beecher see Kathryn Kish Sklar, *Catharine Beecher, A Study in American Domesticity* (New Haven and London: Yale University Press, 1973).

[39] For a prospectus for the New Haven Female Seminary, see Vera M. Butler, *Education as Revealed by New England Newspapers Prior to 1850* (New York: Arno Press & the New York Times, 1969), p. 187.

[40] For the cookery book as a source for history of art education see Michael Steveni, "The Roots of Art Education: Literature Sources," *Journal of Aesthetic Education* 15 (January 1981): 83-92.

SECTION IV.

Matters of Research and Vision

PURPOSE: To increase awareness, promote understanding, and encourage further inquiry into art related sex equity *goals* by exploring sex difference research and alternative approaches and models for sex equity in art and art education.

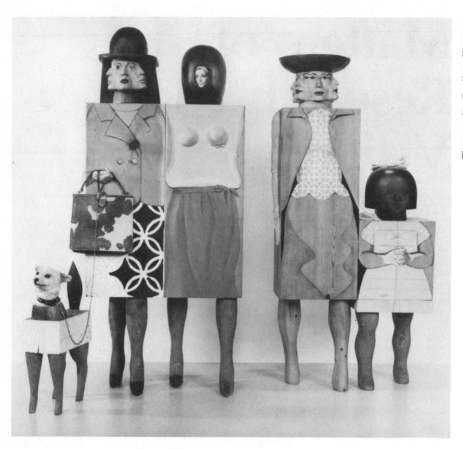

Marisol. *Women and Dog*. 1964. Fur, leather, plaster, synthetic polymer, wood. 72''
× 82″ × 16″. Collection of the Whitney Museum of American Art. Gift of the Friends
of the Whitney Museum of American Art. Acq. #64.17.

CHAPTER 7:

Sex Differences and Research Relevant to Art Education

Many popular beliefs about the psychological characteristics of the two sexes have little or no basis in fact. Yet people continue to believe, for example, that girls are more "social" than boys, or are more suggestible than boys, ignoring the fact that careful observation and measurement show no sex differences.

—Eleanor Maccoby and Carol N. Jacklin (1974)

. . . we need a new standard of pyschological health for the sexes, one that removes the burden of stereotype and allows people to feel free to express the best traits of men and women . . . freeing people from rigid sex roles and allowing them to be androgynous (from "andro," male and "gyne," female) should make them more flexible in meeting new situations, and less restricted in what they can do and how they can express themselves.

—Sandra Lipsitz Bem (1975)

A. INTRODUCTION

The purpose of this chapter is to review and interpret research on sex differences relevant to art education. The chapter begins with an introduction to general issues which underlie sex difference research. Are sex differences the result of heredity or environmental influences? How do various psychological models account for the presence of sex differences? Are sex differences caused, for example, by early psychosexual conflicts with parents, by behavioral conditions, or by children's own self-categorization of sex-role attributes?

After a brief introduction to these issues and models, sex difference research relevant to all curricular areas in education is briefly reviewed. How might teachers, curricular materials, and the hidden curriculum

influence sex differences? By bringing these areas to the fore, we are reminded of the many facets of schooling which must be addressed in promoting sex equity.

The bulk of the chapter is devoted to reviewing general psychological research pertinent to art education and research on sex differences in drawing, artistic preferences, and employment. Given the great volume of sex difference research which has developed in the last decade, the review is necessarily limited, and the reader is encouraged to consult Appendix C (Questions That Those Concerned with Non-Sexist Art Education Should Ask) for further leads and references.

The conclusion includes cautions which should be observed when examining sex difference research and a discussion of research areas which need further investigation.

B. SEX DIFFERENTIATION

1. Sex and Gender

While there are obvious biological differences between men and women, we tend to refer to the sexes as "opposite rather than different."[1] The opposites referred to are usually not biological differences but differences in characteristics such as aggression and mechanical aptitude. Thus, it may be useful to differentiate between the concepts of sex and gender since sex, an ascribed status, refers to the biological aspects of a person, while gender, an achieved status, refers to psychological, social, and cultural characteristics. This distinction can remind us that:

> People learn what behaviors and attitudes they should have according to their label—male or female. Further, when a male is acting in culturally condoned gender-appropriate ways, he is viewed as masculine and when a female is acting in gender-appropriate ways, she is seen as feminine.[2]

It is our contention that gender-role socialization often inhibits the opportunity for individuals of both sexes to develop to their full potential.

2. Sex Stereotypes

The expectations, rituals, and myths pertaining to the "woman's role" or the "man's role" are pervasive, yet they ignore the individual person's talents and capabilities. Stereotyped characteristics of the male include: independent, objective, active, competitive, logical, worldly, decisive, self-confident, and capable of leadership. Stereotyped traits of the female involve the absence of these characteristics: dependent, subjective, passive, noncompetitive, and illogical. Positively valued traits for the female center around warmth and expressiveness.[3] We call these characteristics stereotypes for it has yet to be shown that these are inherently attributes of a particular sex. Yet, they continue to influence even clinicians' judgments of mental health.[4]

3. Nature-Nurture

Kagan has suggested that some early sex differences "may be biological in origin and lead to slightly different developmental routes for boys and girls".[5] He adds, however, that "these differences are subtle, not blatant, and the environment has the power to modify them".[6] Kagan's statements reveal the "nature-nurture" controversy—the debate over whether sex differences are biologically or environmentally determined.

Research on sex differences in intellectual and creative abilities has, for the most part, contradicted strongly-held beliefs that female inferiority in these realms is biologically based. For example, after reviewing hundreds of sex difference studies on children, Maccoby and Jacklin found only a few differences in childhood behavior: males tended to be more aggressive and superior at spatial and mathematical tasks while girls showed earlier verbal facility.[7] They found no general difference between the sexes in intelligence, as measured by tests of motor skills, perceptual performance, and reasoning patterns. Maccoby and Jacklin conclude that:

> many popular beliefs about the psychological characteristics of the two sexes have little or no basis in fact. Yet people continue to believe, for example, that girls are more 'social' than boys, or suggestible than boys, ignoring the fact that careful observation and measurement show no sex differences.[8]

Although sex-role attitudes influence cognitive functioning, cognitively, males and females of all ages are extremely similar.[9]

4. Differences in Achievement

Children of both sexes know their gender label by age three.[10] By the pre-school years, children know the behavior patterns, play preferences, and psychological characteristics expected of them in terms of their sex recognition.[11] As children mature, they act in sex-typed ways which affect their achievement patterns. It is in this area of achievement that we find apparent differences between the sexes.

Research shows that even the brightest women often fail to live up to their intellectual potential and that even those who pursue professional careers rarely achieve eminence.[12] Research on the expectations and motivation needed for a career as an artist has also show sex differences. Barron found that college aged women art students "are less likely to display a single-mindedness in their commitment to art. Their concerns are more diffuse, encompassing a variety of considerations and covering broader areas of life".[13] Horner characterizes bright women as caught in a 'double bind.'[14] They desire intellectual achievement but also fear the loss of femininity and the social rejection that may accompany such achievement. Thus, Horner concludes, women are motivated to avoid success. Horner's conclusion is supported by Torrence's study which found that girls' expectations of success are less than their actual achievements and that both sexes judged boys to do better on achievement tasks.[15]

Yet, these studies do not mean that girls are less motivated to achieve—only that they publicly report less achievement motivation. As Maccoby and Jacklin point out "when researchers observe behavior that denotes a motive to achieve, they find no sex differences or find girls to be superior".[16] They stress that boys' achievement motivation appears more responsive to competitive arousal but this does not mean that boys have generally higher level of achievement motivation. Once again, it appears to be gender-appropriateness which is influencing sex differences.

C. EXPLANATIONS OF SEX DIFFERENCES

1. Theories

There are several theories which attempt to explain sex differences. These theoretical views are important to examine since "believing the tenets of any one system prescribes the types of interactions with children that could encourage or inhibit sex-role stereotyping".[17] Three major psychological theories have been used to explain sex-differentiation. They are the psychoanalytic, behavioral, and cognitive views and, although many researchers adopt a combination of these views, roughly separating them will enable us to see their particular strengths and weaknesses.

a. PSYCHOANALYTIC

The psychoanalytic model views sex-role identity as evolving from the conflicts and resolutions experienced in the five stages of psycho-sexual development (oral, anal, phallic, latency, and genital). The young child initially identifies with the mother (or primary caretaker). The girl's identification with the mother is reinforced because of their similar physical makeup, but the closeness is tempered by the girl's blaming the mother for her 'inadequate' physique. The boy gives up his initial identification with the mother because of the recognized dissimilarity in physique. The boy's closeness with the mother is further destroyed by his fear that the father will punish him if he pursues positive closeness with the mother. The boy's identification and closeness with the father is reinforced out of fear and is tinged with competiveness. These sex-role conflicts are viewed as occurring during the phallic stage (4-6 years of age). Sex-role identity issues are thought to surface again in the genital stage (around 12 years of age) and to be dependent upon the previous experiences in the phallic stage. The psychoanalytic model, dependent upon the biological determination of the child (Freud's "anatomy is destiny"), contrasts with the other two models.

b. BEHAVIORAL

The behavioral model holds that girls and boys are differentially rewarded and punished for certain behaviors. Parents, teachers, and other agents with whom the child is in contact, condition the child ac-

cording to certain values. Research on parental expectations has consistently shown that: "The concept of masculine and feminine characteristics is fixed in the parent's mind, the actual child behaviors are compared with those of ideal sex-role models".[18] The behavioral models sees these ideas as influencing children's behavior through systems of reward and punishment carried out by parents and other socializing agents.

c. COGNITION

Unlike the behavioral model, the cognitive view maintains that sex-role identity is as much a part of internal cognitive development as it is external systems of reward and punishment. For example, Kohlberg states that children's gender identity and sexuality are not directly taught by agents of socialization, but rather children categorize themselves as male or female.[19] This self-categorization accompanies the process of language acquisition and occurs between the ages of eighteen months and three years. After self-categorization, the child similarly proceeds to categorize the rest of the world by sex. This cognitive process is reinforced through sex-typed messages received from the environment, but the process is dependent upon the child's cognitive framework.

2. Influential Factors

None of these models can wholly account for the acquisition of sex-role stereotypes, but the mechansims that they each promote (identification, reinforcement, and cognitive development) all contribute to the process of learning and accepting sex-typed roles. Research on the possible influence of parents, objects, and school on sex role acquisition is voluminous, yet, the research does not indicate how these influences interact. For example, Maccoby and Jacklin found that parents generally treat both sexes similarly;[20] however, parents tend to give more directive responses to boys than girls. Parents also communicate gender appropriateness through the giving of sex-typed toys (e.g., dolls for girls and guns for boys) and show intolerance for activities and behaviors deemed as gender inappropriate.[21] Likewise, children's picture books show males as more prominent and active and place male and female adults in sex-typed roles.[22] Whether these influences are strictly behavioral conditioners or interact with other cognitive and identification factors has yet to be determined.

D. GENERAL SEX DIFFERENCES RELATED TO SCHOOL EXPERIENCE

1. The Cost of Sex Bias

Despite the progress in sex equity advanced by federally mandated Title IX, boys and girls continue to receive differential treatment in schools. A "report card" created by Sadker and Sadker discloses

gender related realities and the cost of sex bias in schools across the country.[23] It highlights research findings related to sex differences and sex discrimination in order to build educators' awareness of the detrimental affects of sex bias. The *Report Card*, included here as Table 2 for the same purpose, is followed by a discussion of sex-differential school experience.

2. Teacher Influences

There is evidence that teachers treat the sexes differentially in the classroom.[24] Teachers, like parents, prefer boys to girls.[25] Boys tend to receive more disciplinary action and praise than girls. Boys are expected to be rougher than girls, while girls are expected to be more obedient and passive in their learning and behavior. Teachers also segregate by sex in activities and directions. Girls are given tasks such as dusting or watering plants, while boys are asked to help move furniture and help with strenuous classroom chores. Even the seemingly negative responses of teachers towards the non-conforming behavior expected from boys can create sex differences by leading boys toward greater independence, autonomy, and activity.[26]

3. Curricular Influences

Despite the educational ideals of developing individual talent and potential, schools frequently limit such development by imposing sexist biases through curricular materials such as books, study problems and visual aids. These reinforce sex-typing as they purport to teach subject matter.[27] Many curricular materials needlessly present limiting sex roles which foster goal-orientation in boys and role-orientation in girls. Sex-typing also occurs through sex stereotypes present in picture books and in supposedly objective materials such as math and science texts.[28] Females are underrepresented in math texts and, when they are portrayed, they are depicted as passively performing "feminine"activities such as cooking, sewing, teaching, and housekeeping. In contrast, boys are portrayed as actively involved in problem-solving situations in sports, building and yard or farm work. Furthermore, certain subjects, themselves such as English and art, are viewed as feminine, while math and science are viewed as masculine-apppropriate disciplines. In every subject, from reading to physical education, sex-typing reinforces children's already established gender-definitions. As Howe has noted, in junior high schools, sexual stereotyping becomes even more overt since:

> curricular sex-typing . . . is extended to such "shop" subjects as cooking and sewing, on the one hand, and metal and woodworking, printing, ceramics, on the other. In vocational high schools, the stereotyping becomes outright channeling.[29]

4. The "Hidden" Curriculum

Sex differential treatment is reinforced by the "hidden curriculum" of schools. Sexton observes that schools are "feminizing institutions."

Table 2
THE REPORT CARD*

GIRLS	BOYS
Academic	
• Girls start out ahead of boys in speaking, reading, and counting. In the early grades, their academic performance is equal to boys in math and science. However, as they progress through school, their achievement test scores show significant decline. The scores of boys, on the other hand, continue to rise and eventually reach and surpass those of their female counterparts, particularly in the areas of math and science.[1]	• Boys are more likely to be scolded and reprimanded in classrooms, even when the observed conduct and behavior of boys and girls does not differ. Also, boys are more likely to be referred to school authorities for disciplinary action than are girls.[6]
• In spite of performance decline on standardized achievement tests, girls frequently receive better grades in school. This may be one of the rewards they get for being more quiet and docile in the classroom. However, this may be at the cost of independence and self-reliance.[2]	• Boys are far more likely to be identified as exhibiting learning disabilities, reading problems, and mental retardation.[7]
• Girls are more likely to be invisible members of classrooms. They receive fewer academic contacts, less praise, fewer complex and abstract questions, and less instruction on how to do things for themselves.[3]	• Not only are boys identified as having learning and reading disabilities; they also receive lower grades, are more likely to be grade repeaters, and are less likely to complete high school.[8]
• Girls who are gifted in mathematics are far less likely to be identified than are gifted boys. Those girls who are identified as gifted, are far less likely to participate in special or accelerated math classes to develop this special talent.[4]	
• Girls who suffer from learning disabilities are also less likely to be identified or to participate in special education programs than are learning-disabled boys.[5]	

*From *Sex Equity Handbook for Schools* by Myra Pollack Sadker and David Miller Sadker. Copyright © 1982 by Longman Inc., pp. 1-8. Reprinted by permission of Longman Inc., New York. Reference notes are listed at the end of this chapter.

Table 2 continued
THE REPORT CARD*

GIRLS	BOYS

Psychological and Physical

- Although women achieve better grades than men, they are less likely to believe that they can do college work. In fact, of the brightest high school graduates who do not go on to college, 70 to 90 percent are women.[9]

- Learned helplessness exists when failure is perceived as insurmountable. Girls are more likely than boys to exhibit this pattern. They attribute failure to internal factors, such as ability, rather than to external factors, such as luck or effort. Girls who exhibit learned helplessness avoid failure situations—they stop trying. Research indicates that teacher interaction patterns may contribute to the learned helplessness exhibited by female students.[10]

- By high school, young women demonstrate a decline in career commitment. This decline is related to their feeling that boys disapprove of a woman using her intelligence.[11]

- Tests reveal that the majority of female and male college students report that the characteristics traditionally associated with masculinity are more valuable and more socially desirable than those characteristics associated with feminity.[12]

- In athletics, females also suffer from sex bias. For example, women's athletic budgets in the nation's colleges are equal to approximately 18 percent of the men's budgets.[13]

- Society socializes boys into an active, independent, and aggressive role. But such behavior is incongruent with school norms and rituals that stress quiet behavior and docility. This results in a pattern of role conflict for boys, particularly during the elementary years.[14]

- Hyperactivity is estimated to be nine times more prevalent in boys than in girls. Boys are more likely to be identified as having emotional problems, and statistics indicate a higher male suicide rate.[15]

- Boys are taught stereotyped behaviors earlier and more harshly than girls; there is a 20 percent greater probability that such stereotyped behavior will stay with them for life.[16]

- Conforming to the male sex role stereotype takes a pyschological toll. Boys who score high on sex-appropriate behavior tests also score highest on anxiety tests.[17]

- Males are less likely than females to be close friends with one another. When asked, most males identify females as their closest friends.[18]

- The strain and anxiety associated with conforming to the male sex stereotype also affects boys physically. Males are more likely to succumb to serious disease and to be victims of accidents or violence. The average life expectancy of men is eight years shorter than of women.[19]

Careers and Family Relationships

- When elementary school girls are asked to describe what they want to do when they grow up, they are able to identify only a limited number of career options, and even these fit stereotypic patterns. The majority identify only two careers, teaching and nursing. Boys, on the other hand, are able to identify many more potential occupations.[20]

- Teachers and counselors advise boys to enter sex stereotyped careers and limit their potential in occupations like kindergarten teacher, nurse, or secretary.[23]

- The majority of girls enter college without completing four years of high school mathematics. This lack of preparation in math serves as a "critical filter," inhibiting or preventing girls from many science, math, and technologically related careers.[21]
- The preparation and counseling girls receive in school contribute to the economic penalties that they encounter in the workplace. Although over 90 percent of the girls in our classrooms will work in the paid labor force for all or part of their lives, the following statistics reveal the cost of the bias that they encounter.[22]
- More than a third of families headed by women live below the poverty level.
- A woman with a college degree will typically earn less than a male who is a high school dropout.
- The typical working woman will earn 59 cents for every dollar earned by a male worker.
- Minority women earn even less, averaging only 50 percent of the wages earned by white males.
- Women are 79 percent of all clerical workers, but only 5 percent of all craft workers.
- Women must work nine days to earn what men get paid for five days of work.
- In contrast to the popular belief that things are getting better for female workers, since 1954 the gap between the wages earned by men and women has not gotten smaller.
- A majority of women work not for "extra" cash, but because of economic necessity. Nearly two-thirds of all women in the labor force are single, widowed, divorced, or separated, or are married to spouses earning less than $10,000 a year.

- Many boys build career expectations that are higher than their abilities. This results in later compromise, disappointment, and frustration.[24]
- Both at school and at home, boys are taught to hide or suppress their emotions; as men they may find it difficult or impossible to show feelings towards their family and friends.[25]
- Boys are actively discouraged from playing with dolls (except those that play sports or wage war). Few schools provided programs that encourage boys to learn about the skills of parenting. Many men, through absence and apathy, become not so much parents as "transparents." In fact, the typical father spends only 12 minutes a day interacting with his children.[26]
- Men and women differ in their beliefs of the important aspects of a father's role. Men emphasize the need for the father to earn a good income and to provide solutions to family problems. Women, on the other hand, stress the need for fathers to assist in caring for children and responding to the emotional needs of the family. These differing perceptions of fatherhood lead to family strain and anxiety.[27]

She stresses the particularly detrimental effects of elementary schools on boys:

> Boys and the schools seem locked in deadly and ancient conflict that may eventually inflict mortal wounds on both . . . The problem is not just that the teachers are too often women. It is that the school is too much a woman's world, governed by women's rules and standards. The school code is that of propriety, obedience, decorum, cleanliness, physical and, too often, mental passivity.[30]

Yet, if the feminizing influences of the school are not "good preparation for manhood," the schools' "feminization" or "domestication" *is* good preparation for "real womanhood."[31] The feminine sex-appropriate behaviors learned at home are reinforced by the school environment; "Girls are reinforced for silence, for neatness, for conformity—and in this dispensation of rewards, the process of learning is thwarted".[32] Reinforcement of the docility that girls have already learned in the home "prepares" them for the future sex stereotyping that they will face in society at large.

5. Hierarchical Structure and Organization

One other way by which stereotyped sex-roles are reinforced is through the hierarchial structure of the school administration. Even if the elementary school is perceived as "woman's domain," the positions of leadership are held by men. Seventy-eight percent of elementary school principals are men, whereas 88 percent of elementary school teachers are women.[33] It is quite likely that children note the imbalance in the school's power structure, seeing that women's place, in education as in other professional areas, is not at the top. This imbalance of power is present at all levels of education—especially at the university.[34]

Stereotyped sex-role expectations, conceptions of educational leaders as business*men*, and myths of female emotional instability and lack of leadership traits may all contribute to women's absence from administrative positions. Research on personality and leadership characteristics clearly shows that women administrators are efficient, have strong, positive self-images, and, in sum, are anything but emotionally unstable.[35] Thus, Lovano-Kerr's contention that: "Of these attributes (sex, marital status, religion, and political preference), sex appears to be the greatest barrier for women to employment and advancement in administration" seems justified.[36]

E. SEX DIFFERENCES IN ART EDUCATION

1. Drawing

Research on sex differences in children's drawings became particularly popular during the onslaught of psychological testing. In 1926, Goodenough reported that children's drawings of a man revealed sex differences favoring girls in mean score and in the treatment of various qualitative aspects of drawing.[37] Motivated by his concern to develop sex-free measures of intellectual maturity, Harris further researched sex differences in children's drawings.[38] He found that: 1) When a drawing of a person was called for, both sexes usually drew a male; 2) When drawing a man, girls excelled on eye detail, proportion, clothing transparencies, body contours, and hair, while boys did better on proportion of foot, indication of heel, nose, and portrayal of action of arms; and 3) When drawing a woman, girls excelled on most facial features, hair depiction, jewelry inclusion, neckline, waistline,

and skirt flare, while boys excelled on nose and were more likely to draw female legs with a distinct angle by separating the feet. Harris interpreted these sex differences in the frame of eliminating sex-biased items from intelligence tests. He appears to have had no commitment to eradicating these differences, but, rather, he accepted the differences and stressed that test makers should take them into account: "Regardless of whether these differences arise from psychological or culturally derived origins, they are consistently noted from early ages in our culture and probably should be taken into account in test building".[39] Harris goes on to say that these differences may be explained in terms of theories of personality organization, culturally reinforced sex differences in libidinal investment of body parts, girls' greater sex-role identification, or because girls' "greater awareness of and concern with people and personal relationships".[40]

A more recent study by Majewski refutes some of Harris' findings while supporting others.[41] Majewski found no sex differences in 22 of her 31 test items. No sex differences were found in areas such as delicate vs. bold lines, spontaneous vs. deliberate style, arbitrary vs. realistic color, composition, and use of medium. Sex differences, with girls excelling, were found in areas such as inclusion of happy faces, environmental cues, and use of curvilinear vs. rectilinear lines. Majewski also analyzed the relationship of these sex differences to parental occupation and grade level (1, 4, and 7). She found that these other variables did have some effect on the presence or absence of sex differences.

Cox further explored the cultural variables which might influence sex differences by studying drawings of Inuit children.[42] Her study supported Majewski's observations that girls draw more detail and better proportioned figures but did not support Majewski's findings that girls draw more happy faces, human figures, gender recognizable figures, environmental cues, and curvilinear lines. In fact, on this last item, Cox found that Inuit boys used more curvilinear lines and girls used more rectilinear lines—exactly the opposite of American boys and girls.

Research on sex differences in children's drawings not initiated by draw-a-person tasks has been a more recent phenomenon. In *Analyzing Children's Art*, Kellogg reports that her observations of children's drawings from around the world revealed no sex differences for children under five.[43] After five, the drawings reflected sex differences only in the choice of subject matter. Sex differences in choice of subject matter were also confirmed by Feinburg.[44] Feinburg examined children's drawings of "fighting" and "helping" in terms of personal-depersonal content and spatial characteristics. Both drawing themes elicited sex differences along the personal-depersonal dimension. Girls portrayed fighting in terms of direct interpersonal conflict between two familiar people while boys portrayed fighting in terms of indirect contact between structured teams and armies. Likewise, girls' drawings of helping focused upon personal portrayals of themselves assisting someone else while boys' drawings focused on the helping situation or task rather than on the individuals doing the helping. In terms of

spatial characteristics, Feinburg found no sex differences except in the area of symmetry. Furthermore, she suggests that the greater frequency of symmetry in girls' drawings may be due to their more personal approach to subject matter than to some kind of innate preference:

> Interpersonal pictures are frequently depictions of two people confronting one another placed in the central part of the paper. This basic notion is more apt to elicit a symmetrical composition.[45]

Her notion that continued portrayal of certain subject matter may induce preferences for certain spatial arrangements is an idea that should be carefully considered when examining research on sex differences in art preferences.

In sum, sex difference research on children's drawing reveals more similarities than differences. Where there are sex differences, age and culture are sometimes contributing factors. Research on cross-grade and cross-cultural sex differences appears most conclusive in supporting girls drawing human figures with more detail and better proportion than boys. However, the number of research studies on sex differences in children's drawings is still too small to draw any conclusive generalizations. Futhermore, research on the reasons for sex differences or similarities has yet to be conducted.

2. Art Preferences

Research on sex differences in preferences for works of art has primarily involved the areas of subject matter, abstract vs. realistic, and color preferences. Lark-Horovitz found that girls preferred pictures where women and children were the main subject matter, while boys preferred pictures of men.[46] Her findings are consistent with research on sex differences in drawing which show that both sexes draw their own sex more than the opposite sex.[47] In terms of sex differences in preferences for abstract art vs. realistic art, Roubertoux et al. found no sex differences, and Coffey found no sex differences with the exception of fourth grade girls.[48] Color studies have show some sex differences with girls preferring somber colors and boys preferring bright colors.[49] However, caution should be exercised in drawing conclusions from so few studies. Furthermore, as Chalmers states:

> a review of the literature indicates that these sex differences in aesthetic preference are considerably less than the differences in preference caused by such variation among groups as age, social class, special training and vocation.[50]

3. Employment

Research on employment in higher education has consistently shown that female art educators hold fewer positions (especially in administration) and are employed at a lower rank and salary than their male counterparts.[51] The differences are particularly acute in two-year colleges where women out-number men two-to-one and 7% of women with doctorates as compared to 1% of men with doctorates teach.[52] Given that the number of women receiving doctorates in art educa-

tion is rising and that "no significant differences were found between male and female respondents in the type and amount of professional contributions when controlling for time of degree, highest degree and rank except in the areas of awards"[53]; the difficulty appears increasingly to be in the hiring practices and the structures of promotion in higher education.

Sex differences also exist in the positions of city art supervisor/director and state art supervisor/director. In the case of the former, the percentage of women has decreased over the years to the present 42% while, in the latter, the ratio of women (currently 37.8%) has consistently been lower than that of men.[54]

F. CONCLUSION

1. Suggestions for Using Available Research

The amount of research relevant to sex equitable art education has grown tremendously in the last ten years. It is crucial that we begin to examine this research. Given that of 5,000 courses offered relating to women's studies or sex-role stereotyping, only 184 of these were identified in schools or departments of education, it appears that educators may not be addressing sex equity as explicitly as they should.[55] However, when examining sex differences research reviewed in this chapter and in other sources, it is crucial to keep the following cautions in mind:

• Remember that constructs such as "spatial ability" may not refer to one, well-defined ability. Different researchers use different kinds of instruments to operationally define what constitutes spatial ability and what other abilities. For example, spatial ability is measured by such tests as mental rotations, perception of horizontality, hidden figures, and paper folding.[56] Similarily, tests of verbal ability may variously focus on verbal fluency, verbal communication versus noise, verbal comprehension, and so forth. Check to see what instrument the author is using to test and define an ability, and weigh this against how the term is used in reference to art education.

• Be careful of research which attempts to provide causal explanations for sex difference or similarities. For example, spatial abilities may be influenced by differences in the play activities of boys and girls, parental reinforcement of mathematics performance, or other environmental factors.

• Be particularly wary of authors who utilize the term "natural" in the causal explanations. If they mean by this that sex differences or similarities are biologically determined, they are treading on very shaky ground. Data on the neonate for the visual and auditory modalities shows little sex differences.[57] Other than the fact that girls' physical maturation or growth exceeds that of boys by about 4-6 weeks, [58]

biological explanations in terms of hormones or hemispheric dominance (the two major views) appear unwarranted.

As McGuiness notes:

> the hemisphere dominance theories (Buffery & Gray, 1972; Levy, 1971; Harris, 1973) imply that cognitive function is 'pre-wired' to specific locations and determines subsequent development of sex differences. Data on the plasticity of neural function is too overwhelming to support this theory (Lashley, 1950; Pribram, 1971; Luria, 1966), besides which the development of sex differences in certain cognitive skills cannot be attributed solely to one hemisphere or another as many female skills are to be found in the right non-dominant 'male' hemisphere; singing ability, intensity judgment, recognition of faces and visual memory, as well as their facility in language, a left-hemisphere function carry on equally implicit assumption that the hormone is regulating or controlling perceptual or cognitive development. But this type of theory presents a greater problem in explaining how sex differences occur so early in life, when hormone levels only increase noticeably at or before puberty.[59]

This is not say that early biological differences may not exist and be influential or that early differences in sensory experiences perhaps caused by differences in maturation levels, may not influence later development. However, separating these factors from the very early differences in the environmental situations of boys and girls is a difficult task which must be carefully examined.

• Closely examine research in art education for discussions of sex differences and similarities. Sometimes researchers will report that they examined the variable of sex but will fail to publish their findings on this variable. Researchers are selective, and unless we express concern about sex equity related research, our views of art education may, unintentionally, become skewed.

• And, finally, be conscious that factors such as race, class, school size, school curricula, private versus public schools, and same-sex versus co-educational schools are all possible influences on sex difference research.

2. Suggestions for Future Research

To date sex difference research relevant to art education has primarily focused upon documenting sex differences rather than exploring their value or causes. Theoretical investigation into the advantages and disadvantages of sex differences is needed if we are to take a stance on promoting or eradicating such differences. Should, for example, sex differences in the personal-depersonal portrayal of "fighting" and "helping" be maintained or eliminated by the schools? Should the schools be responsible for this area, and, if so, can they be effective? Theoretical investigation into the possible causes of sex differences is also needed in order to generate hypotheses. Without developed hypotheses, research can become a collection of unrelated descriptions. Researchers need developed hypotheses in order to know what data should be collected.

As the preceeding review indicates, the areas in which we need

theoretical research accompanied by empirical data are numerous. In particular, there is an absence of research on the effects of sex equitable school programs. How do sex equitable teachers and curricular materials affect students' development? We not only need to develop sex equitable teachers and materials, we must document the effects of our efforts.

Research about art teacher characteristics must also be expanded. Although some information is available on the educational background and employment of art teachers in higher education, such information has not been collected for elementary and secondary teachers. Furthermore, data on teaching styles or modes of interaction has yet to be collected. Finally, careful investigation of the relevance of leads offered by psychological research is needed. How do, for example, sex differences in verbal fluency affect art learning?

In sum, a review of sex differences research reveals questions which require further theoretical and empirical investigation. We desparately need such research if we are to construct and document sex equitable programs in art education.

NOTES AND REFERENCES

[1] Laurel Richardson Walum, *The Dynamics of Sex and Gender: A Sociological Perspective* (Chicago: Rand McNally, 1977).

[2] *Ibid.*, p. 5.

[3] Inge K. Broverman, Donald M. Broverman, Frank E. Clarkson, Paul S. Rosencrantz, and Susan Vogel, "Sex Role Stereotypes and Clinical Judgments of Mental Health," *Journal of Consulting and Clinical Psychology* 34 (1970): 1-17.

[4] *Ibid.*

[5] Jerome Kagan, "The Emergence of Sex Differences," *School Review* 80 (February 1972): 226.

[6] *Ibid.*

[7] Eleanor Maccoby and Carol Nagy Jacklin, "Myth, Reality and Shades of Gray; What We Know and Don't Know About Sex Differences," *Psychology Today* (December 1974): 109-112.

[8] Eleanor Maccoby and Carol Nagy Jacklin, *The Psychology of Sex Differences* (Stanford, California: Stanford University Press, 1974), p. 112.

[9] Eleanor Maccoby, ed., *The Development of Sex Differences* (Stanford, California: Stanford University Press, 1966.)

[10] Betty Levy, "The School's Role in the Sex Role Stereotyping of Girls: A Feminist Review of the Literature," *Feminist Studies* 1 (Summer, 1972):5-23.

[11] Kohlberg, Lawrence, "A Cognitive-Developmental Analysis of Children's Sex-Role Concepts and Attitudes," in *The Development of Sex Differences*, ed. Eleanor Maccoby (Stanford, California: Stanford University Press, 1966).

[12] Alice Rossi, "Equality Between the Sexes," in *The Woman in America*, ed. Robert Jay Lifton (Boston: Houghton-Mifflin, 1964).

[13] Frank Barron, *Artists in the Making* (New York: Seminar Press, 1972), p. 37.

[14] Matina S. Horner, "Fail, Bright Woman," *Psychology Today*, (November 1969), pp. 36-38.

[15] E. Paul Torrence, "Creative Young Women in Today's World," *Exceptional Child*, 38 (April, 1972): 597-603.

[16] Maccoby and Jacklin, *Psychology of Sex Differences*, p. 112.

[17] Marcia Guttentag and Helen Bray, *Undoing Sex Stereotypes—Research and Resources for Educators* (New York: McGraw-Hill Book Company, 1976) p. 14.

[18] *Ibid.*, p. 15.

[19] Kohlberg, *Cognitive-Developmental Analysis of Children's Sex-Role Concepts and Attitudes.*

[20] Maccoby and Jacklin, *Myth, Reality and Shades of Gray.*

[21] Guttentag and Bray, p. 17.

[22] Lenore Weitzman, D. Eifler, E. Hokada and C. Ross, "Sex Role Socialization in Picture Books for Preschool Children," *The American Journal of Sociology* 77, (May 1972): 1125-1150.

[23] Myra P. Sadker and David M. Sadker, *Sex Equity Handbook for Schools* (New York: Longman, Inc., 1982), pp. 1-4.

[24] Patricia Cayo Sexton, *The Feminized Male—Classrooms, White Collars, and the Decline of Manliness* (New York: Random House, 1969), and Judith M. Bardwick, *Psychology of Women—A Study of Bio-Cultural Conflicts,* (New York: Harper & Row Publishers, 1971).

[25] Guttentag and Bray, p. 23.

[26] Levy, p. 12.

[27] Christina J. Simpson, "Educational Materials and Children's Sex Role Concepts," *Language Arts* 55 (February 1978): 161-167.

[28] John Stewig and Margaret Higgs, "Girls Grow Up to be Mommies: A Study of Sexism in Children's Literature," *School Library Journal* 19 (January 1973): 44-49.

[29] Florence Howe, "Sexual Stereotypes Start Early," *Saturday Review* 1 (October 1971): 76-94.

[30] Sexton, p. 57.

[31] Levy, *The School's Role.*

[32] Nancy Frazier and Myra Sadker, *Sexism in School and Society* (New York: Harper & Row, 1973).

[33] *Ibid.,* p. 97.

[34] Alexander, W. Astin, "Data Pertaining to the Education of Women: A Challenge to the Federal Government," paper presented at the Census Bureau Conference on Issues in Federal Statistical Needs Relating to Women, Washington, D.C., 27-28, April 1978.

[35] Jessie Lovano-Kerr, "A Review of the Historical and Current Contextual Factors Affecting the Status of Women Art Educators in Administration," in *Studies in Art Education* 22 (1981): 49-58.

[36] *Ibid.,* p. 53.

[37] Dale Harris, *Children's Drawings as Measures of Intellectual Maturity,* (New York: Harcourt, Brace and World, 1963).

[38] *Ibid.*

[39] Harris, p. 129.

[40] Harris, p. 130.

[41] Margaret Mary Majewski, "The Relationship Between the Drawing Characteristics of Children and Their Sex," (Ed.D. dissertation, Illinois State University, 1978).

[42] Marlene Cox, "A Cross Cultural Study of Sex Differences Found in Drawings by Canadian Inuit and American Children," (Ed.D. dissertation, Illinois State University, 1979).

[43] Rhoda Kellogg, *Analyzing Children's Art,* (Palo Alto, California: National Press Books, 1969).

[44] Sylvia Feinburg: "Conceptual Content and Spatial Characteristics in Boys' and Girls' Drawings of Fighting and Helping," *Studies in Art Education* 18 (1977): 63-72.

[45] *Ibid.,* p. 70.

[46] B. Lark-Horovitz, H. Lewis, and M. Luca, *Understanding Children's Art for Better Teaching* (Columbus, Ohio: Charles E. Merrill Books, Inc. 1967).

[47] Majewski; Cox.

[48] Larry L. Schulte, "The Effects of Visual Art Experiences on Spelling, Reading, Mathematical and Visual Motor Skills at the Primary Level," (Ph.D. dissertation, University of Kansas, 1983).

[49] *Ibid.*

[50] F. Graeme Chalmers, "Women as Art Viewers: Sex Differences and Aesthetic Preference," *Studies in Art Education* 18 (1977): p. 51.

[51] Sandra Packard, "An Analysis of Current Statistics and Trends As They Influence

the Status and Future for Women in The Art Academe," *Studies in Art Education* 18 (1977): 38-48.

52 Jessie Lovano-Kerr, Vicki Semler, and Enid Zimmerman, "A Profile of Art Educators in Higher Education: Male/Female Comparative Data," *Studies in Art Education* 18 (1977): 21-37.

53 *Ibid.*, p. 35.

54 John A. Michael, "Women/Men in Leadership Roles in Art Education," *Studies in Art Education* 18 (1977): 7-20.

55 Shirley D. McCune, Martha Matthews, and Janice Earle, "Teacher Education: A New Set of Goals" *American Education* 13 (June 1977) 24-25.

56 C. Linn and Anne C. Petersen, "Facts and Assumptions About the Nature of Sex Differences," in *Handbook for Achieving Sex Equity Through Education*, ed. Susan Klein, (Baltimore, Maryland: The John Hopkins University Press, forthcoming).

57 Diane McGuinness, "Sex Differences in the Organization of Perception and Cognition," in *Exploring Sex Differences*, ed. B. Lloyd and J. Archer (New York: Academic Press, 1976).

58 Linn and Petersen, "Facts and Assumptions."

59 McGuinness, p. 141.

NOTES from
Table 2 THE REPORT CARD

1 Eleanor Maccoby and Carol Jacklin, *The Psychology of Sex Differences* (Stanford: Stanford University Press, 1974).

2 *Ibid.*
Inas Mullis, *Educational Achievement and Sex Discrimination* (Denver: National Assessment of Educational Progress, 1975).

3 T. Jeana Wirtenberg, "Expanding Girls' Occupational Potential: A Case Study of the Implementation of Title IX's Anti-Segregation Provision in Seventh Grade Practical Arts," (unpublished doctoral dissertation, University of California, 1979).
H. Felsenthal, "Sex Differences in Expressive Thought of Gifted Children in the Classroom," American Educational Research Association, ERIC, Ed. 039-106, 1970.
G. Leinhardt, A. Seewald and M. Engel, "Learning What's Taught: Sex Differences in Instruction," *Journal of Educational Psychology* 71 (1979).
W. Casper, "An Analysis of Sex Differences in Teacher-Student Interaction as Manifest in Berbal and Nonverbal Cues," (unpublished doctoral dissertation, The University of Tennessee)
Lisa Serbin and D. O'Leary, "How Nursery Schools Teach Girls to Shut Up," *Psychology Today,* 9 (1975).

4 Lynn H. Fox, "The Effects of Sex Role Socialization on Mathematics Participation and Achievement," in Lynn H. Fox, Elizabeth Fennema, and Julia Sherman, *Women and Mathematics: Research Perspectives for Change*, NIE Papers in Education and Work, No. 8 (Washington, D.C.: National Institute of Education, 1977).

5 William E. Davis, "A Comparison of Teacher Referral and Pupil Self-Referral Measures Relative to Perceived School Adjustment," *Psychology in the Schools* 15 (January 1978).
Jeremy Lietz and Mary Gregory, "Pupil Race and Sex Determinants of Office and Exceptional Education Referrals," *Education Research Quarterly*, 3 (Summer 1978).
Paula Caplan, "Sex, Age, Behavior, and School Subject as Determinants of Report of Learning Problems." *Journal of Learning Disabilities*, 10 (May 1977).

6 D. L. Duke, "Who Misbehaves? A High School Studies its Discipline Problems," *Educational Administration Quarterly* 12 (1976).
Claire Etaugh and Heidi Harlow, "Behaviors of Male and Female Teachers as Related to Behaviors and Attitudes of Elementary School Children," *The Journal of Genetic Psychology* 127 (1975).
Thomas Good and Jere Brophy, "Questioned Equality for Grade One Boys and Girls." *Reading Teacher* 4 (1971).

[7] Maccoby and Jacklin, *The Psychology of Sex Differences.*
Davis, "A Comparison of Teacher Referral and Pupil Self-Referral Measures Relative to Perceived School Adjustment."
National Assessment of Educational Progress, *Reading Change, 1970-1975; Summary Volume,* Reading Report No. 06-R-21 (Denver: NAEP, 1978).
Patricia Gillespie and Albert H. Fink, "The Influence of Sexism on the Education of Handicapped Children," *Exceptional Children* 41 (1974).

[8] Jere Brophy and Thomas Good, "Feminization of American Elementary Schools," *Phi Delta Kappan 54* (April 1973).

[9] *Facts About Women in Education,* WEAL, Washington, D.C., 1976.

[10] Carol Dweck and N. Reppucci, "Learned Helplessness and Reinforcement Responsibility in Children," *Journal of Personality and Social Psychology* 25 (1973).
J. Nicholls, "Causal Attributions and Other Achievement-Related Cognitions: Effects of Task Outcomes, Attainment Value, and Sex," *Journal of Personality and Social Psychology* 31 (1975).
Carol Dweck and D. Gilliard, "Expectancy Statements as Determinants of Reactions to Failure: Sex Differences in Persistance and Expectancy Change," *Journal of Personality and Social Psychology* 32 (1975).

[11] Peggy Hawley, "What Women Think Men Think," *Journal of Counseling Psychology* 18 (Autumn 1971).

[12] I. K. Broverman, S. R. Vogel, D. M. Broverman, F. E. Clarkson, and P. S. Rosenkranz, "Sex-Role Stereotypes: A Current Appraisal" *Journal of Social Issues* 28 (1972).

[13] *AIAW School Year Summary, 1978-79,* The Association for Intercollegiate Athletics for Women, Washington, D.C. 1979.

[14] Nancy Frazier and Myra Sadker, *Sexism in School and Society* (New York: Harper and Row, 1973).
William Goldman and Anne May, "Males: A Minority Group in the Classroom," *Journal of Learning Disabilities* 3 (May 1970).

[15] Frances Bentzen, "Sex Ratios in Learning and Behavior Disorders," *The National Elementary Principal* 46 (1966).
Diane McGuiness, "How Schools Discriminate Against Boys," *Human Nature* (1979).

[16] S. Fling and M. Manosevitz, "Sex Typing in Nursery School Children's Play Interests," *Developmental Psychology* 7 (1972).
Ruth Hartley, "Sex Role Pressures and the Socialization of the Male Child," *Psychological Reports* 5 (1979).

[17] I. Waldron, "Why Do Women Live Longer than Men?" *Journal of Human Stress* 2 (1976).
S. L. Bem, "The Measurement of Psychological Adrogyny," *Journal of Consulting and Clinical Psychology* 42 (1974).
S. L. Bem, "Sex Role Adaptability: One Consequence of Psychological Androgyny," *Journal of Personality and Social Psychology* 31 (1975).

[18] M. Komarovsky, "Patterns of Self-Disclosure of Male Undergraduates," *Journal of Marriage and the Family* 36 (1974).
Joseph Pleck, "Male-Male Friendship: Is Brotherhood Possible?" in M. Glazer (ed) *Old Family/New Family: Interpersonal Relationships* (New York: Van Nostrand Reinhold, 1975).

[19] Waldron, "Why Do Women Live Longer than Men?"

[20] W. R. Looft, "Sex Differences in the Expression of Vocational Aspirations by Elementary School Children," *Developmental Psychology* 5 (1971).

[21] Lucy Sells, "High School Mathematics as the Critical Filter in the Job Market," in *Developing Opportunities for Minorities in Graduate Education,* proceedings of the Conference on Minority Graduate Education at the University of California, Berkeley, 1973.

[22] These statistics have been compiled from *The Earnings Gap Between Men and Women,* U.S. Department of Labor, Women's Bureau, GPO (1979); *Twenty Facts on Working Women,* U.S. Department of Labor; Women's Bureau, GPO (1978).

[23] Looft, "Sex Differences in the Expressions of Vocational Aspirations by Elementary School Children."
Frazier and Sadker, *Sexism in School and Society.*
Joseph Pleck and Robert Brannon, (ed) "Male Roles and the Male Experience," *Journal of Social Issues* 34 (1978).
[24] Pleck and Brannon, (ed) "Male Roles and the Male Experience."
[25] S. Jourard, *The Transparent Self* (New York: Van Nostrand, 1976).
M. Komarovsky, *Dilemmas of Masculinity: A Study of College Youth* (New York: Norton, 1976).
Herb Goldberg, *The Hazards of Being Male* (New York: Nash, 1976)
[26] Philip Stone, "Child Care in Twelve Counties," in *The Use of Time,* Alexander Szalai, ed. (The Hague, The Netherlands: Mouton, 1972).
[27] Deanna Eversoll "The Changing Father Role: Implications for Parent Education Programs for Today's Youth," *Adolescence* XIV (Fall 1979).

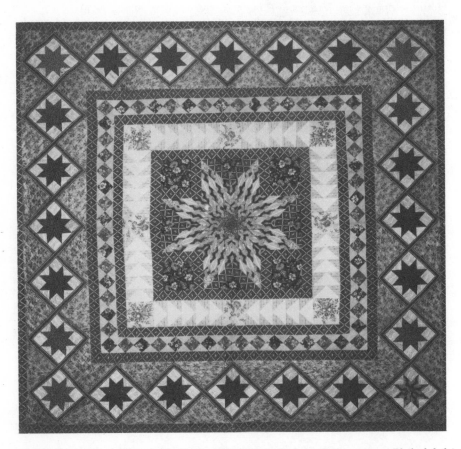

Sophonisba Peale, Patchwork Quilt, 1850. Printed plain cloth, cotton. Philadelphia Museum of Art. Given by Mrs. Horace Wells Sellers. Photographed by Philadelphia Museum of Art.

CHAPTER 8:

Approaches to Sex Equity in Art Education

Perhaps the greatest challenge to the feminist movement in the visual arts, then, is the establishment of new criteria by which to evaluate not only the aesthetic effect, but the communicative effectiveness of art attempting to avoid becoming a new establishment in itself, or God forbid, a new stylistic movement, to be rapidly superseded by some other one.
—Lucy Lippard (1976)

We must ask that the teacher be able to analyze his or her own values and behavior, to see what is really at stake in the process of teaching, and to decide wisely—ethically—what should be done. The restoration of public confidence in teachers can be forwarded by giving more attention to the principles which ought to govern the conduct of teachers.
—Laura Chapman (1982)

A. NEED FOR A DISCIPLINE SPECIFIC MODEL FOR SEX EQUITY IN ART EDUCATION

Sex equity effort among artists, art critics, and art historians has been energetic and effective. Similar effort in many disciplines associated with public school education has been systematic and well documented. Sex equity progress in these fields will inevitably provide standards of comparison and sources of inspiration for art educators subscribing to the goal of sex equity in art education. We cannot expect, however, that models of effort developed by professional artists or public school math teachers will automatically apply to art education. Beyond the challenge all art educators face as we attempt to reconcile the often disparate values of art and education establishments, the low status and feminine identification of art in the public school curriculum and the low status and feminine identifica-

tion of public school art teaching in the artworld must be addressed if these are not to undermine progress toward sex equity in our field.

Sex equity efforts that have taken place in the world of art and education have been many and various: Some have involved mainstreaming and affirmative action while others have segregated women for the purpose of studying their "lost" heritage; some have advocated cooperative effort among women and others have set about to teach them to be more assertive and competitive; some have rejected the concept of femininity as a negative stereotype, while others have sought to give positive value to gender related differences in art. Art educators looking to the "parent" fields of art and education for exemplary approaches to sex equity will find certain of these efforts attractive and reject others as perhaps too politically loaded for use in the public school art classroom. While personal preference and practical considerations will play a major role in devising and adopting particular sex equity efforts in art education, we should be aware that differences in programs, strategies, and methods often reflect important differences in assumptions and goals. The development of coherent, relevant, responsible, and effective sex equity effort in art education will depend in large measure on our ability to discern, evaluate, and articulate these underlying assumptions. Towards these ends, this chapter will first discuss and compare three alternative approaches to sex equity in terms of their theoretical positions and classroom applications. The second section will explore a pluralistic model for sex equity in art education and suggest a pluralistic approach to art teacher education.

B. ALTERNATIVE APPROACHES TO SEX EQUITY: INTEGRATIONISM, SEPARATISM, AND PLURALISM

At least three self-consistent positions can be taken on egalitarian reform: the integrationist, the separatist, and the pluralist.[1] Each position suggests possibilities for approaches to equity effort and may be discerned in movements on behalf of Blacks, ethnic minorities, the elderly, and the handicapped as well as women. As alternative approaches to sex equity in art education, integrationism, separatism, and pluralism present their own particular challenges to the traditional values surrounding art and the female in our society. Each position also provides a coherent rationale for efforts made to bring about its particular vision of sex equity.

The following review will focus on the differences between the integrationist, separatist, and pluralistic approaches to sex equity and suggest how they might find practical application in the art classroom. The reader is reminded that each of these approaches shares common assumptions and goals even while differing with regard to what can and should be changed to improve the relationship between women and art education and women and men in art education. While it is certainly possible to identify leading spokespersons for each approach, it would be a distortion to reduce the thought of particular feminists to the parameters set out for each position. Indeed, these positions

are representative in many cases of the internal debates and doubts arising in the hearts and minds of all individuals concerned to bring about higher degrees of sex equity in our culture. Nevertheless, it is through such speculative structuring of alternative and coherent positions on sex equity, that the underlying assumptions, goals, and issues can be most readily understood and evaluated in terms of their implications for art education.

1. An Integrationist Approach to Sex Equity in Art Education

a. THEORETICAL POSITION

Integrationist goals and assumptions include the following:
- The achievement of sex equity requires the assimilation and integration of women into the pre-existing worlds of art and education.
- Women and men can and should be permitted and encouraged to prepare, participate, compete, be judged, and receive reward and recognition under the same set of standards and within the same set of institutions.
- With respect to all skills, attitudes, and behaviors relevant to art and education, women and men are potentially equal and deserving of similar treatment.
- The central structures, values, and practices of western art and education are legitimate, desirable, and essentially sex-neutral.
- Sexual discrimination within art and education is an extraneous social aberration.
- Women should reeducate themselves or be reeducated to correct stereotypical feminine conditioning which would put them at a competitive disadvantage in existing systems.

b. CLASSROOM APPLICATION

Integrationists in the art classroom will do the following:
- Teachers and students will expect and attribute no differences in art peformance related to gender.
- A single, traditional standard of excellence and achievement will be applied to all students' work.
- Models of artists of both sexes who have successfully participated in mainstream western art will be studied in equal number with equal emphasis.
- The unequal participation and recognition of women in western art will be explained as matters of discrimination and role conditioning.
- The notion of a feminine sensibility will be rejected as a repressive stereotype.
- If female students evidence attitudes, behaviors, self-concepts, or art works that are stereotypically feminine, these will be viewed as negative effects of previous social conditioning.
- Remedial education will be undertaken to develop in female

students behaviors and attitudes which are popularly identified as masculine but which are art relevant and sex-neutral.

2. A Separatist Approach to Sex Equity in Art Education

a. THEORETICAL POSITION

Separatist goals and assumptions include the following:

- The achievement of sex equity requires the establishment of a physically, socially, or psychologically separate world of women's art and education.
- Women can and should develop practices, values, institutional structures, and reward systems more compatible with their experience and more responsive to their needs for self-definition and governance.
- With respect to many skills, attitudes, and behaviors relevant to art and education, women and men are equal but potentially different.
- The central structures, values, and practices of western art and education have been established by white males, and many are essentially masculine and inherently sexist.
- Sexual discrimination is built into western art and education.
- Women should demand or be encouraged to work together in order to arrive at new and positive definitions of themselves, their art, and their education.

b. CLASSROOM APPLICATION

Separatists in the art classroom will do the following:

- Teachers and students will expect sex differences and value authentic experiences of gender-related interests, body and life experiences and predispositions.
- Models of female artists who have participated in feminine identified art forms will be introduced and their work reclaimed as women's art heritage.
- The unequal participation and recognition of women in western art will be explained as matters of masculine bias in art, art history, and art criticism as well as results of overt discrimination.
- The notion of a feminine sensibility will be put forth as an open-ended concept encouraging women to study and explore media, styles, processes, and alternative career patterns historically associated with women.
- If female students evidence attitudes, behaviors, self-concepts, or art works that devalue the female, they will be encouraged to use their art and education to redefine and reevaluate their own experience as women.
- Segregated education will be undertaken when necessary to facilitate the achievement of these goals.

3. A Pluralistic Approach to Sex Equity in Art Education

a. THEORETICAL POSITION

Pluralistic goals and assumptions include the following:
- The achievement of sex equity requires both the assimilation and the accommodation of women through the development of more pluralistic worlds of art and education.
- Irrespective of their traditional association with the sexes, masculinity and femininity are of equal human value, and the character and vitality of art, along with that of women and men, is enhanced by a respect for and the addition of the feminine.
- The perpetuation of rigid sex roles has retarded the development and restricted the artistic horizons of all individuals.
- The systematic devaluation of the feminine in western art and education has worked a hardship on women and has grossly distorted the value of the masculine by equating it with the honorifically human.
- When sex role conditioning has narrowed the range of the expressible for individuals of either sex, remedial education is needed that will increase tolerance and appreciation for individual differences and for the feminine, masculine, and androgynous as equally valid sources of art expression for all individuals.

b. CLASSROOM APPLICATION

Pluralists in the art classroom will do the following:
- Teachers and students will expect and value individual differences in sensibilities, whether these are masculine, feminine, androgynous, or sex-neutral.
- Pluralist standards of excellence and achievement will support and credit a full range of art skills and expression irrespective of their traditional gender identifications.
- Although an androgynous spectrum of skills will be encouraged, the teacher will support each student's search for personally authentic modes of expression.
- Models of artists of both sexes who have been involved in a variety of art activities ranging from part to full-time and from mainstream to hiddenstream traditions will be studied in equal number with equal emphasis.
- The unequal participation of women in the masculine identified art forms and the unequal participation of men in the feminine identified art forms will be explained as matters of discrimination, role conditioning, and sexist values.
- The notions of feminine, masculine, and androgynous sensibilities will be explored for individual meanings and values.
- If female and male students evidence attitudes, behaviors, self-concepts, or art works that are stereotypically attached to their gender, these will be explored for both their enabling and their restricting aspects.

- Remedial education will be undertaken to develop in all individual students behaviors and attitudes which reveal and promote an appreciation and respect for variety in education and art.

4. Comparing the Alternatives

Table 3 presents a simplified breakdown and comparison of the three major approaches to sex equity. The development of a discipline specific model of sex equity effort for art education, we believe, should include elements of all these approaches as they promise benefits for women, men, and art education. It is the pluralistic model which seems to hold open this possibility even as it presents certain problems. In order to maximize the effectiveness and minimize the difficulties of the pluralistic approach, we suggest that it should be conceived in an active, inquiring, and articulate mode. Sex equity effort cannot and should not wait upon the resolution of all theoretical issues and problems. Indeed, systematic effort to increase sex equity in art education promises to bring to light information which will be needed to clarify theory. Our particular efforts will be most helpful in this regard if we make explicit the primary assumptions and goals implied in the strategies we chose to employ. In our initial selection of particular strategies to bring about higher degrees of sex equity in art education, context and individual predispositions will play major roles. Justification for the selections we make should be drawn from our sense of personal as well as professional integrity. And that is as it should be.

C. A PLURALISTIC MODEL FOR SEX EQUITY IN ART EDUCATION

Having compared three different approaches to sex equity in art education, this section provides a pluralistic model for sex equity in art education that can be operationalized by a discipline specific nonsexist approach to professional studies in art teacher education. Through revised and expanded educational emphases, this approach should help foster positive cultural change through greater sex equity in school art programs' curricula and instruction as well as art teacher professionalism. We believe that this is a necessary step in the positive evolution of our field and that such a revisionist approach will not only enhance the relationship of women and art/art education but strengthen the status of the field in general.

1. Assumptions

The pluralistic model for sex equity in art education is based on three fundamental assumptions:

a. That the educational approaches utilized in feminist art education have and promise to continue to expand the boundaries of possibilities within self, art, and society.

b. That psychological, aesthetic, and social change in terms of relating

to the goals of sex equity is possible, desirable, and can be best accomplished by art education in the schools.

c. That sex equity efforts are consonant and must be tied to the three general orientations of art education, as summarized by Elliot W. Eisner: child (individual), subject (art), and society.[2] Each of these educational emphases has been stated in terms of the parallel purposes of art education: personal fulfillment (of individual children and adults) through art experience, appreciation of the artistic heritage, and awareness of art in the society.[3]

2. Model Description

In *Figure 5*, A Pluralistic Model for Sex Equity in Art Education, the solid line indicates the general boundaries of various orientations of art education with its triadic relationship in which each apex represents the child, society, and subject, as diagrammed by Elliot W. Eisner.[4] With the addition of the dotted line, the boundaries of Eisner's paradigm for identifying educational emphases in art education are expanded. This is similar to the expansion effect that feminist art education has made/had on the boundaries of the fields of art and art history, widening the range of contributors to, contexts and evaluative standards of art as a subject.

3. Objectives

The pluralistic model provides the following sex equity objectives as consonant with the fundamental goals of art education related to the child (individual), subject (art), and society.

a. SEX EQUITY OBJECTIVES FOR THE INDIVIDUAL

Toward the art education goal of fostering personal fulfillment and self-realization in the individual, art teachers will re-educate themselves and their students to value and develop an androgynous range of behaviors, attitudes, skills, and values consonant with individual needs and interests, by providing positive role models and equal educational/professional opportunities.

b. SEX EQUITY OBJECTIVES FOR THE SUBJECT

With the art education goal of developing art skills and increasing knowledge of art history, art teachers will reveal, revise, and supplement the white, western and masculine bias of mainstream art as it surfaces in the content/instructional areas of studio art, art history, and art in society.

c. SEX EQUITY OBJECTIVES FOR THE SOCIETY

Consonant with the art education goal of building awareness and appreciation of cultural/social heritage, art teachers will transmit sex-bias-free ideas and values representative of all members of society,

Table 3
ALTERNATIVE APPROACHES AND POSITIONS

	INTEGRATIONIST
1. *Symptoms* of Sex Inequity in Art and Education	Extraneous discrimination against women. Women's lesser participation and achievement in mainstream.
2. *Causes* of Sex Inequity in Art and Education	Extraneous prejudice against women. Sex role conditioning of women (to be feminine).
3. *Goals* of Sex Equity in Art and Education	Equal participation and achievement of de-feminized women within existing systems.
4. *Western Art and Education* Structures, Practices, and Values	Desirable, legitimate, and essentially sex-neutral.
5. *Femininity*	A stereotype with low art, education, and human value.
6. *Masculinity*	A stereotype which has arrogated for men those behaviors, attitudes, and principles of high art education, and human values.
7. *Strategies* of Sex Equity for Art and Education	Expose and eliminate extraneous discrimination against women. Re-educate women in behaviors, values, attitudes associated with participation and achievements in the mainstream. Provide like-sex role models who have been successful in the mainstream.
8. *Problems and Criticisms* of Each Approach	Uncritical acceptance of mainstream structures, practices, and values. Further devaluation of the feminine in our culture. Unequal presure on women to develop new skills and attitudes. Potential sex-role conflict and gender-identity problems.

SEPARATIST	PLURALISTIC
Systematic discrimination against women. Suppression of women's tradition and heritage.	Systematic discrimination against feminine identified individuals, practices, forms, values, and purposes. Distorted emphasis on masculine identified individuals, practices, etc.
Inherent bias against women. Male definition and valuation of women's sex role.	Inherent bias against the feminine. Reinforcement of rigid sex role definitions and conditioning for both sexes.
Full control by women of separate feminine identified systems.	Equal participation, achievement, and control of women and men within pluralistic or androgynous systems.
Undesirable, biased, and essentially sexist.	Unbalanced, distorted and essentially masculine.
Potentially valid concept in need of redefinition and positive valuation by women.	A coherent concept defining behaviors, attitudes, and principles equal in art, education, and human value to those of masculinity.
Potentially valid concept in need of redefinition and devaluation by women.	A coherent concept defining behaviors, attitudes, and principles equal in art, education, and human value to those of femininity.
Expose and repudiate inherent bias against women in the mainstream. Form self-help and self-education groups of women to identify, discover, and establish practices, values, and structures consonant with their own needs and interests. Provide like-sex role models who have been successful in women-identified and dominated endeavors in or outside the mainstream.	Expose and critique the masculine bias of the mainstream. Re-educate women and men to value and develop an androgynous range of behaviors, attitudes, and values consonant with their individual needs and interests. Provide both women and men with like-sex role models who exhibit full range of masculine and feminine characteristics in endeavors in and outside the mainstream.
Cutting women off from mainstream support systems and values. Replacing mainstream norms with ones which might be just as coercive programatic, and limiting. Ignoring the practical, political, legal and moral problems of the separatist stance and double standards.	Providing individuals with unclear, eclectic set of goals and standards. Introducing complexity and ambiguity that might dissipate integrationist and separatist energies and activism. Setting up difficult to meet and potentially rigid andogynous standards.

Table 3 (continued)

	INTEGRATIONIST
9. *Promises and Benefits* of Each Approach	The fair application of existing standards. Women acquiring skills needed for successful competition within existing systems.

mainstream and minority/hiddenstream alike, while revealing the importance of art in society.

4. Positive Outcomes

The expansion effect of the pluralistic model of sex equity for art education would be created from the following kinds of positive change that benefit the individual, subject and society:

a. **PSYCHO-SOCIAL CHANGE.** This affects individual and society as a whole by combatting the limits of sex-typing and opening a wide range of androgynous behavioral objectives to both sexes. The effects on developing children and their self-concepts and career aspirations will counter gender-related self-fulfilling prophesy. This complements the ongoing efforts of feminist educators in other subjects such as math and science.

b. **PSYCHO-AESTHETIC CHANGE.** This would abolish the unnecessary sex-typing of art activities in the classroom, thereby extending to each child, male or female, equal access to art skills and knowledge, which would in turn help children obtain personal fulfillment and knowledge which they need to better function in society, regardless of their professional aspirations.

c. **SOCIO-AESTHETIC CHANGE.** This kind of change will provide for the abolishment of (the view of) art as a ''feminine'' subject by which it is regarded as frill, ornamentation, and recreation. This will potentially enhance art's role in society while strengthening its status in the schools.

d. **IN SUM,** all of these modes of educational change would contribute to the teaching of art in a fuller, more balanced, and accurate way, by including the contributions and opportunities of women in the arts in the context of the past, present, and future. As already mentioned, the enlarging benefits will be extended to the field as well as the individual and society.

D. A PLURALISTIC APPROACH TO SEX EQUITY IN ART TEACHER EDUCATION

This section provides a pluralistic approach to sex equity in art teacher education as a logical and efficient way of increasing sex equity in art

SEPARATIST	PLURALISTIC
A healthy critique of existing systems. Women reclaiming and taking pride in their heritage and developing cooperative self-direction and definition.	Introduction of feminine values into existing systems. Women and men developing and expressing a fuller range of human behaviors and aspirations.

and art education as well as society. Although varying degrees of sex equity awareness and action may have been already achieved by many art teachers, the following sections theoretically describe facets of the pluralistic approach under the headings: who, what, when, where, and how, and why.

1. WHO? The Art Teacher

Since attitudes towards self, society, subject, and careers are developed early in the young, it is the art teacher, working in classroom and other educational settings, who will play a central role in bringing about positive and informed attitudes towards women and art in society. Children "naturally" learn sexual stereotypes and thus cannot be responsible for breaking out of them concurrently. Furthermore, while art teachers teach about and through visual imagery in art and

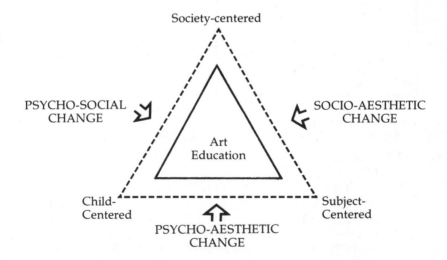

Figure 5
A PLURALISTIC MODEL FOR SEX EQUITY IN ART EDUCATION*

*Renee Sandell, "Feminist Art Education: Definition, Assessment and Application to Contemporary Art Education." Unpublished doctoral dissertation, The Ohio State University, 1978.

society, they themselves are role models, performing many functions beyond classroom teaching such as school and community resource persons and/or active artists. Therefore, the responsibility of teaching with an awareness and avoidance of the damaging effects of stereotyping in self, subject and society remains with the teacher.[5]

2. WHAT? Areas of Content

The pluralistic approach to sex equity will involve the revising of content in both art and education courses which are traditionally part of pre- and in-service art teacher education. Both theory and practice as taught in required education and art courses will be augmented or challenged by new awareness and critical examination. Table 4 indicates the general content areas that will need revision; these areas are described in the sections following:

Table 4

AREAS OF CONTENT FOR A PLURALISTIC
APPROACH TO SEX EQUITY IN ART TEACHER EDUCATION

EDUCATION Theory and Practice	ART Theory and Practice
Sex Equity & The Child in School & Society	Sex Equity and Personal Fulfillment through Studio Art Experience
Sex Equity & Teacher Professionalism	Sex Equity and Artistic Heritage
	Sex Equity and Art in Society

a. EDUCATION THEORY AND PRACTICE

(1) **Sex Equity and the Individual Child in School and Society** involves awareness and critical examination of the following:
 - That the informal education of children and the cultural limitations imposed by overt and covert sexual stereotyping and other forms of discrimination in society are transmitted via the popular media, social customs, products, toys, printed matter, etc.
 - That formal sexist pressures are reinforced in the classroom, particularly in the "hidden curriculum" and are transmitted via school norms, curricular content, instructional materials, use of language, and teacher behavior as well as "feminizing" tendencies of the school which encourage passitivity in students.[6]
 - That the *research* about sex differences, which contradicts strongly-held beliefs of female inferiority, holds that the most conclusive findings are in the area of women's low achievement-motivation and career aspirations.

- That the sex equity needs of students change at *different levels:* Elementary school teachers need to avoid stereotype reinforcement via behavior, language, media, and images. Secondary school teachers need to check their own behavior modeling and curricular biases to prevent damaging the diverse future career orientations and needs of their students.

(2) **Sex Equity and Teacher Professionalism** involves awareness and critical examination of the following:
- That *sexual stereotypes* in beliefs, activities, and career choice can negatively affect art teachers' personal aspirations, levels of confidence, and professional development. Art teachers need to strengthen their teaching abilities to prepare for on-the-job realities as well as their commitment to professional standards of competence in art education.
- That art teachers need to develop *new practical education and art skills.* These include: consciousness-raising and assertiveness training, job search skills and resume writing, budget savvy and advocacy techniques, ways to maintain artistic productivity while teaching, as well as facility in using technical equipment such as video-recorders and computers as well as art materials such as wood, metal, and photography.
- That as strong and sensitive *role models* in the classroom, school, and community, art teachers need to strengthen their efforts at networking and advocacy with school staff, politicians, museum and other art educators, to help make the school a more dynamic learning site for both girls and boys while raising the status of art in schools and society.

b. ART THEORY AND PRACTICE

(1) **Sex Equity and Personal Fulfillment Through Studio Art Experiences** involves awareness and critical examination of the following:
- That all individuals, male and female, need and can benefit from the *"qualitative" learning* that the arts offer—the ability to express (create) and respond (make judgments) related to self, subject and society, necessary for both sexes and persons of all disciplinary fields.
- That there are limiting stereotypes present in the assumptions and instructional practices of studio art processes (in terms of materials, techniques, formal and conceptual principles and aesthetic preferences and sensibilities) and that all students need *equal access to art skills and knowledge.* For example, the prevailing view that power tools used in woodworking are primarily to be used by boys might be nullified by research findings and class observations of skill and proclivity of each individual. The realization that girls not only can operate such equipment, but *need* such equipment and skills in woodworking (for many kinds of activities in life as well as art), widens the range of possible modes for their artistic expression.

- That sex-bias must be avoided in terms of *classroom methods of studio art instruction* such as motivational techniques, types of projects, visual examples, use of language, learning strategies, student critiques, discussion of career applications, as well as soliciting physical aid in transporting supplies/equipment and cleaning up.

(2) **Sex Equity and Artistic Heritage** involves awareness and critical examination of the following:

- That the *history of art* includes the study of women artists and their contributions, the conditions under which art was made by women, and recently discovered modes of expression that comprise women's tradition in the visual arts, and that "today, a feminist or non-sexist approach is being created that is sensitive to women's historical, sociological, political, and psychological situation."[7] A revisionist, and thus more comprehensive, art history includes examination of the historical conditions and women's access to certain kinds of art products (i.e. china painting, weaving, etc.), as well as limitations on women's educational and professional opportunities in general.
- That *art historiography*, the process of writing art history and criticism, accounts in part for unequal treatment of women in art and that "the white western male viewpoint, unconsciously accepted as *the* viewpoint of the art historian is proving to be inadequate."[8] This includes the reasons why women artists, such as Mary Cassatt, have been regarded as tokens in art history, and other women artists, such as Marie Laurencin,[9] have had their artistic works overlooked and minimized, even by feminist art critics.
- That the presentation of *female and minority role models* in art history can complement and enhance existing knowledge of art history as well as stimulate recognition in and contributions to art and art history, thus enlarging the subject of art and its importance.

(3) **Sex Equity and Art in Society** involves awareness and critical examination of the following:

- That the historical and contemporary views of woman, revealed through *iconography*, frequently reinforce stereotypes related to woman's image and activities in the art world and society. For example, many images of women in art, such as that of madonna, muse, and temptress, that reinforce the myth of woman's inferiority in society are also used in advertisements for liquor and cars, as well as direct pornography designed for male consumers. Additionally, stereotyped images of males as patriarchs and superheroes present limiting roles and options for men.
- That female *participation and contribution* to the arts is important. In some societies, women exclusively do the image-making, while in the western world, women's artistic activities are undermined by a male-dominated art world in which art galleries, dealers, museums, etc., have been biased against women's work while frequently servicing elite members of society.

- That the feminine *status* of art in society and art education in the schools be changed via advocacy campaigns and art programmatic excellence to reveal the importance of the visual arts to the individual, school, and society.

3. WHEN? In All Stages of Professional Education and Development:

a. **PRE-COLLEGE EXPERIENCE,** when career aspirations, interests, values, and skills begin to develop.

b. **UNDERGRADUATE SCHOOL AND PRE-SERVICE EXPERIENCE,** when channeling of interests, new knowledge, and initial field experiences help to form teaching skills, habits, and style.

c. **WORK EXPERIENCE IN THE FIELD** (in schools, in local departments of education, recreation centers, museums, etc.), when active professional practice and development occurs.

d. **IN-SERVICE EDUCATION AND/OR GRADUATE EDUCATION,** when workshops, courses, conferences, etc., are pursued for the improvement and/or administration of practical skills, specialization, supplementary knowledge, and/or professional advancement.

4. WHERE and HOW? In and Through Phases of the Educational Process

a. **SELF-EDUCATION.** Through increasing awareness of one's personal life experiences and associations in gender-related roles as child, sibling, spouse, parent, etc., with other family, and non-family members, and colleagues.

b. **FORMAL EDUCATION.** Through pre- and in-service training in educational institutions via courses in areas such as women's studies, education, art, art education, art history, psychology, sociology, and other related subjects from which teachers can develop a greater awareness and skills for sex equity to be applied in art teaching.

c. **INFORMAL EDUCATION.** Through learning that is transmitted via informal, non-school means such as the popular media, books, exhibitions, films that deal with issues related to sexism and sex equity, all of which affects the process of continuing self-education and change.

5. WHY? (Summary)

a. **THE NEED FOR SEX EQUITY REVISIONS IN ART EDUCATION.**

As has already been shown in *Figure 1* in Chapter 4, art teachers as such are not currently part of the women's art movement, and therefore their students may not be experiencing the kinds of sex equity revisions that have developed in the fields of art and education. Through revisions in their own preparation and practice via professional studies,

art teachers can liberate younger members of society to have androgynous values, educational concepts and opportunities in the arts. Further, they can potentially eradicate the need for women's studies, which may be regarded as remedial education, if earlier training in art/education is nonsexist.

b. ALTERNATIVE WAYS OF ACHIEVING SEX EQUITY IN ART EDUCATION.

While there are other ways to achieve sex equity in art education, revisions in art teacher training so that art teachers can meet the sex equity needs of their students is probably the best route to follow. Feminists in general education in both schools and universities would be likely to overemphasize feminist content and underemphasize, and thus bastardize, important art content. Feminist artist-educators, many of whom advocate separate instruction for women and girls by female instructors, might teach a one-sided view of art/art history that would constitute reverse discrimination in schools and universities that teach both sexes. Another way, which is consistent with the "informal" mode of education in the women's art movement, would be to let the art critics, art historians, and museums, do it. This mode is too distant and indirect since, though museums, art historians, and critics educate about art, their purposes differ from that of the art educator who is concerned with creative growth in people, rather than the cultivation of artists and the cataloguing of art objects.

c. THE ART TEACHER AND SEX EQUITY NEEDS OF STUDENTS.

The art teacher, with an awareness of gender-related issues and revisions in education and art, attained through all phases of their educational process in all stages of their professional development, needs to actively work to bring about sex equity in our field. This will assist in meeting the following student needs in "the school of tomorrow's women" and men: (1) the minimization of stereotypes; (2) exposure to experiences, ideas, and models; (3) skill development for choice, problem-solving, and evaluation; and (4) self-differentiation and self-knowledge.[10] These areas are emphasized for girls and women since their psycho-social development reflects such deficiences, while boys and men have developed skills (in the last three areas) in and out of school. However, when nonsexist education influences girls to be more assertive (not aggressive), boys may develop skills to better express their emotions and sensitive response to aspects of life of which they, through their own stereotypes, have been deprived.

d. CONCLUSION

By including a pluralistic approach, art education can address the sex equity needs of the individual and society as it seeks "to change the power that controls women's lives without extending oppression either to other women, to groups of minorities, or to men

themselves;"[11] while enlarging the goals and domain of art education. Such a task may be accomplished through revising the art education of women and men, which begins with the training or re-training of art teachers.

NOTES AND REFERENCES

[1] For a more comprehensive discussion of integrationist, separatist, and pluralist approaches to sex equity in art education, see: Georia C. Collins, "Feminist Approaches to Art Education," *The Journal of Aesthetic Education,* 15, 2, (1981): 83-94. In her concise history of the contemporary women's movement, *What Women Want: The Ideas of the Movement* (Cambridge, Mass.: Harvard University Press, 1975), Gayle Graham Yates similarly discerns three basic ideologies underlying thought and prescription associated with the women's movement: the Feminist, the Women's Liberationist, and the Androgynous. Although the names are different, the ordering principles and methods of analysis employed by each are very similar to what we are calling the integrationist, separatist, and pluralist positions.

[2] Elliot W. Eisner, *Educating Artistic Vision* (New York: The Macmillan Co., 1972), p. 58.

[3] Laura Chapman, *Approaches to Art in Education* (New York: Harcourt, Brace, Jovanovich, Inc., 1978), pp. 19-20.

[4] Eisner, *op.cit.,* p. 58.

[5] For a discussion of the need for the women's movement to affect the schools, with teacher re-education as a top priority, see Florence Howe, "Sexism, Racism and the Education of Women" *Today's Education* 62 (May 1973): 47-48.

[6] Patricia C. Sexton, "Schools Are Emasculating Our Boys," *Saturday Review,* June 1965.

[7] Barbara E. White, "A 1974 Perspective: Why Women's Studies in Art and Art History?" *Art Journal* 35, 4 (1976): 340-344.

[8] Linda Nochlin, "Why Have There Been No Great Women Artists?" *Art News* 69, 9 (1971): 22-39, 67-70.

[9] Renee Sandell, "Marie Laurencin: Cubist Muse or More?" *Women's Art Journal* 1 (Spring 1980): 23-27.

[10] Patricia P. Minuchin, "The Schooling of Tomorrow's Women" *School Review* 80 (February 1972): 199-208.

[11] Florence Howe, ed., *Women and the Power to Change* (New York: McGraw-Hill, 1975), p. 133.

SECTION V.

Matters of Revision, Strategies, and Resources

PURPOSE: To increase awareness, promote understanding, and encourage further inquiry into art related sex equity *strategies* by exploring classroom applications and resources for art and art education.

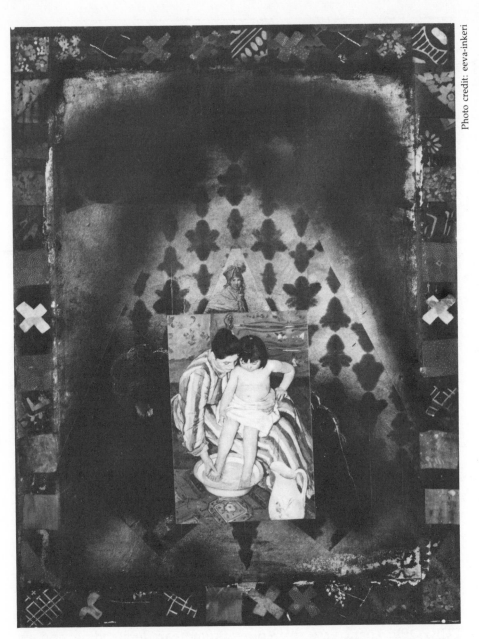

Miriam Schapiro. *Collaboration Series: Mary Cassatt and Me.* 1976 Acrylic and collage on paper.

CHAPTER 9:

Sex Equity Revision Through Practical Applications in Art Education

"Our greatest need is to see ourselves and all people as people with far more potentials for development in far more different ways than our stereotypes would allow . . . To be full persons, we don't need to have the male goal as our goal—but as people, find what is our most natural way to define our individuality. What this means . . . is redefinition of the nature of what society can be. It is the fear of this in ourselves and in society at large that keeps us back. But of all the single factors that could make world systems work more effectively in this limited resource/space capsule we live on is to change that status of women worldwide. . . . Coupled with more intellectually and creatively productive women, we could double our potential to solve our environmental and social problems. This may seem an unattainable dream, but more of us are dreaming, and out of such dreams come ideas, and with the ideas the power to develop them.

—June King McFee (1975)

A. NEED FOR SEX EQUITY EFFORT IN ART EDUCATION

Our reviews of sex equity issues and responses, women's achievements in art and art education, as well as the discussions about research and a pluralistic model for sex equity in art education indicate the need for sex equity across the field and suggest many possibilities for applications through self, informal, and formal art education. Furthermore, since active sex equity revisions are occurring at an increasing rate in most educational subject areas, it is imperative that art educators' activities harmonize with these efforts, aside from the distinct advantages they bring to our field in terms of self, subject, and society. With the basic assumption that nonsexist cultural change will

only be achieved through identification and increased awareness of sex equity issues *and* active effort to remedy the problems surrounding the issues of gender, art, and education, this chapter provides self-, informal, and formal educational tools for art educators. First, a sex equity awareness inventory, exploring values, beliefs, and ideas, and the impact of these on art educators' identity and performance, is provided to increase self-awareness and direct attention to curricular and instructional revisions. Second, eight general guidelines for nonsexist art instruction, which parallel sex equity approaches used in other educational areas, are offered as a foundation for revised instructional practice in the classroom and field. The final section provides a list of sex equity art problems/experiences that can be used in the classroom to enhance personal fulfillment through art, understanding the artistic heritage, and understanding the role of art in society.

B. AWARENESS IS THE KEY TO ACHIEVING SEX EQUITY IN ART EDUCATION

1. Why?

The key to achieving sex equity in art education is to increase professional awareness of sexism and sex equitable alternatives in terms of self, subject, and society. Self-awareness involves personal and professional gender-related issues such as family, home life, personal values and behaviors, work attitudes, and career aspirations. Social awareness includes women's actual and potential roles in home, workplace, society, and history as well as stereotyped roles that limit societal options for men. Art awareness involves women's roles and contributions to art and art education in both historical and contemporary contexts. Such awareness is prerequisite to the promotion of sex equitable practices in art education, and of art in education.

This section provides a sex equity awareness inventory of statements and questions to be used as a consciousness-raiser and self-educating instrument for art educators; it can be used individually, in pre- or in-service courses, or with groups of colleagues. Part I provides a list of statements with which art educators may agree or disagree as they explore thier values, beliefs, and ideas about women, art, and education. Questions in Part II examine the impact of these values, beliefs, and ideas on the identity and performance of art educators.

2. Sex Equity Awareness Inventory: Part I

WHAT ARE MY VALUES, BELIEFS, AND IDEAS ABOUT ART AND ART EDUCATION?

	Agree				Disagree
Do I agree that:	1	2	3	4	5
1. It is a compliment to tell a woman that she paints like a man.					

Do I agree that:

	Agree				Disagree
	1	2	3	4	5

2. Women concerned with sexism in the artworld should put more effort into learning their craft rather than organizing to protest sex discrimination in art education, critical reception, and historical treatment.

3. Women cannot expect to be as successful as men in the artworld unless they are willing to forego marriage and motherhood.

4. Males who choose art for a career tend to be more feminine in attitudes and behaviors than males who choose most other careers.

5. Boy art students who resist needlework and pastels should be immediately provided with alternatives.

6. The fact that there are more women than men who teach elementary school and more men than women who teach art at the college level indicates that women prefer to work with younger children.

7. An art teacher is justified in devoting more time to male than female art students because the former are more likely to have to earn livings through art.

8. A career in art education is more likely to be fulfilling for a woman than for a man.

9. It is an important part of learning sex-roles that teachers call more on boys than girls for lifting heavy equipment or overseeing tasks requiring aggressive leadership.

10. Serious women art students should be encouraged to avoid media, processes, images, styles and subjects which have become associated with femininity.

11. Art is popularly considered a more frivolous and feminine type of activity than science, engineering, and medicine and is therefore a more appropriate career choice for women.

Do I agree that:

	Agree		Disagree		
	1	2	3	4	5

12. Women might be more artistic than men but the great geniuses in art are almost exclusively male.

13. Women who have attained critical and historical acclaim in art are probably rather masculine in their behavior and attitudes.

14. Female art students are more likely than males to benefit from instruction in watercolor, and males are more likely than females to benefit from instruction in welded sculpture.

15. Real creative problem solving in art requires a degree of courage and self-directedness which most females do not possess.

16. Art teachers, parents, and counselors tend to take the career aspirations of male art students more seriously than those of female art students.

17. Parents should be more worried if a son chooses to become an artist than if a daughter chooses to become an artist.

18. The fact that female art students more often than male art students tend to underestimate their own abilities should remind us that success in art requires, in addition to talent, characteristics more commonly found in males than females.

19. The fact that art education has less status than either studio art or art history is entirely unrelated to the fact that more women teach and major in art education than in studio art or art history.

20. Male art students typically are more serious in their commitment to art than are female art students.

21. If feminine identified art forms, media, styles, processes, or subject matters have been given less status, it is not because of their association with women but because they have intrinisically less art value. Monumental public sculpture honoring war heroes is of more value to a community than is miniature flower painting.

Do I agree that:	Agree		Disagree		
	1	2	3	4	5

22. Women have tended to work more often in the crafts and minor arts because achievement in these forms demands less creative talent than the more prestigious of the fine arts.

23. To insist that galleries and museums exhibit equal numbers of works by male and female artists is to invite a lowering of critical standards and to encourage reverse discrimination.

24. Art skills, concepts, and values are neither masculine nor feminine.

3. Sex Equity Awareness Inventory: Part II

HOW DO MY VALUES, BELIEFS, AND IDEAS ABOUT GENDER, ART, AND EDUCATION AFFECT MY *IDENTITY AND PERFORMANCE* AS AN ART EDUCATOR?

Personal/Professional Development:
Curriculum and Art Instruction: (What do I observe/convey in my teaching practice?)

- What multiple roles do I play in my personal life?

- How am I viewed by others in terms of my gender? Am I seen as an active, passive, aggressive, assertive, etc. male/female?

- Do I experience or anticipate any conflict between my roles as a woman, wife, or mother (or man, husband, or father) and my work as an artist and/or teacher?

- Has my gender had any effect on my decision to be an art teacher as well as an artist?

- Has my gender had any effect on the media, style, process, subject matter, content, or scale of my art work?

- Has the women's movement had any real effect on my work as an artist and teacher?

- How is my school/institution organized hierarchically (staff, space, climate, funding of subjects, salaries, etc.)?

- Is there a difference in importance or status of subject areas? Is art perceived as a serious subject or just fun activities and not real learning?

- How do guidance counselors and administrators view the art career aspirations of students? Is there a sex-differential used in art career channeling?

- Aside from my regular school assignment, what contributions am I, as the/an art person, expected to make (such as yearbook, scenery, program designs, decorations, etc.)?

- Am I an assertive, informed, and sensitive advocate for my subject area in school and community?

- What sex differences do I see in art behaviors (interests, art forms, style, etc. in the classroom)? What stereotypes are present?

- Are creative abilities and skills different for boys and girls?

- Do I differentiate on the basis of interest in art? How do I treat (and what are my expectations of) an "interested' boy/girl? "untalented" boy/girl?

- Do I perceive differences in aspirations of boys and girls to be artists, art teachers, etc.?

- Are some kinds of art work (media, style, etc.) more sex-appropriate than others, say sculpture vs. embroidery?

- Are girls more cooperative and boys more disruptive?

- Should girls clean brushes and wipe tables? Should boys move boxes?

- Is my use of language sexist, i.e. "the artist, he . . ."?

- What kind of role model am I in terms of my gender-related teaching style, values, and approach to art education?

- Are my studio problems "quick 'n easy," due to time and space constraints? Following the *Woman's Day* model of "instant" art education"?

- Do I teach art history that includes women's contributions to and participation in art? Do my students learn that professional artists are male but women can use art in homemaking?

- What image of the importance of art and art skills do I give to my students? who are artist-majors, aesthetic consumers, etc.?

- What emphasis do I place on art in society? Are stereotypes related to holidays, gifts, etc. discouraged?

- Do I give all my students, male and female, equal access to art forms, skills, and knowledge?

- Are my students given the art career information they need?

C. SEX EQUITY GUIDELINES TO PRACTICE IN ART EDUCATION

The logical step that follows personal and professional awareness is that of revising teaching practice in art education to be nonsexist. In Table 5, eight guidelines for nonsexist teaching in general education, developed by Myra and David Sadker[1], are paired with a discipline-specific set of guidelines for nonsexist teaching of art. To the extent to which art educators' sex equity efforts link up with those in general education, students' self-development and social understanding, in addition to enhanced art learning, will be augmented in a consistent manner.

Table 5
GUIDELINES FOR NONSEXIST EDUCATION
APPLIED TO ART EDUCATION

GUIDELINES FOR NONSEXIST TEACHING*	GUIDELINES FOR NONSEXIST TEACHING OF ART
1. Nonsexist teaching should be continuous and integral to daily instruction.	1. Nonsexist art teaching involves building a strong, continuous, and nonsexist program that deals with studio art, art history, and art in society and is sensitive to the creative and critical (response) values taught through art which are related to art and all other areas of learning.
2. Nonsexist teaching must direct attention to the stereotypes and problems that affect boys as well as girls.	2. Nonsexist art teaching involves keeping art content and practice androgynous, avoiding stereotypes in terms of student interest and ability as well as media, style, subject matter, approach to art study, art careers, role models, etc.
3. Nonsexist teaching must also be concerned with discrimination on the basis of race/ethnicity/religion/class/age/and handicap.	3. Nonsexist art teaching must be concerned with art/gender related inequities: status of women and girls, status of art and education in society, status of art in education as well as discrimination on the basis of race/ethnicity/religion/class/age/ and handicap.
4. Nonsexist teaching should be a partnership between the teacher and parents and community members.	4. Nonsexist art teaching should be visible and strong in the school and community. Go public; lobby for your program and its strengths to other teachers, principals, and guidance counselors as well as parents and community members.

GUIDELINES FOR NONSEXIST TEACHING	GUIDELINES FOR NONSEXIST TEACHING OF ART
* 5. Nonsexist teaching is a total process. It should involve all aspects of the classroom environment.	5. Nonsexist art teaching involves all aspects of teaching: keep language and visual examples nonsexist as you provide art content and instruction which is free of sexist bias.
6. Nonsexist teaching is good teaching.	6. Nonsexist art teaching includes doing additional research to remove any sexist bias from your program. Be a strong role model as a teacher, artist, and person. Fortify yourself with other art teachers and join the NAEA and NAEA Women's Caucus.
7. Nonsexist teaching must include both the affective and cognitive domains.	7. Nonsexist art teaching should deal with the acquisition of awareness, skills, and knowledge in the areas of studio art, art history, and art in society, addressing both the creative and critical needs of girls and boys.
8. Nonsexist teaching is active and affirmative.	8. Nonsexist art education must provide role models (in history and the present) and a supportive system to promote aesthetic growth in girls and boys. Present a positive view of the importance of art for all people's personal and professional development.

*from Sadker & Sadker, *Sex Equity Handbook,* pp. 134-7

D. SEX EQUITY ART PROBLEMS TO SOLVE THROUGH EXPRESSION AND RESPONSE

1. Use

This section provides sample art ideas as problems to be solved by students and teachers. The content and skills involved in each activity can be scaled upwards or downwards in terms of depth and difficulty, by adjusting for differences in age/grade level. The activities/problems are offered as a set of initial concepts for exploration regarding gender, art, and education. In order to use them effectively, the art educator will have to link them to their existing curricula and instructional methods in a meaningful way. Lesson plans will have to be worked out; examples will have to be sought; and other specifics such as motivation, materials, evaluative criteria, strategies for response activities, demonstrations, procedures, etc. will have to be elaborated

by individual teachers in accordance with their field situation, and students' needs. The art educator using these ideas should recognize that they are merely suggestions for student involvement and are by no means exhaustive.

2. Scope

The sex equity activities are divided into three important art learning areas: personal fulfillment through art, understanding artistic heritage, and understanding the role of art in society.[2] Within each area, students should utilize the skills involved in both methods of art exploration: expression/activity and response/discussion. Expression relates to the *creative* experience by which students generate ideas, refine them, and put them into a meaningful form. Response involves the *critical* process by which students develop and apply their skills of perception, interpretation, and judgment.

3. Sex Equity Art Problems

a. SEX EQUITY ART PROBLEMS FOR PERSONAL FULFILLMENT THROUGH ART

EXPRESSION/ACTIVITY	RESPONSE/DISCUSSION
Make a collage of photographs/snapshots of yourself, creating a visual history of yourself. Add, by drawing, any other necessary details.	Discuss visual self-image in terms of sex and other roles, oneself as a changing subject and object.
Cut up a photograph of yourself and recompose it on a page using drawing media to create a new self-portrait of the person you really are.	Discuss the pros and cons of portraits/image. Create a fuller more substantial self-portrait.
Using drawing media and/or collage materials, create a self-portrait that reflects your view of yourself in ten years. Include your personal and professional aspirations.	Discuss self-image in terms of sex roles and aspirations projecting into the future. Compare and contrast to parents' and others' values and possibilities.
Do a large tracing of your body (whole or part); then imaginatively and *visually* create/complete the internal portions. These figures may later be cut out and mounted and used in another way.	Discuss the human body as source of art ideas and gender-related experiences.

EXPRESSION/ACTIVITY	RESPONSE/DISCUSSION
Select an object that has had great personal meaning to you. Do several different drawings of that object in the following contexts: domestic setting, professional setting, fantasy situation.	Discuss personal identification with objects and their relationship to gender-related experiences.
Design an ornament that beautifies and expresses your feeling about a part of the body (or an object) usually not adorned.	Discuss the nature of adornment as it relates to body image and appreciation.
Create/design a nonsexist jewelry to be worn by either sex—that you would proudly wear. Do the same for clothing.	Discuss the nature of clothing and jewelry in terms of sex roles, utilitarian and aesthetic functions.
Take a childhood object (such as a toy or baby blanket) that has had great personal meaning for you and recycle it into an art work that reflects your feelings about your past.	Discuss one's roots, early experiences, objects of attachment, and current reflections in terms of sex and other roles. Can you still relate to this meaningful object?
Create two still lifes of objects that you associate with the stereotypical male role and female role, using a varied style/approach to the media and subject matter.	Discuss the gender-identification of objects and their treatment in works of art. For example: *My Gems* by William Harnett can be compared to *Channel* (1974) by Audrey Flack.
Select and transform an utilitarian object from your household to make a statement about domesticity while creating a fine art object.	Discuss domestic objects and their utilitarian and aesthetic functions. Look at Meret Oppenheim's ''Object (Breakfast in Fur)'' and works by Duchamp to explore the relationship between subjects of mainstream and hiddenstream art.
Select a masculine-identified material/media and use it to express a typically feminine concept. Select a female-identified media (i.e. embroidery) and use it to make a masculine statement.	Discuss gender identification of media and materials and the degree to which it affects art content.
Gather many types of media and select one to work with; try to bring out its non-stereotypical style and handling, as you explore its possibilities. For example, utilize a masculine-approach to watercolor.	Discuss gender-association of styles connected with certain kinds of media. Find mainstream examples of art that shows a departure from stereotypical styles.

EXPRESSION/ACTIVITY	RESPONSE/DISCUSSION
Select a theme, subject, style, or design from your favorite mainstream artist and develop a utilitarian object that incorporates what you have selected. Any media can be used.	Discuss how mainstream art influences aesthetics in everyday life, and how it can be made more intimate.
Select a hero or heroine that you identify with (from comics, mythology, history, films, art) and create a painting that depicts the conflicts and weaknesses of the hero/heroine as well as the outward achievements and strengths.	Discuss the role and impact of heroes and heroines and their human dimensions. Examine mainstream works of art in terms of stereotypical depiction of heroes as well as diverse artists' interpretations. For example, study portrayals of David by Donatello, Michelangelo, and Bernini.
Keep a sketchbook/journal based on your observations of sex roles that you feel are positive or negative as you perceive them in your daily experience.	Discuss the prevalence, value, and harm of rigid sex roles for students, family life, and professional careers.
Make a large scale sculpture based on a small, fleeting, intimate personal feeling. Make a miniature sculpture or painting based on an archetypical/serious human emotion, idea, or event.	Discuss the function of scale in terms of the expressiveness and the valuation of works of art. Look for mainstream and hiddenstream examples in art history.
Research your female ancestors and develop an illustrated family tree. Do likewise for male ancestors. You may incorporate portraits, letters, memorabilia.	Explore one's roots and one's feelings about them as well as how art can be used to preserve heritage.
During a critique of art work, record the adjectives used to describe, analyze, interpret, and judge works of art. Also note style of responding to art work.	Discuss the impact of language as well as delivery (critique style) as they effectively/constructively provide feedback for class work.
Create a plan (strategies, organization, portfolio, opportunities to be sought, professional contacts to be made) that will help you become a successful artist. Try to be realistic and thorough; role playing with other class members might help.	Discuss the need for planning in terms of art careers. Discuss student preparation and realities of the art market (including financial planning).

EXPRESSION/ACTIVITY	RESPONSE/DISCUSSION
Modify a traditional pattern for quilting, embroidering, applique, etc., to express your feelings about contemporary society.	Discuss traditional and changing roles, values, patterns, for the individual, society, expressed in works of art. See the art of Miriam Schapiro.
Plan a special opening for a class exhibition of art work. Cooperatively decide on different tasks (i.e. hanging work, invitations, refreshments, clean-up, etc.), avoiding sexual stereotypes.	Discuss the importance and role of exhibiting art work and the tasks associated with it. Explore the values to personal growth that accompany the avoidance of stereotyped sex roles.
Create an art problem you will solve yourself. Specifiy criteria (i.e. media, idea, style, etc.). Document and analyze your progress towards your goal.	Discuss the steps of the creative process: general ideas, refining them and putting them into a meaningful form. Explore the importance of discipline and hardwork as opposed to instant gratification promised by craft magazines and how-to-do-it books.

b. SEX EQUITY ART PROBLEMS FOR UNDERSTANDING THE ARTISTIC HERITAGE

EXPRESSION/ACTIVITY	RESPONSE/DISCUSSION
Start an artist-of-the-week series, alternating male and female artists. Include artist's portrait or photo with an example of work.	Discuss artist, period, work, conditions, education, career patterns, main- or hiddenstream achievements. Relate to other art learning.
Examine works of art for their male and female attributes in terms of scale, style, media, subject matter.	Discuss stereotypes and assumptions that affect interpretation and judgment in criticizing works of art.
Examine contemporary art forms and methods by women artists such as "Womanhouse," "The Dinner Party," as well as body art.	Discuss the relationship between art and life and how these forms raise personal and cultural consciousness.
Study and compare portraits and self-portraits of an artist. For example, compare Picasso's *Self-Portrait* of 1908 with his image in Marie Laurencin's *Group of Artists*.	Discuss personality and image held by self and others as portrayed in art.

EXPRESSION/ACTIVITY	RESPONSE/DISCUSSION
Examine the works and study the biographies of husband and wife artist teams, their collaboration, individual achievements, career development, etc. For example, Sonia and Robert Delaunay. See Chapter 5 for other examples.	Discuss professional and personal relationships and mutual influences on career and quality of life.
Study women artists, their living conditions, and minor hiddenstream achievements in conjunction with learning about history and the history of art.	Discuss the lives and roles of female artists. Link them and their work with your knowledge of their male counterparts in different periods of art history.
Study unusual life styles for women artists such as those who refused to marry, those who undertook to fully support their families through their art, those whose husbands took over domestic duties to allow them to fully pursue their careers. (See Chapter 5)	Discuss atypical and role reversal situations of women artists to dispel stereotypes of women as well as the starving male artist cliché.
Examine male and female artists in terms of different creative periods in their careers and key works.	Discuss importance of artistic achievement occurring at different periods in terms of living conditions, world situations, etc.
Examine art of other cultures—strength of design, subject matter, and its impact on western art history. For example, the influence of Japanese prints on impressionism, primitive art on Cubism.	Discuss relationship and influence of art forms on art forms and the subsequent transfer of positive aesthetic value.
Examine the relationship between art and politics, particularly in art works by women artists such as Kollwitz, Chicago, May Stevens, etc.	Discuss women's political responses to sex roles in the art world and world-at-large in terms of the longstanding relationship between art and politics that includes: art as propaganda, artistic responses to political situations, government/church support of art.
Study the image of woman as portrayed in art works. What consistancies and what conflicts are there in representation? Differences at different periods/cultures? Depictions by male vs. female artists?	Discuss the images of women and their societal roles as depicted by male and female artists.

EXPRESSION/ACTIVITY	RESPONSE/DISCUSSION
Examine different artistic images of motherhood created by male and female artists such as Modersohn-Becker, Kollwitz, Kahlo, Cassatt, Renoir, Picasso.	Discuss the artist's view of motherhood. Explore the nature of traditional motherhood and contrast in terms of our changing societal roles for male and female parents.
Study the use of male and female nudes in private and public works of art throughout history. How do these relate to sex roles and self-concepts in the prevailing periods of history?	Discuss artistic treatment of the human body and its reflection of religious, social, political, and economic values.
Compare religious images of women such as the madonna or biblical heroines, during different periods of art history. Compare the images done by male and female artists.	Discuss the relationship of art and religion and compare artists' interpretations of religious themes at different historical periods (e.g. Renaissance vs. Baroque).
Examine and compare/contrast art of the Black and women's art movements of the 1960s and 70s respectively. What commonalities of concerns are expressed in these works? What materials, styles, subject matter are used?	Discuss the element of protest and affirmation within the mainstream of art. Relate and contrast these social concerns with earlier aesthetic concerns of avant garde movements such as Cubism, Futurism, Dada.
Examine the change of mainstream art institutions (guild, academy, avant-garde) over the history of art in terms of female access and participation. (For example, when women finally gained access to the major academies, the importance of the latter had diminished in mainstream significance, in deference to the avant-garde movements.)	Discuss major shifts in training of artists and producing works of art in the context of personal and art history.
Select several works of art by female and male artists and criticize them. Decide on your criteria and then apply it as you describe, analyze, interpret, and make a judgment.	Discuss the process and role/impact of art criticism/critic on traditional and modern art as well as male and female artists.

EXPRESSION/ACTIVITY	RESPONSE/DISCUSSION
Have all class members study male and female artists of a given period. Learn about historiography, the process of writing art history, by doing an art historical research project.	Discuss how art history is made using various tools/methods of research. Compare methods and findings.
Examine historical support systems for artists ranging from guild and academies to artist's circles (i.e. Cubists), family circles (i.e. Peale family of artists), artists' associations, etc.	Discuss the importance of support for the visual artist who works individually, frequently with a lack of social status and financial resources.

c. **SEX EQUITY ART PROBLEMS FOR UNDERSTANDING THE ROLE OF ART IN SOCIETY**

EXPRESSION/ACTIVITY	RESPONSE/DISCUSSION
Make a collage about women using images from women's magazines, men's magazines.	Discuss the function, prevalence, and nature of sex roles of women in society as portrayed in advertisements.
Make a collage about women using images from a feminist magazine such as *Ms.*	Discuss the changing sex roles of women portrayed in advertisements and illustrations.
Make a collage about men using images from diverse magazines: women's, men's, sports, etc.	Discuss the male role and image in society. What is the male "ideal"? Is it desirable?
Search for and develop a composite of new images of men and women as shown in advertising.	Discuss and analyze the new images in terms of credibility, role reversal, and likeliness to remain. For example, see Vantage cigarettes advertisement of woman artist that emphasizes the word "success."
Make a drawing or painting of important life events such as marriage, children, job, etc., for women . . . Then make one for men. Indicate as many details as you can.	Critique these works in terms of what is depicted, style, tone of work, and discuss personal response and attachment to what is portrayed.

EXPRESSION/ACTIVITY	RESPONSE/DISCUSSION
Create craft objects such as baskets, pottery, etc. that reflect influences from other cultures.	Learn about other cultures and their values and beliefs as you study their design and art forms.
Create a collage which is a mini-bulletin board of yourself. What images/objects would have to be there? With what prominence? What items will you save always? Why?	Discuss personal identity in terms of sex and other roles (age, class, interests, etc.) Build appreciation for diversity while revealing the importance of visual records.
Choose a holiday to study. Create a work of art to celebrate the occasion, avoiding stereotypes in terms of colors, content, and style. For example, in studying Thanksgiving, stick to meaning and multidimensions of the holiday, avoiding stereotyped portrayals of female cooks, Indians, etc.	Discuss holidays and other commemorative events and the need to retain/observe tradition by enriching it through creative and thoughtful extensions of its personal and social meaning.
Create a holiday for all Americans to celebrate. Plan out the rituals, symbols, ornaments, colors, etc., and describe the participatory observance of all.	Discuss sextyping in holidays and rituals—i.e. division of labor, in American and other cultures and among different ethnic groups.
Design a sex-neutral toy for a baby. What skills would it encourage/develop? Determine details—size, color, material, name, marketing approach.	Discuss sexism in toys and books for children and examine alternatives.
Create a unique gift for Mother's Day/Father's Day, avoiding stereotypes usually associated with the holiday.	Discuss the need for nonsexist approaches to holidays and avoidance of stereotyped gifts. Examine typical "suggestion" gift lists and critique for the sex-appropriateness of gifts.
Create a piece of folk art from elements of your home and family.	Define and discuss folk art, its appearance, strength, individual and social importance, despite its hiddenstream social valuation.

EXPRESSION/ACTIVITY	RESPONSE/DISCUSSION
Gather artifacts from your home and community (local, religious, etc.). Create a display/exhibit with other class members, by organizing, cataloguing, and presenting them to the larger group.	Discuss the role and importance of artifacts (their utilitarian and aesthetic importance in your life). Look for similarities and differences among individuals in interests and tastes/preferences and discover non-stereotypes about your classmates.
Keep a record of all the ways that society views art as an important subject; a less-important (feminine-identified) subject. Create arguments/examples that counteract these views.	Discuss the feminine-identification of art in society, and find ways of reversing.
Make a diagram or drawing that revises your environment and its artifacts (furniture, etc.) to be an ideal one.	Discuss the importance of artifacts and personal environment as an extension of self. Critique "suburban ideal" of home and sculptured garden in terms of individual values and taste.
Create a role play about women's traditional roles in the arts as well as home and society. Then make up a role play about women's equal participation and recognition in the arts and society.	Discuss the traditional role of women in the arts—as hiddenstream artist, inspiring muse, patroness, and preserver—and how it applies to women's other roles/participation in society.
Create a visual image of the woman artist as a heroine, using mixed media.	Discuss the current role of women in the arts as activist/radical and as mixtures of main- and hiddenstream artists, in relationship to other women's roles in society as well as role models for women and men in the arts.
Go to non-art museums and treat the artifacts and other items on display as art objects by drawing them; (1) in the display and (2) in their original context.	Discuss the importance of non-art museums as sources for historical, natural, and other kinds of images and ideas. Stress awareness of original vs. museum context for studying and appreciating diverse objects in society.

EXPRESSION/ACTIVITY	RESPONSE/DISCUSSION
Go on a field trip to local, hiddenstream artists' studios and study their development, work habits, achievements, and sources of satisfaction.	Discuss the kinds of valuable art contributions being made by individuals in your local community. What traditions are they a part of? Does meeting them in person and seeing their work stimulate your art interests and aspirations.
Go on a field trip or bring in to school artists/artisans who work with a variety of materials such as carpenters, architects, construction workers, etc.	Discuss the careers and work habits involved in art and their effect on personal life. Relate type of work to skills and ideas learned in art class.
Create a poster that portrays men/women in nonstereotyped roles.	Discuss sex roles as depicted in posters, advertisements, and art work as well as the nature of politics and art.
Re-design a label, advertisement or commercial to be nonsexist.	Discuss appeal and impact of sex role/consumer identification with products (cars, liquor, soap powders).
Make a portrait of yourself as an artist, art historian, architect, etc.	Discuss and analyze your view of yourself and your aspirations in terms of stereotypes and nonstereotypes.
Examine visual images that are frequently regarded as taboo. For example, critique images from pornographic magazines and contrast with art images such as Manet's *Déjeuner sur l'Herbe*.	Discuss the nature of taboo in works of art. What is the artist saying about women? Why is this approach being used to attract viewer attention? What kind of viewer is attracted to this kind of work? Should something be done about this?
Make a self-portrait of yourself that shows how you will relate to the arts as an adult. Will you be professional fine artist, craftsperson, commercial artist, art appreciatior/consumer, dabbler, etc.?	Discuss the range of participation possibilities with regard to art, thinking along the lines of your lifetime interests and other compatibilities.
Make a fine art object using industrial arts media and skills. What kind of convergence is involved?	Discuss the relationship of the fine arts to the industrial arts in terms of history, processes, and contemporary social needs. Discuss the overlap and contrast.

NOTES AND REFERENCES

[1] Sadker, Myra P. and Sadker, David M. *Sex Equity Handbook for the Schools*, (New York: Longman, Inc., 1982), pp. 134-137.

[2] For further discussion of these areas, see *Guidelines for Planning Art Instruction in the Elementary Schools of Ohio*, (1970) and *Approaches to Art in Education* (1978) by Laura Chapman.

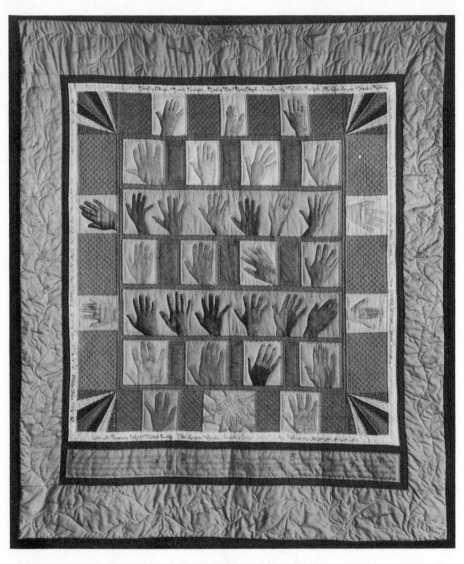

Signature Quilt #1. Charlotte Robinson, Bonnie Persinger, Bob Douglas, and members of the Quilt Research Staff, 1982. Raw silk, cotton. 96'' x 79''. (For additional information, see page 217.)

CHAPTER 10:

Strategies and Resources for Sex Equity in Art Education

Women artists' segregationism will . . . be justified if it can die, like a phoenix, to give birth to a radically nonsexist study of art, removing once and for all the need for any feminist books, periodicals or exhibitions.
— *Francine du Plessix Gray (1977)*

A. SEX EQUITY STRATEGIES FOR ART EDUCATORS

In keeping with our focus on awareness and action as a means to achieving sex equity in the field of art education, this chapter provides strategies and resources. The first section offers suggestions for art educators working in various modes and diverse field situations. The suggestions offered in each area are neither inclusive nor prioritized but rather intended only to stimulate creative thinking in the realm of positive sex equity effort in the field.

1. All Art Educators

All art educators, those listed in the following separate categories as well as art educators working in other capacities such as art therapy and museum education, concerned with bringing about an increase of sex equity in the field need to find *ways to increase their knowledge and awareness of sex equity issues in art education*. A few possibilities include:
- taking women's studies courses in art, education, and art education, and reading related literature;
- identifying and discussing sex inequities experienced in their own education;
- raising questions relevant to their own field situations at state and national meetings;
- examining existing art education literature for sex bias.

All art educators need to look for *ways to identify and implement effective sex equity strategies in art education.* Some possibilities include:

- reviewing existing sex equity materials and modifying these for use in art education;
- developing and testing nonsexist art instructional materials and sharing findings;
- reviewing and revising use of language and visual examples so that they are nonsexist;
- initiating cooperative efforts to secure support for the implementation, evaluation, and dissemination of effective sex equity strategies in art education.

2. Art Educators as Public School Teachers

Finding *ways to identify and evaluate art related sex differences among students is an important area of inquiry for teachers.* Two possibilities include:

- monitoring sex differences in the acquisition of skills, attitudes, and concepts essential to participation and achievement in art;
- preparing and testing remedial and compensatory instruction and documenting the results.

Teachers can also look for *ways to eliminate sex bias in their art curriculum content and instruction.* Possibilities include:

- keeping a journal on classroom practices and interactions which reinforce or mitigate sex role behaviors with low art value;
- increasing the number of slides of women's art and introducing both female and male role models for all types and levels of art occupations;
- comparing the social and pyschological impact of the women's and Black art movements;
- preparing a slide show on women's and men's leisure time art activity;
- developing a visual literacy unit on gender and racial stereotypes in commercial art and mass media;
- working with school counselors on career education in art that eliminates sex bias in the interpretation of student interest, aptitude, and aspiration;
- volunteering to review textbook illustrations and visual materials used in other subjects for their effectiveness and possible sex bias.

3. Art Educators as Teacher Educators

Teacher educators should look for *ways to identify and eliminate sex bias in their art teacher education programs.* This can be achieved by:

- reviewing levels and types of art and teaching interest in their students for possible sex differences;
- investigating possible sex bias in their students' required art studio and art history courses;
- developing non-sexist career counseling materials for use by art education, art, and education advisors;

- preparing and teaching women's studies courses in art education;
- developing and demonstrating sex equity art education materials for use in their own teaching, the public school classroom, and in-service workshops.

Increasing the status of art in education and the status of education in art should be a goal of teacher educators. A few possibilities to accomplish this include:

- investigating whether art education students are receiving equal treatment in art courses, student exhibitions, and general education courses;
- speaking to faculty in art and education departments on the feminine identification and marginal status of art education and how this effects the quality of public school art programs and art teacher education;
- working with public school art teachers and administrators to develop mutual support systems, art education scholarships, nonsexist art career packets, and cooperative exhibitions.

4. Art Educators As Supervisors and Administrators

Supervisors and administrators can identify *ways to build awareness and increase the status of women in art teaching and administration.* A few possibilities include:

- documenting sex differences in position, tenure, salary, promotion, and job satisfaction in their areas;
- identifying and working to eliminate institutional structures, practices, and values which effectively discriminate against women;
- conducting leadership workshops for women in art education;
- establishing a support network and grievance system for women art teachers;
- working on developing nonsexist curricula and career education in art;
- speaking to public school art classes about art administration as a career and the achievements of women in the field;
- working with public school art teachers and teacher educators to increase community and governmental support for public school art programs and sex equity efforts in art education.

5. Art Educators as Artists

Artists can find *ways to promote their own and other art educators' growth as artists, art critics, and/or historians.* Possibilities are:

- forming an art educators' art support and critique group;
- exhibiting with other art educators;
- developing a slide collection of art teachers' art work;
- speaking to art classes and community groups about the art work of art educators;
- making known success as an artist as well as an art teacher;
- investigating and preparing a unit on great artists who have also been art teachers.

Artists also can look for *ways to promote the development and recognition of women artists.* Methods for accomplishing this include:
- forming a women's art support and critique group;
- studying women's art history and the contemporary women's art movement;
- developing a slide-lecture on local women's art work and inviting women artists to speak on the relationship of their work and their work habits to gender experiences;
- encouraging local women's organizations to promote women's art;
- participating in the NAEA Women's Caucus slide sharing sessions and initiating similar sessions at state meetings.

6. Art Educators as Researchers

Researchers can look for *ways to increase their knowledge and awareness of sex inequity in art teacher education and public school art programs.* A few possibilities include:
- studying art related sex differences in student input and learner outcome;
- developing materials for teacher use in the identification and evaluation of art related sex differences;
- studying and documenting sex bias in the art content, classroom practice, and curricular status of art teacher and public school art programs.

The *elimination of sex inequities in research and art education occupational hierarchies* is another domain of concern to researchers. Possibilities include:
- helping art administrators and public school art teachers secure grants for sex equity research and programs in public school art education;
- preparing research reviews and presentations for audiences of public school art teachers and administrators;
- monitoring and reporting sex inequities in publications and the awarding of grants for art education research.

7. Summary

Increasing sex equity in art education will require both individual initiative and cooperative group effort in the realms of theory and practice. If we are to learn from our mistakes and take heart from our achievements, each of us must take the time to clarify our goals and assumptions and to document and share the results of those efforts. As sex equity programs in art education are implemented, continued dialogue and inquiry will be needed to insure both their education effectiveness and their artistic relevance.

B. SEX EQUITY RESOURCES FOR ART EDUCATORS: PLANNING AND WORKING FOR CHANGE

This section contains a beginning set of references and instructional materials for consumption by art educators working in schools and

other educational settings. Items have been selected on the basis of their strong educational value in the context of sex equity and art education. The sex equity resources for art education are presented under the separate headings *Art* and *Education* in each of the following three sections: Bibliography and Resource Guides, Recommended Reading Materials, and Audio/Visual and Instructional Materials.

1. Bibliographies and Resource Guides

a. ART

Bachmann, Donna G. and Piland, Sherry. *Women Artists: An Historical, Contemporary, and Feminist Bibliography.* Metuchen, N.J.: The Scarecrow Press, Inc., 1978.

This publication provides a comprehensive bibliography as well as brief, biographical sketches on women artists from the fifteenth to the early twentieth century.

Fine, Elsa Honig, Gellman, Lola B. and Loeb, Judy, eds., *Women's Studies and the Arts.* New York: The Women's Caucus for Art, 1978.

This publication contains additional course syllabi of women's studies programs in the arts, offered since the 1975 edition by Spear and Gellman. It also contains essays by Mary Garrard, Barbara E. White and Judy Loeb regarding the effects of women's studies on the arts.

Grant, Lynn O. *Anger to Action: A Sex Discrimination Guidebook.* The Women's Caucus for Art, 1978.

This is a self-help guide for identifying problems and developing plans of action. It includes a bibliography of resource and aid organizations.

Hill, Vicki Lynn, ed. *Female Artists Past and Present.* Berkeley, Ca.: Women's History Research Center, 1974. Also, Moe, Louisa, ed. *Female Artists Past and Present—International Women's Year 1975 Supplement.* Both available from: Women's History Research Center, 2325 Oak St., Berkeley, Ca. 94708.

These publications are annotated directories of practicing women artists as well as women working in other areas of the visual arts. They include organizations, galleries, slide registries, articles, publications devoted to women in the arts, books, exhibitions, festivals and other events comprising the contemporary female artists movement.

Krasilovsky, Alexis Rafael. "Feminism in the Arts: An Interim Bibliography." *Artforum* June 1972, pp. 72-75.

One of the earliest compilations on "women and the arts" issues, especially useful for modern art.

Navaretta, Cynthia, ed. *Guide to Women's Art Organizations: Groups/ Activities/Networks/Publications.* New York: Midmarch Associates, 1982.

This guide explores resources for women artists in the visual arts as well as in crafts, architecture, and design, music, dance, theater, and film, and electronic print media. The section on the visual arts provides a listing (by state) of major women's centers, groups, co-ops, and other spaces, catalogues of exhibitions, periodicals, articles, and special issues as well as directories and special projects by/for women artists. Also included are resources on archives, slide registries, and sources, financial opportunities, health hazards in the arts, and art business.

Spear, Athena Tacha and Gellman, Lola B., eds. *Women's Studies in Art and Art History.* 2nd edition. New York: The Women's Caucus for Art, 1975.

This publication contains course syllabi of women's studies courses in the visual arts as well as bibliographic materials of the early 1970s.

Women's Institute for Freedom of the Press, *Index/Directory of Women's Media.* Washington, D.C.: Anaconda Press, 1983.

This annual directory lists individuals and groups concerned with women in communication media for all types, including art, graphics, theatre, film, music, radio-tv, video and cable, and multimedia. This organization also published *Syllabus Sourcebook on Media and Women* edited by Dana Densmore, and *Women in Media: A Documentary Source Book* by Maurine Beasley and Sheila Gibbons.

B. EDUCATION

Artel, Linda and Wengraf, Susan. *Positive Images: A Guide to Non-Sexist Films for Young People.* San Francisco: Booklegger Press, 1976.

A guide consisting of more than 400 visual resources including video-tapes, filmstrips, slide shows and photograph collections with critical annotations.

Cusick, Judy, ed. *A Resource List for Non-Sexist Education.* Washington, D.C.: The Resource Center on Sex Roles in Education, National Foundation for the Improvement of Education (NEA), 1976.

This comprehensive resource list is divided into three sections providing:
(1) a compilation of resources which help define the problem of sexism,
(2) specific resources for educators to use with students,
(3) direction for locating further resources.

Froschl, Merle and Williamson, Jane. *Feminist Resources for Schools and Colleges—A Guide to Curricular Materials.* Old Westbury, New York: The Feminist Press, 1977.

This guide contains references to basic readings, book studies, and curriculum ideas for preschool, elementary, secondary, and higher education levels as well as sources for further information.

Howard, Suzanne. *Liberating Our Children, Ourselves—Handbook of Women's Studies Course Materials for Teacher Educators.* Washington, D.C.: American Association of University Women, 1975.

This booklet is useful for teacher educators, providing a rationale for women's studies in teacher education as well as course objectives, learning projects, syllabi, readings, and resources.

Olsen, Laurie, ed. *Nonsexist Curricular Materials for Elementary Schools,* Old Westbury, New York: The Feminist Press.

This guide offer a perspective on the need for nonsexist curriculum with exercises, readings, recommendations, and facts as supportive information. It is divided into two sections: for the teacher and for the classroom. The package includes a student workbook on discovering sex-role stereotypes.

Shaffer, Susan and Gordon, Barbara, compilers. *Resource Notebook.* Washington, D.C.: Mid-Atlantic Center for Sex Equity, American University, 1980.

This publication lists information on services provided by organizations on Title IX and sex equity. It also provides information on textbooks and instructional materials, community, parents, and students, advocacy and networking, personnel policies and practices, and major publishers of sex equity materials.

2. Recommended Reading

a. ART

(1) Books:

Bank, Mirra. *Anonymous Was a Woman.* New York: St. Martin's Press, 1979.

Berger, John. *Ways of Seeing.* New York: Penguin Books, 1977.

Broude, Norma and Garrard, Mary D., eds. *Feminism and Art History—Questioning the Litany.* New York: Harper and Row, 1982.

Callen, Anthea. *Women Artists of the Arts and Crafts Movement: 1870-1914.* New York: Pantheon Books, 1979.

Chicago, Judy. *Through the Flower—My Struggle as a Woman Artist.* New York: Doubleday and Co., Inc., 1975.

Chicago, Judy. *The Dinner Party—A Symbol of Our Heritage.* Garden City, New York: Anchor Books, 1979.

Clement, Clara Erksine. *Women in the Fine Arts: From the Seventh Century B.C. to the Twentieth Century A.D.* (1904), reprint ed., New York: Hacker Art Books, 1974.

Dewhurst, C. Kurt, MacDowell, Betty, and MacDowell, Marsha. *Artists in Aprons. Folk Art by American Women.* New York: Dutton in association with the Museum of American Folk Art, 1979.

Fine, Elsa Honig. *Women and Art—A History of Women Painters and Sculptors from the Renaissance to the 20th Century.* Montclair, N.J.: Allanhead & Schram, 1978.

Goffman, Erving. *Gender Advertisements.* New York: Harper Colophon, 1976.

Greer, Germaine. *The Obstacle Race—The Fortunes of Women Painters and Their Work.* New York: Farrar, Straus Giroux, 1979.

Harris, Ann Sutherland and Nochlin, Linda. *Women Artists: 1550-1950.* New York: Alfred A. Knopf, Inc., 1976.

Haskell, Molly. *From Reverence to Rape—The Treatment of Women in the Movies.* New York: Holt, Rinehart and Winston, Inc., 1973.

Hedges, Elaine and Wendt, Ingrid. *In Her Own Image: Women Working in the Arts.* Old Westbury, New York: The Feminist Press, 1980. (Teacher's manual also available).

Hess, Thomas B. and Baker, Elizabeth, eds. *Art and Sexual Politics—Women's Liberation, Women Artists and Art History.* New York: Collier Books, 1973.

Lippard, Lucy R. *From the Center—Feminist Essays on Women's Art.* New York: Dutton, 1976.

Loeb, Judy, ed. *Feminist Collage—Educating Women in the Visual Arts.* New York: Teachers College Press, 1979.

Mann, Margery and Noggle, Ann. *Women in Photography: An Historical Survey.* San Francisco, California: San Francisco Museum of Art, 1975.

Miller, Lynn F. and Swenson, Sally S. *Lives and Works: Talks with Women Artists.* Metuchen, N.J.: The Scarecrow Press, Inc., 1981.

Munro, Eleanor. *Originals: American Women Artists.* New York: Simon and Schuster, 1979.

Munsterberg, Hugo. *A History of Women Artists.* New York: Clarkson N. Potter, Inc., 1975.

Nemser, Cindy. *Art Talk: Conversations with Twelve Women Artists.* New York: Charles Scribner's Sons, 1975.

Parker, Rozsika and Pollack, Griselda. *Old Mistresses: Women, Art, and Ideology.* New York: Pantheon Books, 1981.

Petersen, Karen and Wilson, J.J. *Women Artists: Recognition and Reappraisal from the Early Middle Ages to the Twentieth Century.* New York: Harper Colophon Books, 1976.

Robinson, Charlotte, ed. *The Artist and the Quilt.* New York: Alfred A. Knopf, 1983.

Rubenstein, Charlotte Streifer. *American Women Artists—From Early Indian Times to the Present.* New York: Avon, 1982.

Sherman, Claire R. and Holcomb, Adele M., eds. *Women as Interpreters of the Visual Arts.* Westport, Conn.: Greenwood Press, 1981.

Snyder-Ott, Joelynn. *Women and Creativity.* Millbrae, Calif.: Les Femmes Publishing, 1978.

Sparrow, Walter Shaw. *Women Painters of the World.* New York: Hacker Art Books, 1976. (First published in London, 1905.)

Torre, Susanna, ed. *Women in American Architecture: An Historical and Contemporary Perspective.* New York: Whitney Library of Design, 1977.

Tucker, Anne, ed. *The Woman's Eye.* New York: Alfred A. Knopf, 1974.

Tufts, Eleanor, *Our Hidden Heritage: Five Centuries of Women Artists.* New York: Paddington Press, Ltd., 1974

Wald, Carol and Papchristou, Judith. *Myth American: Picturing Women 1865-1945.* New York: Pantheon, 1975.

Wilding, Faith. *By Our Own Hands: The Women Artists' Movement Southern California 1970-76.* Santa Monica, Calif.: Double X, 1977.

Zimmerman, Enid and Stankiewicz, Mary Ann, eds. *Women Art Educators.* Bloomington, Indiana: Mary Rouse Memorial Fund, 1982.

(2) Periodicals: Articles and Special Issues

Art in America. May/June 1976. "Women's Art in the 70s" by Lawrence Alloway.

Art Education. Journal of the National Art Education Association, November 1975. Issue dedicated to women's issues in art and art education.

Art Journal. (College Art Association) Summer 1976. Issue on women artists including article "Of Men, Women, and Art: Some Historical Reflections" by Mary D. Garrard. See also Fall/Winter 80.

Art News. January 1971. "Why Have There Been No Great Women Artists?" by Linda Nochlin.

Art News. October 1980. Issue focuses on women artists; articles include "Redefining the Whole Relationship Between Art and Society" by Grace Glueck.

Arts and Society. Vol. 2, Spring/Summer 1974. "Women and the Arts."

Chrysalis. No longer published; See back issues.

Exposure. Vol. 19, No. 3. Issue on women and photography.

Feminist Art Journal. No longer published; See back issues.

Feminist Studies. Winter 1973-74. "Fine Arts and Feminism: The Awakening Consciousness" by Lise Vogel.

Heresies: A Feminist Publication on Art and Politics. Published quarterly by Heresies, P.O. Box 766, Canal Street Station, New York, N.Y. 10013. Subscription rates $15 for four issues.

Hue Points, Newsletter of Women's Caucus for Art.

Signs, Journal of Women in Culture and Society. Winter 1975. "Art History" by Gloria Feman Orenstein.

Studies in Art Education, Vol. 18, No. 2, 1977. Dedicated to sex-role and leadership issues in art education.

Visual Dialog, Winter 1976, Summer 1977. "Women in the Visual Arts" issue.

Womanart Magazine, No longer published; see back issues.

Woman's Art Journal, published twice a year. Order from 7008 Sherwood Drive, Knoxville, Tenn. 37919.

Women Artists News. Bimonthly publication. Order from Box 3304, Grand Central Sta., New York, N.Y. 10163.

Women's Caucus for Art Newsletter. Fall 1980. "Women Artists: A Bibliographic Update."

Women's Studies Quarterly, published by The Feminist Press and the National Women's Studies Assn., Box 334, Old Westbury, N.Y. 11568.

b. EDUCATION

(1) Books

Bem, Sandra L. and Bem, Daryl. "Case Study of a Non-Conscious Ideology: Training the Woman to Know Her Place." in *Beliefs, Attitudes, and Human Affairs,* edited by Daryl J. Bem. Belmont, California: Brooks/Cole, 1970.

Frazier, Nancy and Sadker, Myra. *Sexism in School and Society.* New York: Harper and Row, 1973.

Greenleaf, Phyllis Taube. *Liberating Young Children from Sex Roles—Experiences in Day Care Centers, Play Groups and Free Schools.* Somerville, Mass.: New England Free Press, 1972.

Guttentag, Marcia and Bray, Helen. *Undoing Sex Stereotypes—Research and Resources for Educators.* New York: McGraw-Hill Book Company, 1976.

Harrison, Barbara Grizzuti. *Unlearning the Lie: Sexism in School.* New York: Liveright, 1973.

Klein, Susan, ed. *Handbook for Achieving Sex Equity Through Education.* Baltimore, Md.: Johns Hopkins University Press, forthcoming.

Maccia, Elizabeth Steiner, Colemen, Martha Ann, Estep, Myrna, and Shiel, Trudy Miller, eds. *Women and Education.* Springfield, Ill.: Charles C. Thomas Publisher, 1975.

Maccoby, Eleanor Emmons and Jacklin, Carol Nagy. *The Psychology of Sex Differences,* Stanford, California: Stanford University Press, 1974.

McClure, Gail Thomas and McLure, John W. *Women's Studies—Developments in Classroom Instruction.* Washington, D.C.: National Education Association, 1977.

National Project on Women in Education (US Department of Health, Education, and Welfare). *Taking Sexism Out of Education.* Washington, D.C.: U.S. Government Printing Office, 1978.

Nonsexist Education for Survival. Washington, D.C.: National Education Association, 1973.

Sadker, Myra Pollack and Sadker, David Miller. *Sex Equity Handbook for Schools.* New York: Longman, 1982.

Sex Role Stereotyping in the Schools. Washington, D.C.: National Education Association, 1973.

Sexton, Patricia C. *The Feminized Male: Classroom, White Collars, and the*

Decline of Manliness. New York: Random House, 1969.

Stern, Marjorie, ed. *Changing Sexist Practices in the Classroom.* Washington, D.C.: The Women's Rights Committee, American Federation of Teachers, AFL-CIO (Publication #600).

Sprung, Barbara. *Non-Sexist Education for Young Children: A Practical Guide.* New York: Scholastic Book Service, 1975.

Sprung, Barbara, ed. *Perspectives on Non-Sexist Early Childhood Education.* New York: Teachers College Press, 1978.

Stacey, Judith, Bereaud, Susan and Daniels, Joan, eds. *And Jill Came Tumbling After: Sexism in American Education.* New York: Dell, 1974.

(2) Periodicals: Articles and Special Issues

Feminist Studies. Summer 1972. "The School's Role in the Sex-Role Stereotyping of Girls: A Feminist Review of the Literature" by Betty Levy.

History Teacher. August 1973. "Discovering Women's History Through Art in the Classroom" by Susan Groag Bell.

Journal of Teacher Education. Winter 1975. Special issue on "the molding of the nonsexist teacher."

Language Arts. February 1978. "Educational Materials and Children's Sex Role Concepts" by Christina J. Simpson.

Psychology Today. December 1974. "Myth, Reality and Shades of Gray, What We Know and Don't Know About Sex Differences" by Eleanor Maccoby and Carol Nagy Jacklin.

Psychology Today. September 1975. "Androgyny vs. The Little Lives of Fluffy Women and Chesty Men" by Sandra Lipsitz Bem.

Saturday Review. October 17, 1971. "Sexual Stereotypes Start Early" by Florence Howe.

School Review. February 1972. Special issue on "Women and Education"

TABS: Aids for Ending Sexism in School. A quarterly journal that includes practical aids for sex equity in education.

Today's Education. May 1973. "Sexism, Racism and Education of Women" by Florence Howe.

3. Audio/Visual and Instructions Materials

a. ART

(1) Slides:

Garrard, Mary, ed. *Slides of Work by Women Artists: A Source Book.* Falls Church, Va.: West End Printing, Inc., 1974. One of the earlier compilations, now out-of-date, that includes sources for slides by women artists located in museums as well as commerical companies, in the U.S., Canada, and Europe. Also includes a listing of women artists by media and nationality. The author currently recommends the following other sources of slides sets of women's art:

Harper and Row, Colophon Books, 10 E. 53rd St., New York, N.Y. 10022. Four sets of slides developed in connection with their publica-

tion, J.J. Wilson and Karen Petersen, *Women Artists: Recognition and Reappraisal* plus two more sets. For information write to Harper and Row Media, 2350 Virginia Ave., Hagerstown, Md. 21740.

Sandak, Inc., 4 East 48th Street, New York, N.Y. 10017. Sets of slides by women, including one set of works from the FOCUS festival, Philadelphia, 1974

American Library Color Slide Co., 305 East 45th St., N.Y.C. 10017. A set of slides of works by women.

Environmental Communications, 69 Winward, Venice, California 90291. A set of slides of works from the Los Angeles County Museum exhibition, *Women Artists, 1550-1950,* prepared by Ann S. Harris and Linda Nochlin.

Alliance of Women in Architecture, Box 5136, FDR Sta., N.Y., N.Y. 10022. Two-projector, 150 slide presentation (with script) of American women architects' work from 1880s to present.

(2) Filmstrips

Four Women Artists, Educational Dimensions Corporation, Box 126, Stamford, Conn. 06904. This set includes two color film strips with 18 minute audio cassettes.

(3) Audiotapes

"Women in Art" and "Artists" Pacifica Audiotapes, 5316 Venice, Ca. 90019. Audiotapes on and by women in the arts and their issues. Tapes available on cassette or reel-to-reel. The programs include: "The Role of Women in the Arts," "Erotic Art by Women," "Women in the Art," "Women's Liberation and the Arts," "The Image of Women in Art," "A Conversation with Cindy Nesmer," "From One Struggle to Another."

(4) Videotapes

Signed by a Woman, Women's Arts Video, Los Angeles, Ca. 90026. A sixty minute color videotape illuminating the diversity of art produced by contemporary women artists. This documentary consists of interviews with visual artists, educators, and curators throughout California.

Women Artists Here and Now, Video Productions, South Bend, Indiana.

This is a black-and-white, 60 minute videotape documentary of the 1976 Women Artists' Workshop at the University of Notre Dame. It presents Alice Neel, Mary Miss, Selina Trieff, Mary Stoppert, and other artist in various roles—as teachers, as artists, as feminists. The artists and the artists' works, as well as their ideas, are presented.

Women in Art: Past and Present, Professor Alan Garfield, Southwest Missouri State University, Springfield, Missouri 65802. Five 30-minute color videotapes on women artists of various nationalities and historical periods.

Women in Art series, The Video Data Bank, Art Institute of Chicago, Columbus Drive and Jackson Blvd., Chicago, Ill. 60604. Videotaped interviews with Agnes Martin, Louise Bourgeois, Audrey Flack, Nancy Graves, Mary Miss, and Lucy Lippard.

(5) Films

The Originals: Women in Art, Films Incorporated, Wilmette, Illinois 60091. A six-part film series produced and directed by Perry Miller Adato. Highlighted in the films are artists Georgia O'Keeffe, Mary Cassatt, Louise Nevelson, Betye Saar, Helen Frankenthaler as well as numerous unknown women folk artists.

(6) Instructional Materials

"The Woman Artist" from the Art and Man series, published by *Scholastic Magazines,* Englewood Cliffs, N.J. 07632. This multi-media package examines the woman artist. It contains varied materials for classroom study such as 30 full-color copies of *Art and Man* magazine, a Teaching Guide, and related audiovisual aids.

"Cultural Pluralism and the Arts," University of Kansas, School of Education, Lawrence, Kansas 66045, 1983. This set of teacher materials was prepared for the teacher educator interested in implementing a multicultural perspective in visual art education and music education. It contains rationale, concepts, interpretations, and classroom activities on multi-cultural education.

b. EDUCATION

(1) Instructional Materials

Identity: FEMALE. Dun-Donnelley Publishing Corporation, New York, N.Y. 10074. This multi-media learning package is designed for grades 9 through 12 and junior college levels to build self-awareness, self-motivation, and self-confidence through the study of women.

Sex Stereotyping in Education. Education Development Center/WEEAP Distribution Center, 55 Chapel St., Newton, Mass. 02160. This is a set of 13 instructional modules, one of which is called "Repainting the Sexist Picture: Stereotyping in the Fine Arts." The latter examines reasons for the lack of women's recognition in the fine arts and explores stereotyped images of artists in American society. Encouragement of both sexes' artistic development is suggested.

Sex Role Stereotyping eduPak. National Education Association, Washington, D.C. 20036, 1973. This package includes filmstrips, cassettes, books, and pamphlets.

(2) Others Sources of Instructional Materials[1]

American Federation of Teachers, AFL-CIO, Human Rights and Community Relations Dept., 11 Dupont Circle, N.W., Washington, D.C. 20036. Publishes bibliographies, books, resource lists and curriculum materials on sex equity for parents, teachers, and students.

The Feminist Press, SUNY/College at Old Westbury, Box 334, Old Westbury, N.Y. 11568. Publishes nonsexist (children's, text, and other) books; compiles and provides bibliographies, outlines, and guides on women's studies courses, and serves as a clearinghouse for nonsexist educational materials.

Lollipop Power, Inc., Box 1171, Chapel Hill, N.C. 27514. Publishes bibliographies of nonsexist publications and specializes in nonsexist books for young children, ages 2 to 9

KNOW, Inc., P.O. Box 86031, Pittsburgh, Pa. 15221. Publishes books, pamphlets, and curriculum materials related to sex equity.

Women's Action Alliance, The Non-Sexist Child Development Project, 370 Lexington Avenue, Room 603, New York, N.Y. 10017. Publishes teaching packets and materials to assist educators in providing nonsexist education, especially for young children and parent education. Staff has developed toys, books, classroom materials, and multimedia resources such as nonsexist films.

Women's Educational Equity Act (WEEA) Publishing Center, Educational Development Center, Inc., 55 Chapel Street, Newton, Mass. 02160. Publishes (catalogue of) extensive resources for educational equity, products which have been developed under grants from the U.S. Department of Education under the auspices of the Women's Educational Equity Act. Materials include: curriculum materials for grades K-12, post-secondary, and women's studies, career and staff development materials, as well as specialized materials for multicultural, gifted and talented, minority and rural populations.

NOTES AND REFERENCES

[1] These are only a few sources for instructional materials. For a more extensive listing, see Sadker and Sadker, *Sex Equity Handbook for Schools,* New York: Longman, 1982, pp. 292-331.

Additional Information on *Signature Quilt #1*

Part of "The Artist and the Quilt" exhibition, touring 8/83 - 1/86. This quilt contains the working hand of each of the eighteen artists and sixteen quilters who worked together to produce the twenty quilts in the "Artist and the Quilt" exhibition. Organized by artist Charlotte Robinson, the exhibition, which will travel for two and a half years across the country, is a tribute to the artistic forerunners of today's women artists. Contemporary women artists, freed of constraints which bound our foremothers, have found new richness in exploring this ancient American art form, and in doing so they salute the often overlooked efforts of the women who came before. Artists in the Exhibition - 18 from five states and the District of Columbia - are: Alice Baber, Lynda Bengli, Isabel Bishop, Elaine Lustig Cohen, Mary Beth Edelson, Dorothy Gillespie, Harmony Hammond, Marcia King, Joyce Kozloff, Marilyn Lanfear, Ellen Lanyon, Alice Neel, Petty Parsons, Faith Finggold, Charlotte Robinson, Miriam Schapiro, Betye Saar, Rosemary Wright. Quilters in the Exhibition - 16 from eleven states - are: Amy Chamberlin, Bob Douglas, Chris Wolf Edmonds, Theresa Helms, Marie Ingalls, Angela Jacobi, Judy Mathieson, Sharon McKain, Edith Mitchel, The Mitchell Family, Patricia Newkirk, Bonnie Persinger, Willi Posey, Marilyn Price, Nancy Vogel, Winda F. Von Weise.

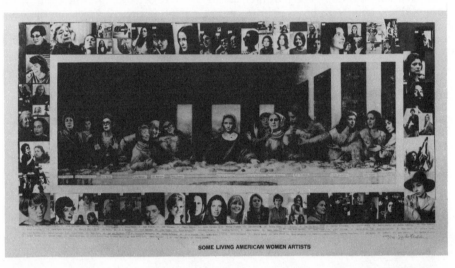

SOME LIVING AMERICAN WOMEN ARTISTS

Mary Beth Edelson. *Some Living American Women Artists/Last Supper.* 1972. Offset poster. Central figures depicted at this "Last Supper" (left to right): Lynda Benglis, Helen Frankenthaler, June Wayne, Alma Thomas, Lee Krasner, Nancy Graves, Georgia O'Keeffe, Elain DeKooning, Louise Nevelson, M. C. Richards, Louise Bourgeois, Lila Katzen, Koko Ono. (From top right corner, counter-clockwise): Agnes Martin, Joan Mitchell, Grace Hartigan, Yayoi Kusama, Marisol, Alice Neel, Jane Wilson, Judy Chicago, Gladys Nilsson, Betty Parsons, Miriam Schapiro, Lee Bontecou, Sylvia Stone, Chryssa, Suellen Rocca, Carolee Schneeman, Lisette Model, Audrey Flack, Buffie Johnson, Vera Simmons, Helen Pashgian, Susan Lewis Williams, Racelle Strick, Ann McCoy, J. L. Knight, Enid Sanford, Joan Balou, Marta Minnjin, Rosemary Wright, Cynthia Bickley, Lawra Gregory, Agnes Denes, Mary Beth Edelson, Irene Siegel, Nancy Grossman, Hannah Wilke, Jennifer Bartlett, Mary Corse, Eleanor Autin, Jane Kaufman, Muriel Castanis, Susan Crile, Anne Ryan, Sue Ann Childress, Patricia Mainardi, Dindga McCannon, Alice Shaddle, Arden Scott, Faith Ringgold, Sharon Brant, Daria Dorsch, Nina Yankowitz, Rachel bas-Cohain, Loretta Dunkelman, Kay Brown, CeRoser, Norma Copley, Martha Edelheit, Jackie Skyles, Barbara Zuker, Susan Williams, Judith Bernstein, Rosemary Mayer, Maud Boltz, Patsy Norvell, Joan Danziger, Minna Citron.

Appendixes

APPENDIX A:

Some Women Artists

I. SOME WOMEN ARTISTS OF THE PAST

PREHISTORY

Traditional accounts attribute cave paintings, small stone sculptures, and Stonehenge to male artists. Counter speculations suggest that women may had more than a figurative hand in these works.

ANTIQUITY (GREECE AND ROME)

Although no work remains, there is some documentation for the following:

Kora (7th century B.C.): Said to have "invented" relief sculpture.

Calypso: "Portrait of Theodorus, the Juggler"

Eirene: Paintings of "An Aged Man" and "Alcisthenes, the Dancer"

Laya (1st century B.C.): Said to have originated miniature painting and to have commanded high prices for work.

MIDDLE AGES

Manuscript Illumination

St. Harlinde and St. Relinde (8th century): artist/teachers.

Ende (10th century): *Beatus Apocalpyse of Gerona*

St. Hildegarde of Bingen (1098-1179): *Scivias.*

Herrade (12th century): *Hortus Deliciarum* (original destroyed)

Guda (12th century): Illuminated homily with signed self-portrait.

Tapestry/Stitchery

Queen Matilda and court ladies (11th century): Bayeux Tapestry.

Sculpture

Sabina von Steinbach (early 14th century): Stone figures, South portals of Strasbourg Cathedral.

RENAISSANCE TO 19th CENTURY

Italian

Caterina dei Vigri (1413-1463): Miniatures: "St. Ursula and Her Maidens"

Properzia di Rossi (c. 1490-1530): Sculpture. "Minute Carvings on Eleven Peach Stones."

Sofonisba Anguissola (1532/35-1625): Portraits and genre. "Three Sisters Playing Chess."

Lavinia Fontana (1552-1614): Portraits. "Portrait of a Lady with a Lap Dog"

Marietta Robusti Tintoretto (1560-1590): Many of her father's assigned works reattributed to her. "Portrait of an Old Man and Boy."

Artemisia Gentileschi (1593-1652): Female Biblical heroines. "Judith" paintings.

Elisabetta Sirani (1638-1665): Painter and teacher of women artists. "Salome"

Rosalba Carriera (1675-1757): Pastel portraits and allegories. "Louis XV as a Boy"

Flemish and Dutch

Levina Teerlinc (c. 1520-1576): Miniatures. "Portrait of Lady Hunsdon"

Caterina van Hemessen (1528-c.1587): Portraits and religious themes. "Self-Portrait"

Clara Peeters (1594-c.1657): Still lifes. "Breakfast Piece"

Anna Maria Schurmann (1607-1678): Miniatures, carvings, poetry, and music. "Self-Portrait"

Judith Leyster (1609-1660): Portraits, still lifes, genre. "The Jolly Toper" originally attributed to Hals.

Maria van Oosterwych (1630-1693): Flowers. "Flowers and Shells"

Rachel Ruysch (1664-1750): Flowers. "Fruits and Insects"

Spanish

Josefa de Ayala (1630-1684): Portraits, still lifes, religious themes. "The Mystical Marriage of St. Catherine"

Luisa Roldan (1656-1704): sculpture. "The Mystical Marriage of St. Catherine"

German and Swiss

Maria Sibylla Merian (1647-1717): Insect and Plant life. Naturalist. *The Metamorphosis of the Insects of Surinam.*

Anna Waser (1679-1713): Miniatures. "Self-Portrait"

French

Louise Moillon (1610-1696): Still lifes. "At the Greengrocer"

Sophie Cheron (1648-1711): Portraits, allegory, history. "Self-Portrait"

Anne Vallayer-Coster (1744-1818): Still lifes, allegory. "Allegory of Music"

Adelaide Labille-Guiard (1749-1803): Pastels, portraits. "Portrait of the Artist with Two Pupils, Mlle. Marie Gabrille Capet and Mlle. Carreaux de Rasemond

Marie Louise Elizabeth Vigee-Lebrun (1755-1842): Portraits, figures. "Mme. Vigee-Lebrun and Her Daughter"

Marguerite Gerard (1761-1837): Genre. "Motherhood." Collaborated with Fragonard on several paintings.

Constance Marie Charpentier (1767-1849): Heroic paintings. "Portrait of Mlle. Charlotte du Val d'Ognes" originally attributed to David.

Marie Guillemine Benoist (1768-1826): Student of Vigee-Lebrun and Labille-Guiard. "La Negresse"

Antoinette Cecile Hortense Haudebourt-Lescot (1784-1845): Italian genre scenes, portraits. "Self-Portrait"

Felicie de Fauveau (1802-1886): Sculpture. "Tomb of Louise Favreau"

Rosa Bonheur (1822-1899): Animals in landscape. "The Horse Fair"

English

Joan Carlile (1600-1679): Portraits, copies. "Stag Hunt at Lamport"

Mary Beale (1632-1697): Portraits. "Self-Portrait with Two Sons"

Anne Killegrew (1660-1685): Portraits, Biblical and mythological scenes. "Portrait of James II"

Catherine Read (d. 1786): Portraits: "Portrait of a Man with a Turban"

Frances Reynolds (1729-1807): Painting and Writing. "Portrait of Dr. Johnson"

Angelica Kauffmann (1741-1807) Swiss born: Portraits, history and mythology painting. "Self-Portrait"

Mary Moser (1744-1819): Flowers. "Tulips"

Anne Seymour Damer (1748-1828): Sculpture. "Elizabeth, Countess of Derby as Thalia"

Marie Cosway (1759-1838): Portraits, allegories. "Self-Portrait"

Margaret Carpenter (1793-1872): Portraits. "Portrait of John Gibson"

Barbara Leigh Smith Bodichon (1827-1891): Landscapes and feminist writings. "The Sea at Hastings"

Lucy Maddox Brown Rossetti (1843-1894): Figure paintings. "The Fugitive"

American

Henrietta Johnston (d. c. 1728): Itinerant painter. Small portraits. "Portrait of Thomas Moore as a Child."

Patience Lovell Wright (1725-1786): Sculpture. "William Pitt, Earl of Chatham"

Eunice Griswold Pinney (1770-1849): Watercolors. "Two Women"

Sarah Goodridge (1788-1835): Miniatures on ivory. "Portrait of Gilbert Stuart"

Ann Hall (1792-1863): Miniatures. "Ann Hall, Mrs. Henry Ward, and Henry Hall Ward"

Anna Claypoole Peal (1791-1878): Miniatures. "Portrait of Miss Susannah Williams"

Sarah Mirian Peale (1800-1885): Full size portraits. "Children of Commodore John Daniel Danels"

Herminia Borchard Dassel (d. 1858): Portraits. "Portrait of Ann Saltonstall Seabury"

Jane Stuart (1812-1886): Portraits, narratives, writings. "A Literary Subject"

Ann Whitney (1821-1915): Sculpture. "Roma"

Lilly Martin Spencer (1822-1902): Portraits, literary and allegory themes. "We Both Must Fade"

Elisabet Ney (1833-1907): Sculpture. "Portrait Bust of Arthur Schopenhauer"

Harriet Hosmer (1830-1908): Sculpture "Zenobia in Chains"

Edmonia Lewis (1843-1900): Sculpture. "Forever Free"

II. SOME MODERN AND CONTEMPORARY WOMEN ARTISTS

GERMAN AND SWISS

Kathe Kollwitz (1867-1945)

Paula Modersohn-Becker (1876-1907)

Gabriele Munter (1877-1962)

Hannah Hoch (b. 1889)

Sophie Taeuber-Arp (1889-1943)

Meret Oppenheim (b. 1913)

RUSSIAN

Marie Bashkirtseff (1859-1884)

Natalya Sergeevna Goncharova (1881-1962)

Alexandra Exter (1882-1949)

Nadezhda Andreevna Udaltsova (1885-1961)

Olga Vladimirovna Rozanova (1886-1918)

Liubov Serbeevna Popova (1889-1924)

FRENCH

Berthe Morisot (1841-1895)

Eva Gonzales (1849-1883)

Suzanne Valadon (1865-1938)

Sonia Delaunay (b. 1885)

Marie Laurencin (1885-1956)

Germaine Richier (1904-1959)

LATIN AMERICA

Leonor Fini (b. 1908)

Frida Kahlo (1910-1954)

ENGLISH

Elizabeth Thompson (Lady Butler) (c. 1850-1933)

Gwen John (1876-1939)

Vanessa Bell (1879-1961)

Barbara Hepworth (1903-1975)

Leonora Carrington (b. 1917)

Bridget Riley (b. 1931)

AMERICAN

Mary Cassatt (1844-1926)

Susan MacDowell Eakins (1851-1938)

Cecilia Beaux (c. 1855-1942)

Anna Elizabeth Klumpke (1856-1942)

Florine Stettheimer (1871-1944)

Romaine Brooks (1874-1970)

Gertrude Vanderbilt Whitney (1875-1942)

Meta Vaux Warrick Fuller (1877-1968)

Georgia O'Keeffe (b. 1887)

Marguerite Thompson Zorach (1887-1968)

Malvina Hoffman (1887-1966)

Kay Sage (1893-1963)

Anni Albers (b. 1899)

Louise Nevelson (b. 1899)

Alice Neel (b. 1900)

Isabel Bishop (b. 1902)

Lois Mailou Jones (b. 1905)

Irene Rice Pereira (1907-1971)

Lee Krasner (b. 1908)

Loren MacIver (b. 1909)

Dorothea Tanning (b. 1910)

Louise Bourgeois (b. 1911)

Elaine de Kooning (b. 1920)

Grace Hartigan (b. 1922)

Nell Blaine (b. 1922)

Jane Wilson (b. 1922)

Joan Mitchell (b. 1926)

Helen Frankenthaler (b. 1928)

Marisol (Escobar) (b. 1930)

Niki de Saint Phalle (b. 1930)

Lee Bontecou (b. 1931)

Lila Katzen (b. 1932)

Varda Chryssa (b. 1933)

Eva Hesse (1936-1970)

Audrey Flack

Idelle Weber

Joan Semmel

Diane Burko

Janet Fish

Catherine Murphy

Ellen Lanyon

May Stevens

Sylvia Sleigh

Shirley Gorelich

Miriam Schapiro

Judy Chicago

Mary Miss

Michelle Stuart

Lynda Benglis

Joyce Kozloff

June Wayne

Howardena (Doreen) Pindell

Joan Snyder

Jennifer Bartlett

Nancy Graves

Betye Saar

Nancy Grossman

Mary Frank

Barbara Chase-Riboud

Jackie Winsor

Faith Ringgold

Alice Aycock

Patricia Johanson

Rosemary Mayer

Eleanor Antin

Nancy Spero

Muriel Castanis

Juliette Gordon

Deborah Butterfield

Ida Kohlmeyer

June Blum

Sharon Wybrants

Barbara Zucker

Charmion von Wiegan

Mary Beth Edelson

Jane Kauffman

Kay Hines

Stephanie Brody Lederman

Ida Applebroog

Judith Shea

Patsy Norvell

Cecile Abish

Martha Edelheit

Anne Truitt

Ilse Greenstein

Ree Morton

Agnes Denes

Lynn Hershman

Dotty Attie

Valerie Jaudon

Mary Grigoriadis

Nancy Spero

Blythe Bohnen

Anne Healy

Hannah Wilke

Suzanne Lacy

Laurie Anderson

III. SOME WOMEN SCULPTORS

Sabina von Steinbach

Properzia di Rossi

Louisa Roldan

Anne Seymour Damer

Felicie de Fauveau

Harriet Hosmer

Florence Freeman

Margaret Foley

Edmonia Lewis

Barbara Hepworth

Germaine Richier

Louise Nevelson

Marisol

Niki de Saint Phalle

Lee Bontecou

Gertrude Vanderbilt Whitney

Eva Hess

Lila Katzen

Mary Miss

Alice Aycock

Betye Saar

Nancy Grossman

IV. SOME WOMEN GRAPHIC ARTISTS

Ida van Meckenen

Diana Ghisi

Sirani

Merian

Kauffman

Cosway

Kate Greenaway

Mary Cassatt

Kathe Kollwitz

Valadon

Laurencin

Modersohn-Becker

Munter

Vieira da Silva

L. Finni

Nevelson

June Wayne

V. SOME WOMEN PHOTOGRAPHERS

Julia Margaret Cameron (1815-1874)

Gertrude Kasebier (1852-1934)

Frances Benjamin Johnston (1864-1952) (feminist)

Imogen Cunningham (b.1833)

Hannah Hoch (1889-1971)

Dorothea Lange (1895-1965)

Berenice Abbott (b. 1898)

Tina Modotti (1886-1942)

Barbara Morgan (b. 1900)

Margaret Bourke-White (1904-1971)

Diane Arbus (1923-1971)

Alisa Wells (b. 1929)

Judy Dater (b. 1941)

Bea Nettles (b. 1946)

Helen Levitt

Eve Arnold

Louise Dahl-Wolfe

Gisele Freuna

Laura Gilpin

Lotte Jacobi

Lisette Model

Ruth Orkin

Marion Palfi

Doris Ulmann

Marion Post Wolcott

VI. SOME BLACK WOMEN ARTISTS

Gwendolyn Bennett

Selma Burke

Elizabet Catlett

Barbara Chase-Riboud

Minnie Evans

Meta Warrick Fuller

Clementine Hunter

Lois Mailou Jones

Edmonia Lewis

Howardena Pindell

Faith Ringgold

Betye Saar

Augusta Savage

Alma Thomas

Laura Wheeler Waring

Samella Lewis

VII. SOME NATIVE AMERICAN WOMEN ARTISTS

Tonita Vigil Pena

Lois Smoky

Pablita Velarde

Helen Hardin

Pop Chalee

Yeffe Kimball

Linda Lomahaftewa

Phylis Fife

Joan Hill

Ruth Blalock Jones

Virginia Stroud

Valjean McCarty Hessing

Jaune Quick-To-See Smith

Amanda Crowe

Veronica Cruz

Maria Martinez

Helen Codera

VIII. SOME CHICANO/LATINA WOMEN ARTISTS

Margaret Herrera Chavez

Consuelo Amezcua

Consuelo Gonzales Amezcua

Judith F. Baca

Judithe E. Hernandez

Carmen Lomas Garza

Las Mujeres Muralistas

Eloisa Castellanos-Sanchez

Susana Lasta

Luchita Hurtado

Ana Mendieta

IX. SOME ARTISTS ASSOCIATED WITH THE WOMEN'S ART MOVEMENT

Nancy Spero

Muriel Castanis

Juliette Gordon

Faith Ringgold

Judy Chicago

Deborah Butterfield

Ida Kohlmeyer

Joyce Kozloff

June Blum

Shirley Gorelick

Sharon Wybrants

Miriam Schapiro

Barbara Zucker

Eleanor Antin

Mary Beth Edelson

Jane Kauffman

Kay Hines

Stephanie Brody Lederman

Ida Applebroog

Judith Shea

Patsy Norvell

Mary Miss

Jackie Winsor

Cecile Abish

Alice Neel

Ilse Greenstein

Sylvia Sleigh

May Stevens

Alice Aycock

Ree Morton

Lynn Hershman

Betsy Damon

Lee Bontecou

Louise Bourgeois

Valerie Jaudon

Dotty Attie

Mary Grigoriadis

Blythe Bohnen

Hannah Wilke

Anne Healy

Suzanne Lacy

Laurie Anderson

Charlotte Robinson

Rosemary Wright

APPENDIX B:

Women's Publications for Art Education

(Compiled by Mary Ann Stankiewicz and Enid Zimmerman)

I. BOOKS AND SOME IMPORTANT ARTICLES PUBLISHED BEFORE 1960 BY WOMEN ART EDUCATORS AND WOMEN WRITING IN FIELDS RELATED TO ART EDUCATION

Addams, Jane. "The Art-Work Done by Hull-House, Chicago." *The Forum* 19 (July 1895): 614-617.

_____. *Twenty Years at Hull-House.* New York: The New American Library, 1910.

Alschuler, Rose H., and Hatwick, LaBerta. *Painting and Personality.* 2 vols. Chicago: University of Chicago Press, 1947.

Beecher, Catharine E., and Stowe, Harriet Beecher. *The American Woman's Home: or, Principles of Domestic Science.* New York: J. B. Ford and Company, 1869.

Berry, Anna. *Art for Children.* New York: Studio, Pub., 1947.

Bland, Jane Cooper. *Art of the Young Child.* New York: Museum of Modern Art, 1957.

Boas, Belle. *Art in the School.* Garden City, N.Y.: Doubleday, Doran & Company, Inc., 1924.

Cane, Florence. *The Artist in Each of Us.* New York: Pantheon, 1951.

Cole, Natalie Robinson. *The Arts in the Classroom.* New York: The John Day Company, 1940.

Dwight, Mary Ann. *Introduction to the Study of Art.* New York: D. Appleton & Company, 1856; microfilm reprint, Ann Arbor: University Microfilm, American Culture Series, reel 27: 3.

_____. "Art.—Its Importance as a Branch of Education." [Barnard's] *The American Journal of Education* 2-4 (September 1856, December 1856, June 1857, September 1857): 409-418, 587-592, 467-476, 191-198.

Ellsworth, Maude. *Art for the High School.* Syracuse, N.Y.: L.W. Singer, Co., 1957.

_____, and Andrews, Michael F. *Growing with Art.* Chicago: Benjamin H. Sanborn & Co., 1950.

Emery, Mabel Sarah. *How to Enjoy Pictures.* Boston: Prang Education, Co. 1898.

Goldstein, Harriet, and Goldstein, Vetta. *Art in Everyday Life.* New York: Macmillan, 1925.

Goodenough, Florence L. *Measurement of Intelligence by Drawings*. New York: World Book Co., 1926.

Harrison, Elizabeth. *Self-Expression through Art*. Toronto: Gage, 1951.

Hartman, Gertrude, and Shumaker, Ann, eds. *Creative Expression*. New York: John Day Co. or Reynale Hitchcook, 1932.

Hicks, Mary Dana. "Color in Public Schools." *Proceedings of the National Educational Association Convention, Asbury Park, N.J., 1894*. St. Paul, Minnesota: National Education Association, 1895.

Hurll, Estelle May. *How to Show Pictures to Children*. Boston: Houghton Mifflin Co., 1914.

Kainz, Luise C., and Riley, Olive L. *Exploring Art*. New York: Harcourt, Brace, and Co., 1947.

Kramer, Edith. *Art Therapy in a Children's Community: A Study of the Function of Art Therapy in the Treatment Program of Wiltwyck School for Boys*. Springfield, Ill.: Charles C. Thomas, 1958.

Landis, Mildred M. *Meaningful Art Education*. Peoria, Il.: Chas. A. Bennett Co., Inc., 1951.

Lindstrom, Miriam. Children's Art: *A Study of Normal Development in Children's Modes of Visualization*. Berkeley, California: University Press, 1957.

MacDonald, H. Rosabell. *Art as Education*. New York: Henry Holt & Co., 1941.

Mathias, Margaret E. *Art in the Elementary School*. New York: Charles Scribner's Sons, 1929.

———. *The Beginnings of Art in the Public Schools*. New York: Charles Scribner's Sons, 1924.

———. *The Teaching of Art*. New York: Charles Scribner's Sons, 1932. Columbia University Press, 1932.

Mellinger, Bonnie Eugenie. *Children's Interest in Pictures*. New York: Columbia University Press, 1932.

Naumburg, Margaret. *Child and the World: Dialogues in Modern Education*. New York: Harcourt, 1928.

Richardson, Marion. *Art and the Child*. Peoria, Illinois: Charles A. Bennett, 1952.

Tannahill, Sallie B. *Fine Arts for Public School Administrators*. New York: Teachers College, Columbia University, 1932.

———. *P's and Q's, A Book on the Art of Letter Arrangement*. Garden City, NY: Doubleday, Doran & Company, Inc., 1923.

Urbino, Mme. Levina Buoncuore (Mrs. S.R.). *Art Recreations*. Boston: J.E. Tilton, 1864; microfilm reprint, Ann Arbor: University Microfilm, American Culture Series, reel 42: 7.

II. BOOKS PUBLISHED AFTER 1960 BY WOMEN ART EDUCATORS

(1) Art Making Processes and Art Appreciation

Anderson, Yvonne. *Teaching Film Animation to Children*. New York: Van Nostrand Reinhold, 1971.

Betts, Victoria B. *Exploring with Finger Paint*. Worcester, Massachusetts: Davis Publishing Co., Inc., 1962.

Blumenean, Lili. *Creative Design in Wall Hanging.* New York: Crown Publishing Co., 1967.

Campbell, Ann. *Let's Find Out About Color.* New York: Watts, 1966.

Chase, Alice E. *Looking at Art.* New York: Crowell, 1966.

Enthoven, Jacqueline. *Stitchery for Children.* New York: Reinhold Book Corp., 1968.

Erickson, Janet, and Sproul, Adelaide. *Printmaking without a Press.* New York: Reinhold Publishing Corp., 1966.

Guyler, Vivian. *Design in Nature.* Worcester, Massachusetts: Davis Publications, 1970.

Harvey, Virginia. *The Art of Creative Knotting.* New York: Reinhold Publishing Co., 1967.

Holden, Patra. *Photography without a Camera.* New York: Van Nostrand Reinhold, 1972.

Hurwitz, Elizabeth. *Design: A Search for Essentials.* Scranton, Pennsylvania: Internation Textbook Co., 1964.

Laliberte, Norman, and Jones, Maureen. *Wooden Images.* New York: Reinhold Publishing Corp., 1966.

Maile, Ann. *Tie and Dye as a Present-Day Craft.* New York: Reinhold Publishers Corp., 1964.

Meliach, Donna Z. *Creating Art from Anything.* Chicago: Reilly and Lee, 1968.

————. *Contemporary Batik and Tie Dye.* New York: Crown, 1973.

————. *Soft Sculpture.* New York: Crown Publishers, Inc., 1977.

Moseley, Spencer; Johnson, Pauline; and Koeng, Hazel. *Crafts Design: An Illustrated Guide.* Belmont, California: Wadsworth Publishing Co., 1962.

Pile, Naomi. *Art Experiences for Young Children.* New York: Threshold Division, Macmillan, 1972.

Rainey, Sarita. *Weaving without a Loom.* Worcester: Davis Publishing, 1968.

Timmons, Virginia G. *Painting in the School Program.* Worcester, Massachusetts: Davis Publishing Co., Inc., 1962.

Wankelman, Willard F.; Wigg, Philip; and Wigg, Marietta. *A Handbook of Arts and Crafts for the Elementary and Junior High School Teacher.* 2nd ed., Dubuque, Iowa: Wm. C. Brown Co., 1968.

(2) Art and Child Development

Golumb, Claire. *Young Children's Sculpture and Drawing: A Study in Represenational Development.* Cambridge, Massachusetts: Harvard University Press, 1974.

Goodnow, Jacqueline. *Children Drawing.* Cambridge, Massachusetts: Harvard University Press, 1977.

Kellogg, Rhoda. *Analyzing Children's Art.* Palo Alto, California: Mayfield, 1970.

————, and O'Dell, Scott, *The Psychology of Children's Art.* New York: CRM - Random House Publication, 1967.

Yochim, Louise D. *Perceptual Growth in Creativity.* Scranton, Pennsylvania: International Textbook Co., 1967.

(3) Curriculum and Methods of Teaching Art

Barkan, Manuel, and Chapman, Laura H. *Guidelines for Art Instruction through Television for the Elementary Schools.* Bloomington, Indiana: National Center for School and Television, 1967.

_____. Chapman, Laura H.; and Kern, Evan J. *Guidelines: Curriculum Development for Aesthetic Education.* Aesthetic Education Curriculum Program: CEMREL, Inc., 1970.

Brouch, Virginia M. *Art Education: A Matrix System for Writing Behavioral Objectives.* Phoenix: Arbo Publishing Co., 1973.

Chapman, Laura H. *Approaches to Art in Education.* New York: Harcourt, Brace, Jovanovich, 1978.

Churchill, Angiola R. *Art for Preadolescents.* New York: McGraw-Hill, 1971.

Cole, Natalie Robinson. *Children's Art from Deep Down Inside.* New York: John Day, 1966.

Dimondstein, Geraldine. *Exploring the Arts with Children.* New York: Macmillan, 1974.

Edwards, Betty. *Drawing on the Right Side of the Brain.* Los Angeles: J.P. Tarcher, 1979.

Greenberg, Pearl. *Art and Ideas for Young People.* New York: Van Nostrand Reinhold, 1970.

_____. *Children's Experiences in Art: Drawing and Painting.* New York: Van Nostrand Reinhold, 1966.

_____. *Art Education: Elementary.* Washington, D.C.: National Art Education Association, 1972.

Herberholz, Donald W., and Herberholz, Barbara. *A Child's Pursuit of Art.* Dubuque, Iowa: William C. Brown, 1967.

Herberholz, Barbara. *Early Childhood Art.* Dubuque, Iowa: William C. Brown, 1974.

Jefferson, Blanche. *Teaching Art to Children: Content and Viewpoint.* 3rd ed. Boston; Allyn and Bacon, 1969.

Knudsen, Estelle S. *Children's Art Education.* Peoria, Illinois: Charles A. Bennett, 1971.

Lally, Ann M., ed. *Art in the Secondary School.* Washington, D.C.: National Art Education Association, 1961.

Lark-Harovitz Betty; Lewis, Hilda P.; and Luca, Mark, *Understanding Children's Art for Better Teaching.* Columbus, Ohio: Charles E. Merrill Books, 1967.

Lewis, Hilda P., ed. *Child Art: The Beginnings of Self-Affirmation.* Berkeley, California: Diablo Press, 1966.

_____. ed. *Art for the Preprimary Child.* Washington, D.C.: National Art Education Association, 1977.

Merritt, Helen. *Guiding Free Expression in Children's Art.* New York: Holt, Rinehart, and Winston, 1964.

McFee, June K. *Preparation for Art.* 2nd ed. Belmont, California: Wadsworth Publishing Co., 1970.

_____, and Degge, Rogena M. *Art, Culture and Environment: A Catalyst for Teaching.* Dubuque, Iowa: Kendall/Hunt, 1980.

Packwood, Mary, ed. *Art Education in the Elementary School.*

Washington, D.C.: National Art Education Association, 1967.

Paterakis, Angela, ed. *Art Education: Senior High School*. Washington, D.C.: National art Education Association, 1972.

Wilson, Marjorie, and Wilson, Brent. *Teaching Children to Draw: A Guide for Teachers and Parents*. Englewood Cliffs, New Jersey: Prenctice-Hall, Inc., 1982.

(4) Policy Criticism and Feminist Issues

Chapman, Laura H. *Instant Art, Instant Culture: The Unspoken Policy for American Schools*. New York: Teachers College Press, 1982.

Loeb, Judy, ed. *Feminist Collage: Educating Women in the Visual Arts*. New York: Teachers College Press, 1979.

MacGregor, Nancy P., ed. *A Critique: Competency and Art Education*. Columbus, Ohio: Ohio State University Press, 1977.

_____, ed. *The Arts 9: The Present, Past, and Future of Art Education*. Columbus, Ohio: Ohio State University Press, 1977.

Zimmerman, Enid, and Stankiewicz, Mary Ann. *Women Art Educators*. Bloomington, Indiana: Mary Rouse Memorial Fund, 1982.

(5) Student Textbooks

Clark, Gilbert, and Zimmerman, Enid. *Art/Design: Communicating Visually*. Blauvelt, New York: Art Education, Inc., 1978.

Gardner, Helen. *Art through the Ages*. 4th ed. New York: Harcourt, Brace and Co., 1957.

Hubbard, Guy, and Rouse, Mary. *Art 1-6: Meaning, Method and Media*, 6 vols. Westchester, Illinois: Benefic, Press, 1972.

_____, and Zimmerman, Enid. *Artstrands: A Program of Individualized Art Instruction* Chicago: Waveland Press, Inc., 1982.

Morman, Jean Mary. *Art: Of Wonder and a World*. Revised ed. Blauvelt, New York: Art Education, Inc., 1978.

_____. *Art: Tempo of Today*. Revised ed. Blauvelt, New York: Art Education, Inc., 1978.

(6) Art for Special Populations

Anderson, Frances E. *Art for All the Children: A Creative Sourcebook for the Impaired Child*. Springfield, Illinois: Charles E. Thomas, 1978.

_____. Colchado, Jose D., and McAnally, Pat, eds. *Art for the Handicapped*. Normal, Illinois: Illinois State University, 1979.

Atack, Sally M. *Art Activities for the Handicapped: A Guide for Parents and Teachers*. Englewood Cliffs, New Jersey: Prentice Hall, Inc., 1982.

Baumgartner, Bernice, and Schultz, Joyce. *Reaching the Retarded through Art*. Johnstown, PA.: Mafex Associations, Inc., 1965.

Fitzner, Dale; Greenberg, Pearl; and Hoffman, Donald, eds. *Lifelong Learning and the Visual Arts: A Book of Readings*. Reston, Virginia: National Art Education Association, 1980.

Kramer, Edith. *Art as Therapy with Children*. New York: Schocken Books, 1971.

Lindsay, Zaidee. *Learning about Shape - Creative Experience for Less Able*

Children. New York: Taplinger Publishing Co., 1970.

————. *Art is for All.* New York: Taplinger Publishing Co., 1967.

Naumburg, Margaret. *Dynamically Oriented Art Therapy.* New York: Grune and Stratton, 1966.

————. *An Introduction to Art Therapy.* New York: Teachers College Press, 1973.

Sussman, Ellen J. *Art Projects for the Mentally Retarded Child.* Springfield, Illinois: Charles C. Thomas, 1970.

Winsor, Maryann T. *Arts and Crafts for Special Education.* Belmont, California: Lear Siegler/Fearon, 1972.

(7) Young Reader's Books About Art

Chase, Alice E. *Famous Paintings.* New York: Platt and Munk, 1962.

Downer, Marion. *The Story of Design.* New York: Lothrop, Lee and Shepard, 1963.

————. *Roofs over America.* New York: Lothrop, Lee and Shepard, 1967.

————. *Children in the World's Art.* New York: Lothrop, Lee and Shepard, 1967.

Glubok, Shirley. *The Art of Ancient Egypt.* New York: Atheneum, 1962.

————. *The Art of Ancient Greece.* New York: Atheneum, 1963.

————. *The Art of the Lands of the Bible.* New York: Atheneum, 1963.

————. *The Art of Ancient Rome.* New York: Harper and Row, 1964.

————. *The Art of the Eskimo.* New York: Harper and Row, 1964.

————. *The Art of the North American Indian.* New York: Harper and Row, 1964.

Gracza, Margaret. *The Ship and the Sea in Art.* Minneapolis: Lerner Publishing Co., 1964.

————. *The Bird in Art.* Minneapolis: Lerner Publishing Co., 1965.

Hoban, Tana. *Shapes and Things.* New York: The MacMillan Co., 1970.

Katz, Herbert, and Katz, Marjorie, *Museum Adventures.* New York: Coward - McCann, Inc., 1969.

Lerner, Sharon. *The Self-Portrait in Art.* Minneapolis: Lerner Publishing Co., 1964.

MacAgy, Douglas, and MacAgy, Elizabeth. *Going for a Walk with a Line: A Step into the World of Modern Art.* Garden City, New York: Doubleday & Co., Inc., 1959.

Moore, Janet G. *The Many Ways of Seeing.* New York: World Publishing Co., 1968.

Munro, Eleanor C. *The Golden Encyclopedia of Art.* New York: Golden Press, Inc., 1961.

Riley, Olive L. *Your Art Heritage.* 2nd ed. New York: McGraw-Hill, 1963.

Spencer, Cornelia. *Made in Japan.* New York: Alfred A. Knopf, 1963.

————. *Made in the Renaissance.* New York: E.P. Dutton, 1963.

————. *How Art and Music Speak to Us.* Revised ed. New York: John Day, 1968.

Young, Mary. *Singing Windows: The Stained Glass Windows of Chartres.* New York: Abington Press, 1962.

Zuelke, Ruth. *The Horse in Art.* Minneapolis: Lerner Publishing Co., 1964.

APPENDIX C:

Questions That Those Concerned With Non-Sexist Art Education Should Ask*

Ann Sherman

1. Do you generally rely upon girls to perform the helping activities in the classroom (e.g. passing out supplies, collecting work, etc.)? (Belotti, 1978)
2. Do you generally rely upon boys to perform duties such as moving tables, mixing batches of slip, pulling down the screen, etc.& (Belotti, 1978)
3. Do you discourage disproportionate selfish and helping behavior in children of both sexes? (Belotti, 1978)
4. When showing female and male nudes, do you discuss the role of the observer and the idea of person as object? Do you discuss how these ideas have been influenced by the mass media as well as the fine arts? Do you discuss the implications of these conceptions for the development of self concept and body image in boys and girls? (Berger, 1974)
5. Do you examine the gender stereotypes present in mass media images? (Goffman, 1979)
6. Do you find differences between the statements that boys and girls make about theirs and others' work? Do both groups use statements which encompass expressive and technical aspects?
7. Are students made aware of female and male role models in the arts and arts education?
8. Is work in the arts seen by both sexes as crucial to self development as well as to a possible vocational choice? (Kuhn, 1980)
9. Do you find differences in the willingness and ways in which males and females respond to working on group art projects? (Kuhn, 1980)
10. Are the individual social experiences (including gender specific ones) of each student taken into account and their expression encouraged in discussions and judgments of students' work and ideas? (Sandell, 1980)
11. If necessary, are males and females allowed to first talk separately about

*Following each question are references to sources which directly or indirectly cover the topic addressed by the question. These references are merely suggestive and certainly not exhaustive. Furthermore, each question should be followed by the question: Do you provide experiences which allow both genders to acquire these skills?

their art work and the experiences which inspired it? (Sandell, 1980; Collins, 1978)

12. When studying art history, is the question: "Why have there been no great women artists?" raised? (Nochlin, 1973)

13. Are those theories of art education which are based on the work of sexist philosophers and psychologists (i.e. Rousseau, Aristotle, and Freud) carefully examined? (Whitbeck, 1976)

14. Are males and females encouraged to develop and express ideas and fantasies about their own bodies and others which transcend mass media stereotypes? (Whitbeck, 1976)

15. In art historical examples of female muses and male artists, do you point out that the "feminine" quality of joining together or relating (in these two cases linking artist to divine or to creativity) is not necessarily only a quality of men? (Whitbeck, 1976)

16. When art historical examples of Adam and Eve are shown, is the idea of woman as seducer of man to evil and the role that this and other myths have had in creating stereotypes of women, discussed? (Berger, Whitbeck, 1976)

17. At the administrative and higher education levels are women art educators seen as subversive to the political system or as potential contributors? (Pateman, 1980)

18. Do you tend to label disorderly qualities in art work and art education as feminine and attribute them to women? (Pateman, 1980)

19. Do you find many female students choosing "earthy" colors and subject matter from nature? Are connections to notions of "mother nature," females' "natural" tie to irrational nature, and so forth discussed in terms of both their positive and negative roles in women's development? (Pateman, 1980)

20. Are there differences between girls' and boys' level of moral development as revealed in the stealing of art supplies, caring for others' feelings during a critique, etc.? (Golding & Laidlaw, 1979; Gilligan, 1977; Kohlberg, 1966)

21. When you discuss the emotions portrayed in works of art, are the gender role implications of these traced?

22. Do you find females less willing than males to become involved in "dirty" activities like working with clay? Are possible ties with the idea of cleanliness and purity as elite feminine qualities discussed? (Pateman, 1980)

23. Do you find differences between the tendency of males and females to choose the themes of justice or love? Are females encouraged to explore conceptions of justice and males encouraged to explore conceptions of love? (Pateman, 1980)

24. Do you avoid the responsibility of countering sexist attitudes by viewing them as a natural part of the society's framework which students expect you to reinforce? Do you maintain a similar position with regard to racist attitudes or attitudes about the frivolity of the arts? (Ricks & Pycke, 1973)

25. Do you reward dependency in girls but not in boys? (Levitne & Chananine, 1972)

26. Do you pay more attention to boys than girls when they are *not* within close range but pay equal attention to boys and girls when they are close by? (Servin, O'Leary, Kent & Tonick, 1973)

27. How do you handle girls and boys who underestimate their abilities? Do you find this problem equally distributed across genders? (Crandall, et al., 1962)

28. Do both genders receive negative as well as positive evaluations? (Jackson & Lahademe, 1967)

29. When girls perform exceptionally well, do you reinforce their good work habits or their agreeable dispositions? (Sears & Feldman, 1966)

30. Do both genders receive rewards for creative (i.e. innovative) behavior? Do you consider that students may be less likely to exhibit such behavior in a sphere which they see as gender specific? (Torrance, 1965)

31. Do you find that males excel over females in gross motor responses to direct visual stimuli? (Shephard, 1958; Noble & Hays, 1966; Fairweather & Hutt, 1972)

32. Do you find that females excel over males in fine motor responses to semantic or symbolic material? (Tyler, 1965; Garai & Scheinfield, 1968; Fairweather & Hutt, 1972)

33. Do you find that females excel in their tactile sensitivity?(Axelrod, 1959; Weinstein & Sersen, 1961; Ippolitiov, 1972)

34. Given possible connections between tactile sensitivity and fine motor dexterity, are experiences provided for both genders in this area?

35. Do you find that females are better able to discriminate intense sounds in music and speech? (Eagles et al, 1963; Hull et al. 1971; McGuinness, 1972; Elliot, 1971; Zaner, 1968; Watson, 1969; Simner, 1977; Kagan & Lewis, 1965)

36. Do you find differences in the visual sensitivity of males and females in light versus dark conditions (especially during and after mid teens)? (Burg & Hulbert, 1961; Burg, 1966; Skoff & Polick, 1969; McGuinness, 1977)

37. Do you find that females appear more sensitive to the long-wave spectrum of light? (McGuinness & Lewis, 1977)

38. Do you find males more adept than females in performing rapid reversals of reversable figures? (Garia & Scheinfeld, 1968; Immergluck & Mearini, 1969)

39. Do you find differences between genders in the interest in and discriminating ability of faces? (Lewis, et al, 1966; Lewis, 1969; Fagan, 1972)

40. More specifically, do you find differences between genders in the ability to discriminate between realistic and unrealistic line drawings, between photographs of people of different ages and sex, and between photographs of two similar faces? (Fagan, 1972)

41. Do you find males more likely than females to prefer blinking lights, geometric patterns, colored photographs of objects, and three-dimensional objects? (Meyers & Cantor, 1967; McCall & Kagan, 1970; Pancratz & Cohen, 1970; Kagan & Lewis, 1965; Cornell & Strauss, 1973)

42. Do you find that girls respond to visual stimuli with social meaning, whereas boys are particularly responsive to non-social visual input? (McCall & Kagan, 1970; Pancratz & Cohen, 1970; Cornell & Strauss,

1973)

43. If you have access to stereoscopic equipment, do you find presenting photographs of objects paired with photographs of people results in differences between males' and females' responses? (McGuinness & Symonds, 1977)

44. Do you find that males are more likely than females to associate an action with an object? (McGuinness & Symonds, 1977)

45. Do you find differences between males and females in their ability to remember visual and/or verbal information? (Guilford, 1967)

46. Do you find that females show more of an analytic (i.e. complex descriptive) attitude towards social relationships than males? (Lively & Bromley, 1973; Little, 1968; Yarrow & Campbell, 1963)

47. Do you find that females tend to be more field dependent than males in terms of visual discrimination? (Witkin, et al, 1962)

48. Do you find that males perform better than females on tasks which require manipulating objects and/or breaking set (restructuring)? (Greenberg, et al, 1971; Hutt, 1972)

49. Do you find that girls are especially attracted to highly saturated reds? (Child, Hansen & Hornbeck, 1967)

50. On specific hue comparisons (e.g. purple-blue and yellow) do you find girls consistently prefer the 'cooler' color? (Child, Hansen & Hornbeck, 1967)

51. Do you find that the differences between boys' and girls' preferences for high chroma colors increases with age with both groups increasingly preferring higher chroma colors? (Child, Hansen & Hornbeck, 1967)

52. Do you find girls preferring colors of higher value than boys? (Child, Hansen & Hornbeck, 1967)

REFERENCES AND ADDITIONAL SOURCES

S. Axelrod, *Effects of early blindness: Performance of blind and sighted children on tactile and auditory tasks.* New York: American Foundation for the Blind, 1959.

D. Bachmann, & S. Piland, *Women artists: an historical, contemporary and feminist bibliography.* New Jersey: Metuchen, 1978.

E.G. Belotti, *What are little girls made of?* New York: Schocken Books, 1978.

J. Berger, (Producer). *Ways of seeing: painting, nudes and women.* New York: Time-Life Films, 1974. (Film)

R. Bolton-Smith, & W. Truettner, *Lily Martin Spencer, 1822-1902, the joys of sentiment.* Washington, D.C., 1973.

A. Burg, Visual acuity as measured by dynamic and static tests: a comparative evaluation. *Journal of Applied Psychology,* 1966, 50, 460-466.

A. Burg, & S. Hulbert, Dynamic visual acuity as related to age, sex and static activity. *Journal of Applied Psychology,* 1961, 45, 111-116.

A. Callen, *Women artists of the arts and crafts movement: 1870-1914.* Patnean Books, 1979.

J. Chicago, *Through the flower: My Struggle as a woman artist.* New York: Doubleday, 1973.

G. Collins, Reflections on the head of medusa. *Studies in art education,* 1978, 19 (2), 10-18.

E.H. Cornell, & M.S. Strauss, Infants' responsiveness to compounds of habituated

visual stimuli. *Developmental Psychology*, 1973, *2*, 73-78.

V.J. Crandall, W. Kathkowsky, & A. Preston, Motivational and ability determinants of young children's intellectual achievement behaviors. *Child Development*, 1962, *33*, 643-661.

E.L. Eagles, S.M. Wishik, L.G. Doefler, W. Melnick, & H.S. Levine, *Hearing sensitivity and related factors in children*. Pittsburgh: University of Pittsburgh Press, 1963.

J.F. Fagan, Infant recognition memory for faces. *Journal of Experimental Child Psychology*, 1972, *14*, 453-476.

H. Fairweather, & S.J. Hutt, Sex differences in a perceptual motor skill in children. In C. Ounstead & D.C. Taylor (Eds.), *Gender differences: their ontogeny and significance*. Edinburgh: Churchill Livingstone, 1972.

E. Fine, *Women and art*. Montclair, New Jersey: 1978.

C. Fowler, *Contributions of women: art*. Minneapolis: Dillon Press, 1976.

M. Froschl, & J. Williamson, (Eds.), *Feminist resources for schools and colleges: a guide to curricular materials*. New York: Feminist Press, 1977.

J.E. Garai, & A. Scheinfeld, Sex differences in mental and behavioral traits. *Genetic Psychology Monographs*, 1968, *77*, 169-299.

C. Gilligan, In a different voice: women's conceptions of self and morality. *Harvard Educational Review*, 1977, *47*, 481-517.

G. Golding, & T. Laidlaw, Women and moral development: a need to care. *Interchange*, 1979, *10* (2), 95-103.

E. Greenberger, J. O'Connor, & A. Sorensen, Personality, cognitive and academic correlates of problem solving flexibility. *Developmental Psychology*, 1971, *4*, 416-424.

G. Green, *The obstacle race*. New York, 1979.

Guidelines for creating positive sexual and racial images in educational materials. New York: School Division, Macmillan, 1975.

J.P. Guilford, *The nature of human intelligence*. New York: McGraw-Hill, 1967.

A. Harris, & L. Nochlin, *Women artists 1550-1950*. New York: Alfred Knopf, 1979.

E. Hedges, & I. Wendt, *In her own image: women working in the arts*. New York: Feminist Press, 1981. (Text with teaching guide available.)

A. Hinding, (Ed.), *Women's history sources: a guide to archives and manuscript collections in the U.S.* New York: R.R. Bower, 1979.

N. Hoffman, *Woman's "true" profession: voices from the history of teaching*. New York, Feminist Press, 1981. (Text with teaching guide available.)

F.M. Hull, P.W. Mielke, R.J. Timmons, & J.A. Willeford, The national speech and hearing survey: preliminary results. *ASHA*, 1971, *3*, 501-509.

C. Hutt, Neuroendrocrinological behavior and intellectual aspects of sexual differntiation in human development. In C. Ounsted & D.C. Taylor, (Eds.), *Gender differences: their ontogeny and significance*. Edinburgh: Churchill Livingstone, 1972.

L. Immergluck, & M.C. Mearini, Age and sex differences in response to embedded figures and reversible figures *Journal of Experimental Child Psychology*, 1969, *8*, 210-221.

F.V. Ippolitov, Interanalyser differences in the sensitivity-strength parameter for vision, hearing and cutaneous modalities. In V.D. Nebylistyn & J.A. Gray (Eds.), *Biological bases of individual behavior*. London: Academic Press, 1972.

P.W. Jackson, & H.M. Lahademe, Inequalities of teacher-pupil contacts. *Psychology in the schools*, 1967, *4*, 204-211.

J. Kagan, & M. Lewis, Studies of attention in the human infant, *Merrill-Palmer Quarterly*, 1965, *11*, 95-127.

L.H. Kohlberg, Cognitive developmental analysis of children's sex-role concepts and attitudes. In E.E. Maccoby (Ed.), *The development of sex differences*. Stanford: University Press, 1966.

M. Kuhn, The ninth decade: women, work and cultural equity in the art world. In F. Mills & D. Irwing (Eds.), *The visual arts in the ninth decade*. National Council of Art Administration, 1980.

B. LaDuke, *Women and art of third world cultures*. Unpublished manuscript, Oregon State University.

T.E. Levitan, & J.D. Chaananine, Responses of female primary teachers to sex-typed behavior in male and female children. *Child Development*, 1972, *43*, 1309-1316.

M. Lewis, Infants' response to facial stimuli during the first year of life. *Developmen-*

tal Psychology, 1969, *1,* 75-86.

M. Lewis, J. Kagan, & J. Kalafat, Patterns of fixation in the young infant. *Child Development,* 1966, *37,* 331-334.

P.H. Lindsay, Multichannel processing in perception. In D.E. Mostofsky (Ed.), *Attention: contemporary theory and analysis.* New York: Appleton Century Crofts, 1970.

L. Lippard, *From the center: feminist essays on women's art.* New York: E.P. Dutton, 1976.

B.R. Little, Factors affecting the use of psychological versus non-psychological constructs on the repetory test. *Bulletin of British Psychological Society,* 1968, *21,* 34.

W.J. Livesley, & D.B. Bromely, *Person perception in childhood and adolescence.* London: Wiley and Sons, 1973.

J. Loeb, *Feminist collage.* New York: Teachers College, 1979.

E.E. Maccoby, & C.N. Jacklin, *The psychology of sex differences.* Stanford: Stanford University Press, 1974.

D.F. Marks, Visual imagery and differences in the recall of pictures. *British Journal of Psychology,* 1973, *64,* 17-24.

R.B. McCall, Smiling and vocalization in infants as indices of perceptual cognitive processes. *Merrill-Palmer Quarterly,* 1972, *18.*

R.B. McCall, & J. Kagan, Individual differences in the infant's distribution of attention to stimulus discrepancy. *Developmental Psychology,* 1970, *2,* 90-98.

D. McGuinness, Away from a unisex psychology: individual differences in visual perception. *Perception,* 1977.

D. McGuinness, Hearing: individual differences in perceiving. *Perception,* 1972, *1,* 465-473.

D. McGuinness, Sex differences in the organization of perception and cognition. In B. Lloyd & J. Archer (Eds.), *Exploring sex differences.* New York: Academic Press, 1976.

D. McGuinness, & I. Lewis, Sex differences in visual persistence: experiments on the ganzfeld and the afterimage. *Perception,* 1977.

D. McGuinness, & J. Symonds, Sex differences in choice behavior: the object-person dimension. *Perceptual and Motor Skills,* 1977.

E. Munro, *Originals: American women artists.* New York: Simon & Schuster, 1979.

H. Munsterberg, *A history of women artists.* New York: Clarkson N. Potter, 1975.

W.J. Myers, & G.N. Cantor, Observing and cardiac responses of human infants to visual stimuli. *Journal of Experimental Child Psychology,* 1967, *5,* 16-25.

W. Neilson, & F. Neilson, *Seven women: great painters.* Philadelphia, 1969.

L. Nochlin, Why have there been no great women artists? In T. Hess & E. Baker (Eds.), *Art and sexual politics.* New York: Collier Books, 1973.

R.M. Oetzel, Annotated bibliography. In E. Maccoby (Ed.), *The development of sex differences.* London: Taurstock Publications, 1967.

G. O'Keeffe, *Georgia O'Keeffee.* New York: Viking Press, 1978.

C.N. Pancratz, & L.B. Cohen, Recovery of habituation in infants. *Journal of Experimental Child Psychology.* 1970, *9,* 209-216.

C. Pateman, The disorder of women: women, love, and the sense of justice. *Ethics,* 1980, *91,* 20-34.

P.O. Peretti, Cross-sex and cross-educational levels performance in a colorward interference task. *Psychonomic Science,* 1969, *16, 321-324.*

K. Petersen, & J. Wilson, *Women artists.* New York: Harper & Row, 1976.

F. Ricks, & S. Pyke, Teacher perceptions and attitudes that foster or maintain sex role differences. *Interchange,* 1973, *4,* 26-33.

B. Rose, *Frankenthaler.* New York, 1970.

R. Sandell, Female aesthetics: the women's art movement and its aesthetic split. *Journal of Aesthetic Education,* 106-110.

P. Sears, & D.H. Feldman, Teacher interventions with boys and girls. *National Elementary Principal,* 1966, *46,* 30-35.

L. Serbin, K.D. O'leary, R. Kent, & I.A. Tonick, A comparison of teacher response to the preacademic and problem behavior of boys and girls. *Child Development,* 1973, *44,* 796-804.

J. Sherman, Problem of sex differences in space perception and aspects of intellectual functioning. *Pyschological Review,* 1967, *74,* 290-299.

M.L. Simner, Newborn's response to the cry of another infant. *Developmental Psychology*, 1971, *5*, 136-150.

W.E. Simpson, & G.M. Vaught, Visual and auditory autokinesis. *Perceptual and Motor Skills*, 1973, *36*, 1199-1206.

E. Skoff, & R.H. Pollack, Visual acuity in children as a function of hue. *Perception and Psychophysics*, 1969, *6*, 244-246.

J. Snyder-Ott, *Women and creativity*. Millbrae, California: Les Femmes, 1978.

B. Sprung, *Non-sexist education for young children: a practical guide*. New York: Citation Press, 1975. (order from: Women's Action Alliance, 370 Lexington, Ave., New York, NY 10017)

F. Sweet, *Miss Mary Cassatt, Impressionist from Pennsylvania*. Norman, Oklahoma, 1966.

E.P. Torrance, *Rewarding creative behavior: Experiment in classroom creativity*. Englewood Cliffs, New Jersey: Prentice-Hall, 1965.

E. Tufts, *Our hidden heritage: five centuries of women artists*. New York: Paddington, 1974.

L. Tyler, *The psychology of human differences*. New York: Appleton Century Crofts, 1965.

E. Vurpillor, The development of scanning strategies and their relation to visual differentiation. *Journal of Experimental Child Psychology*, 1968, *6*, 632-650.

J.S. Watson, Operant conditioning of visual fixation in infants under visual and auditory reinforcement, *Developmental Psychology*, 1969, *1*, 508-516.

S. Weinstein, & E.A. Sersen, Tactual sensitivity as a function of handedness and laterality. *Journal of comparative and Physiological Psychology*, 1961, *54*, 664-665.

L. Weitzman & D. Rizzo, *Biased textbooks: images of males and females in elementary school textbooks*. Washington, 1974. (order from Resource Center on sex roles in education, 1201 16th Street, N.W., Washington, D.C. 20036).

C. Whitbeck, Theories of sex difference. In C. Gould & Marx Wartofsky (Eds.), *Women and Philosophy*. New York: G.P. Putnam's Sons, 1976.

J. Williamson, *New feminist scholarship: A guide to bibliographies*. Old Westburg, New York: Wiley & Son, 1962.

H.A. Witkin, R.B. Dyk, H.F. Faterson, D.R. Goodenough, & S.A. Karp, *Psychological differentiation*. New York: Wiley & Sons, 1962.

N.R. Yarrow, & D.J. Campbell, Person perception in children. *Merrill-Palmer Quarterly*, 1963, *9*, 57-72.

A.R. Zaner, R.F. Levee, & R.R. Gunta, The development of auditory perceptual skills as a functions of maturation. *Journal of Auditory Research*, 1968, *8*, 313-322.

This article is reprinted from *Art Education*, May 1982, pp. 26-29.

About the Co-authors:

Georgia C. Collins is an Associate Professor in Art Education at the University of Kentucky where she served as Director of Graduate Studies and Chairperson of the Program Faculty in Art Education from 1979 to 1982. She is currently on the Editorial Board of *Studies in Art Education* and Chairperson of the Higher Education Division of the Kentucky Art Education Association. Dr. Collins did undergraduate work in studio at the University of Wisconsin in the 1950s. While raising three children, she returned to school in 1970 to earn her teaching certificate and MA in Education from the University of Kentucky. Prior to receiving her Ph.D. in Art Education from The Ohio State University in 1978, she was a research assistant in the Teacher Corps and taught art at Innisfree School in Lexington, Kentucky. Her dissertation was an historical and philosophical analysis of the value systems associated with art and feminity, and it examined alternative approaches to achieving equality for women in art and art education. Dr. Collins' research and art continue to explore the problematic relationship between women and art education. She has presented papers and taught workshops and courses on this topic, organized slide sharing sessions on behalf of the Women's Caucus of the National Art Education Association, and published articles on women and art in *Studies in Art Education* and the *Journal of Aesthetic Education*. Most recently she has co-authored with Drs. Renee Sandell and Ann Sherman a chapter on the visual arts for the *Handbook for Achieving Sex Equity Through Education* edited by Susan Klein.

Renee Sandell received her BA from The City College of New York and her M.A. and Ph.D. in Art Education from The Ohio State University. From 1975-79, she was on the faculty of the Department of Art Education at The Ohio State University Newark Campus and director of the Newark Campus Art Gallery. In 1980, Dr. Sandell was awarded a fellowship at the National Endowment for the Arts. Working as a consultant for the U.S. Department of Education and the National Endowment for the Arts, she was the production coordinator and designer of the poster/brochure "Federal Guide to Arts Education Assistance," issued in March 1981. She has served as consultant to the Extension Program of the National Gallery of Art, reviewer of federal grants, and juror of art and art education awards. Dr. Sandell has taught at the University of Maryland, and since 1980, has taught courses for the Department of Education, George Washington University. She is currently Adjunct Associate Professor of Art at George Mason University. Dr. Sandell's research, as well as her artistic endeavors, have centered on women, art, and education. Her other research interests include: curriculum development, instructional materials design, arts administration, studio, and elementary art education. She has published articles on women and art in *Studies in Art Education, The Journal of Aesthetic Education* and *Woman's Art Journal*. With Georgia Collins and Ann Sherman, she co-authored a chapter on sex equity in visual arts education in *Handbook for Achieving Sex Equity*

Through Education edited by Susan Klein. Dr. Sandell has taught courses and workshops on women and art; she has regularly presented papers at national, regional, state, and local conferences including those of the NAEA and College Art Association. Renee Sandell has served as editor of *The Report*, newsletter of the NAEA Women's Caucus; she is currently completing her term as president of the NAEA Women's Caucus. Renee Sandell has exhibited her paintings, drawings, and photographs. In addition to her teaching activities, she operates an art education consulting business in her home, which she shares with her economist husband and two preschool sons.

About the Contributors:

Ann L. Sherman earned a B.F.A. from the University of Illinois at Champaign and a Ph.D. in art education from Stanford University with a minor in philosophy. She taught public school art classes in California, served as a research assistant at the Center for Education Research at Stanford, and taught at San Jose State University before joining the faculty at the University of Kansas. Her major research interest involves historical and philosophical investigation into how the separation of reason and emotion has influenced the status of women, art, and education. Dr. Sherman has contributed articles on sex equity, evaluation, and emotions to journals in art education and the philosophy of education. She was president of the NAEA Women's Caucus from 1980-1982.

Mary Ann Stankiewicz received her B.F.A. and M.F.A. degrees in art education from Syracuse University. From 1970 through 1974 she was an elementary art teacher in the public schools of Lenox, Massachusetts. In 1979 she completed her Ph.D. in art education at The Ohio State University. Since receiving the doctorate she has been an assistant professor in the Art Department, University of Maine at Orono, where she teaches a variety of courses in art education and directs the art teacher preparation program. Dr. Stankiewicz' current research interests are in art history and the philosophy of art education in the late 19th and early 20th centuries. With Enid Zimmerman, she co-edited the monograph, *Women Art Educators*. She is historian/archivist for the NAEA Women's Caucus.

Enid Zimmerman is Assistant Professor of Art Education at Indiana University. She has taught art in elementary school and was director of the visual arts program in an art school in New York State. Zimmerman is past president of the NAEA Women's Caucus. In addition to writing about women's issues in art education, she has published a number of articles on art education, has co-authored two art education texts, and has recently completed writing a textbook, *Educating Artistically Talented Students*. She has developed materials about women artists for use in the elementary schools. In 1979 Dr. Zimmerman received the Manuel Barkan Award for an article on curriculum research, co-authored with Gilbert Clark. She has had several one-woman and group shows of her paintings and batik sculptures.